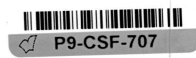

P9-CSF-707

# ANIMALS

## 1419 Copyright-Free Illustrations of Mammals, Birds, Fish, Insects, etc.

A Pictorial Archive from Nineteenth-Century Sources
selected by
JIM HARTER

Dover Publications, Inc.
New York

Copyright © 1979 by Dover Publications, Inc.
All rights reserved under Pan American and International Copyright Conventions.

Published in Canada by General Publishing Company, Ltd., 30 Lesmill Road, Don Mills, Toronto, Ontario.
Published in the United Kingdom by Constable and Company, Ltd.

*Animals: 1419 Copyright-Free Illustrations of Mammals, Birds, Fish, Insects, etc.* is a new work, first published by Dover Publications, Inc., in 1979.

DOVER *Pictorial Archive* SERIES

This book belongs to the Dover Pictorial Archive Series. You may use the designs and illustrations for graphics and crafts applications, free and without special permission, provided that you include no more than ten in the same publication or project. (For permission for additional use, please write to Dover Publications, Inc., 31 East 2nd Street, Mineola, N.Y. 11501.)

However, republication or reproduction of any illustration by any other graphic service whether it be in a book or in any other design resource is strictly prohibited.

*International Standard Book Number: 0-486-23766-4*
*Library of Congress Catalog Card Number: 78-73302*

Manufactured in the United States of America
Dover Publications, Inc.
31 East 2nd Street
Mineola, N.Y. 11501

# PUBLISHER'S NOTE

Artists and designers today are finding that pictures rendered in wood engraving, the nineteenth century's chief illustrative medium, are highly desirable for their own new projects. This elegant black-and-white artwork, which can be simple and bold or can achieve exquisite effects of tonal gradation, sustains no loss in reproduction and is a perfect complement to typography.

Animal illustration, for both instruction and delight, was widely practiced in the era of wood engraving. The pictures in such works as Brehm's *Tierleben* (Animal Life), the source of hundreds of items in the present volume, achieved extremely accurate and lifelike results that were unobtainable by photography at that time— even if the photos could have been reproduced in popularly priced works!

Other major sources for the present selection were *The Pictorial Museum of Animated Nature* (Charles Knight, London), *The Riverside Natural History* (Houghton Mifflin, Boston), *Johnson's Natural History* (Alvin J. Johnson & Son, N.Y.) and the French periodical *La Nature*.

Mr. Harter, himself a distinguished graphic artist, has chosen material that will be of maximum use to artists. For example, while the variety of different species represented is enormous (over a thousand), special attention has been given to the most familiar animals (such as dog, cat, horse, cow, sheep, pig, chicken, pigeon, rabbit, lion, tiger, elephant), which are illustrated in many breeds, poses and activities.

For the majority of animals included, it has been possible to supply current English common names. In many other cases, where precise identification presented great difficulties, a more generalized caption has been used: for example, "a species of sawfish," "a type of duck" or "unidentified beetle." The pictorial interest of these illustrations fully warrants their inclusion, and the generalized identification will certainly be adequate for most purposes.

The extensive index will aid you in locating the type of animal you are looking for and—in hundreds of instances—such very specific animals as "side-striped jackal," "great black-backed gull," "criss-cross butterfly-fish" or "Reinwardt's gliding frog."

# CONTENTS

*Page Nos.*

MAMMALS       1 - 97

BIRDS       98 - 167

REPTILES       168 - 198

AMPHIBIANS       199 - 206

FISH       207 - 233

INSECTS       234 - 257

OTHER INVERTEBRATES       258 - 279

INDEX       281 - 284

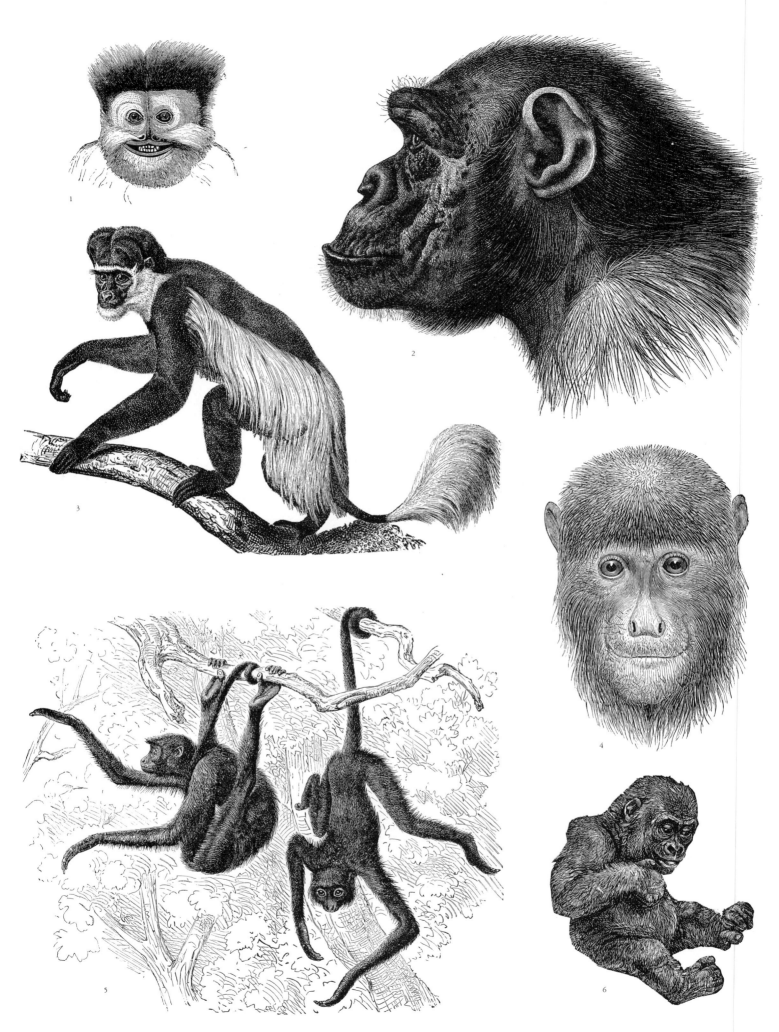

**MAMMALS.** 1: A type of monkey. 2: Chimpanzee. 3: Colobus monkey. 4: A type of macaque. 5: Spider monkeys. 6: Baby gorilla.

**MAMMALS.** **7:** Fanciful orangutan. **8:** Fanciful ape. **9:** Hand of anthropoid ape. **10:** Type of baboon.

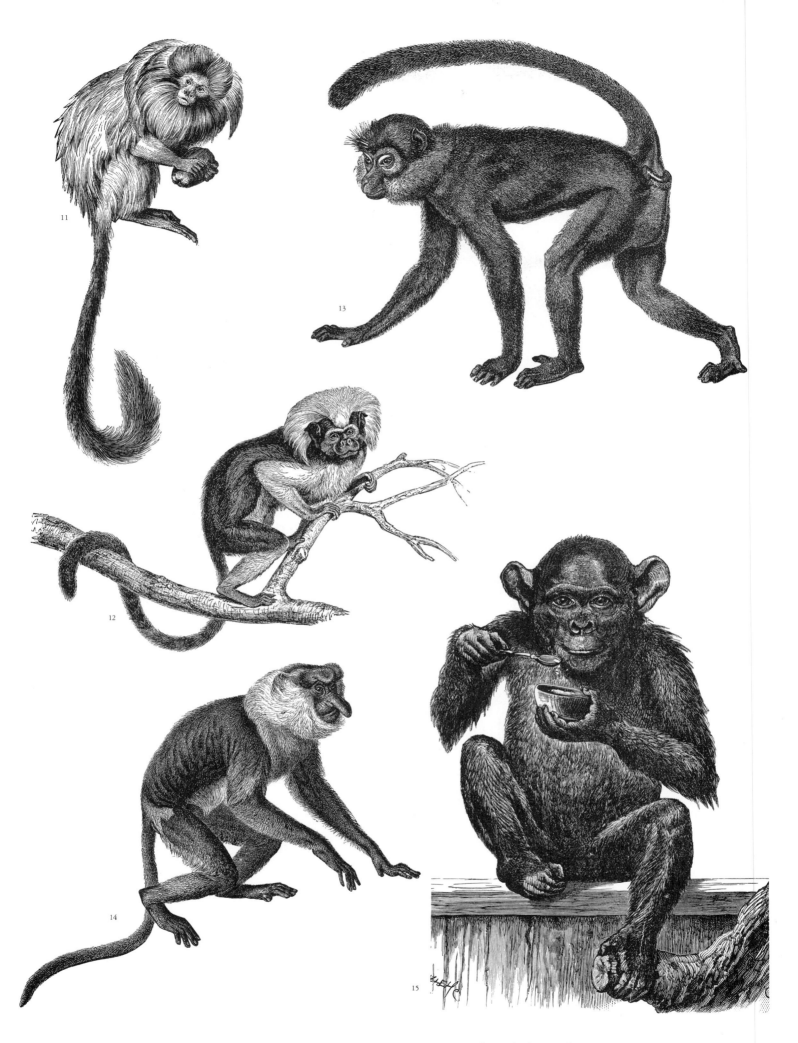

**MAMMALS. 11:** Golden marmoset. **12:** Tamarin monkey. **13:** A type of mangabey. **14:** Proboscis monkey. **15:** Young chimpanzee.

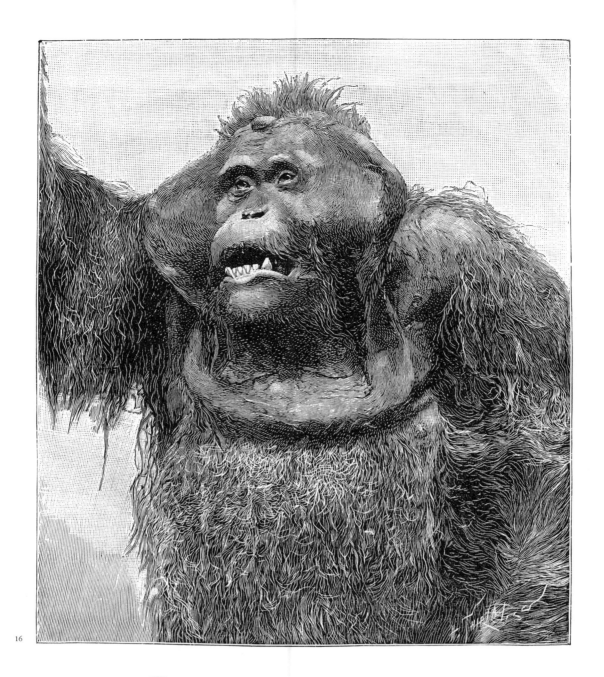

**MAMMALS. 16:** Orangutan. **17:** Squirrel monkey. **18:** Entellus or Hanuman monkey.

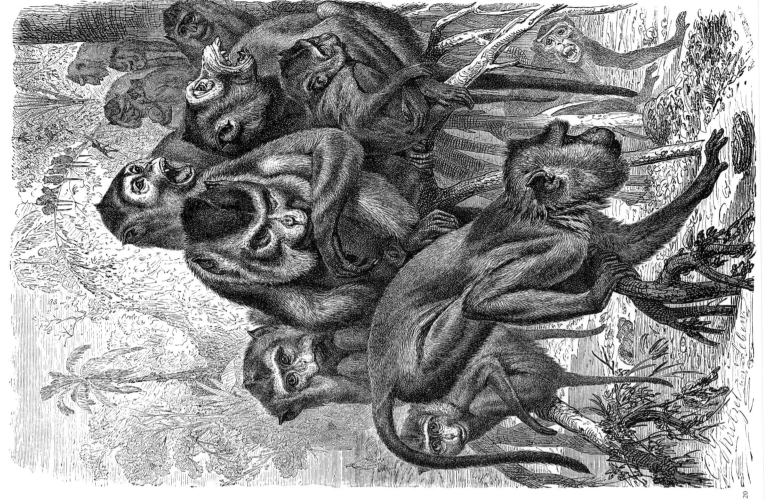

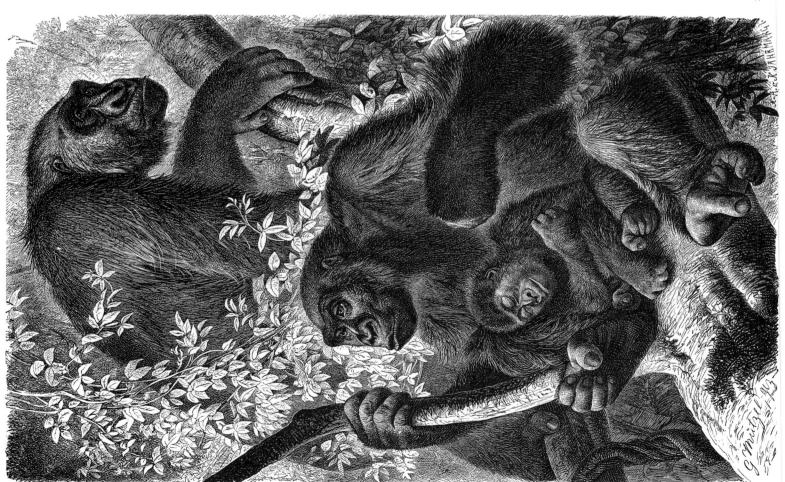

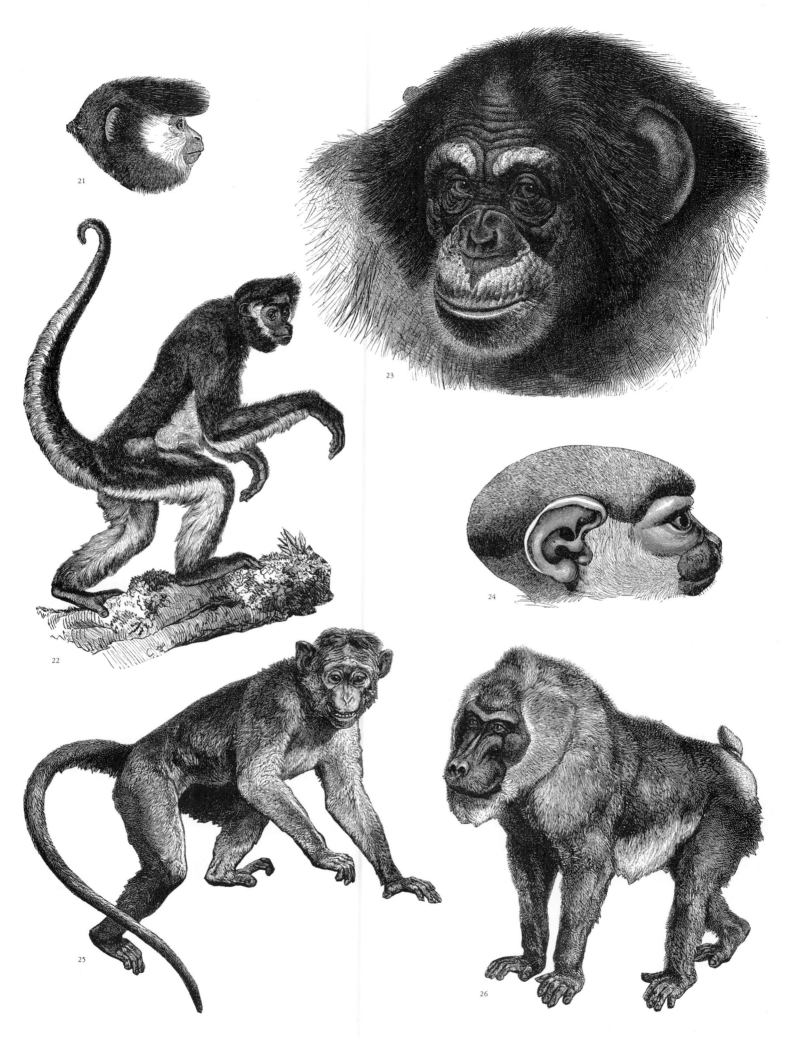

**MAMMALS. 21, 24, 25:** Various monkeys. **22:** A type of spider monkey. **23:** Chimpanzee. **26:** Drill.

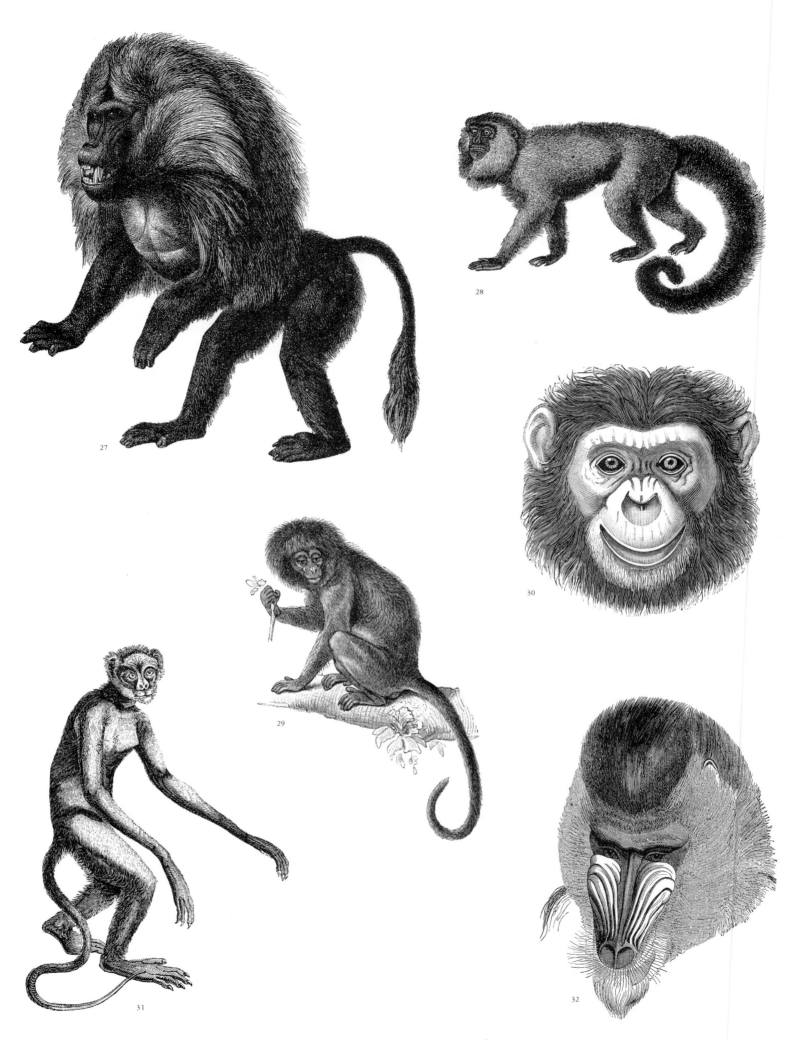

**MAMMALS. 27:** Hamadryas baboon. **28:** Woolly monkey. **29:** Marmoset.
**30:** Chimpanzee (?). **31:** Fanciful monkey-like creature. **32:** Mandrill.

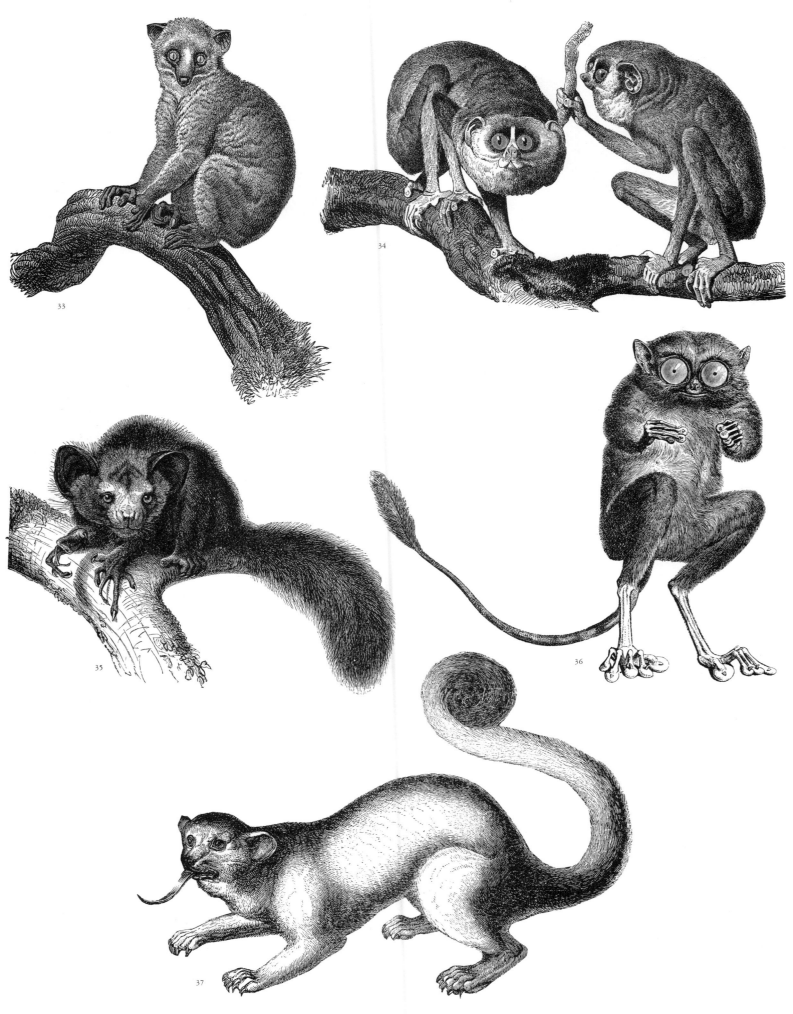

**MAMMALS. 33:** Potto. **34:** Slender loris. **35:** Aye-aye. **36:** Tarsier. **37:** Kinkajou (?).

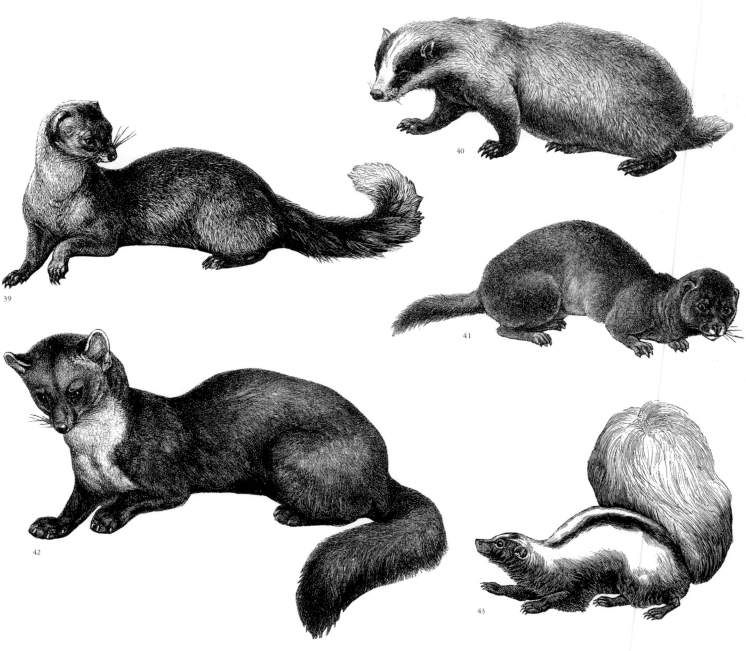

**MAMMALS. 38:** Ermine. **39:** Mink. **40:** Badger. **41:** Polecat. **42:** Mammal of the weasel family. **43:** Skunk.

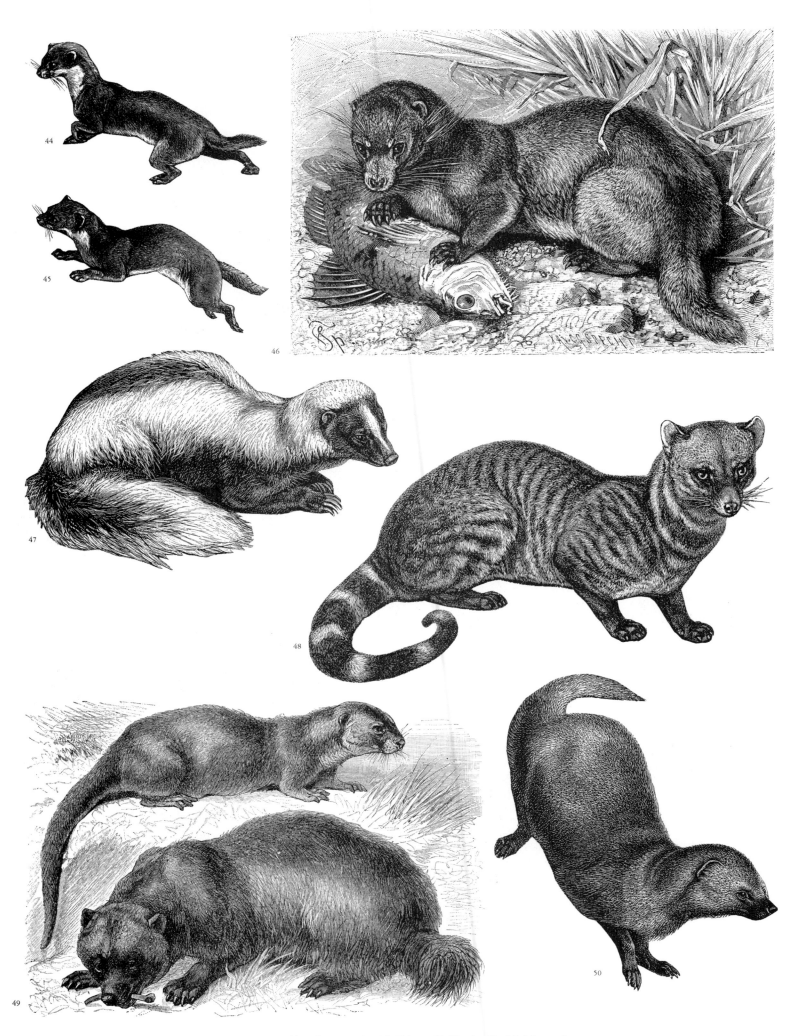

**MAMMALS. 44 & 45:** Weasels. **46:** Fisher. **47:** Skunk. **48, 50:** Mammals of the weasel family. **49:** Otter (above) and wolverine.

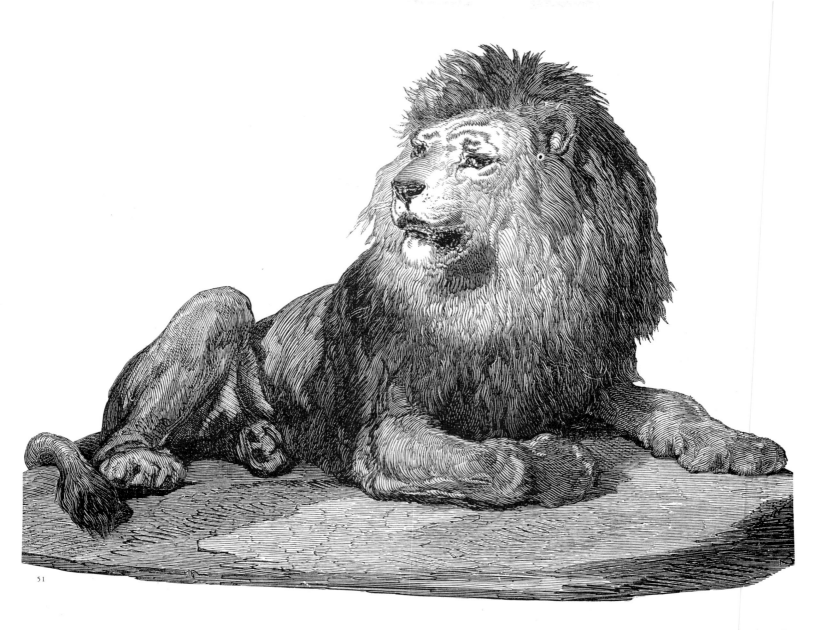

51

52

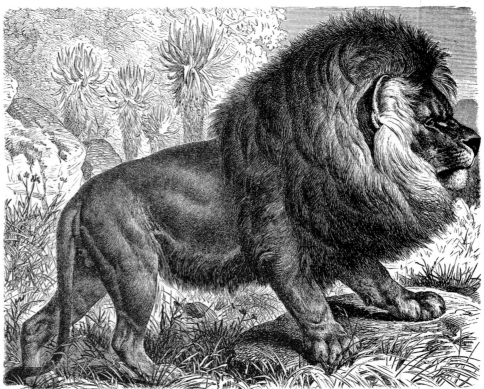

53

**MAMMALS. 51–53:** Lions.

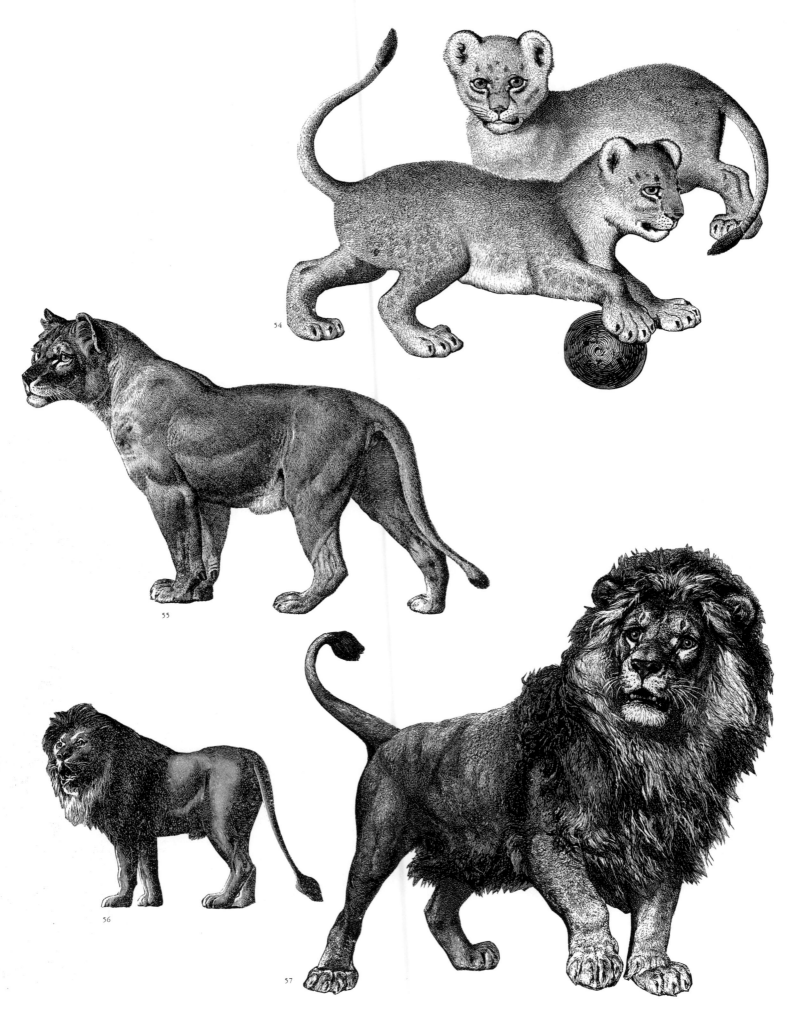

**MAMMALS. 54–57:** Lions.

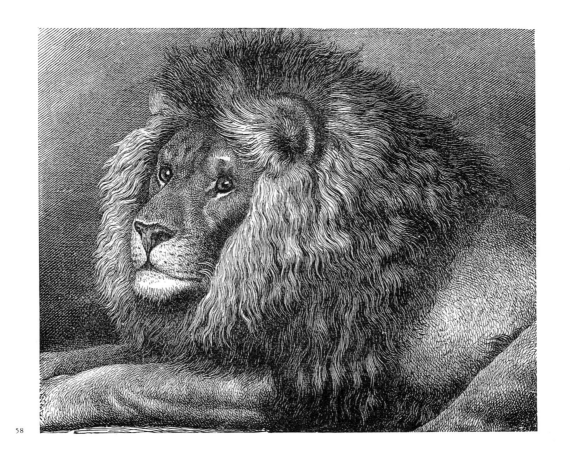

58

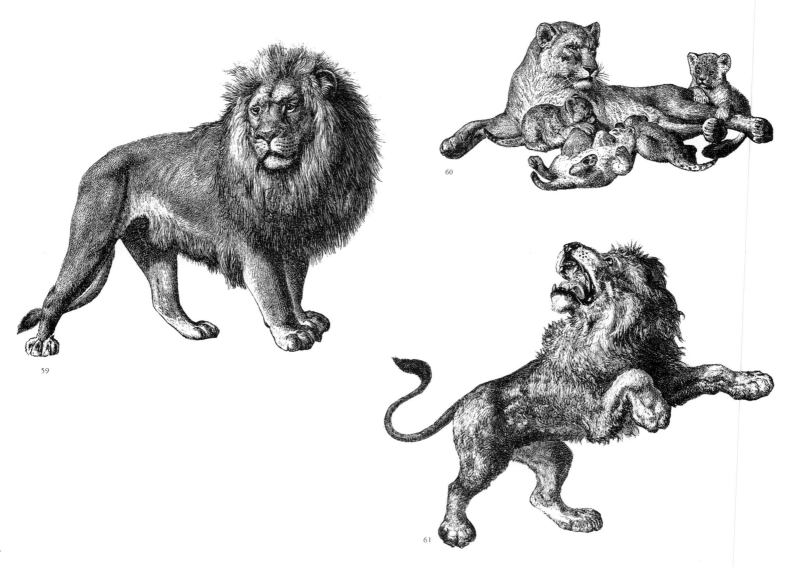

59

60

61

**MAMMALS. 58–61:** Lions.

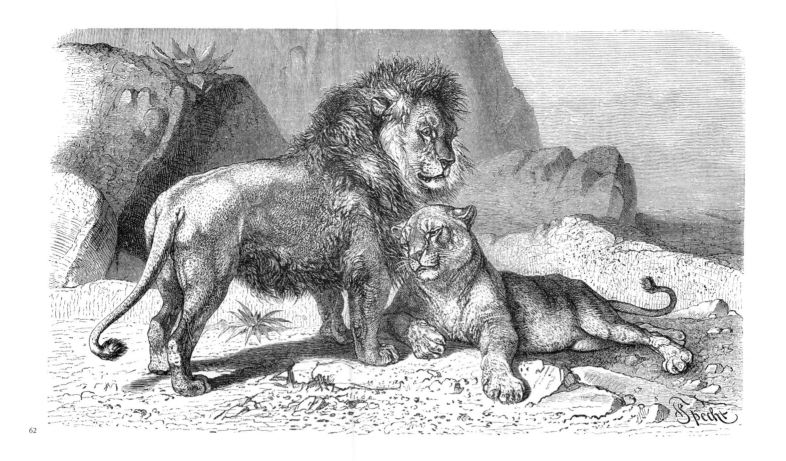

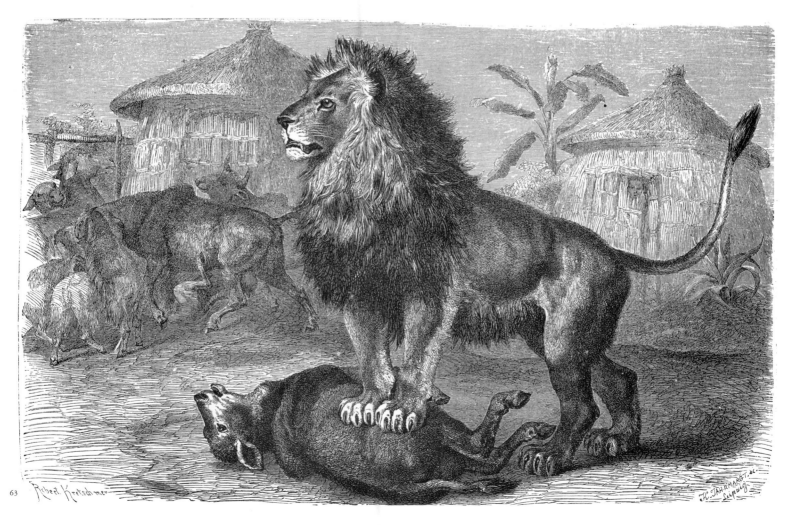

**MAMMALS.** 62 & 63: Lions.

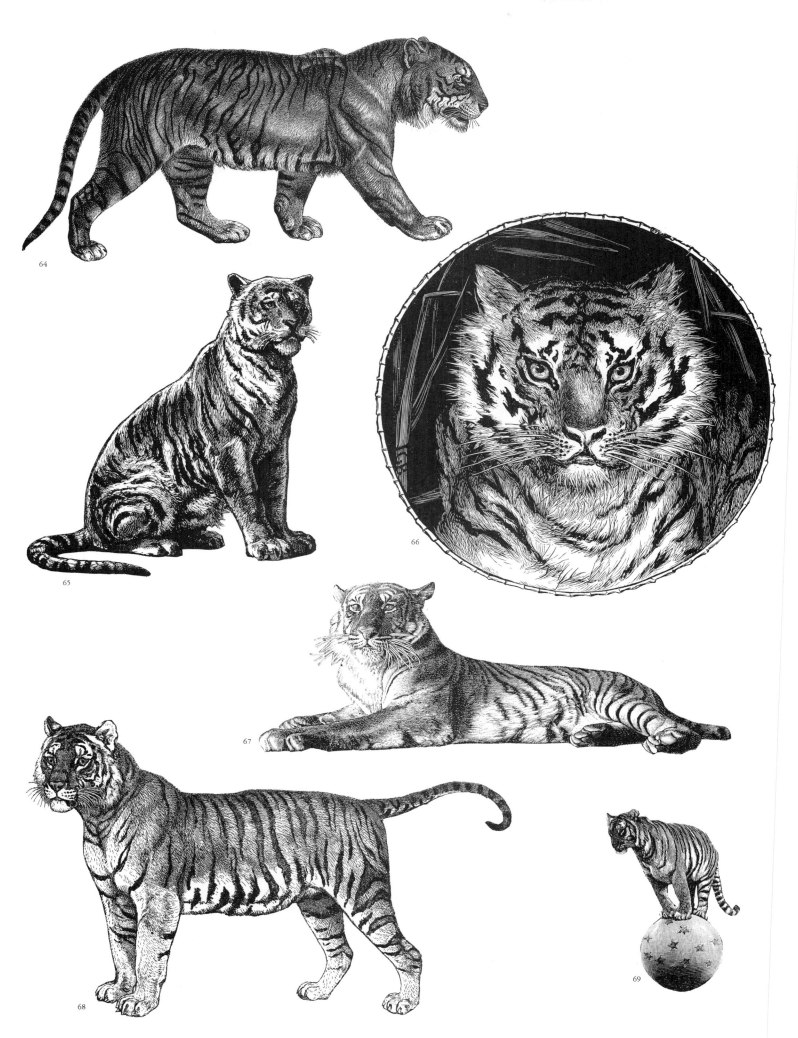

**MAMMALS. 64–69:** Tigers.

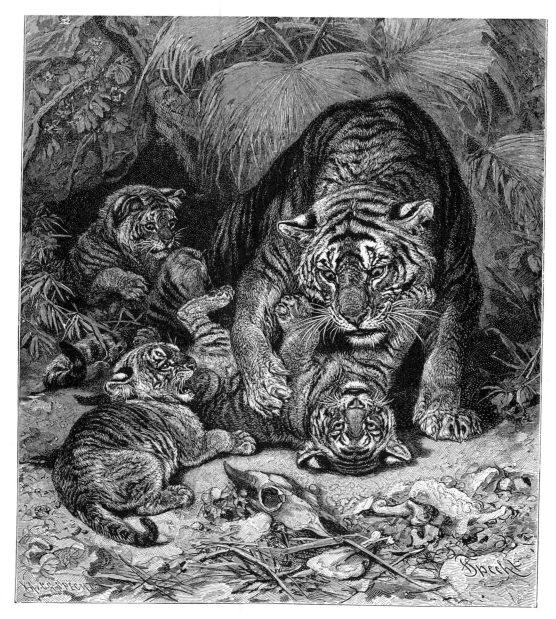

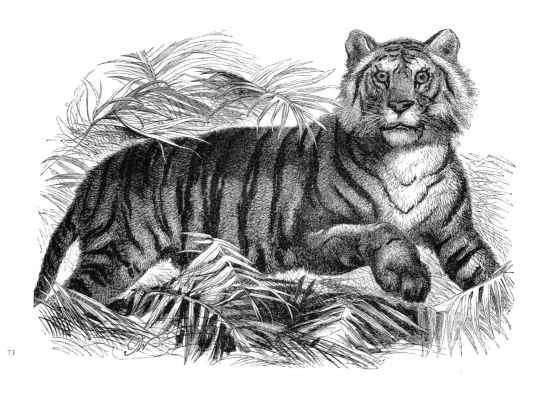

**MAMMALS.** 70 & 71: Tigers.

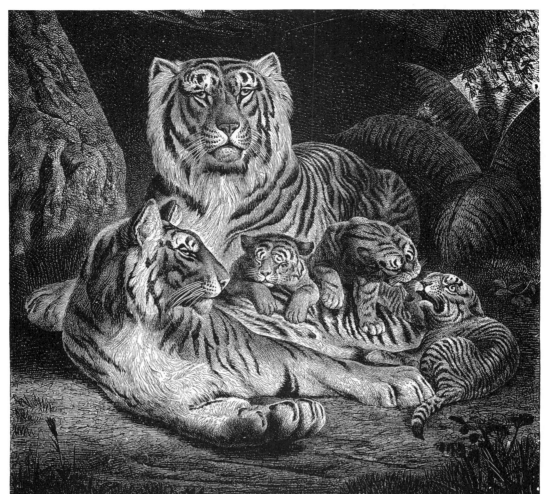

72

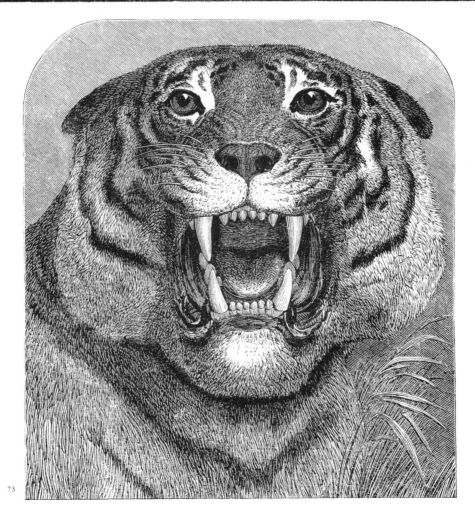

73

**MAMMALS.** 72 & 73: Tigers.

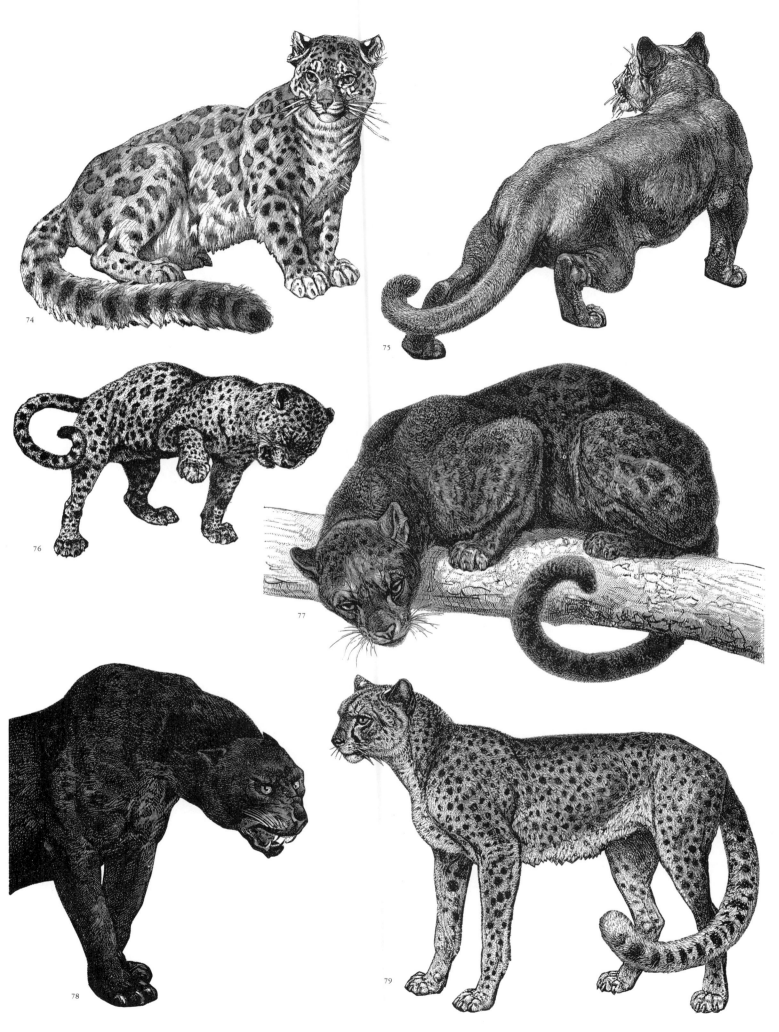

**MAMMALS. 74, 76–78:** Types of leopard. **75:** Lioness. **79:** Cheetah.

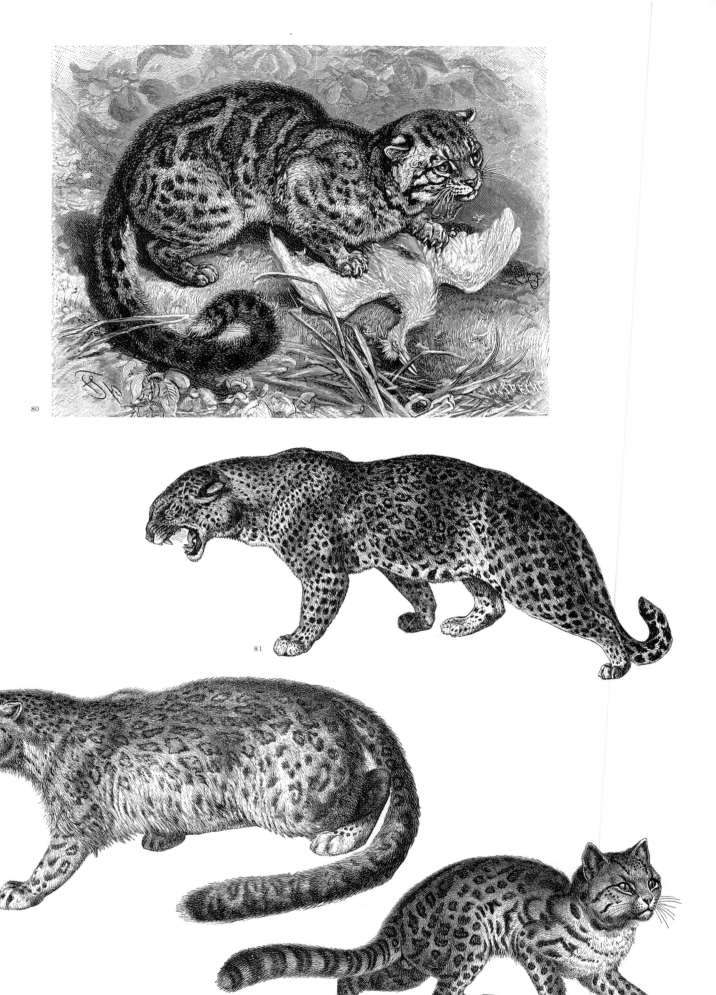

**MAMMALS. 80:** Marbled tiger cat. **81 & 82:** Types of leopard. **83:** Mammal of the cat family.

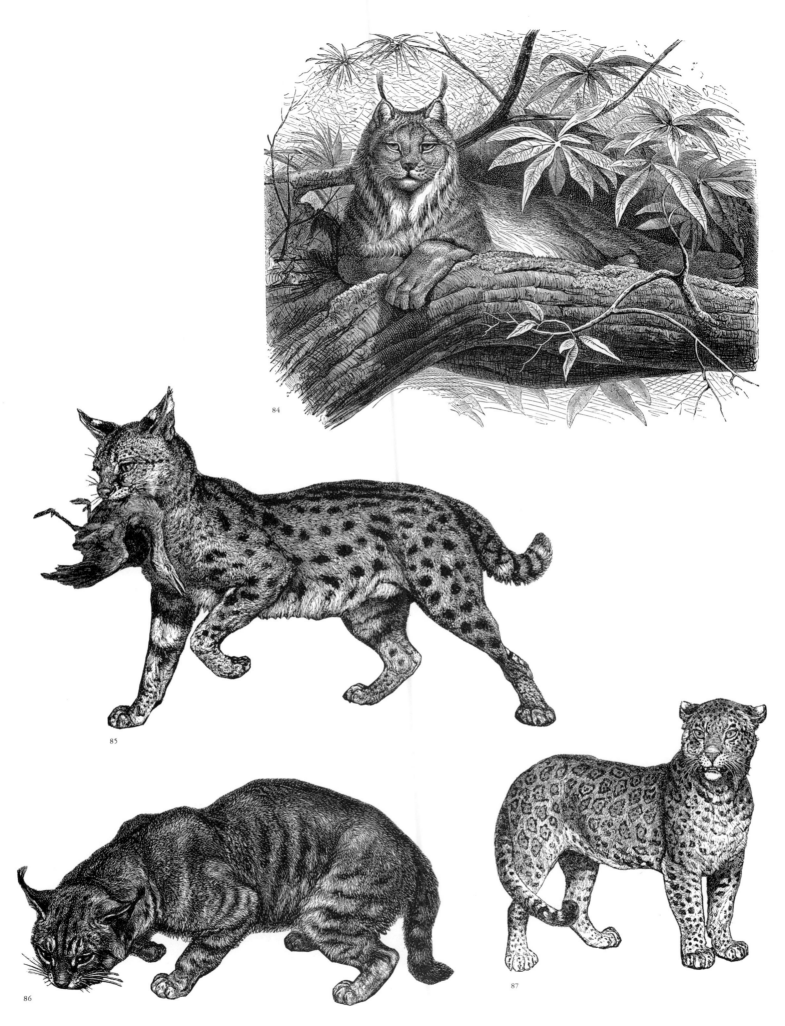

**MAMMALS. 84:** Canada lynx. **85, 86:** Species of wildcat. **87:** Jaguar.

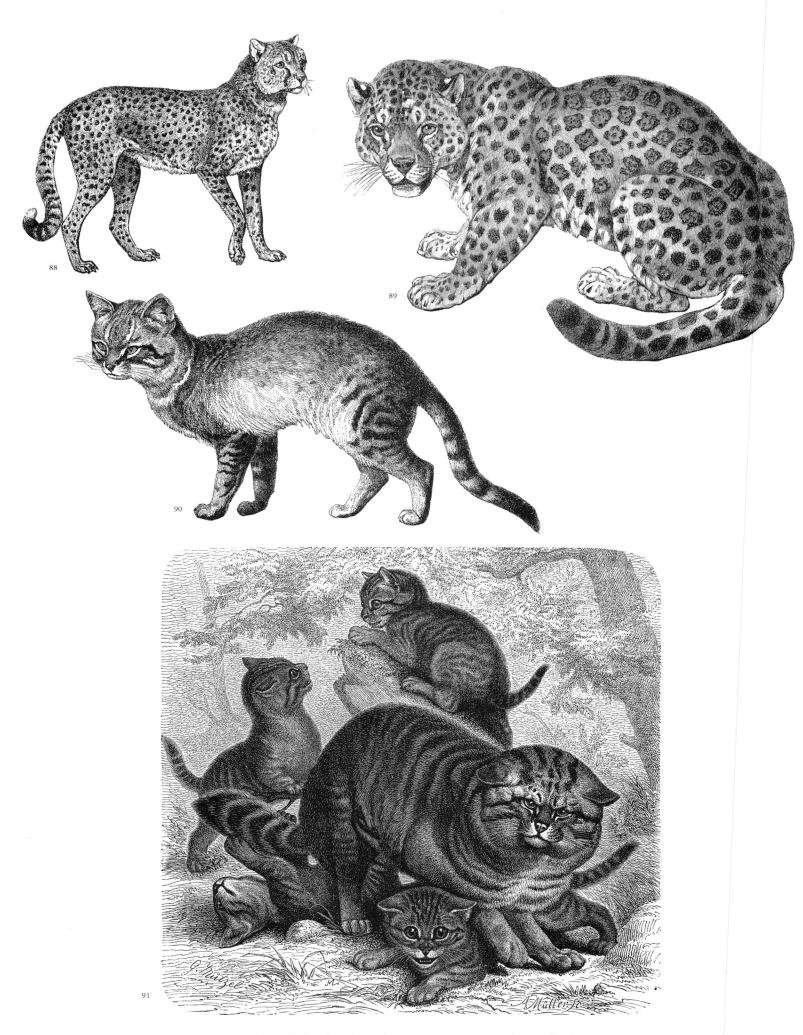

**MAMMALS. 88:** Cheetah. **89:** Jaguar. **90, 91:** Mammals of the cat family.

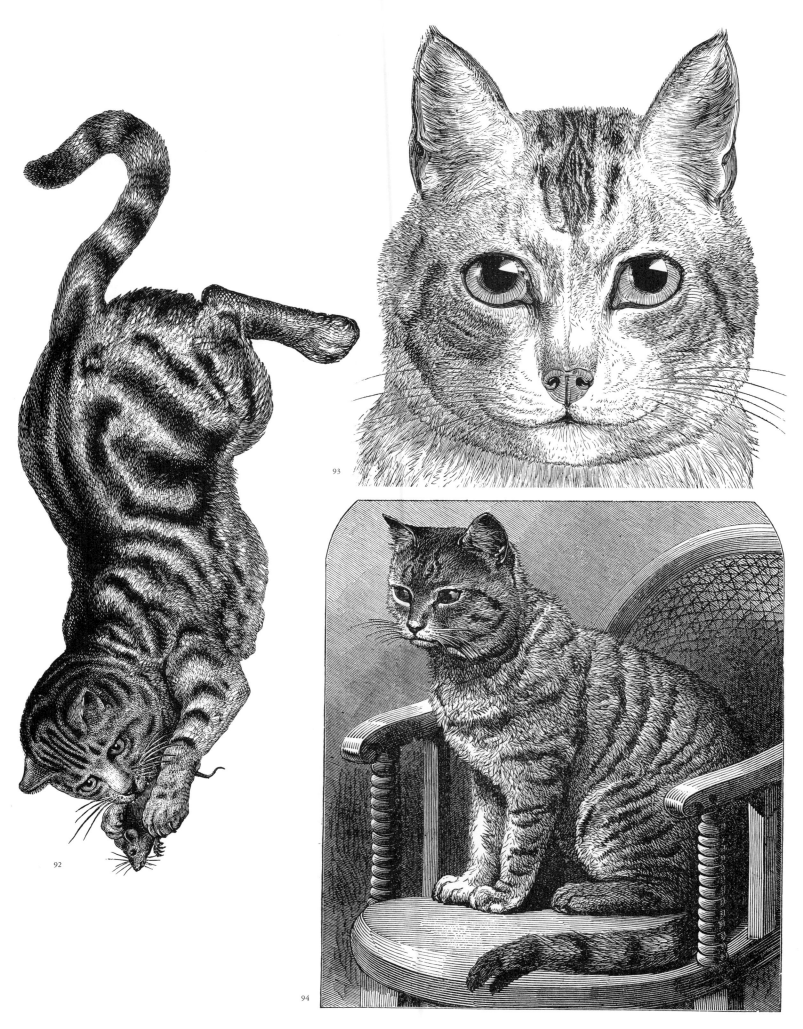

**MAMMALS. 92–94:** Domestic cats.

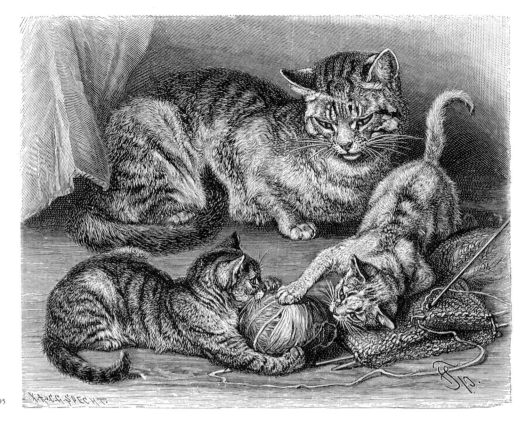

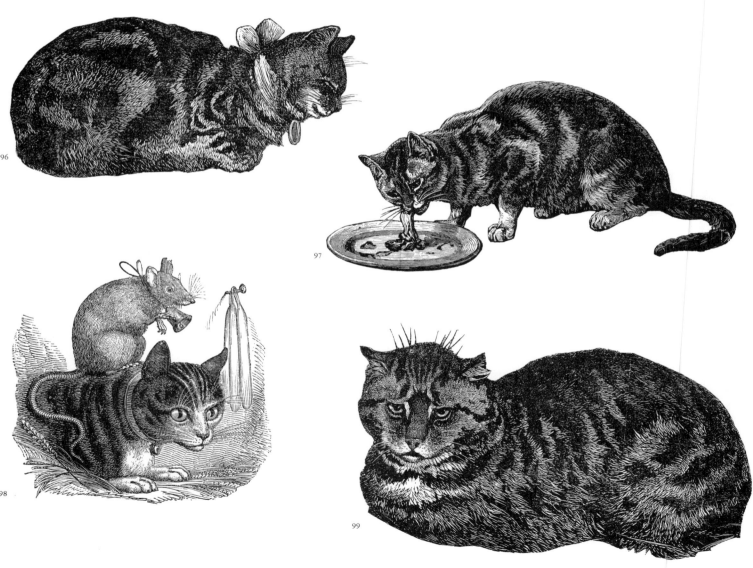

**MAMMALS. 95–99: Domestic cats.**

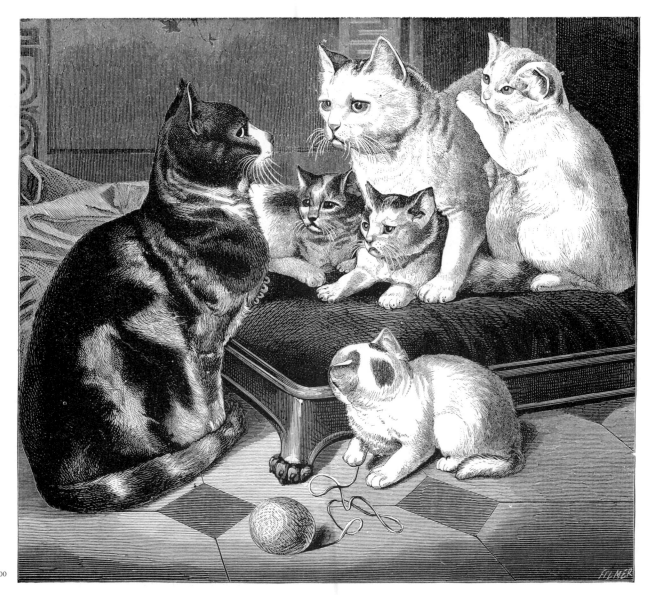

100

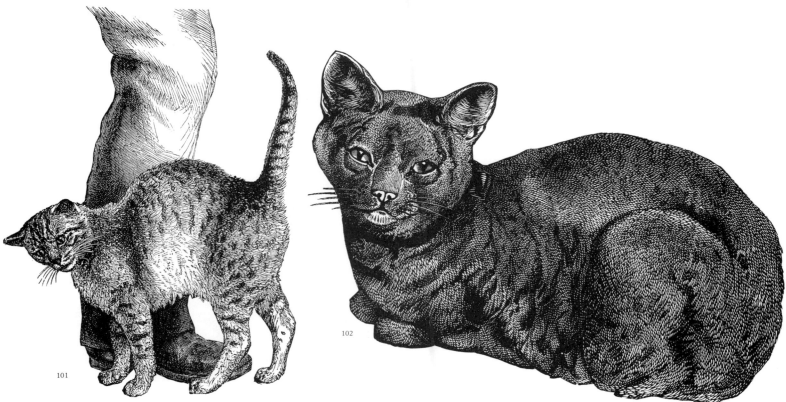

101

102

**MAMMALS. 100–102: Domestic cats.**

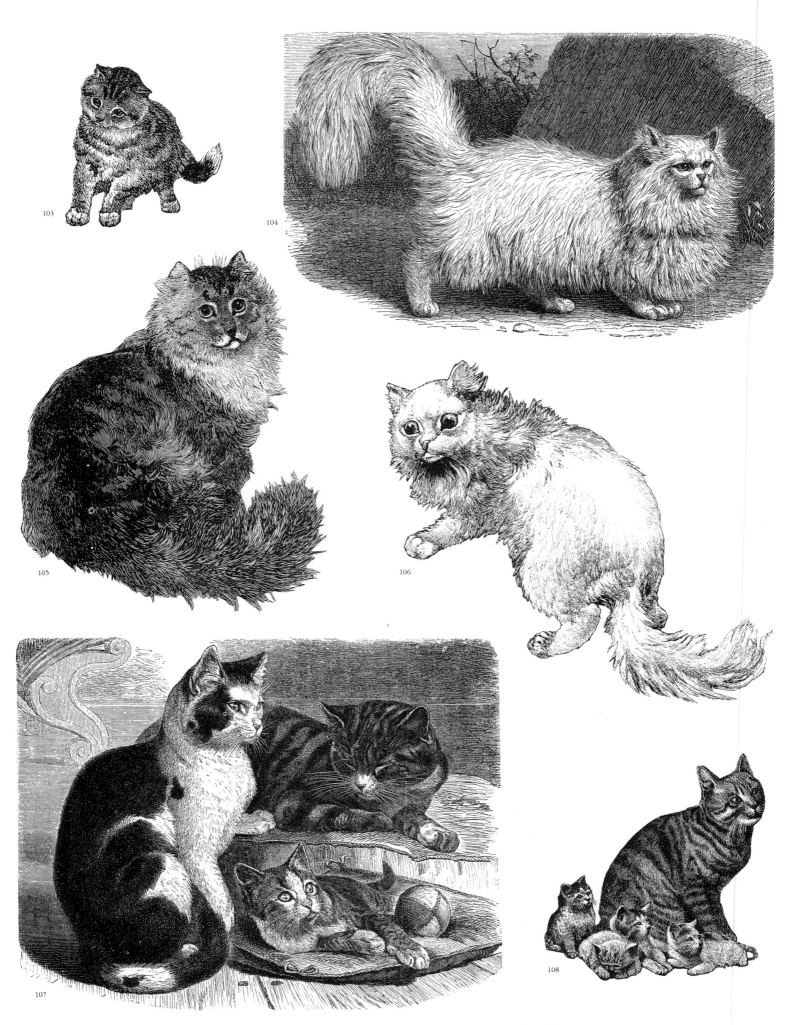

**MAMMALS.** 103–108: Domestic cats (105 is a Persian or Angora).

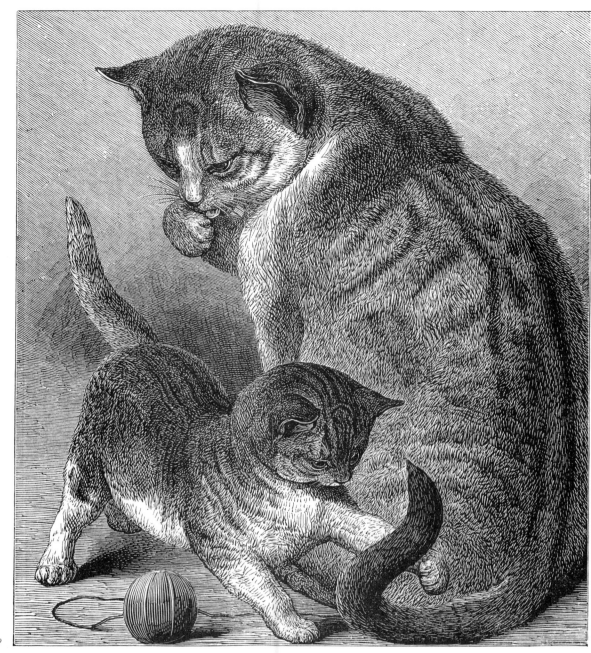

109

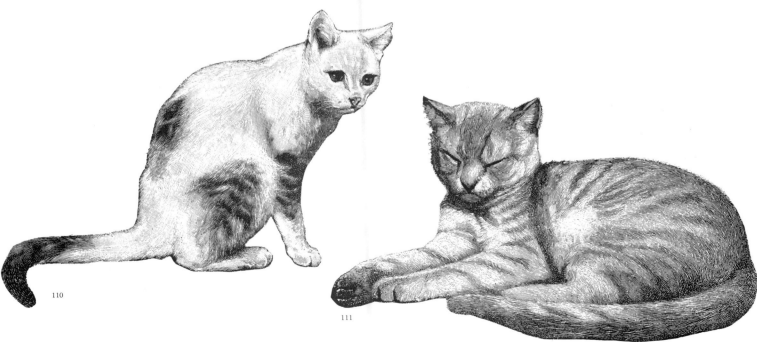

110

111

MAMMALS. 109–111: Domestic cats.

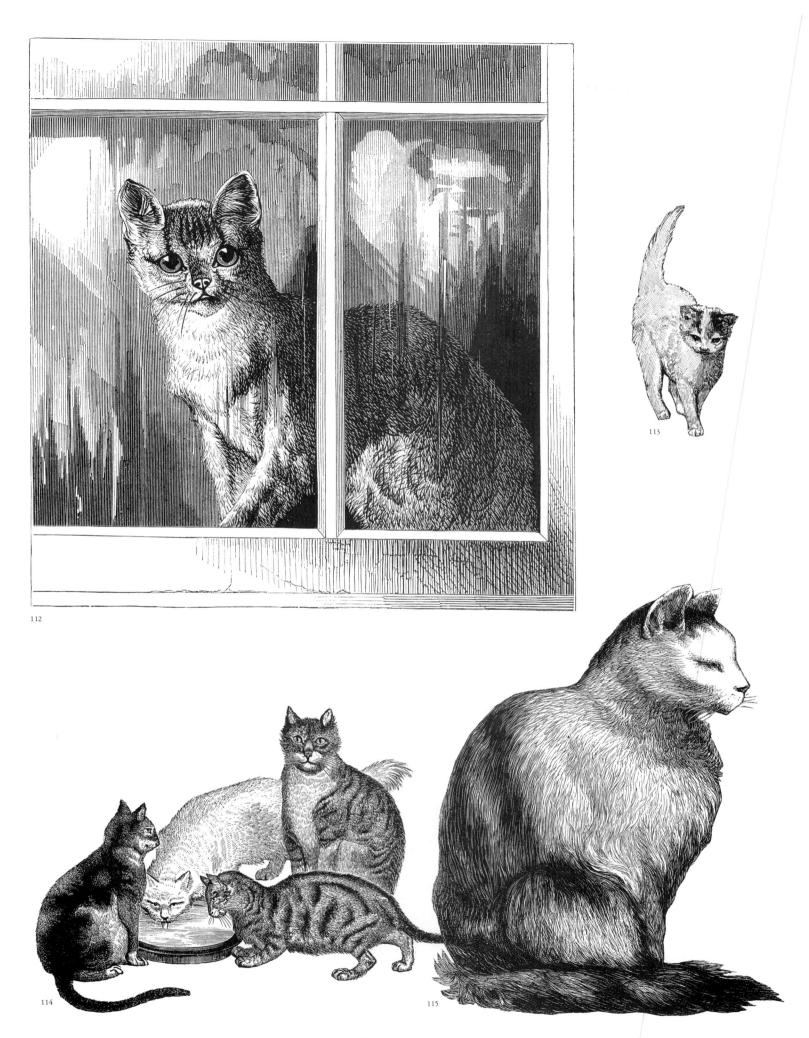

**MAMMALS.** 112–115: Domestic cats.

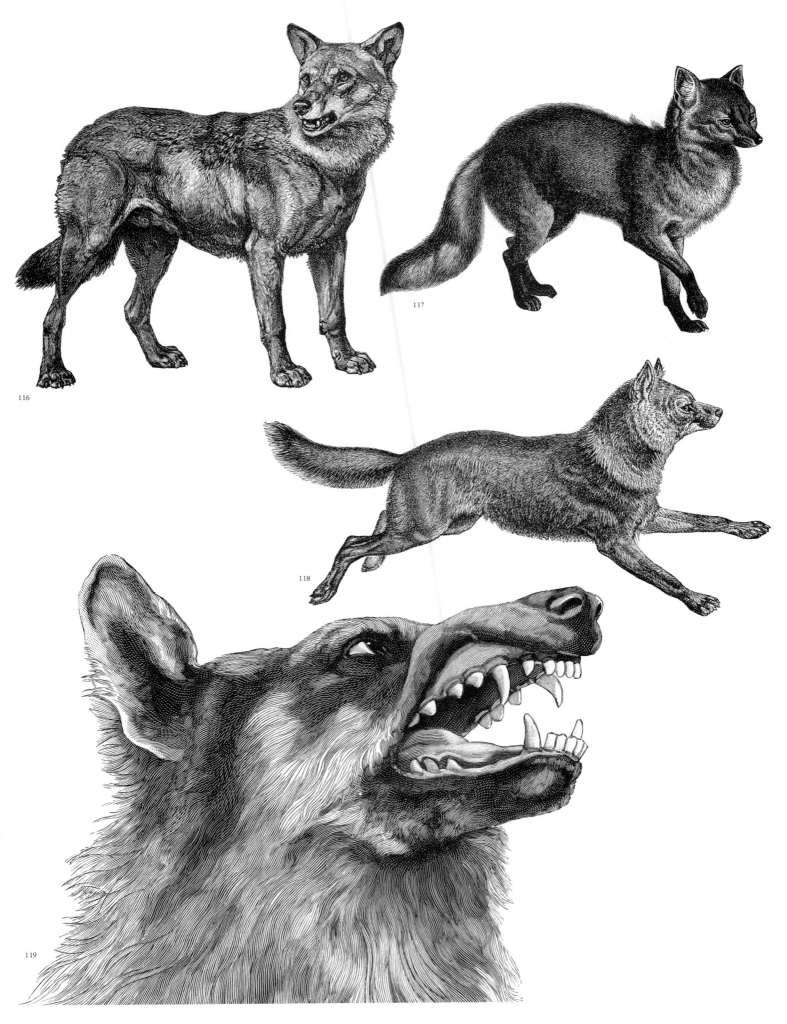

**MAMMALS. 116, 118, 119: Wolves. 117: Fox.**

120

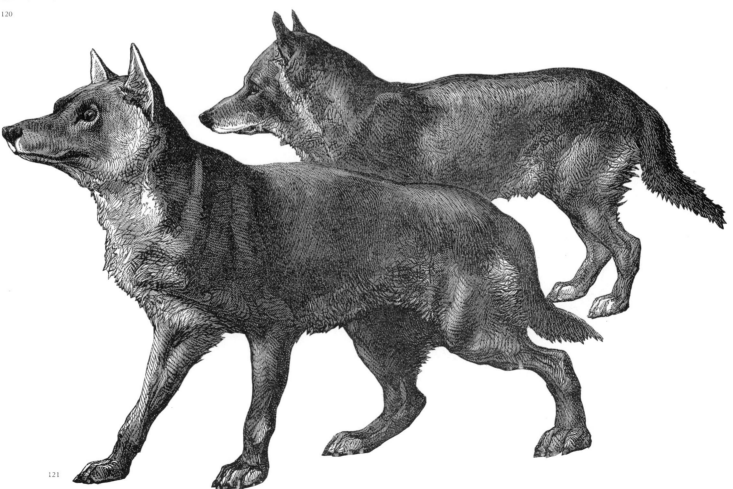

121

**MAMMALS. 120:** Wolf cubs. **121:** Wolves.

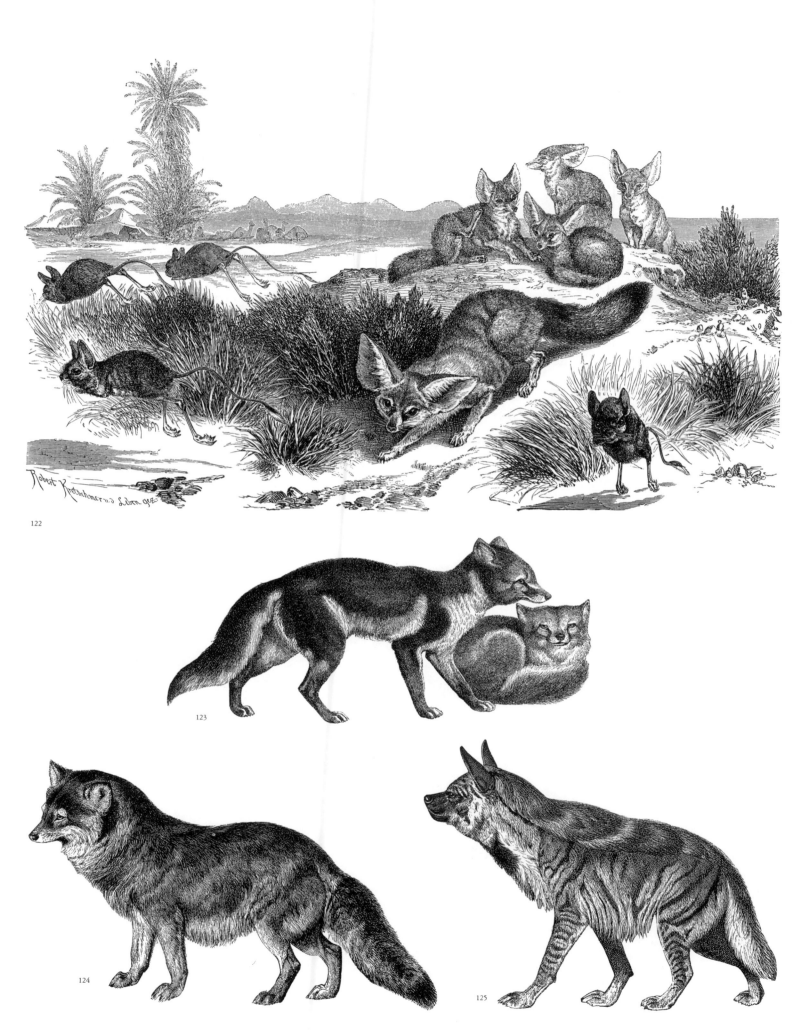

**MAMMALS. 122:** Fennecs ("desert foxes") and jerboas. **123:** Type of fox.
**124:** Coyote. **125:** Striped hyena.

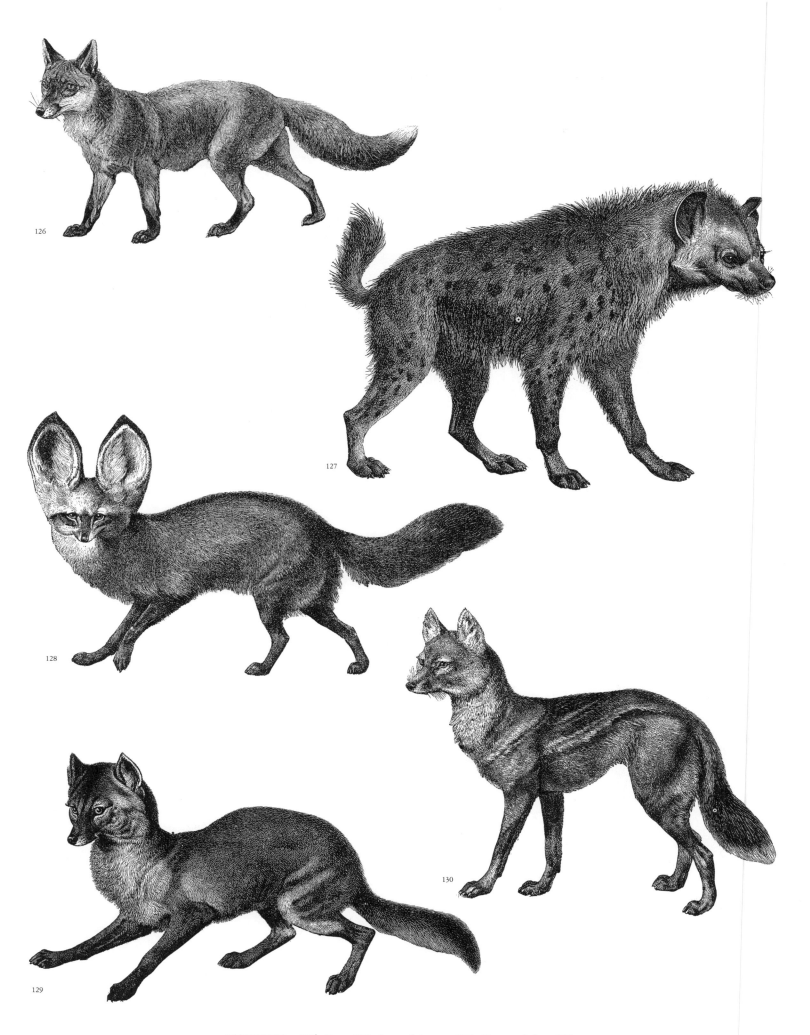

**MAMMALS. 126:** Fox. **127:** Spotted hyena. **128:** Bat-eared fox. **129:** Common jackal. **130:** Side-striped jackal.

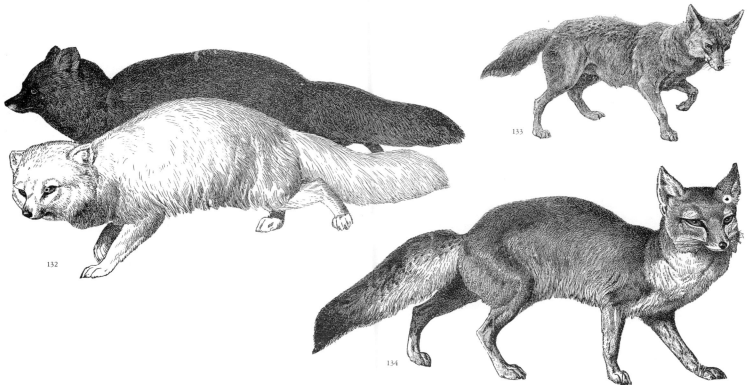

**MAMMALS. 131:** Fox. **132:** Arctic fox in summer and winter coat. **133:** Fox. **134:** Corsac.

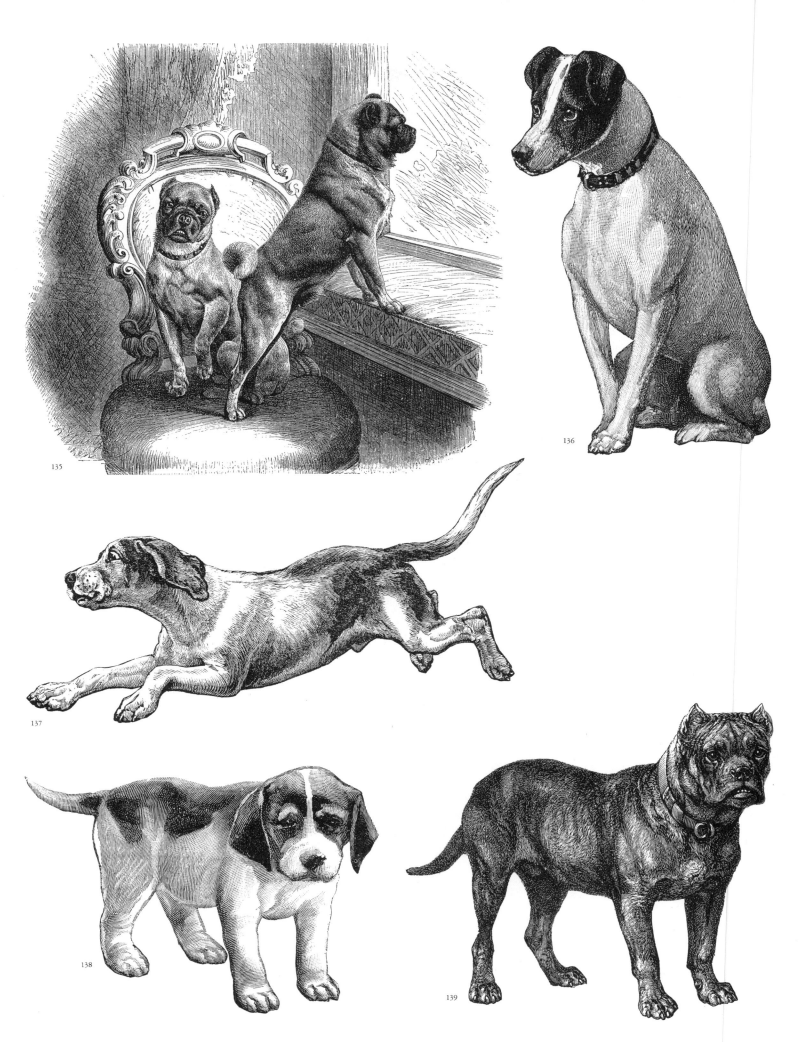

**MAMMALS. 135–139:** Dogs (135 shows pugs or French bulldogs, 136 a fox terrier, 139 a mastiff; breed identifications are approximate).

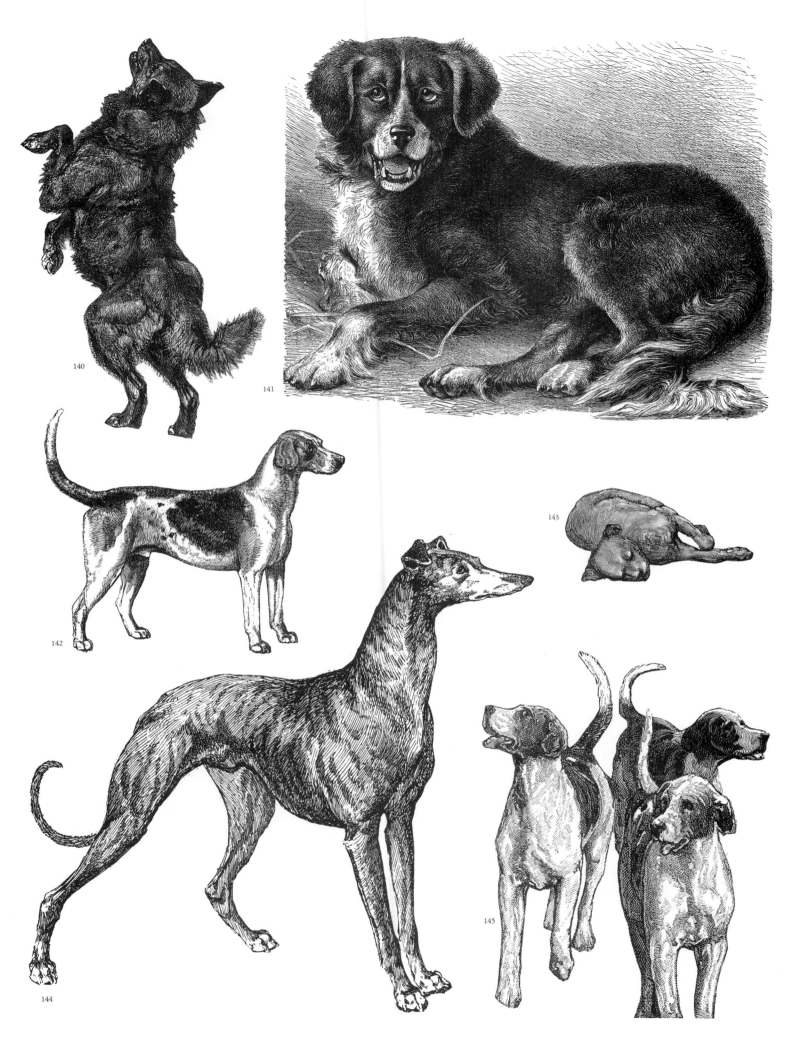

**MAMMALS. 140–145:** Dogs (141 is a Newfoundland, 142 a type of pointer, 144 a greyhound).

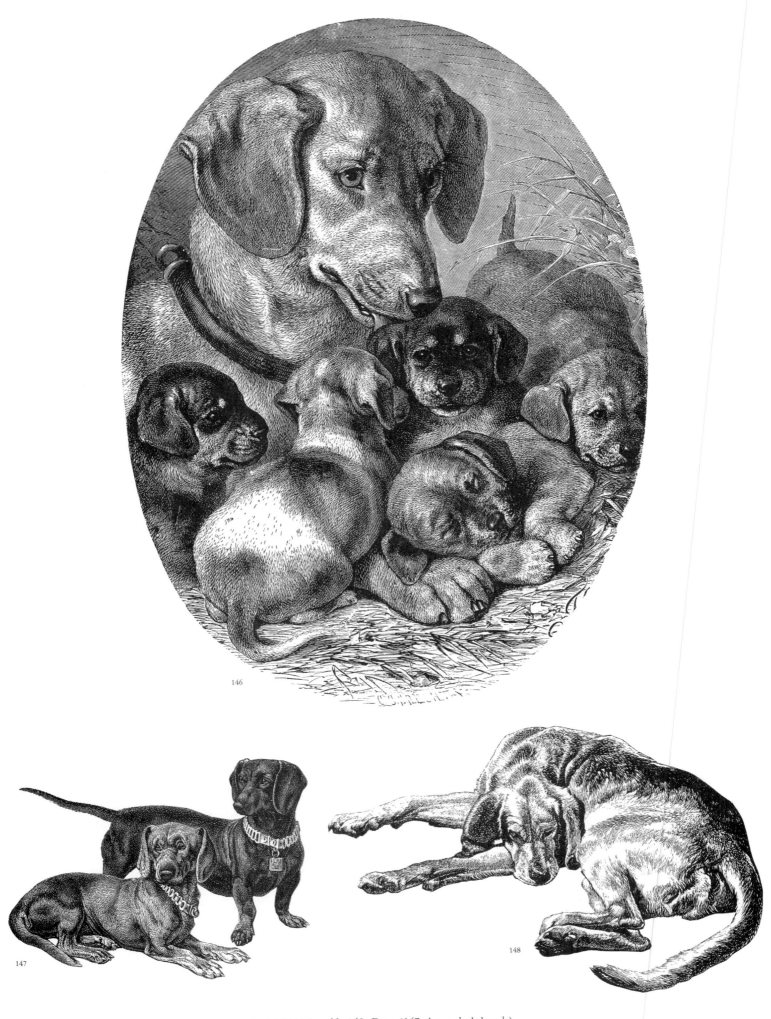

**MAMMALS. 146–148:** Dogs (147 shows dachshunds).

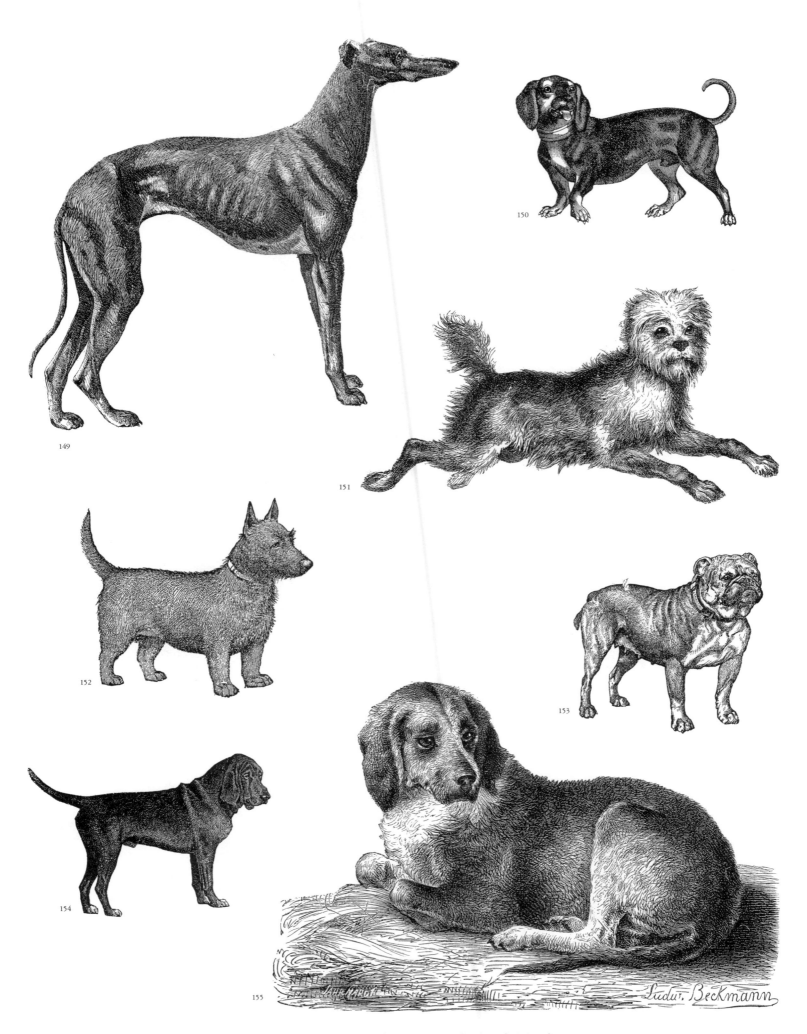

**MAMMALS. 149–155:** Dogs (149 is a greyhound, 150 a dachshund, 151 an affenpinscher, 152 a Scottish terrier, 153 a bulldog, 154 a bloodhound).

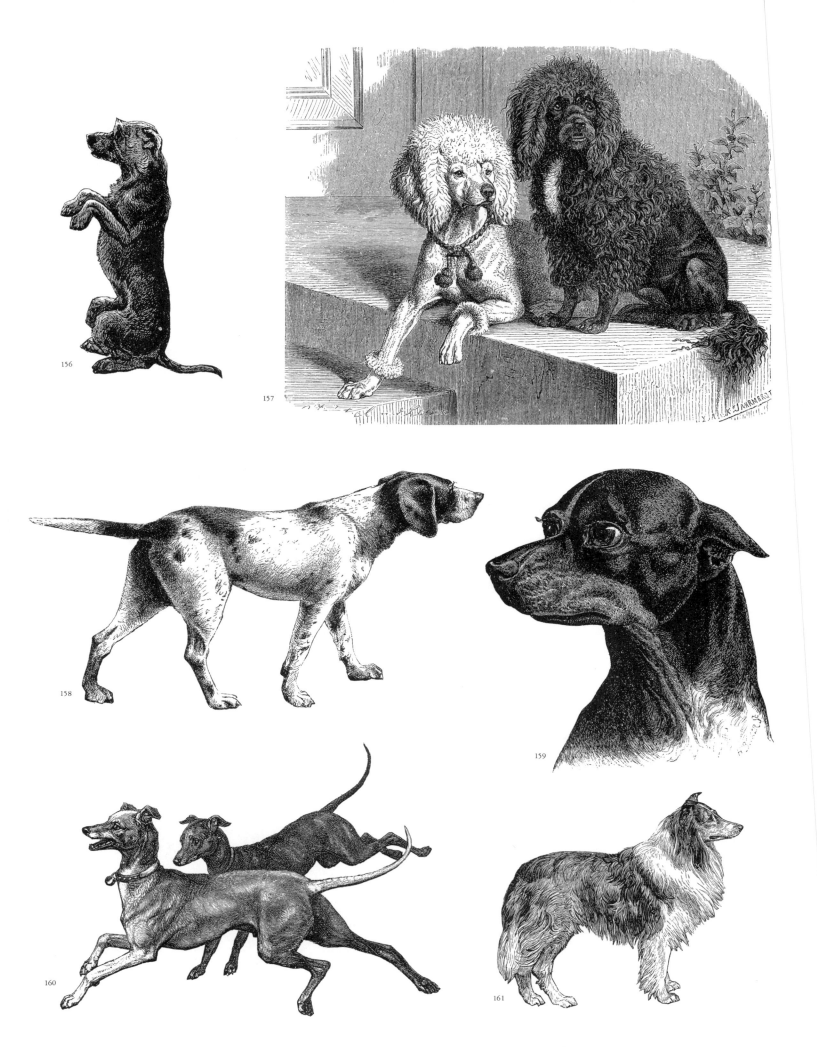

**MAMMALS. 156–161:** Dogs (157 shows poodles, 158 a pointer, 161 a collie).

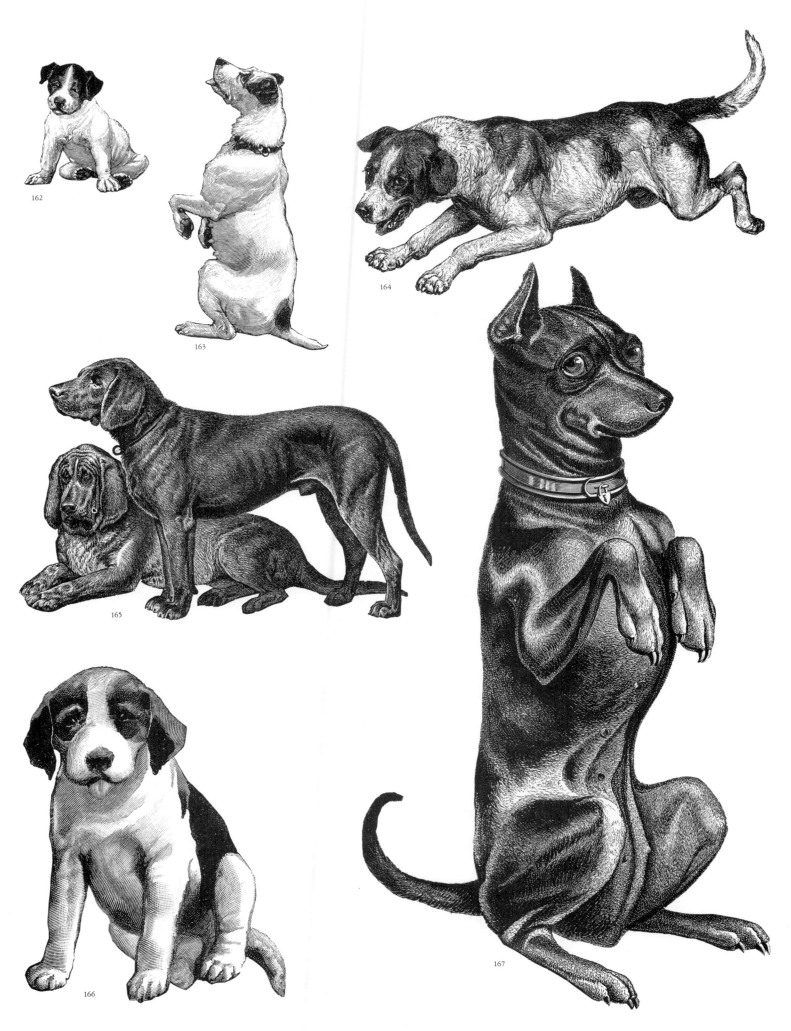

**MAMMALS. 162–167:** Dogs (165 shows bloodhounds).

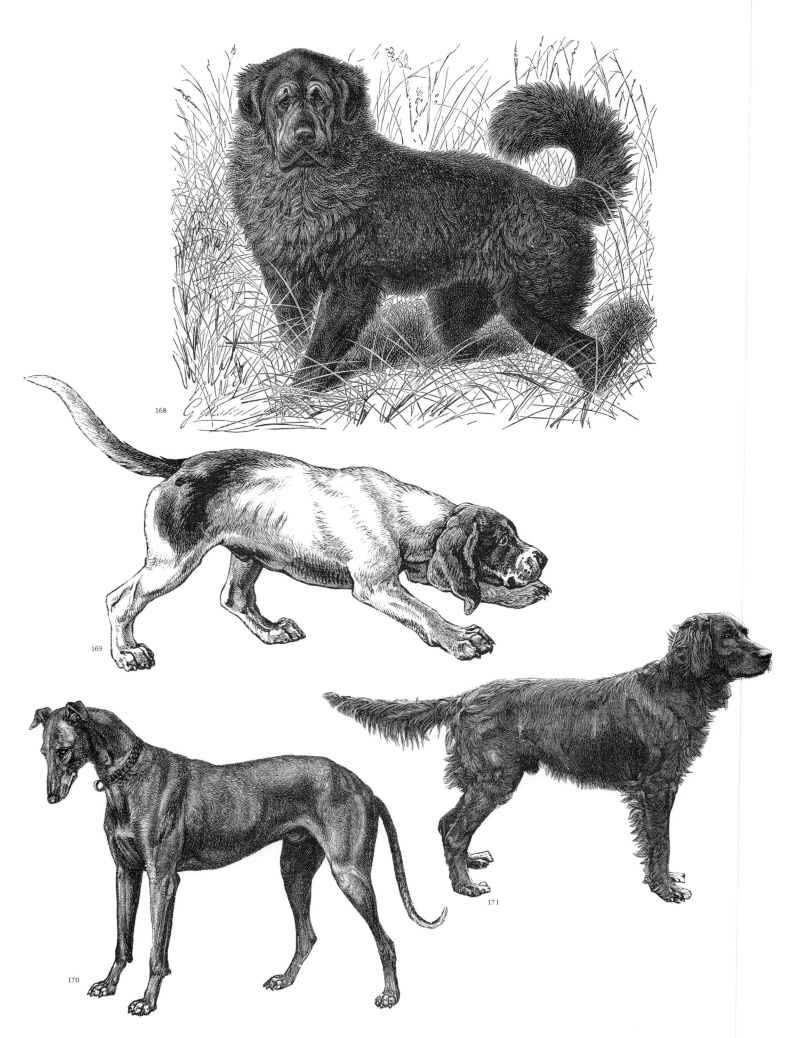

**MAMMALS.** 168–171: Dogs (168 is a Newfoundland, 170 a greyhound, 171 a setter).

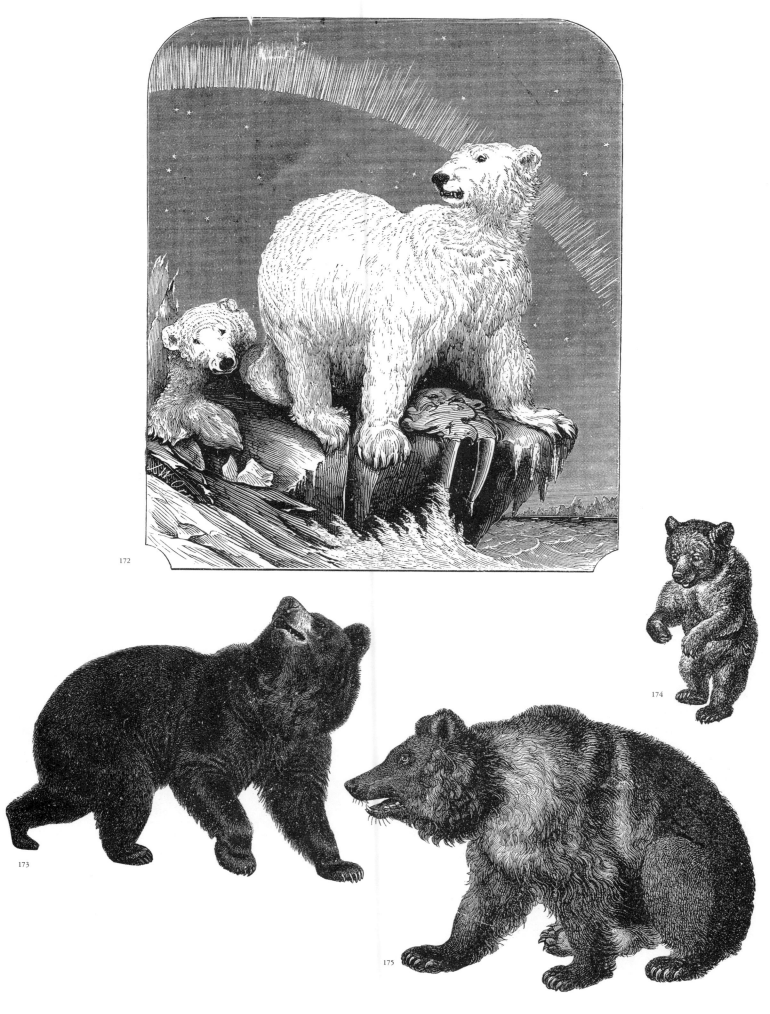

**MAMMALS.** 172–175: Bears (172, polar bears).

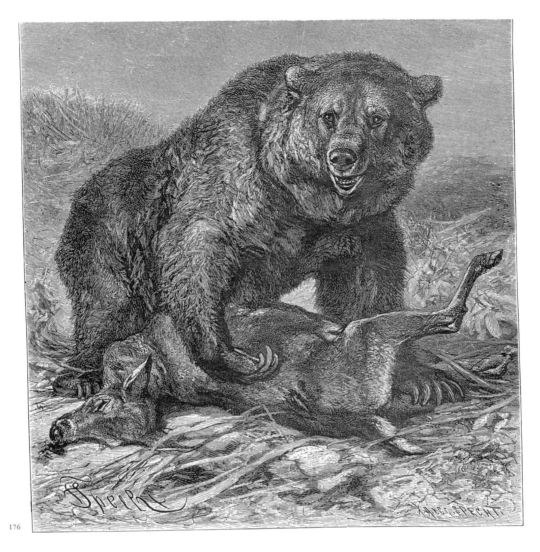

176

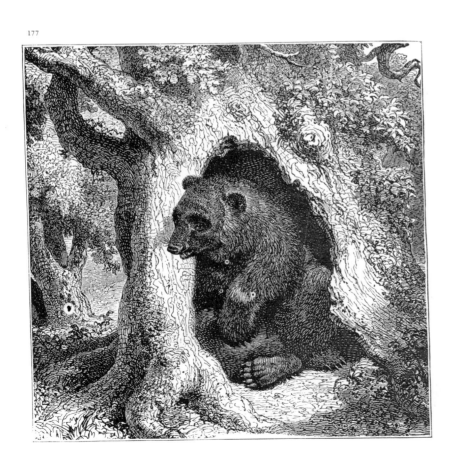

177

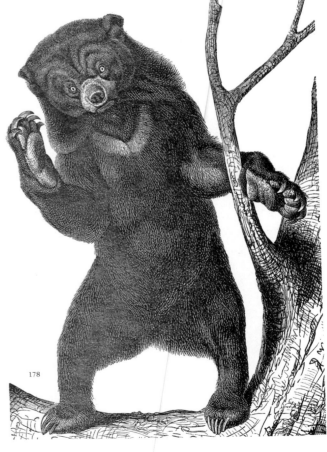

178

**MAMMALS.** **176–178**: Bears (176, grizzly).

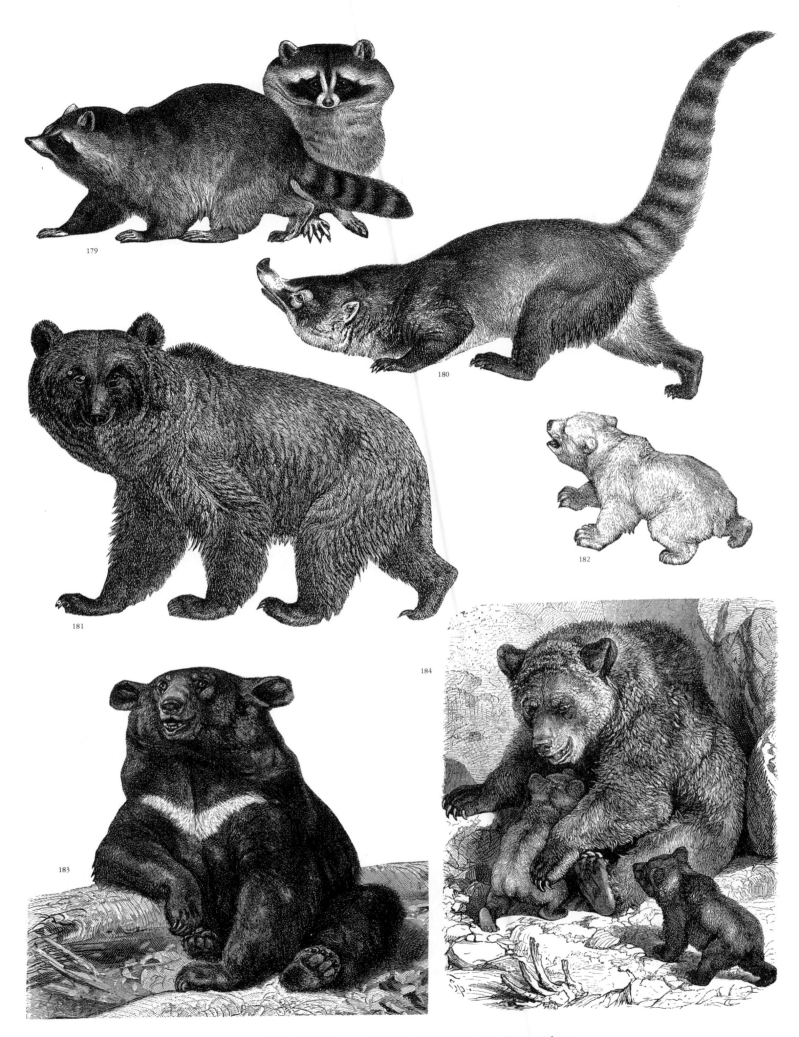

**MAMMALS.** **179:** Raccoons. **180:** Coati. **181:** Common European bear.
**182:** Polar bear. **183:** Himalayan black bear. **184:** Bears.

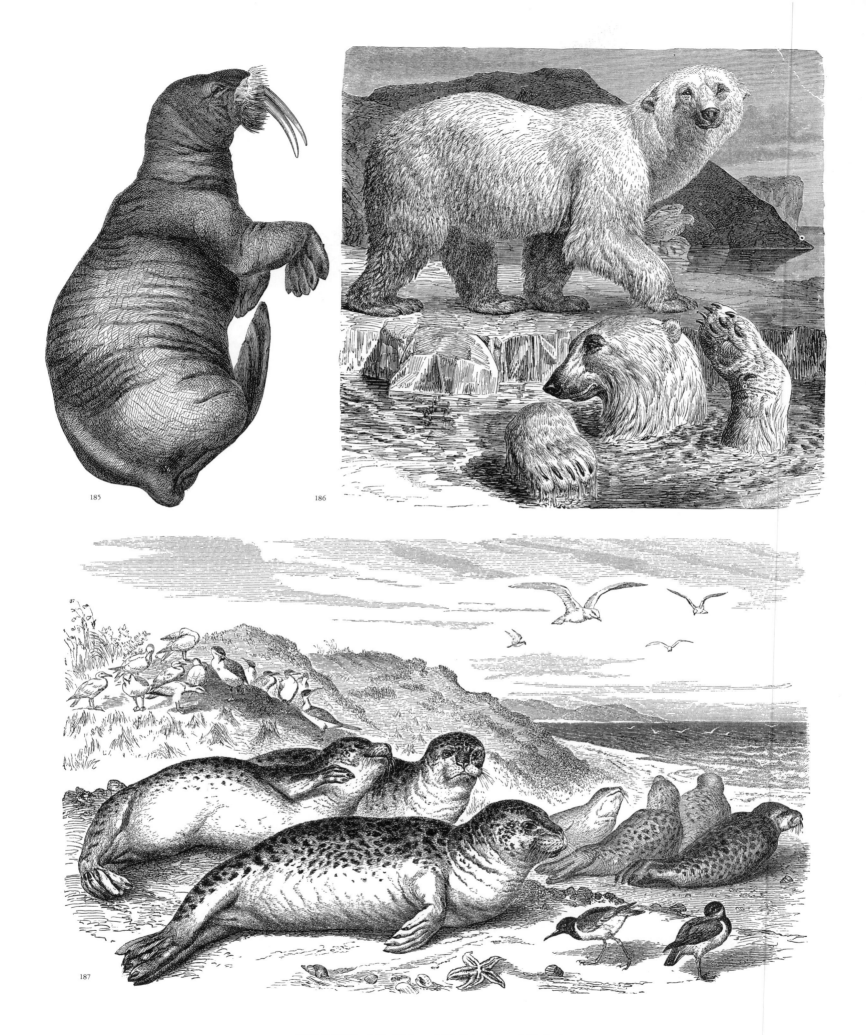

**MAMMALS.** **185:** Walrus. **186:** Polar bears. **187:** Seals.

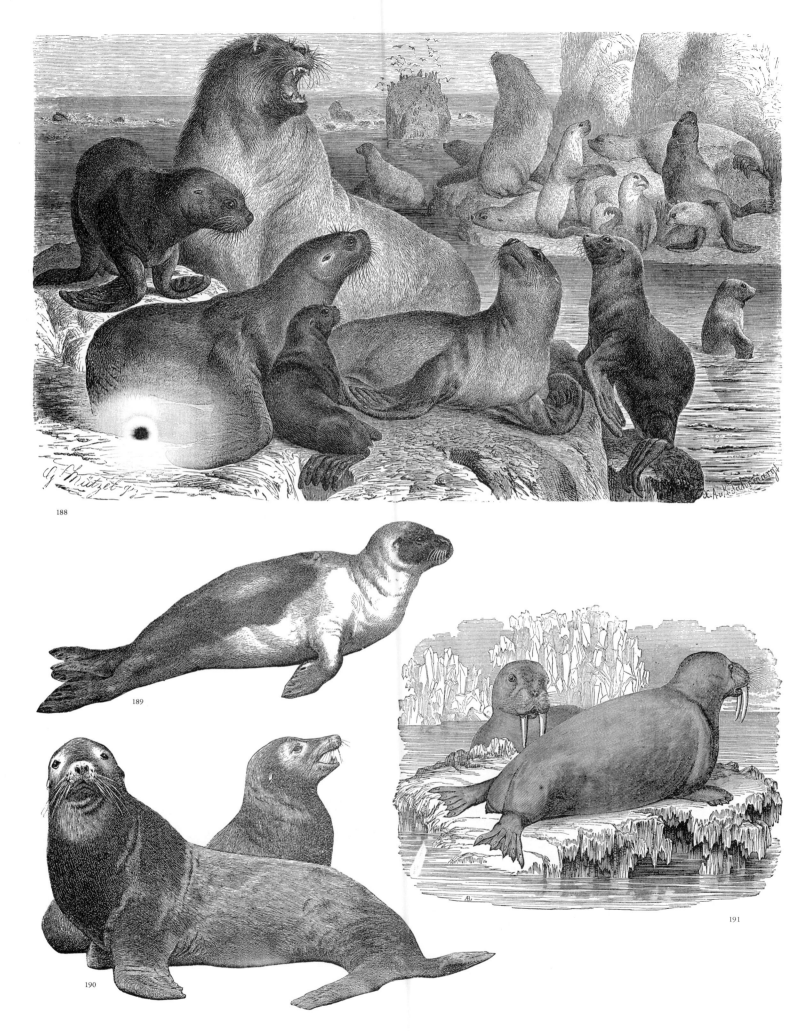

**MAMMALS.** 188–190: Various seals and sea lions. 191: Walruses.

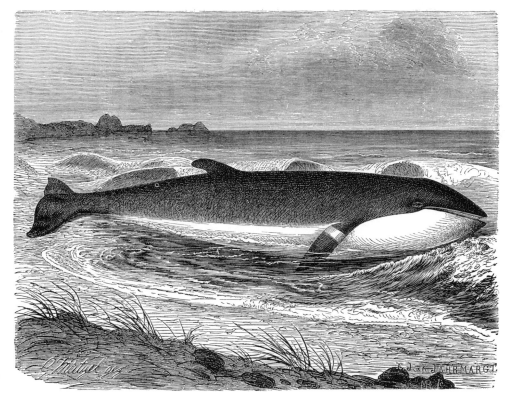

192

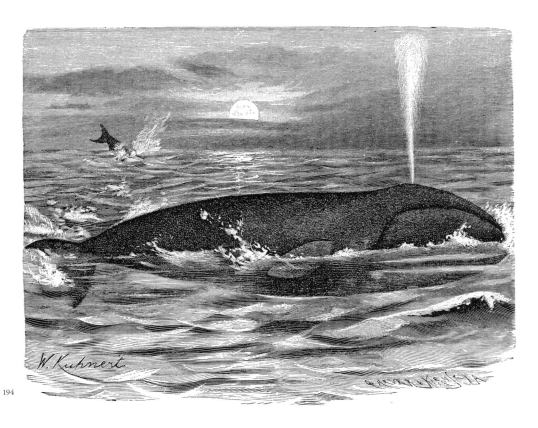

193

194

**MAMMALS.** 192: Piked whale. **193 & 194:** Right whales.

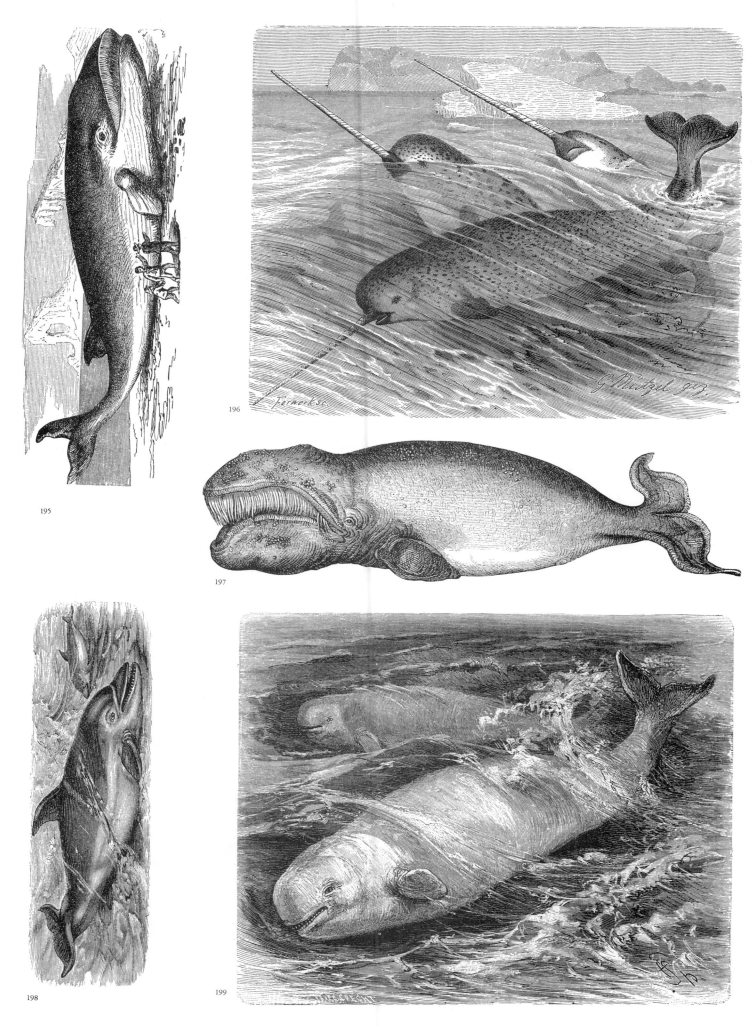

**MAMMALS.** 195, 197: Right whales. 196: Narwhals. 198: Porpoise. 199: Beluga or white whale.

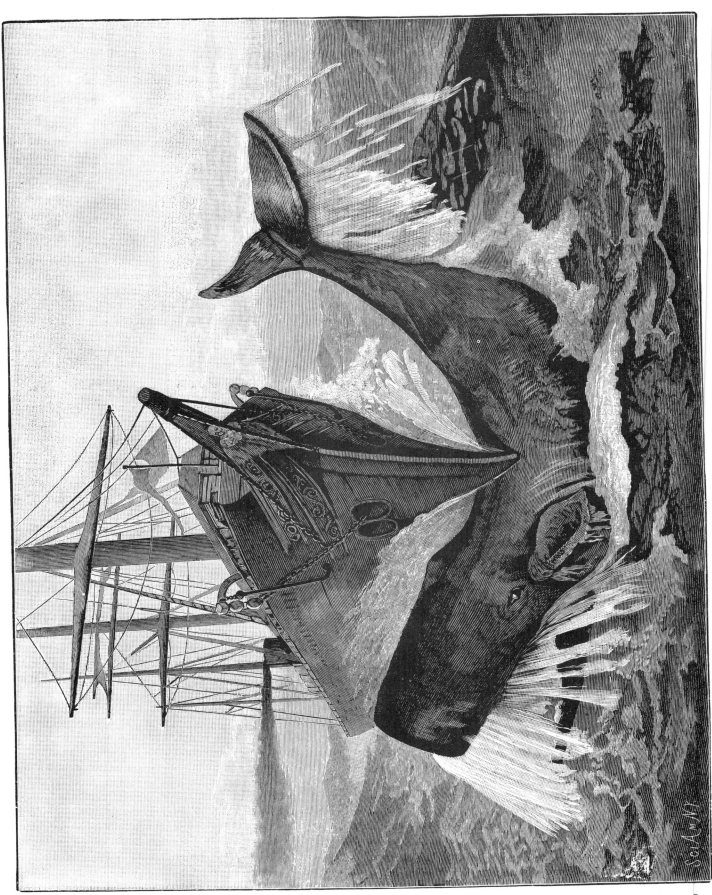

MAMMALS. 200: Sperm whale.

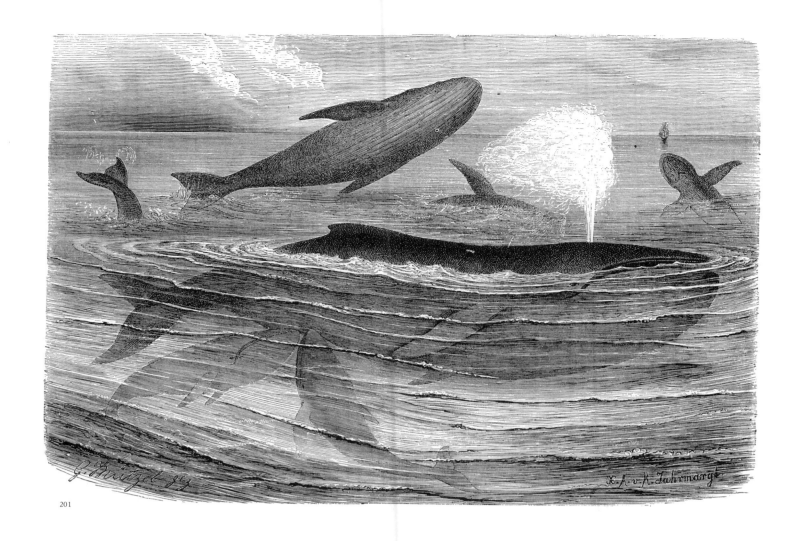

201

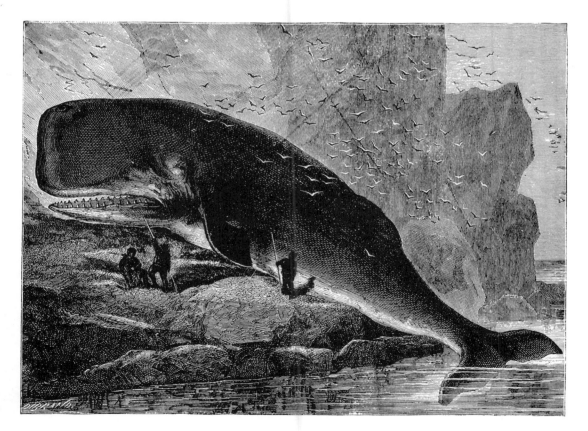

202

**MAMMALS.** 201: Humpback whale or rorqual. 202: Sperm whale.

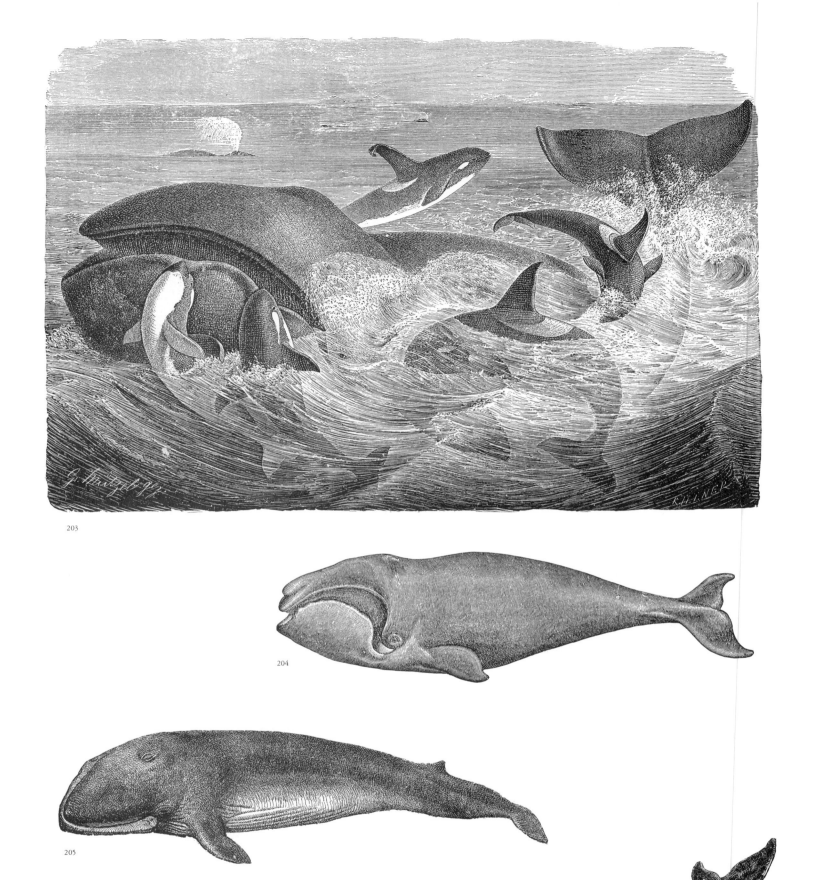

**MAMMALS.** 203: Killer whales attacking a Greenland whale. 204: Right whale. 205: Finback whale. 206: Narwhal.

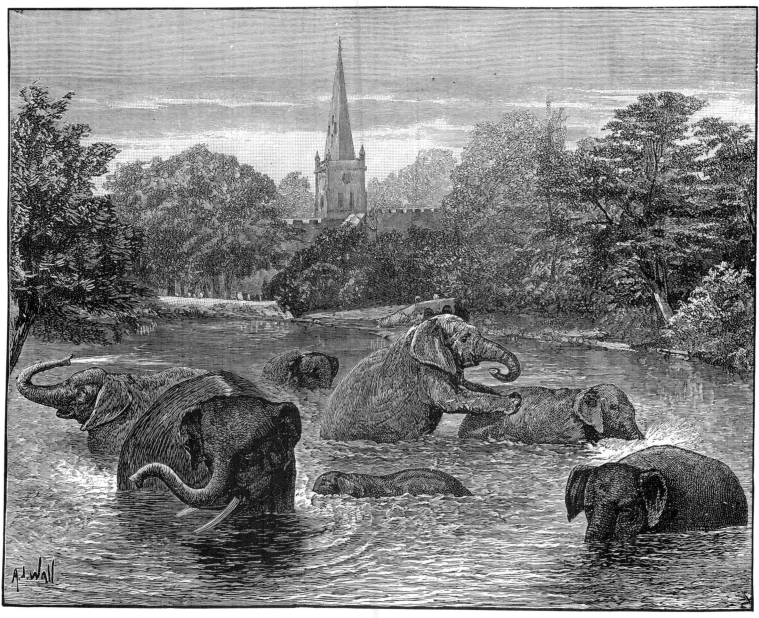

207

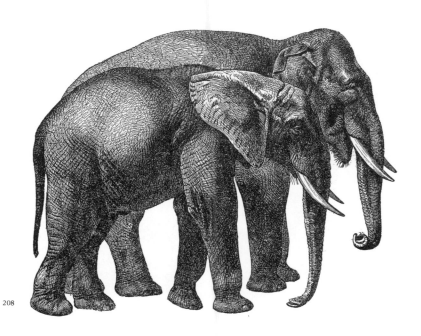

208

**MAMMALS.  207 & 208:** Elephants.

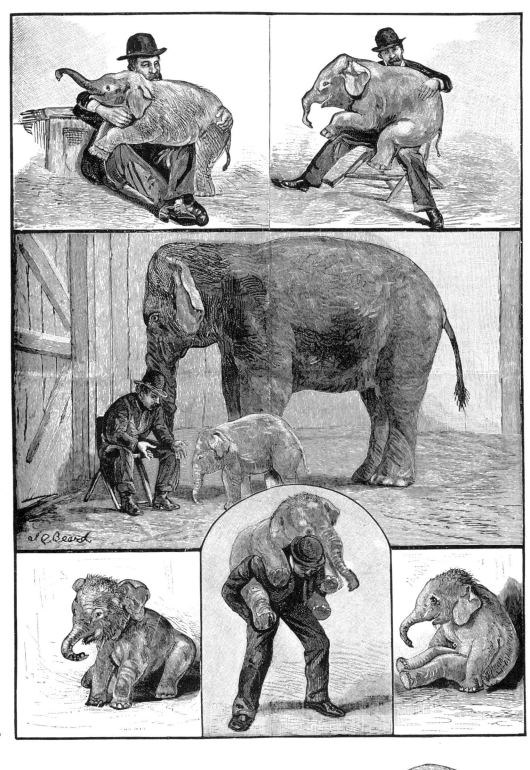

209

210

**MAMMALS.** 209 & 210: Elephants.

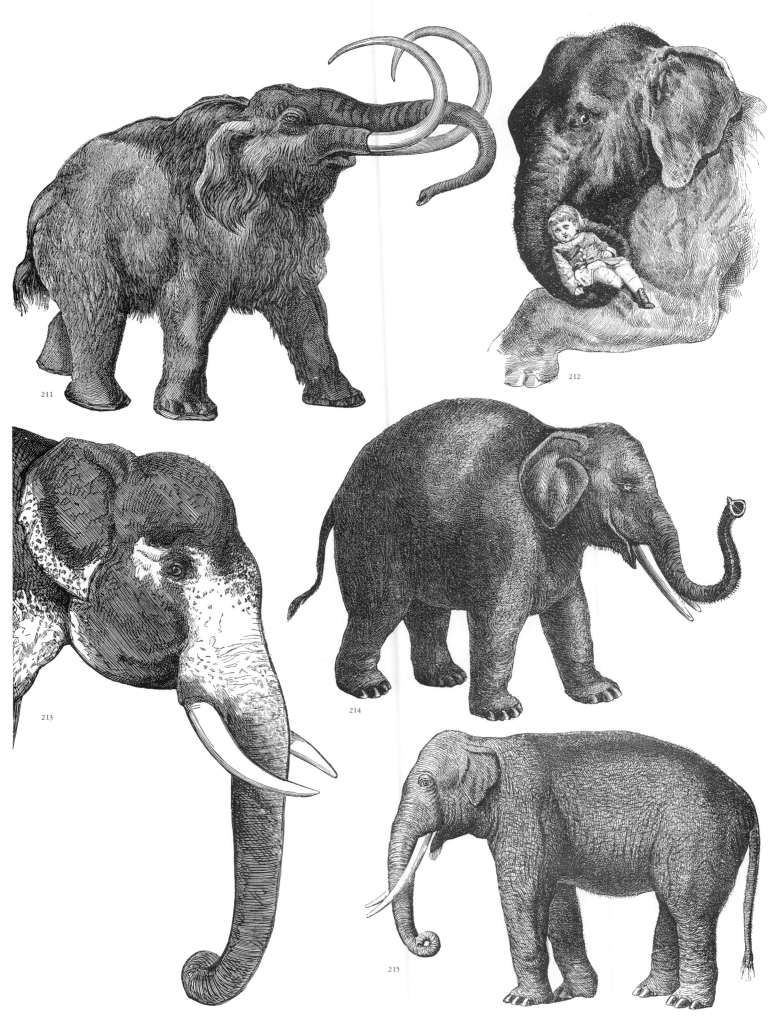

**MAMMALS.** 211: Mammoth. 212–215: Elephants.

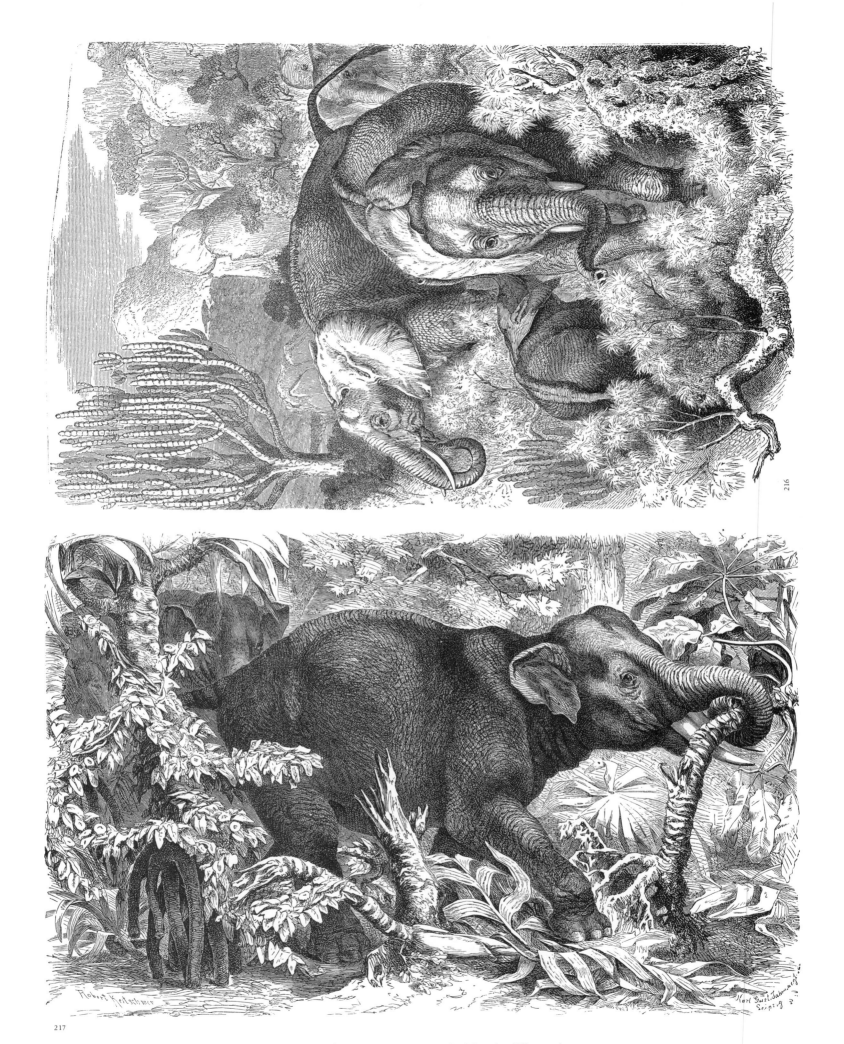

**MAMMALS.** 216 & 217: Elephants, emphasizing the difference between
the larger-eared African and the smaller-eared Indian.

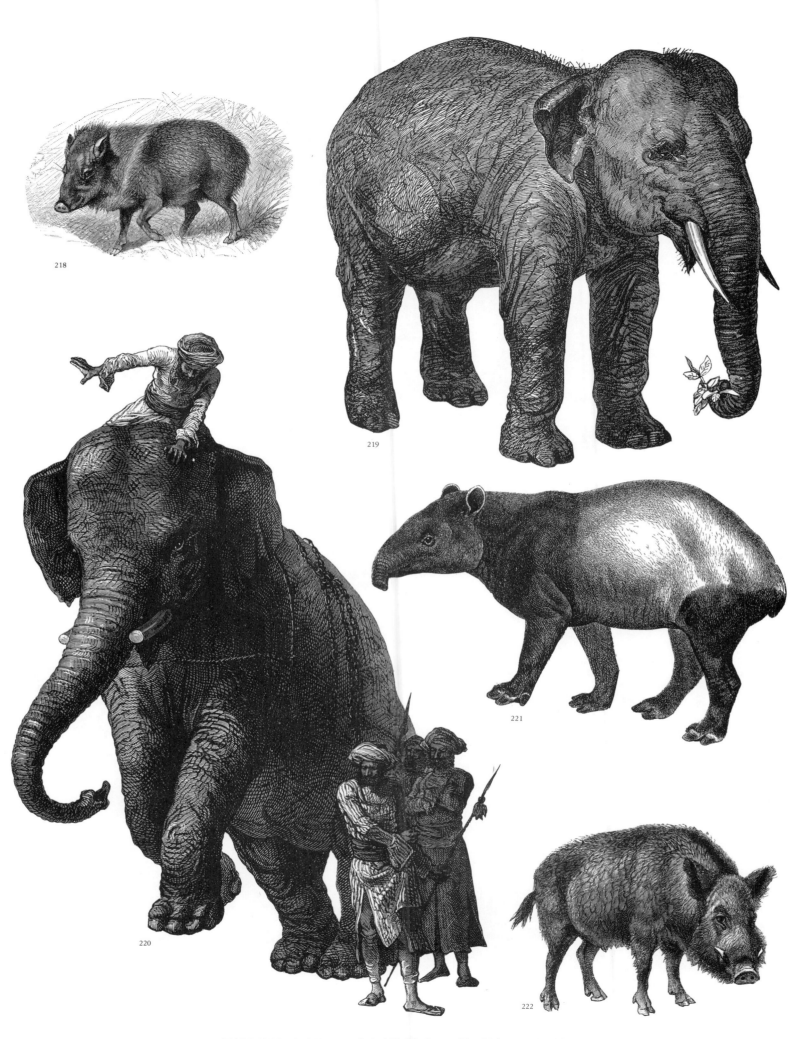

**MAMMALS.** 218: Peccary. 219, 220: Elephants. 221: Malayan tapir. 222: Wild boar.

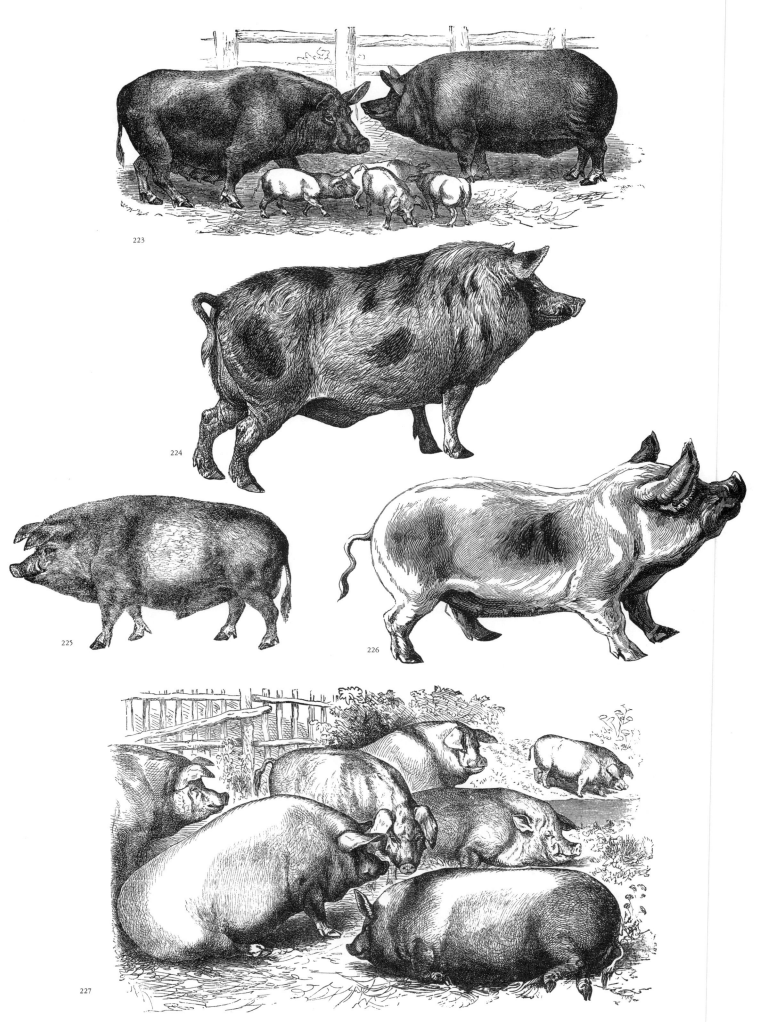

**MAMMALS.  223–227:** Pigs (224 is of the Berkshire breed).

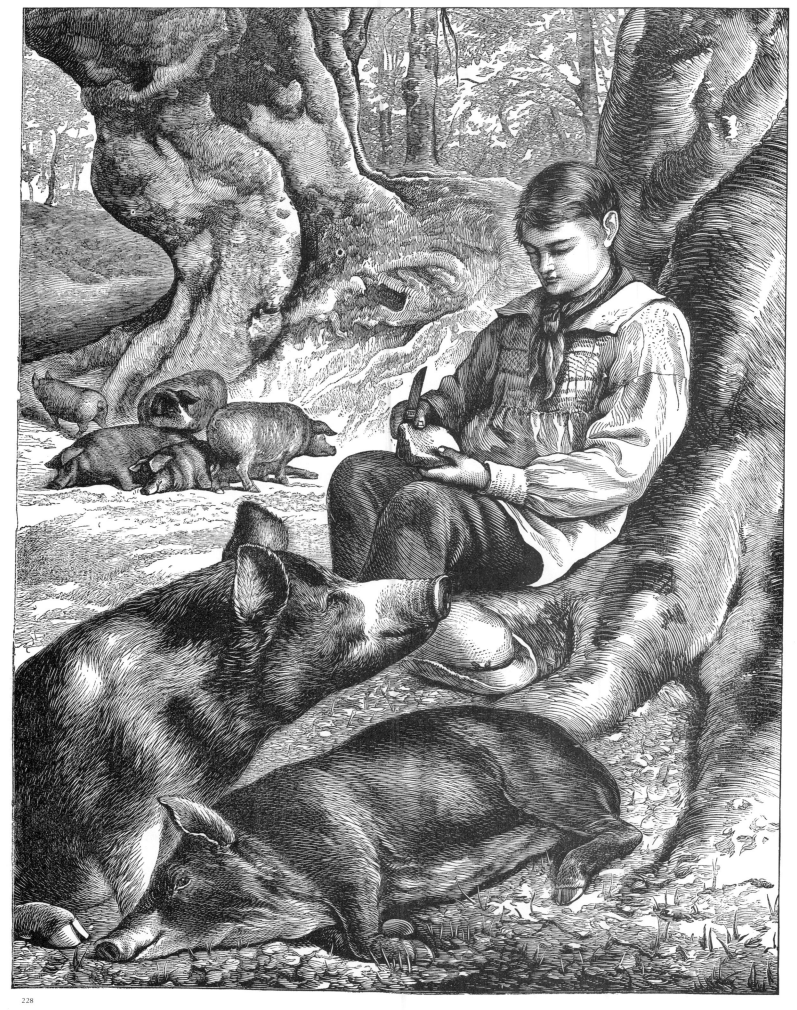

228

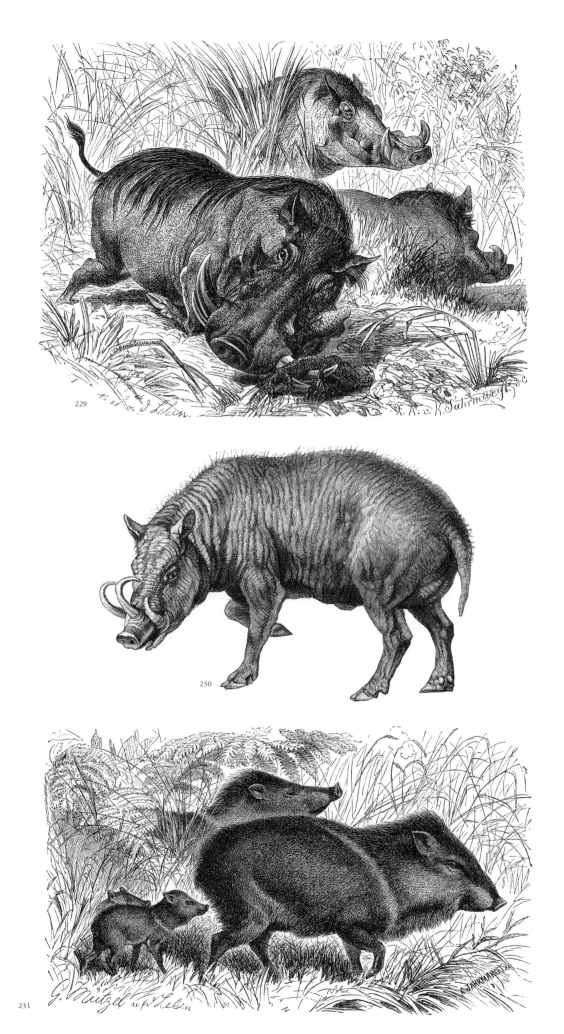

**MAMMALS.** 229: Wart hogs. 230: Babirusa. 231: Collared peccaries.

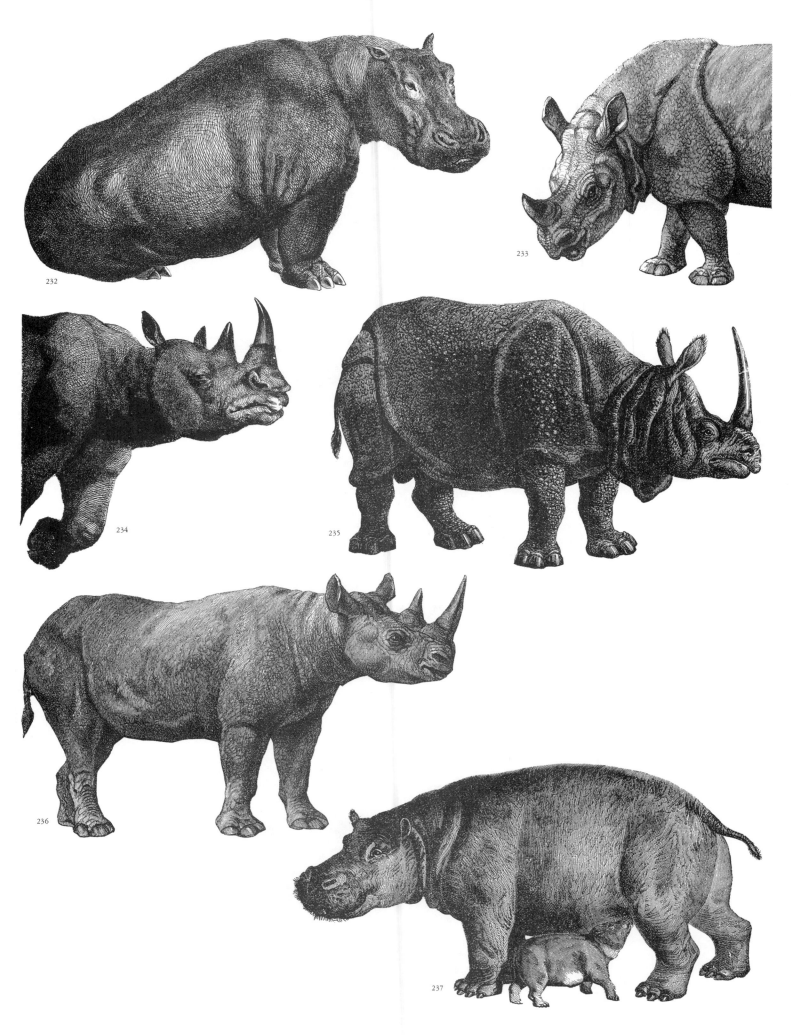

**MAMMALS.** **232, 237:** Hippopotamus. **233–236:** Various species of rhinoceros.

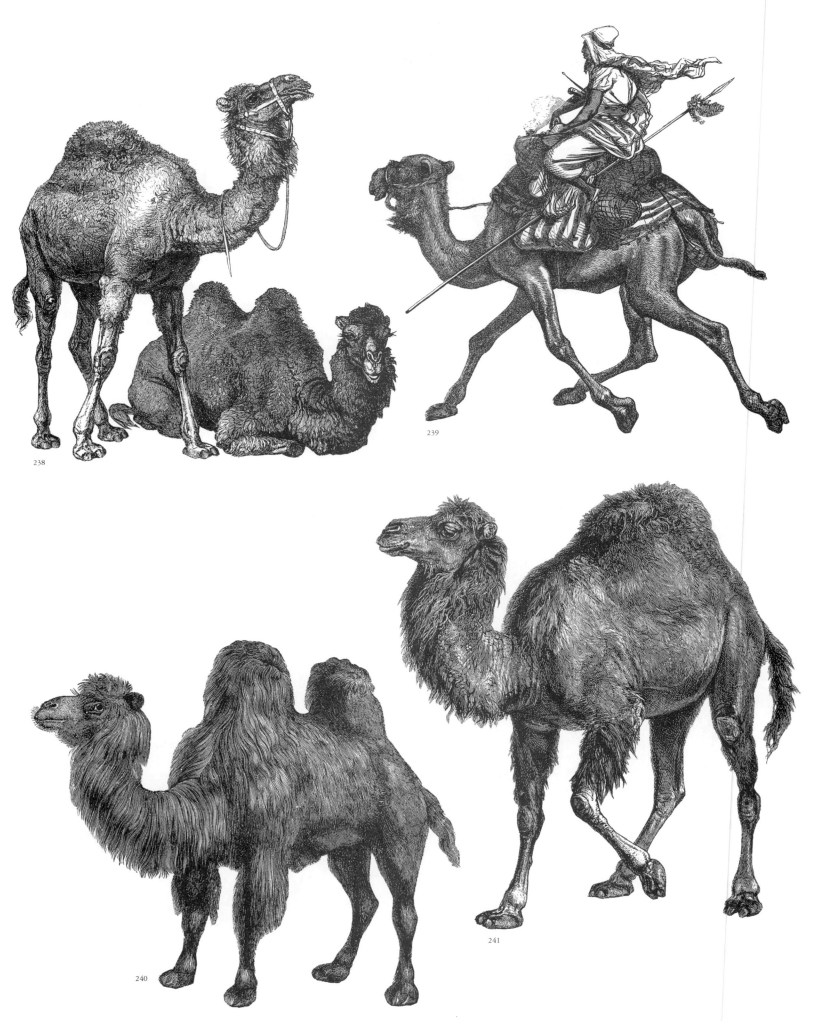

238

239

240

241

**MAMMALS.** 238–241: Camels (one-hump dromedaries and two-hump
Bactrians).

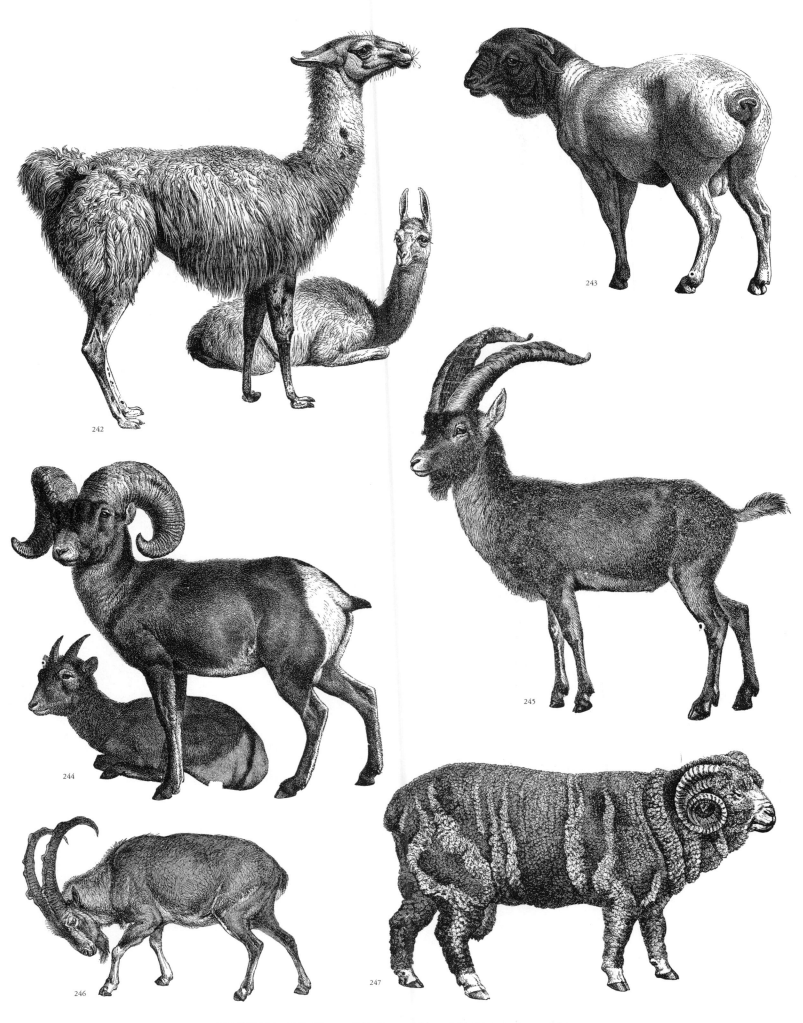

**MAMMALS.** **242:** Llamas. **243:** Type of sheep. **244:** Bighorn sheep. **245:** Type of wild goat. **246:** Bezoar goat. **247:** Merino sheep.

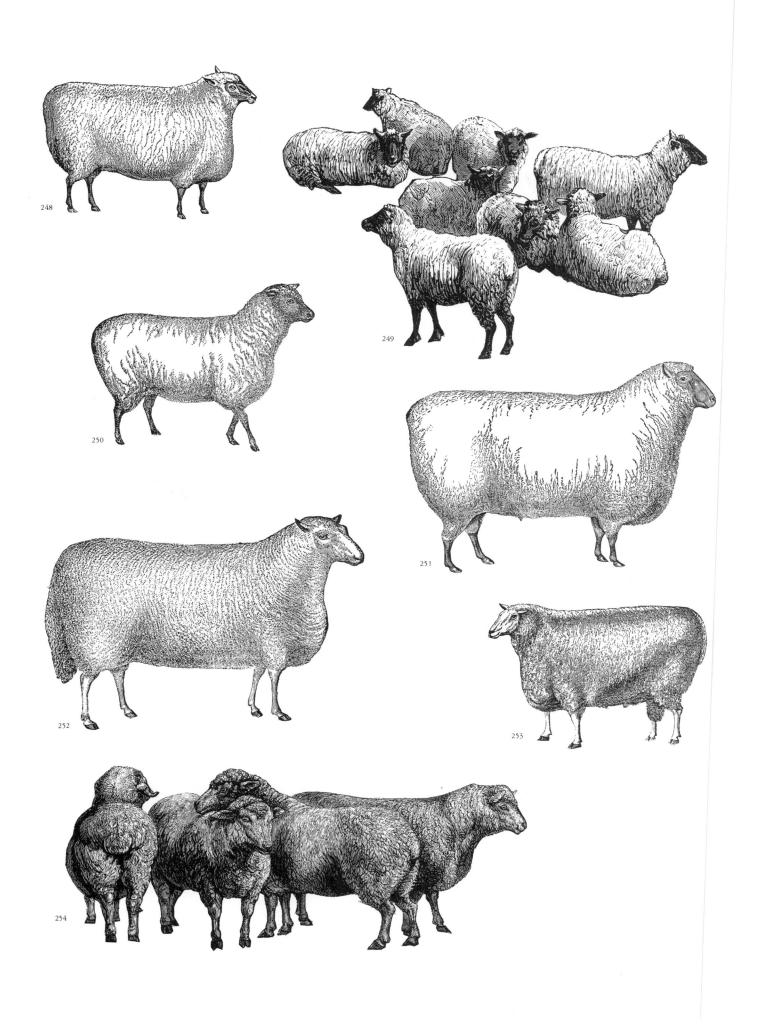

**MAMMALS.** 248–254: Various breeds of domesticated sheep.

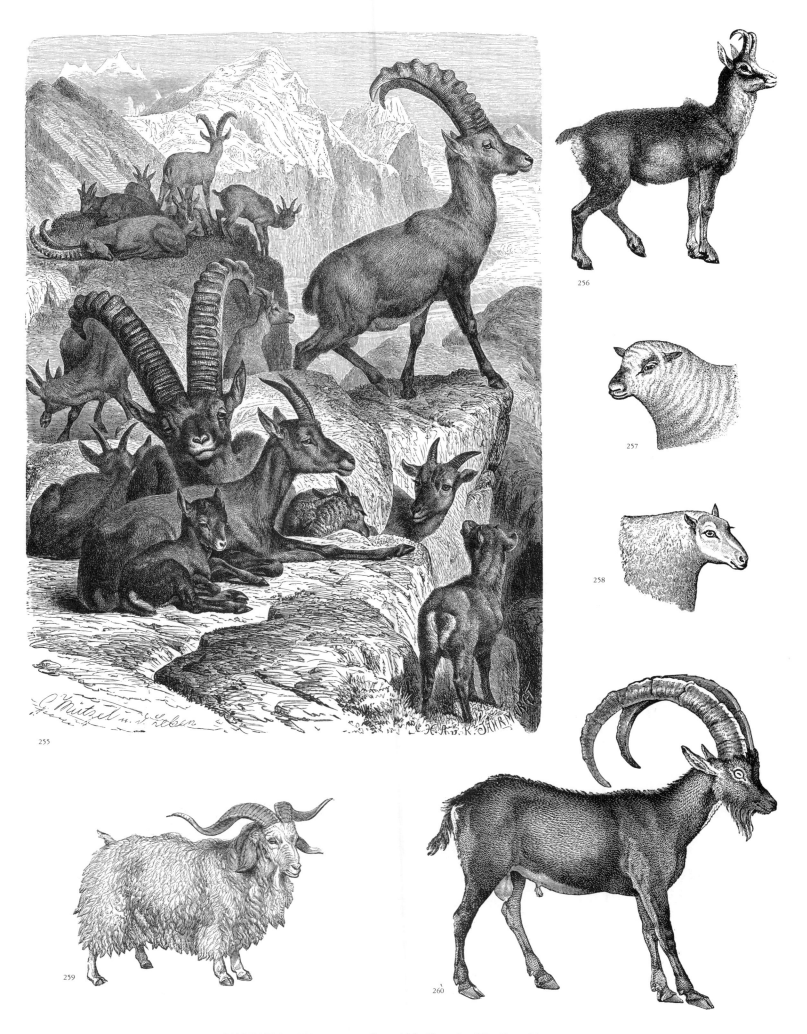

**MAMMALS.** 255: European ibex. 256: Chamois. 257: Shropshire ram.
258: Leicester ram. 259: Angora goat. 260: Type of ibex.

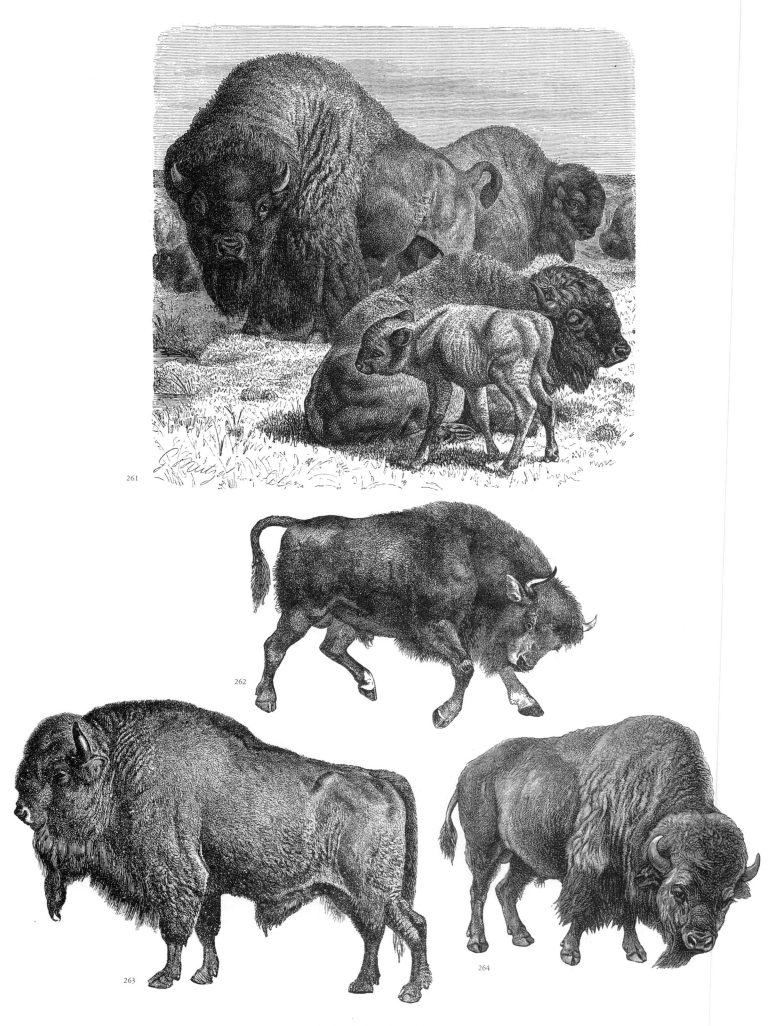

**MAMMALS.** 261–264: Bison.

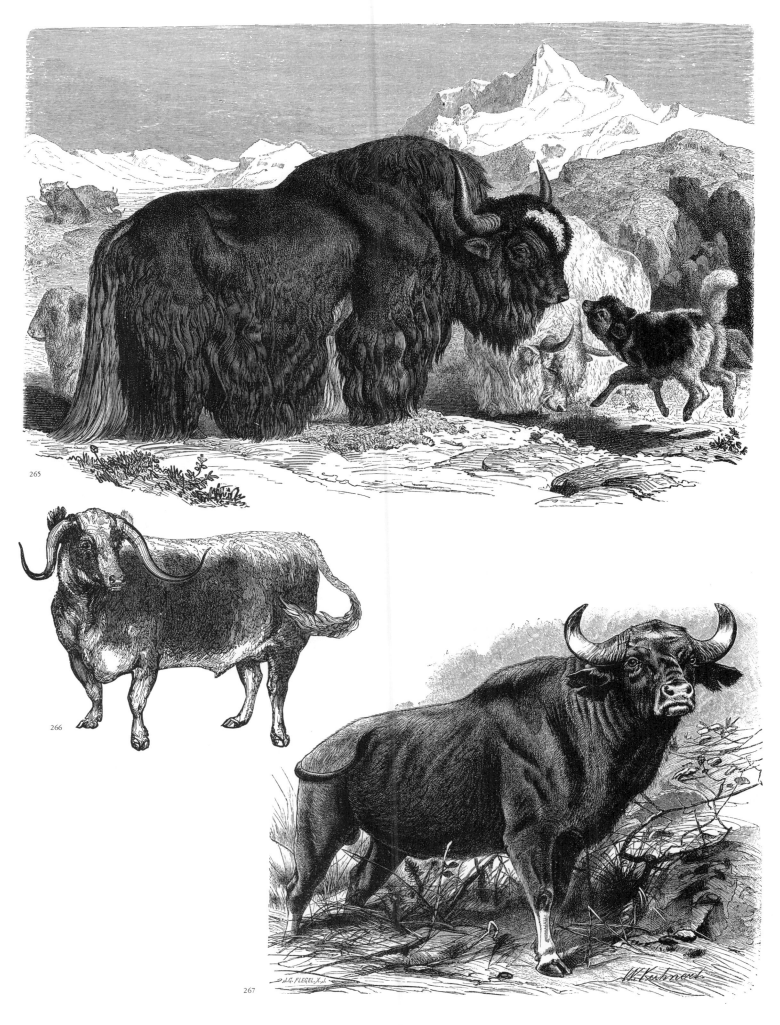

**MAMMALS.** 265: Yaks. 266: Type of cattle. 267: Water buffalo.

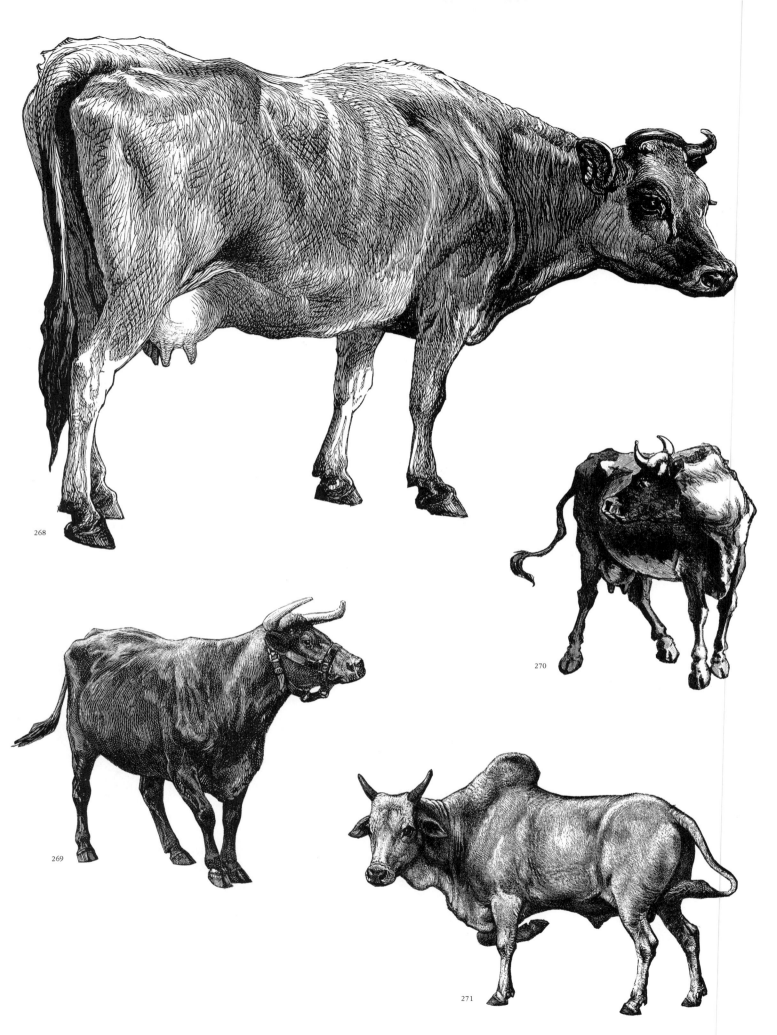

**MAMMALS.** 268–271: Domesticated cattle (271, zebu).

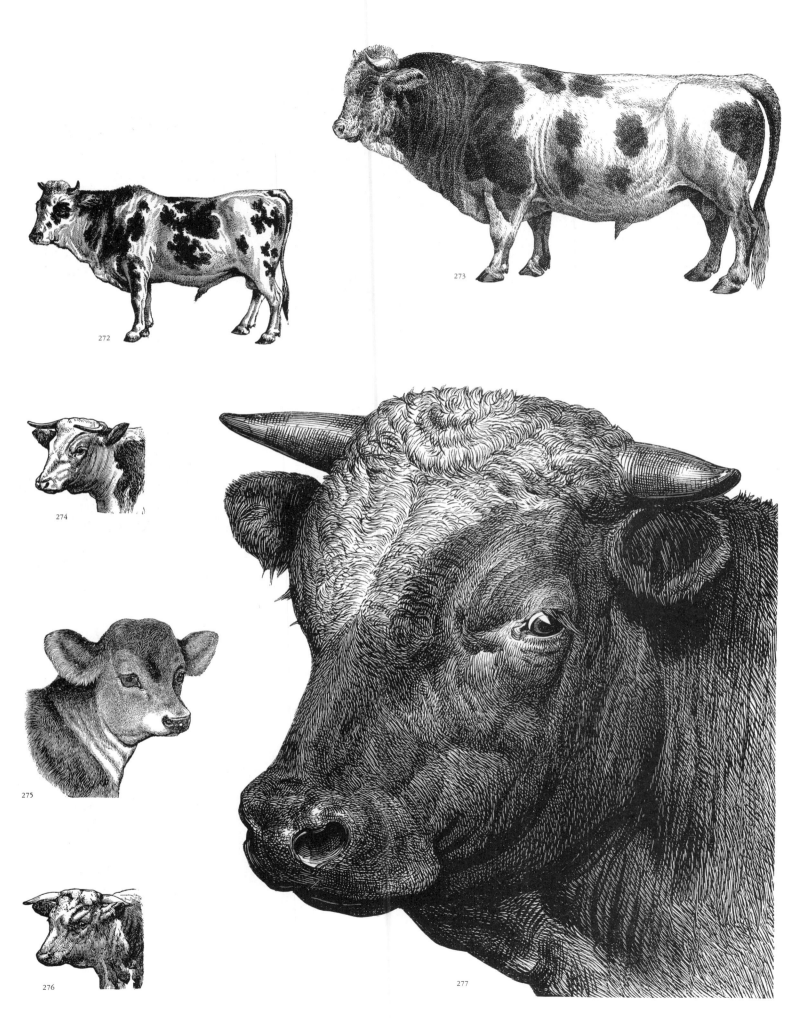

**MAMMALS.** 272–277: Domesticated cattle (273 is the Freiburg breed).

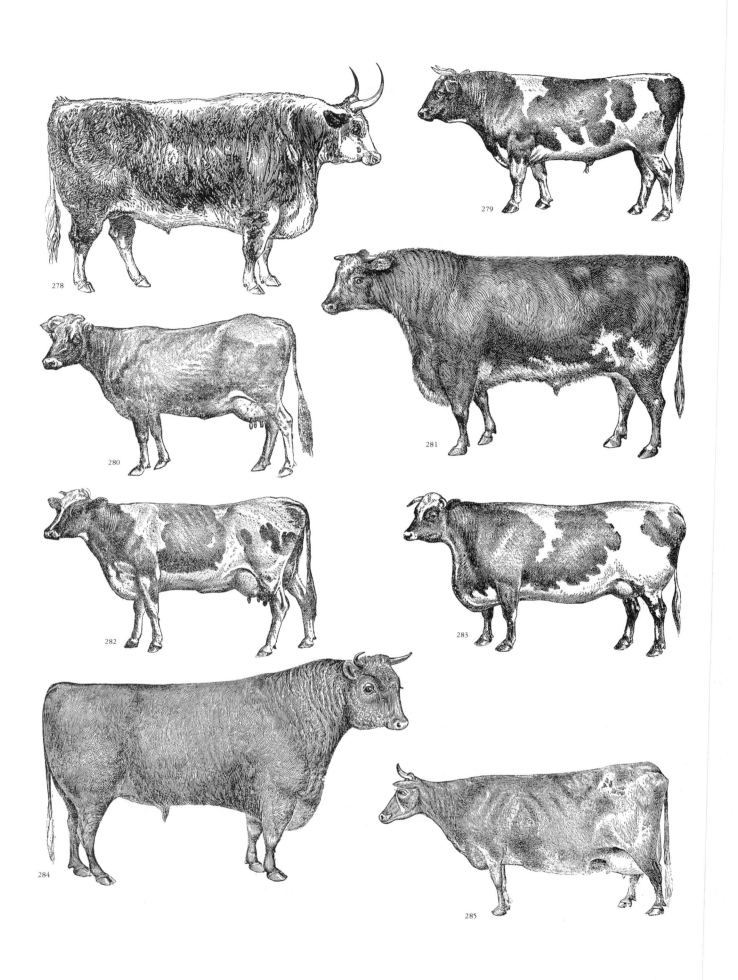

**MAMMALS.** **278–285:** Domesticated cattle (278, Hereford; 279 & 283, Holstein; 280, Jersey; 281, shorthorn; 282, Guernsey; 284, Devon; 285, Ayrshire).

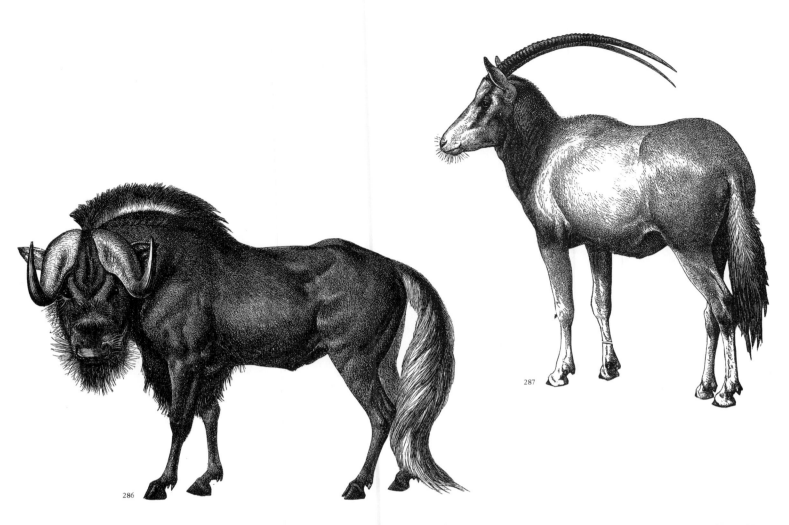

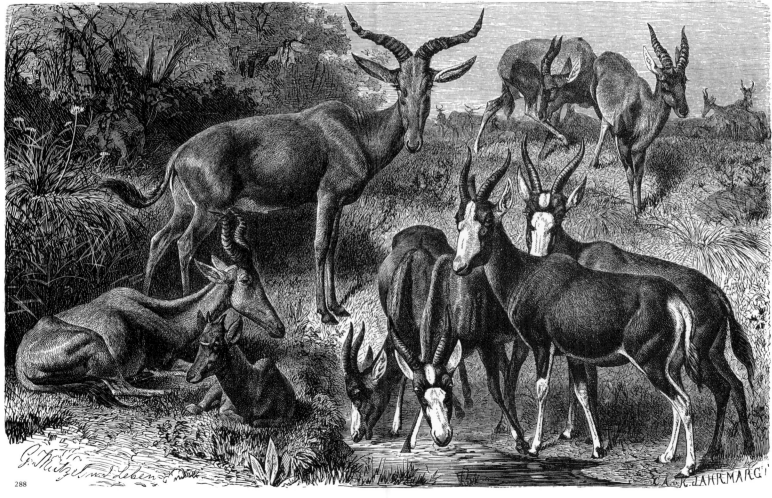

**MAMMALS.** **286:** Gnu. **287:** Sable antelope. **288:** Group of African antelopes, including tora (left half), and bontebok and blesbok (together in right foreground).

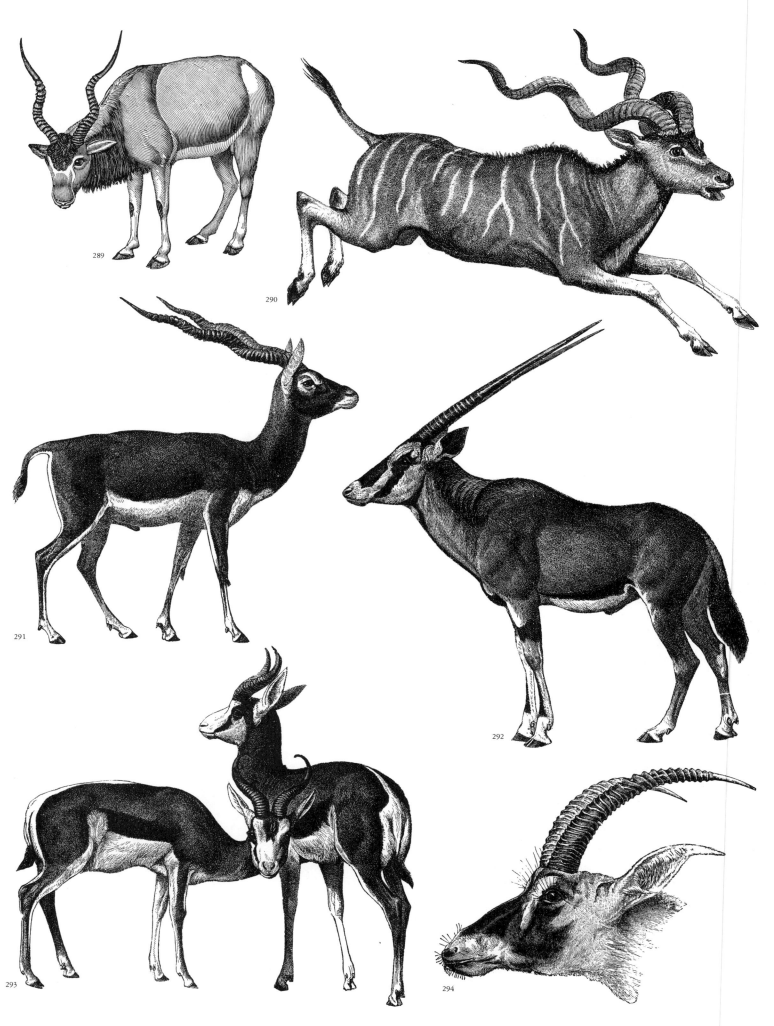

**MAMMALS.** **289**: Addax. **290**: Greater kudu. **291**: Blackbuck. **292**: Beisa oryx. **293**: Springbok. **294**: type of antelope.

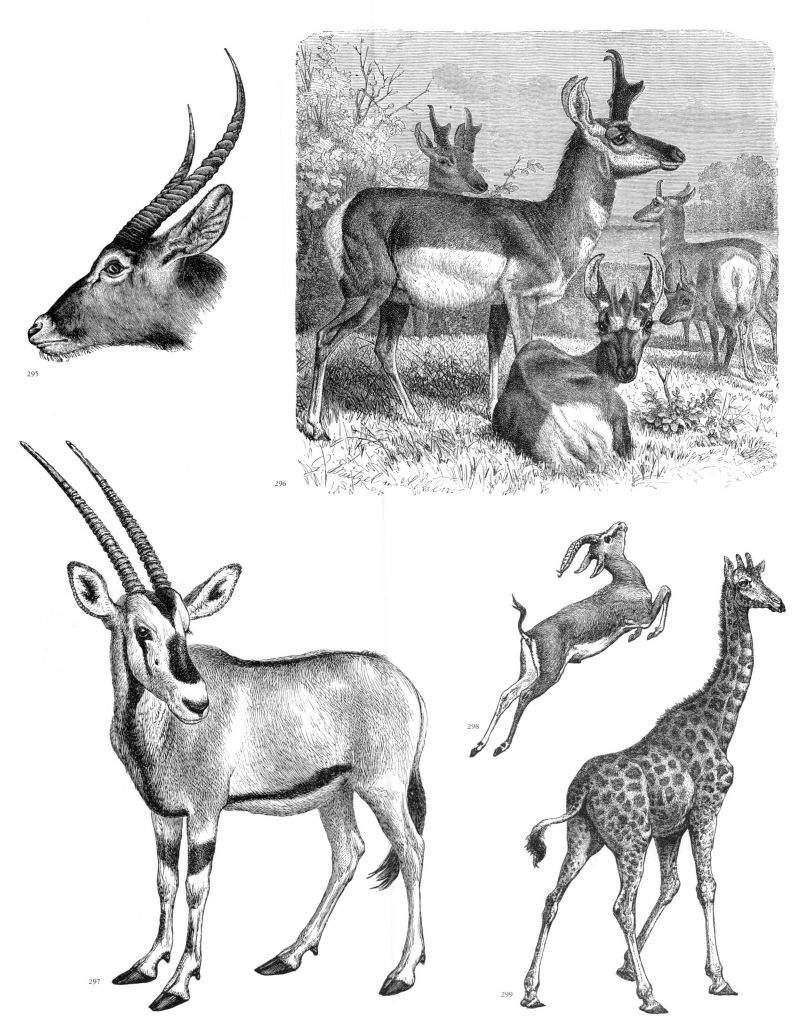

**MAMMALS. 295, 298:** Gazelle. **296:** Pronghorn. **297:** Beisa oryx. **299:** Giraffe.

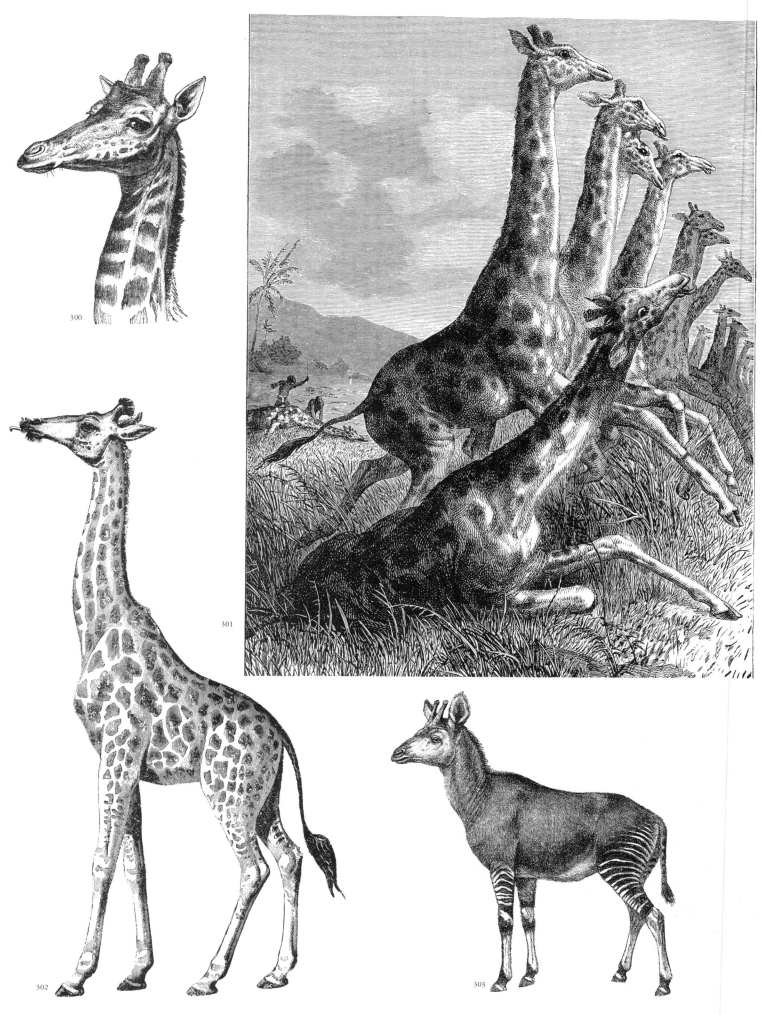

**MAMMALS.** 300–302: Giraffe. 303: Okapi.

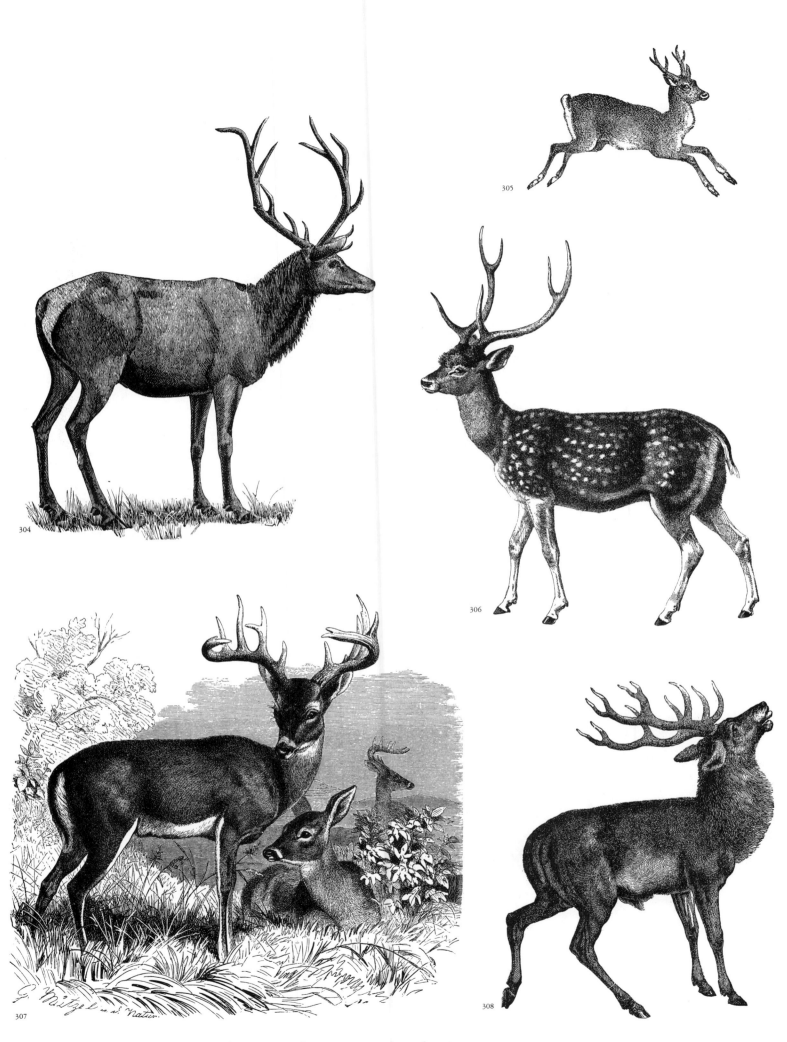

**MAMMALS.** 304: Red deer. 305: Roe deer. 306: Axis deer. 307: White-tailed deer. 308: Red deer stag.

**MAMMALS.** 309: Deer.

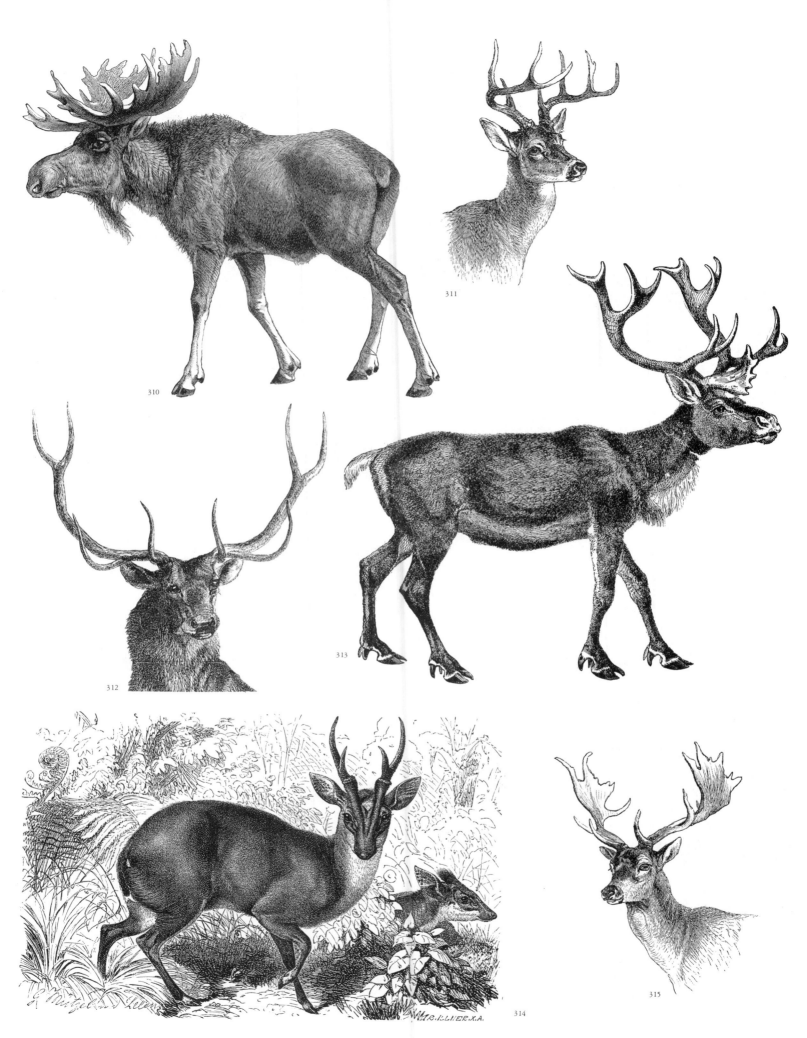

**MAMMALS.** 310: Moose. 311: White-tailed deer. 312: Wapiti. 313: Reindeer. 314: Muntjac. 315: Fallow deer.

317

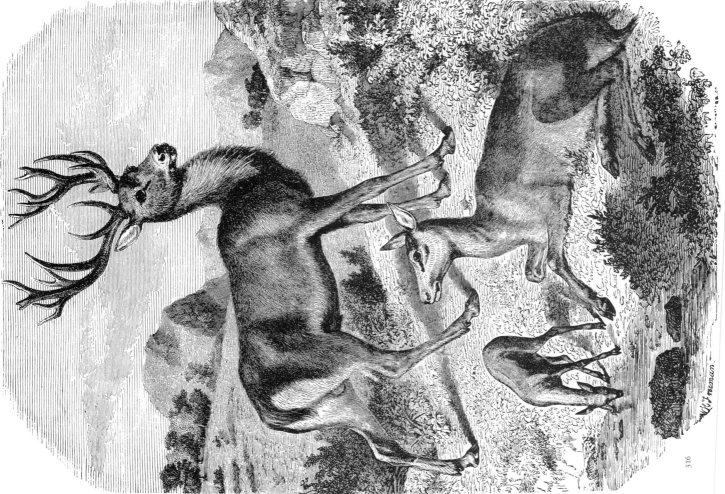

316

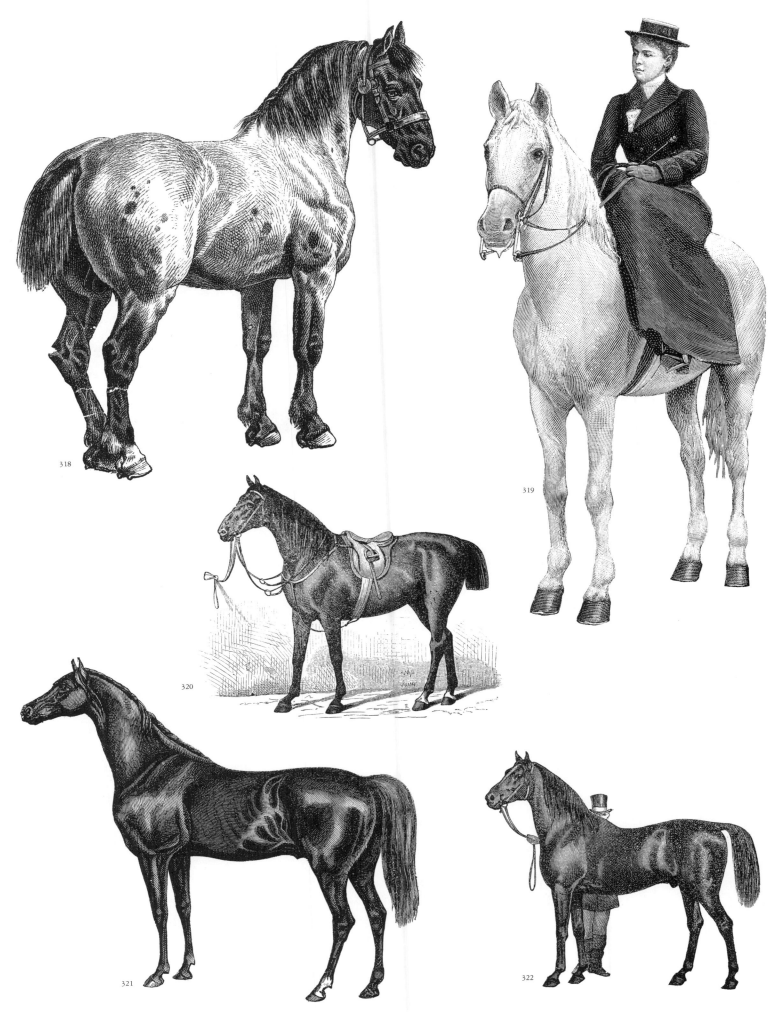

**MAMMALS. 318–322:** Domesticated horses (318 is a Percheron).

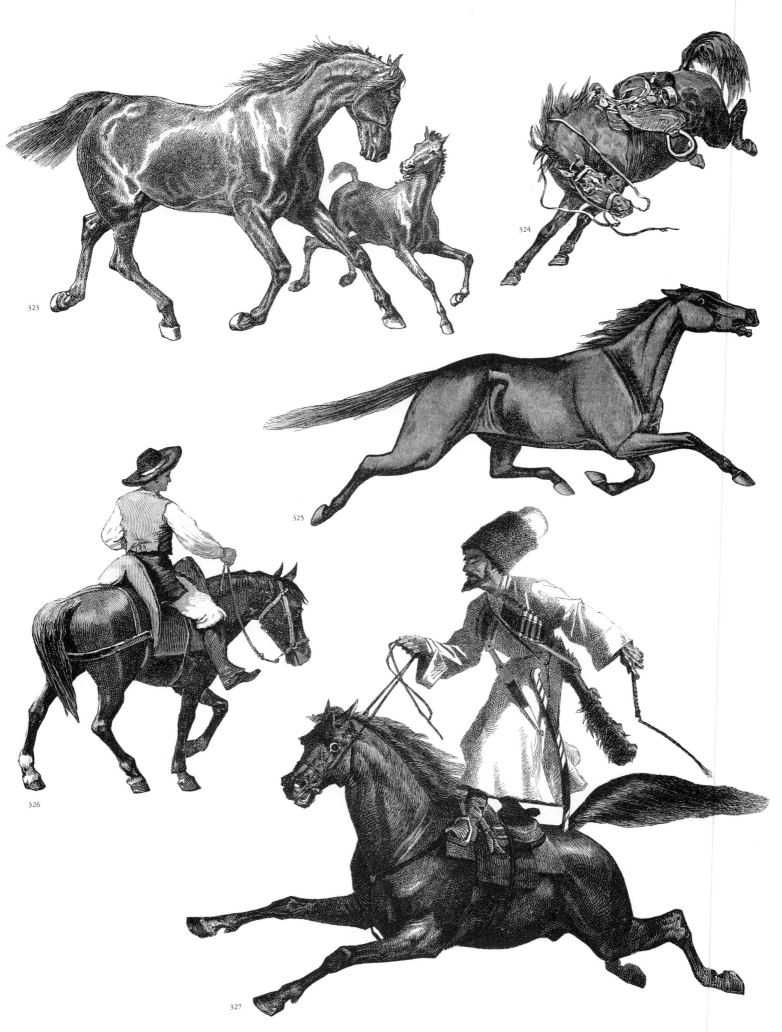

**MAMMALS.  323–327: Domesticated horses.**

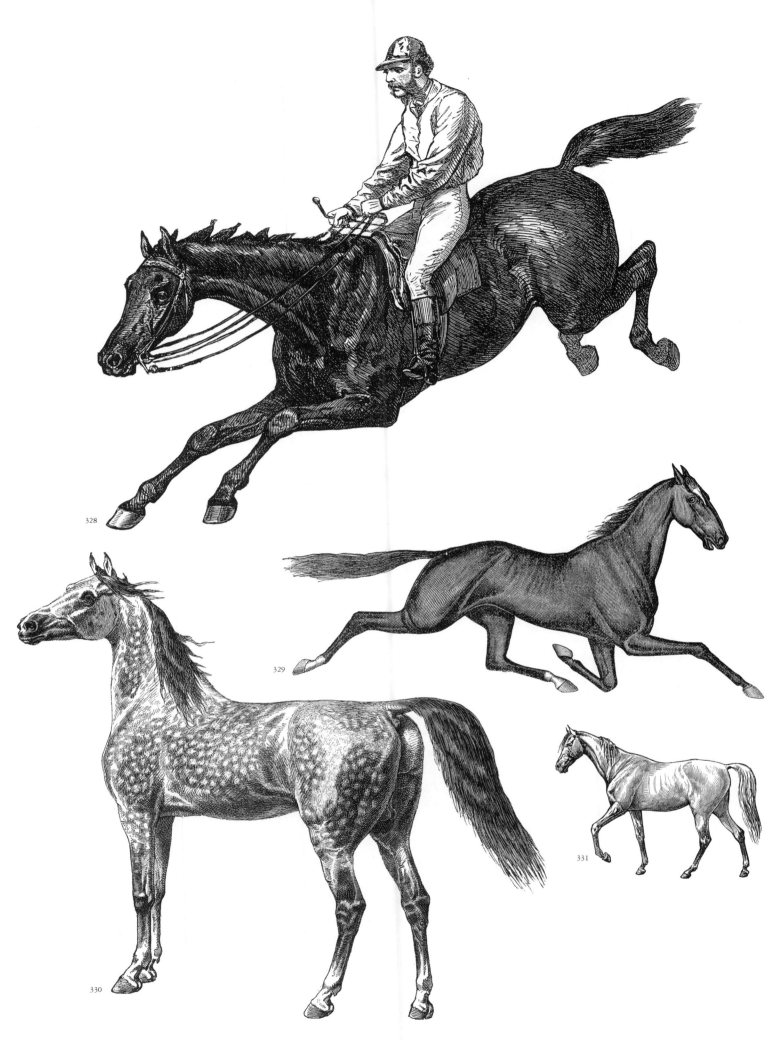

**MAMMALS.** **328-331:** Domesticated horses (330 is an Arab).

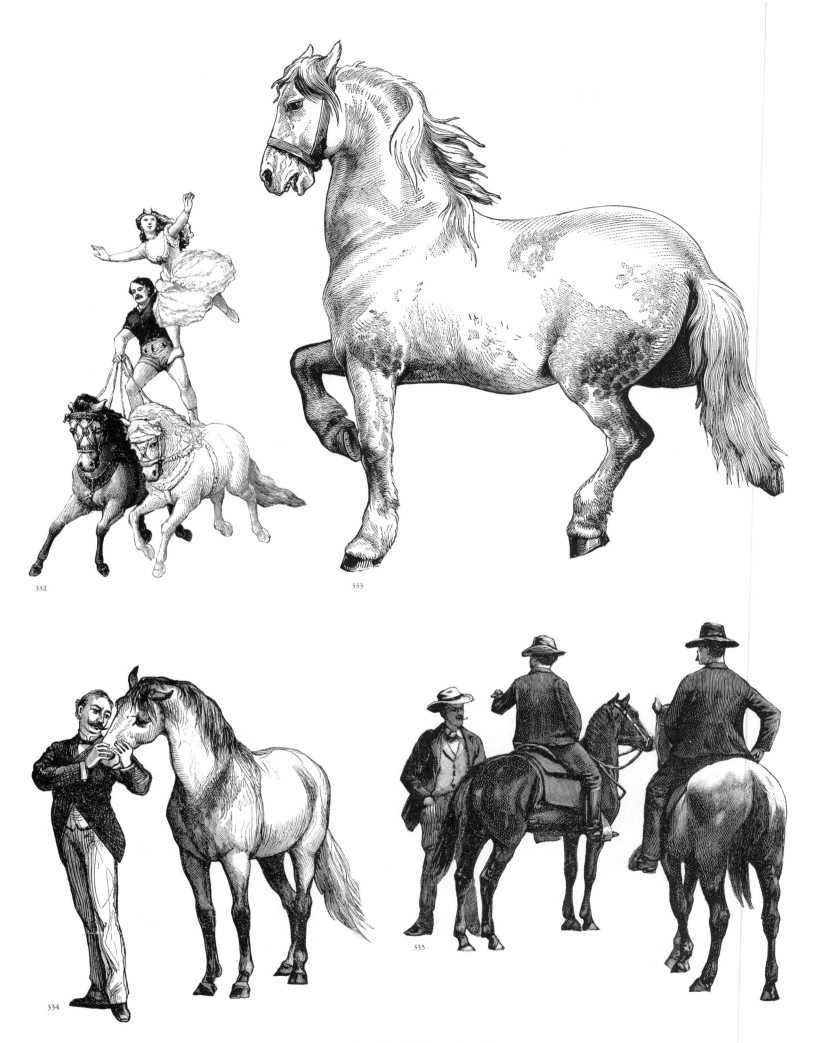

**MAMMALS. 332–335:** Domesticated horses.

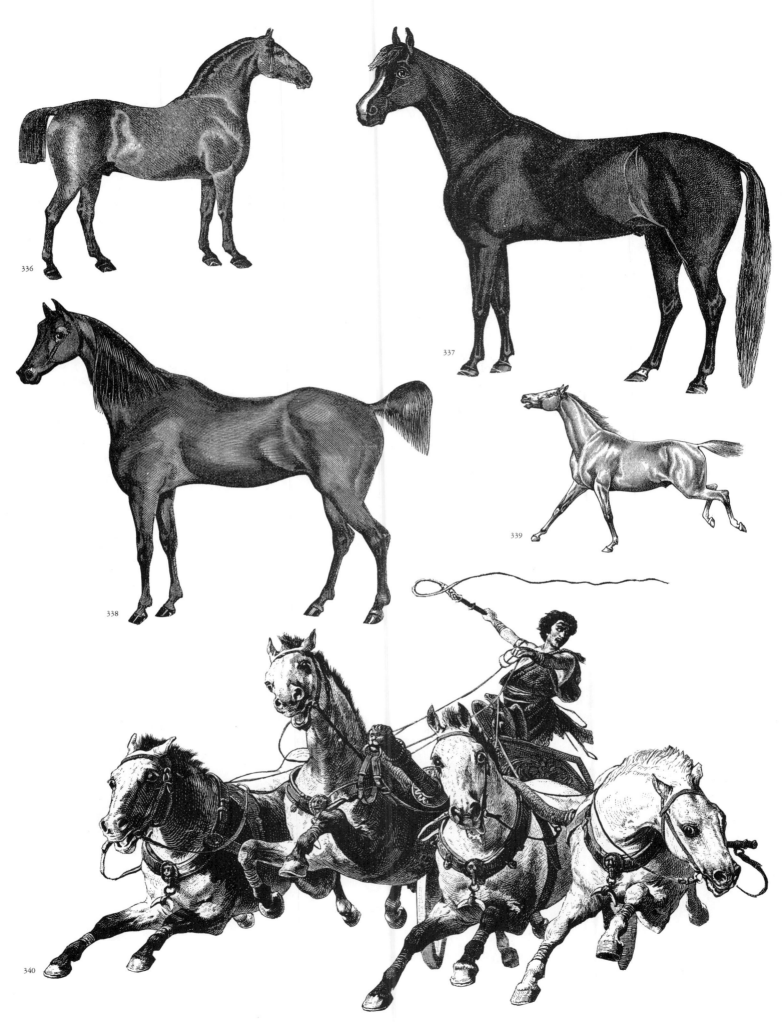

**MAMMALS.** 336–340: Domesticated horses.

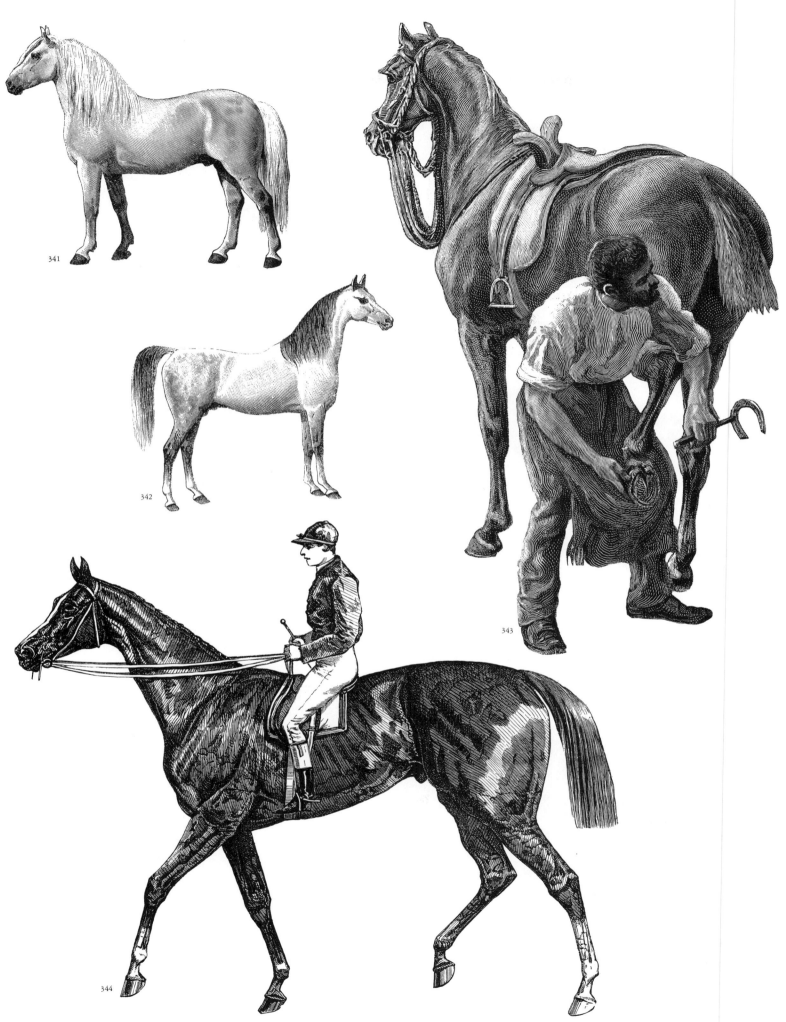

**MAMMALS.** 341–344: Domesticated horses.

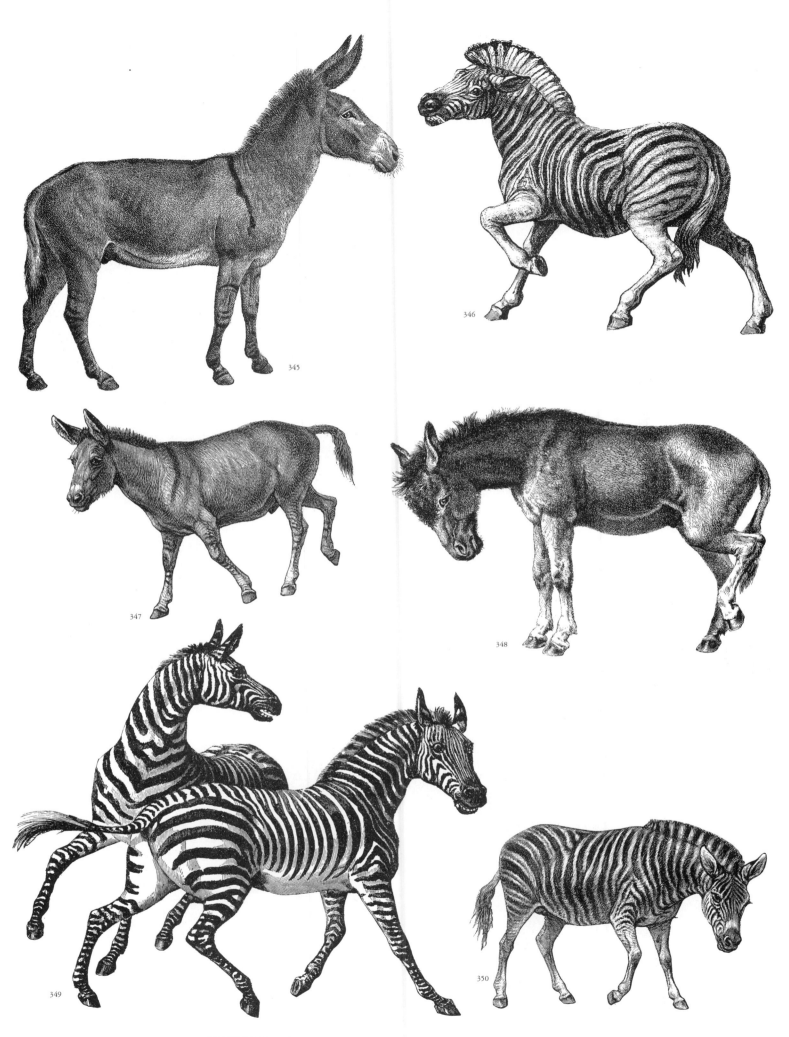

**MAMMALS.  345 & 347:** North African wild ass. **346, 349, 350:** Zebras (all Chapman's?). **348:** Donkey.

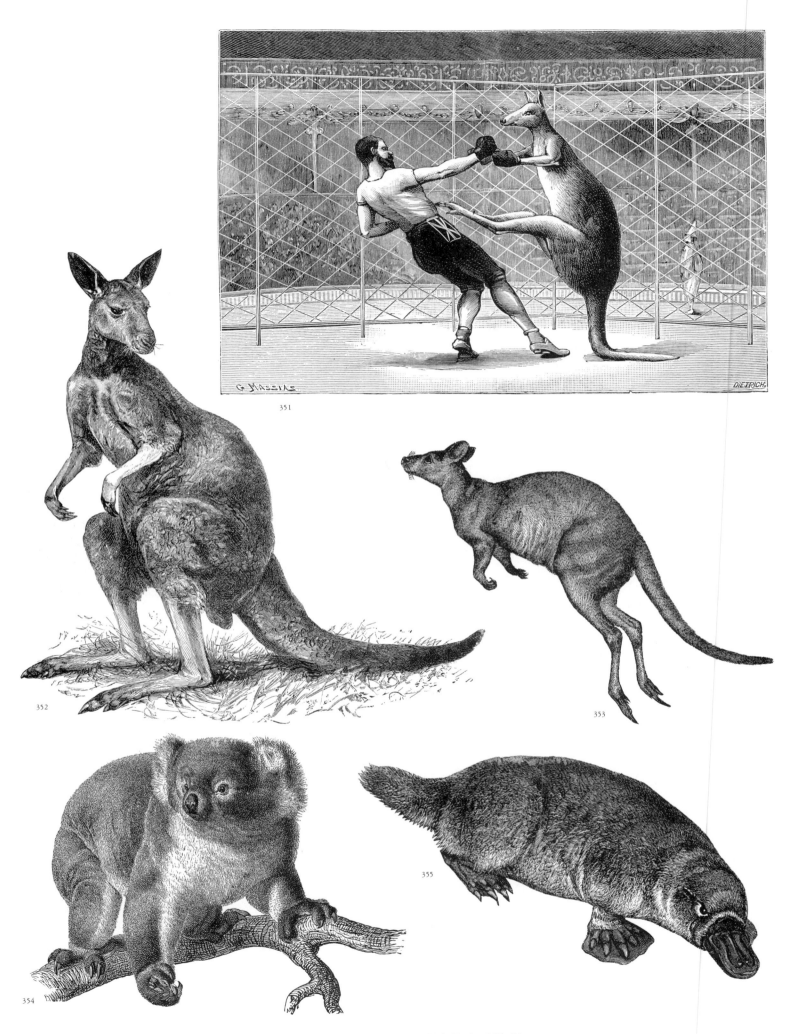

**MAMMALS.** 351–353: Kangaroos. 354: Koala. 355: Platypus.

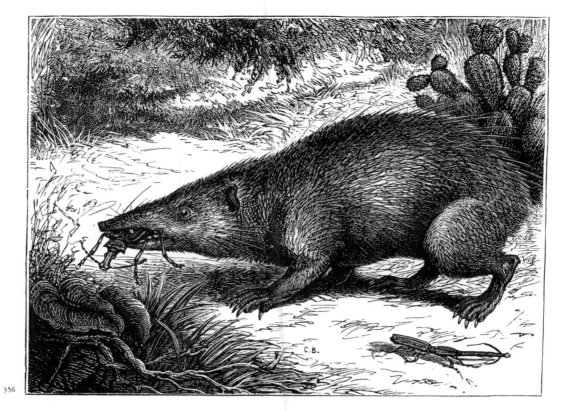

356

357

358

359

360

**MAMMALS.** 356: Tenrec. 357 & 359: Giant armadillo. 358: Kangaroo.
360: Opossum.

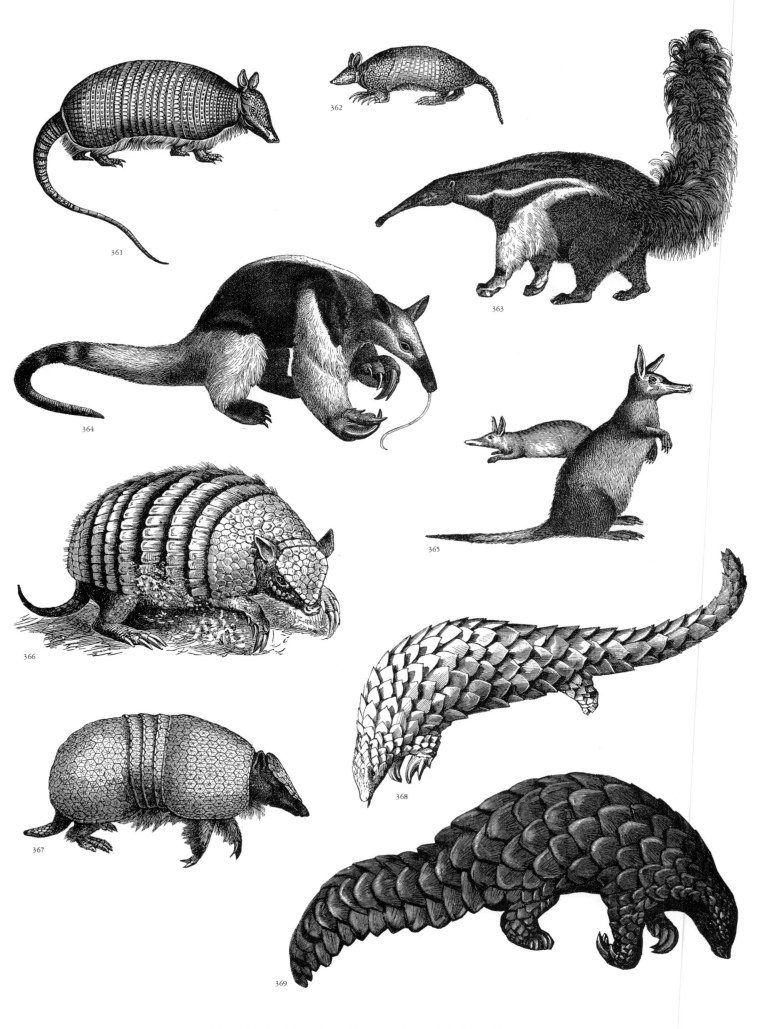

**MAMMALS.** 361 & 362: Nine-banded armadillo. 363: Giant anteater. 364: Tamandua. 365: Type of edentate mammal (?). 366: Six-banded armadillo. 367: A three-banded species of armadillo. 368 & 369: Pangolins.

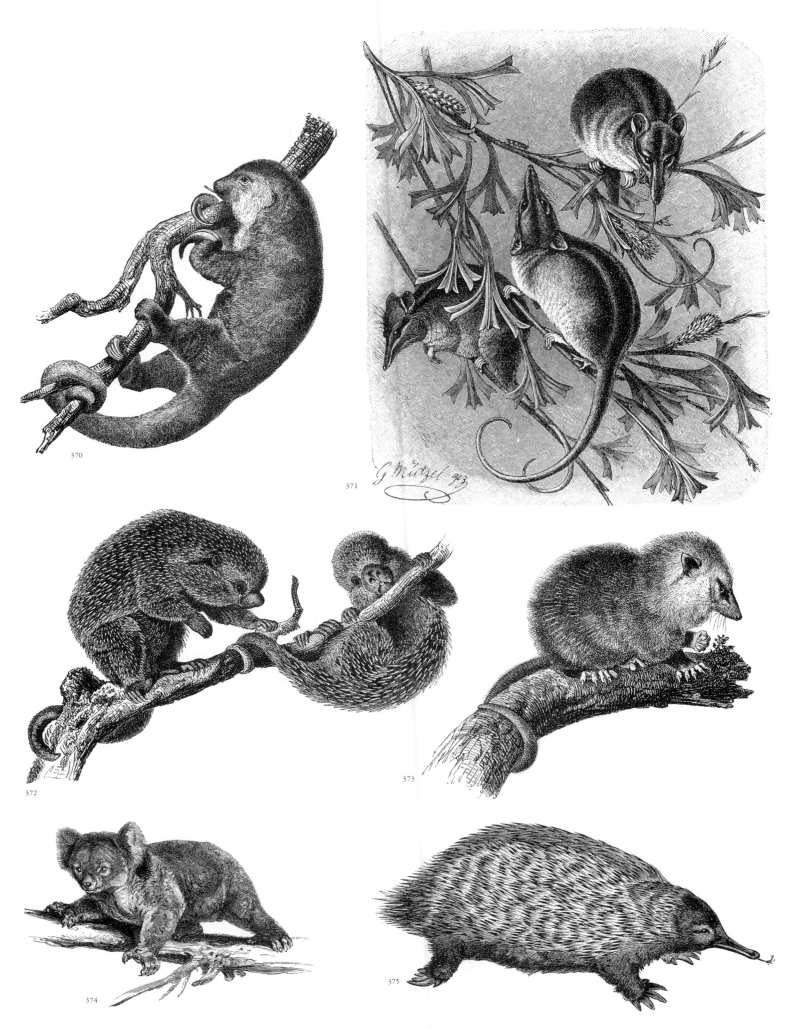

**MAMMALS.** 370: Silky anteater. 371: Tree shrews. 372: Tree porcupines.
373: Opossum. 374: Koala. 375: Spiny anteater (echidna).

**MAMMALS.** 376–379: Rabbits.

**MAMMALS.  380 & 381:** Rabbits.

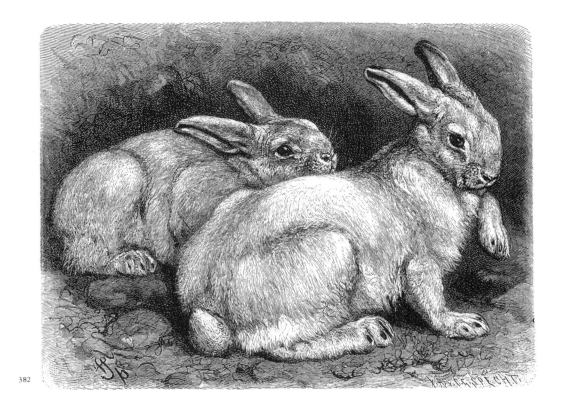

382

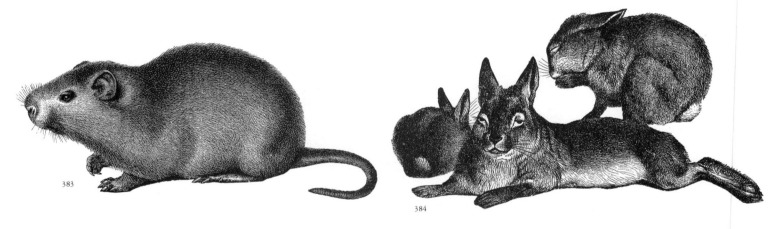

383

384

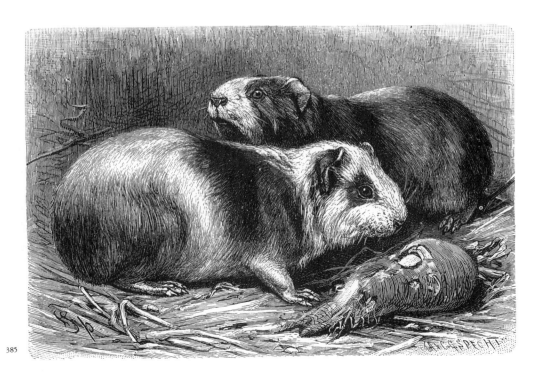

385

**MAMMALS.  382, 384:** Rabbits. **383:** Type of rodent. **385:** Guinea pigs.

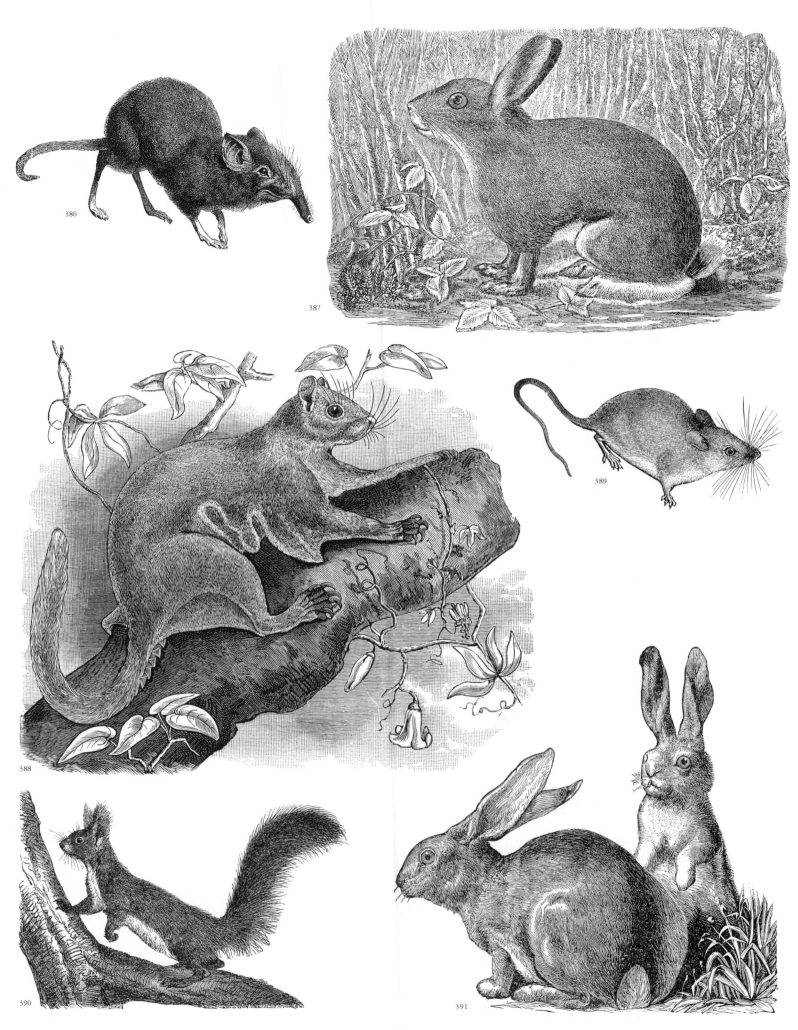

**MAMMALS. 386:** Elephant shrew. **387:** Varying hare. **388:** Type of flying squirrel. **389:** House mouse. **390:** European red squirrel. **391:** Hares.

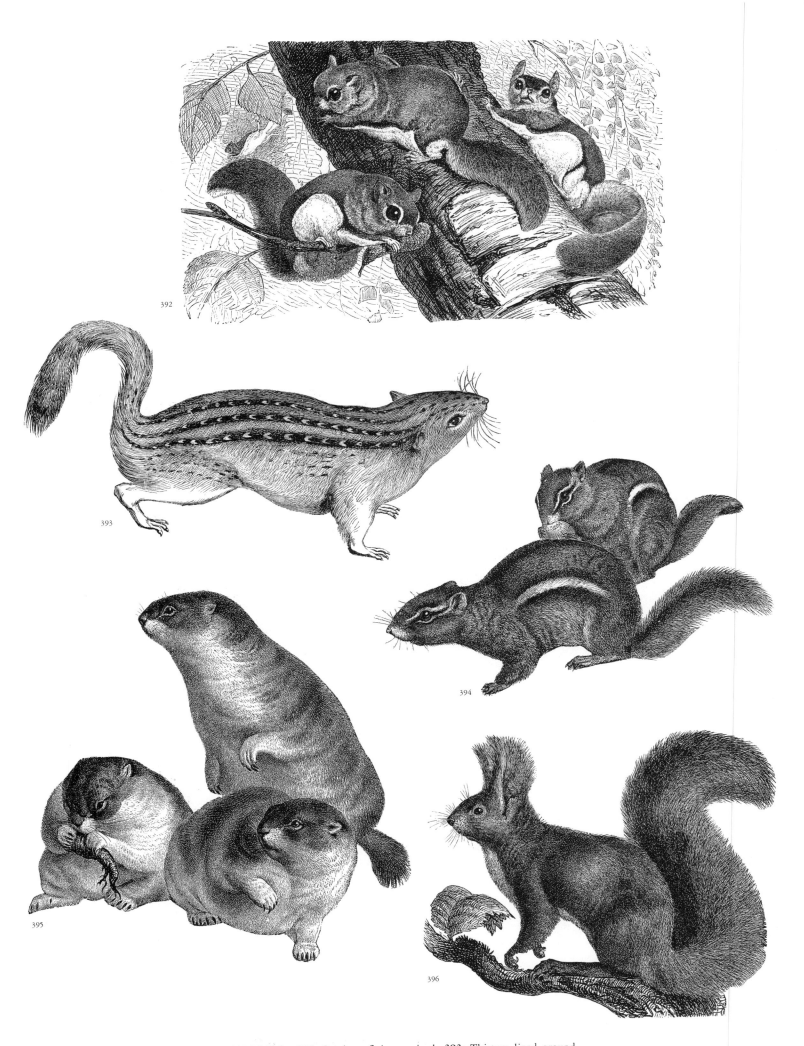

**MAMMALS. 392:** Southern flying squirrel. **393:** Thirteen-lined ground squirrel. **394:** Eastern chipmunk. **395:** Bobac. **396:** European red squirrel.

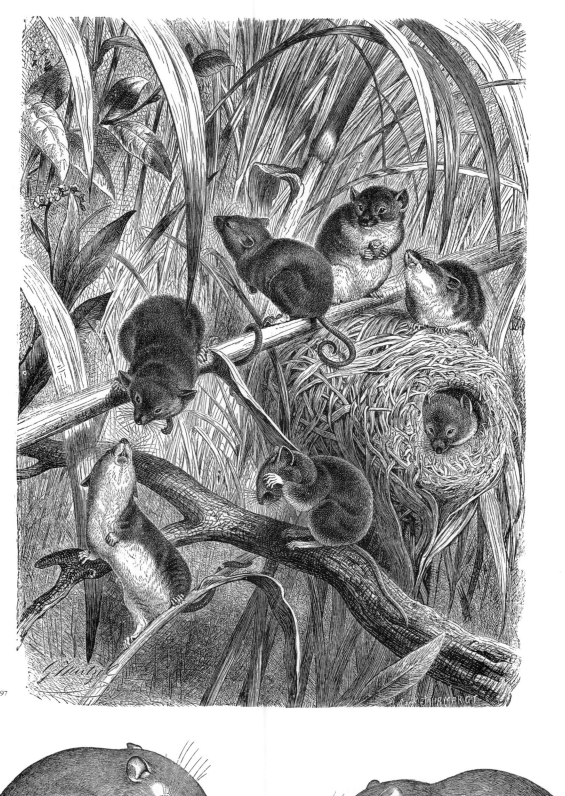

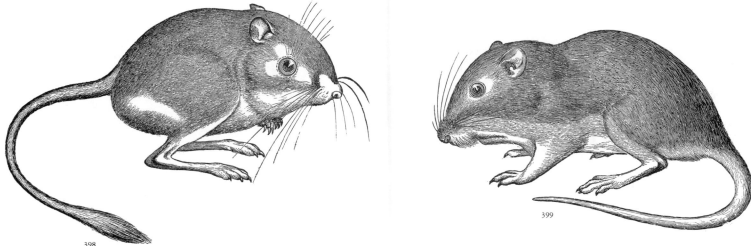

**MAMMALS.** **397:** Harvest mouse. **398:** Ord´s kangaroo rat. **399:** Pocket mouse.

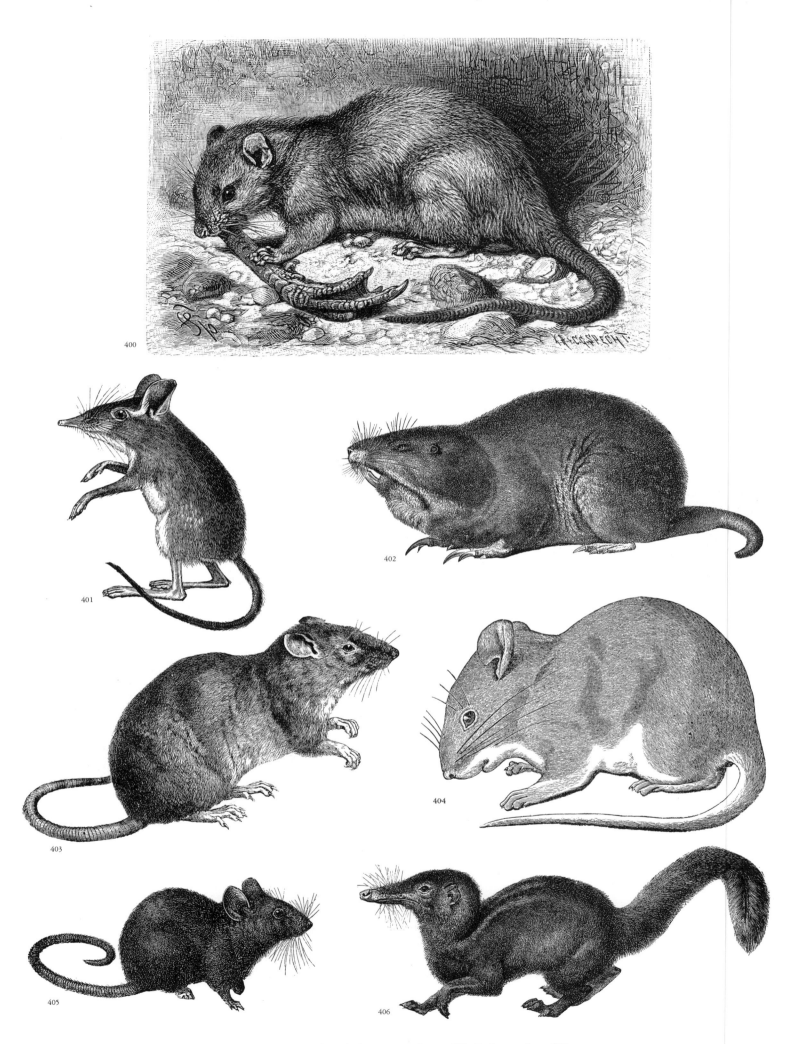

**MAMMALS.** 400, 401, 404: Various rodents. 402: Pocket gopher. 403: Norway rat. 405: A type of mouse. 406: Tana.

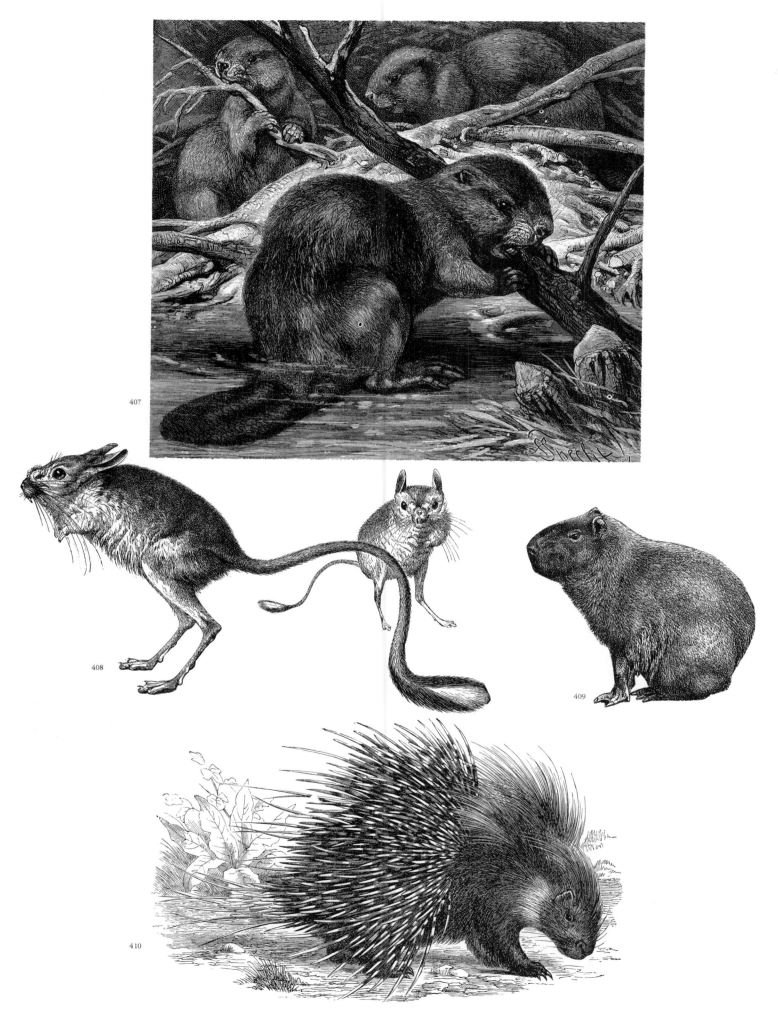

**MAMMALS.** 407: Beaver. 408: Jerboas. 409: Capybara. 410: Crested porcupine.

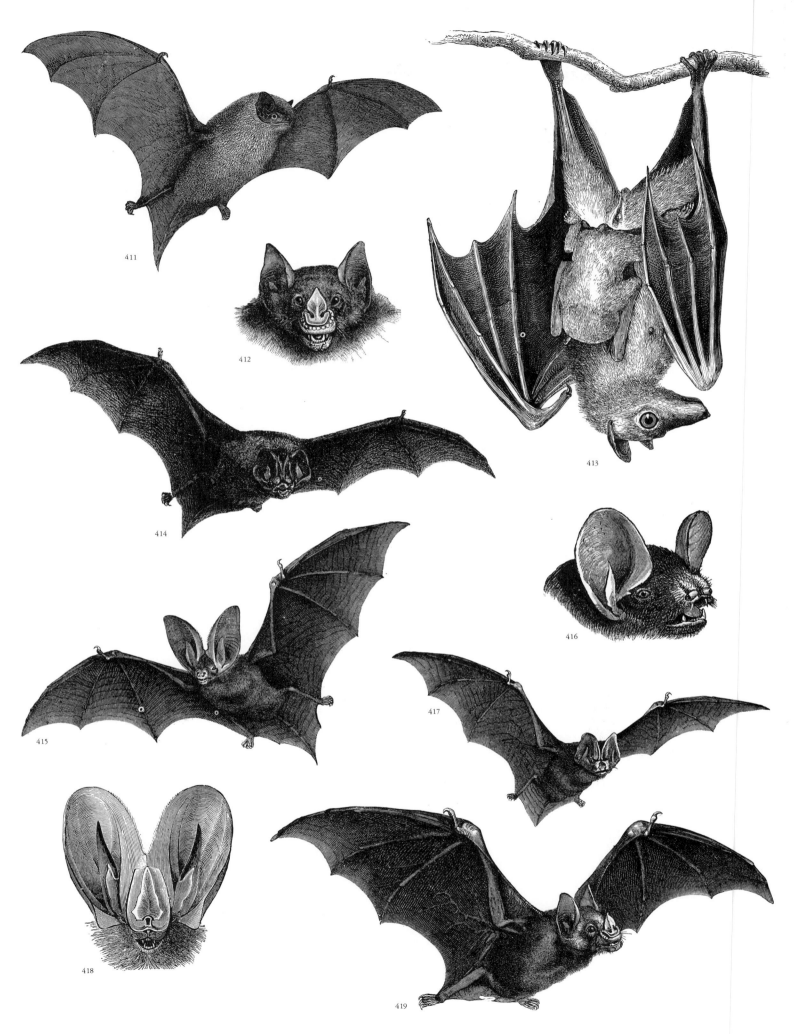

**MAMMALS.** 411: Common European bat. 412, 418, 419: Leaf-nosed bats. 413: A type of fruit bat. 414–417: Species of bat.

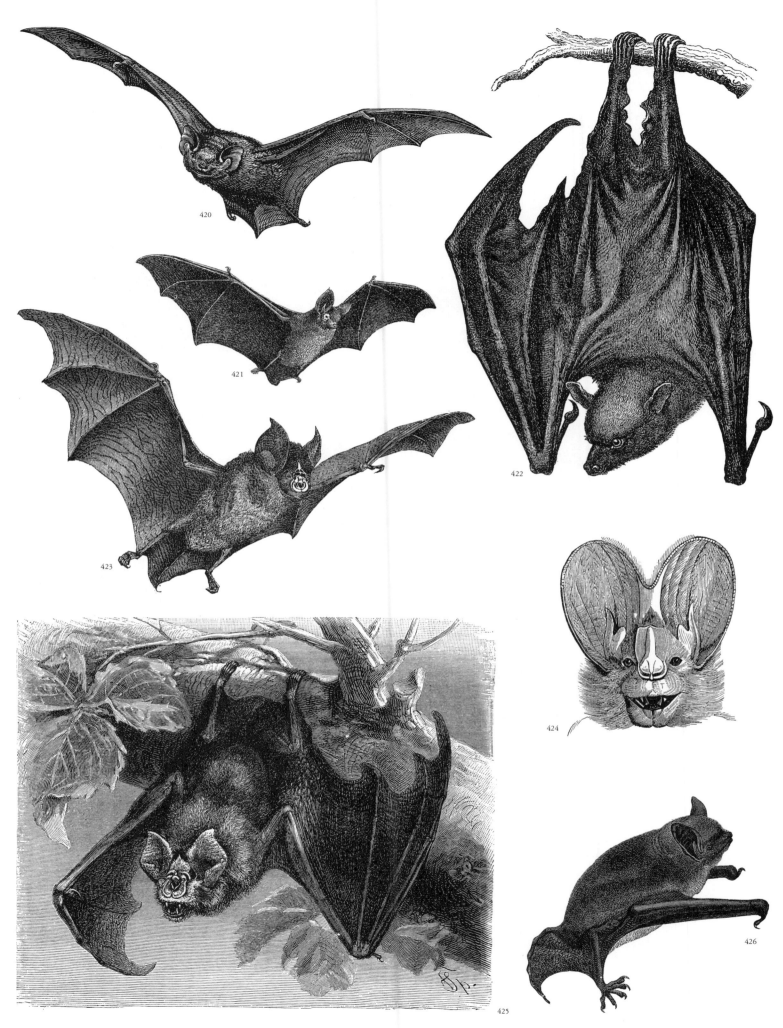

**MAMMALS.** 420: Common European bat. 421, 424, 426: Various bats.
422: "Flying dog" fruit bat. 423, 425: Horseshoe bats.

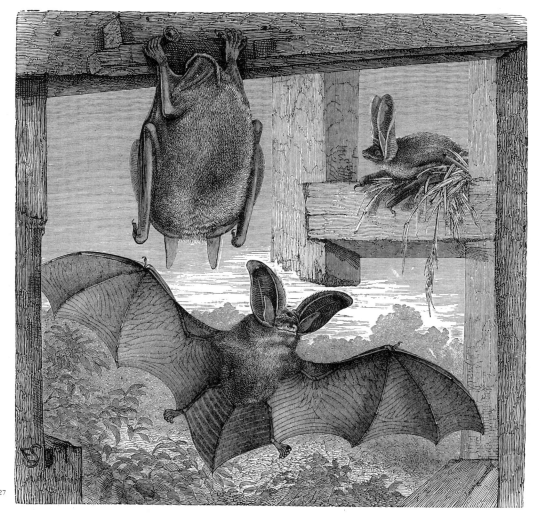

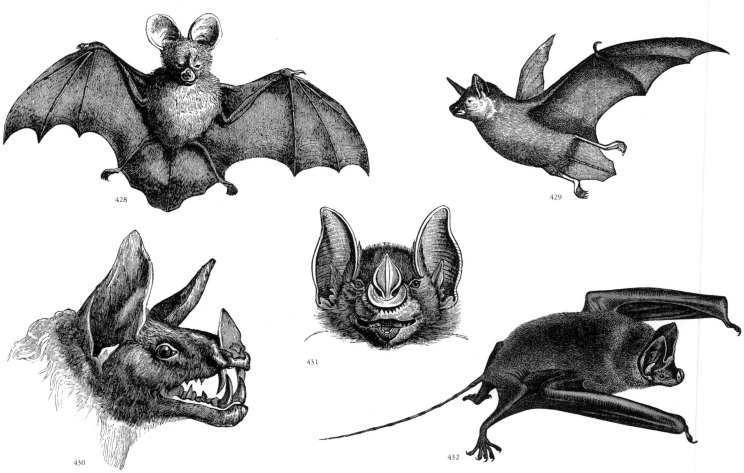

**MAMMALS.** **427:** A type of long-eared bat. **428, 429, 432:** Various bats.
**430, 431:** Species of leaf-nosed bat.

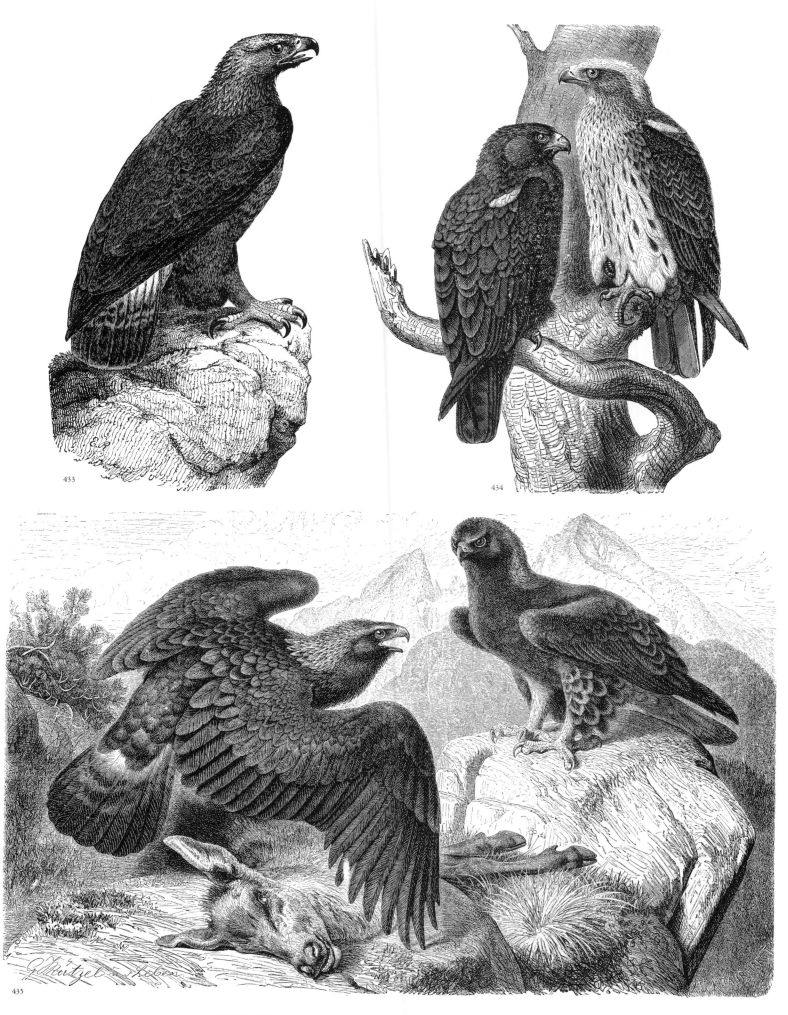

**BIRDS. 433:** Immature golden eagle. **434:** Booted eagles. **435:** Golden eagles.

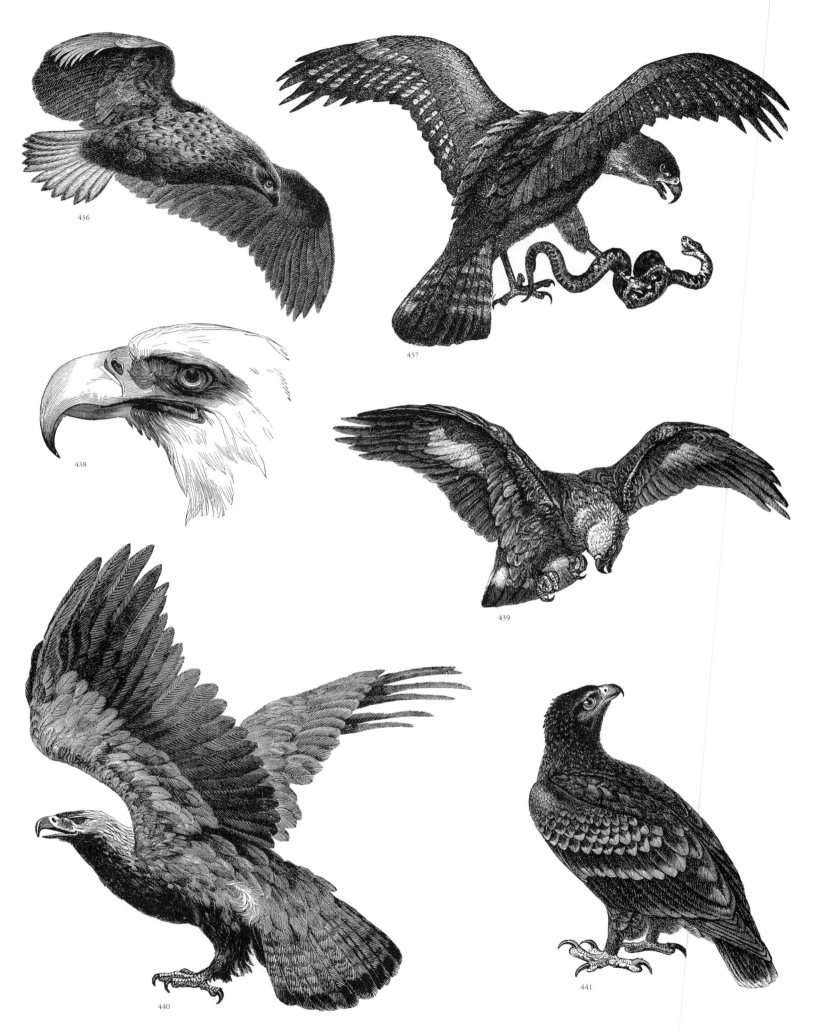

**BIRDS.** 436: White-tailed eagle. 437: Type of eagle. 438: Bald eagle.
439: Golden eagle. 440: Imperial eagle. 441: Spotted eagle.

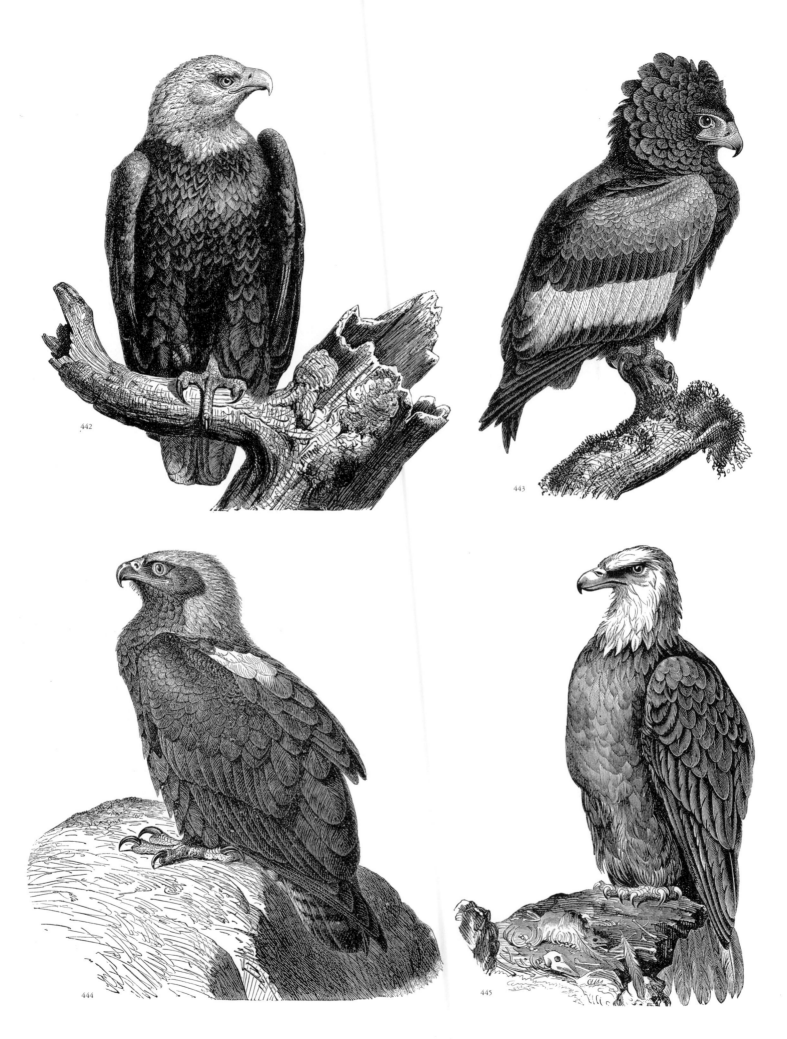

BIRDS. **442, 445:** Bald eagle. **443:** Bateleur eagle. **444:** Imperial eagle.

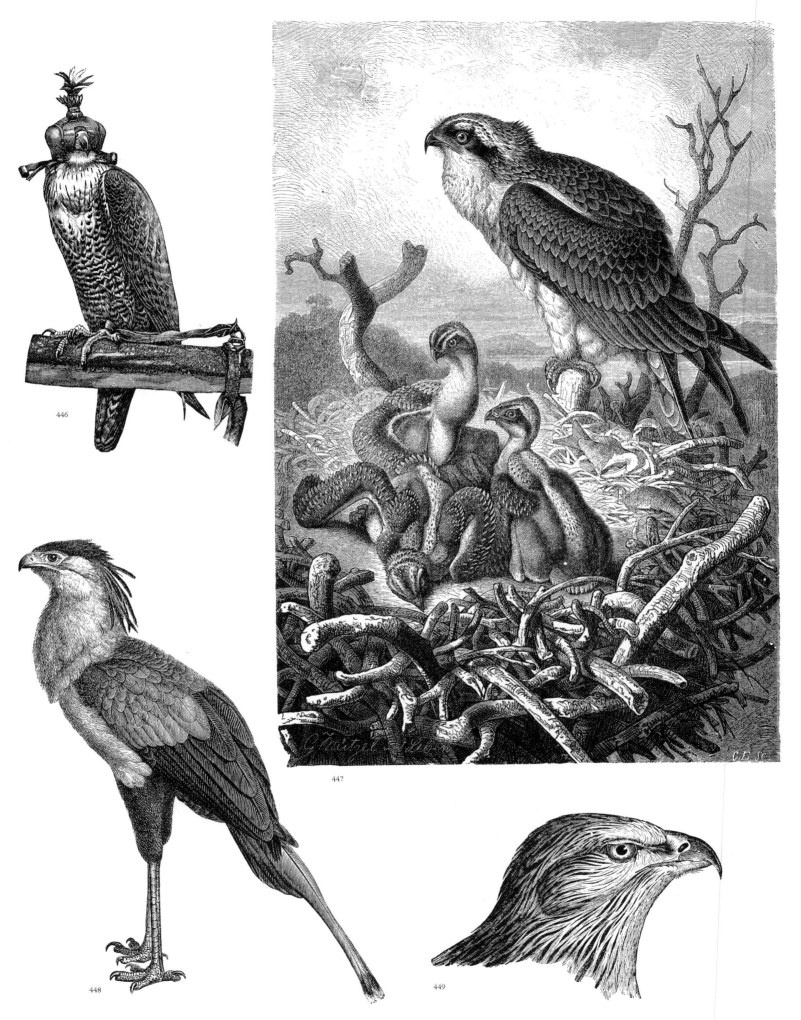

**BIRDS. 446:** A species of falcon wearing a hunting hood. **447:** Osprey.
**448:** Secretarybird. **449:** Buzzard.

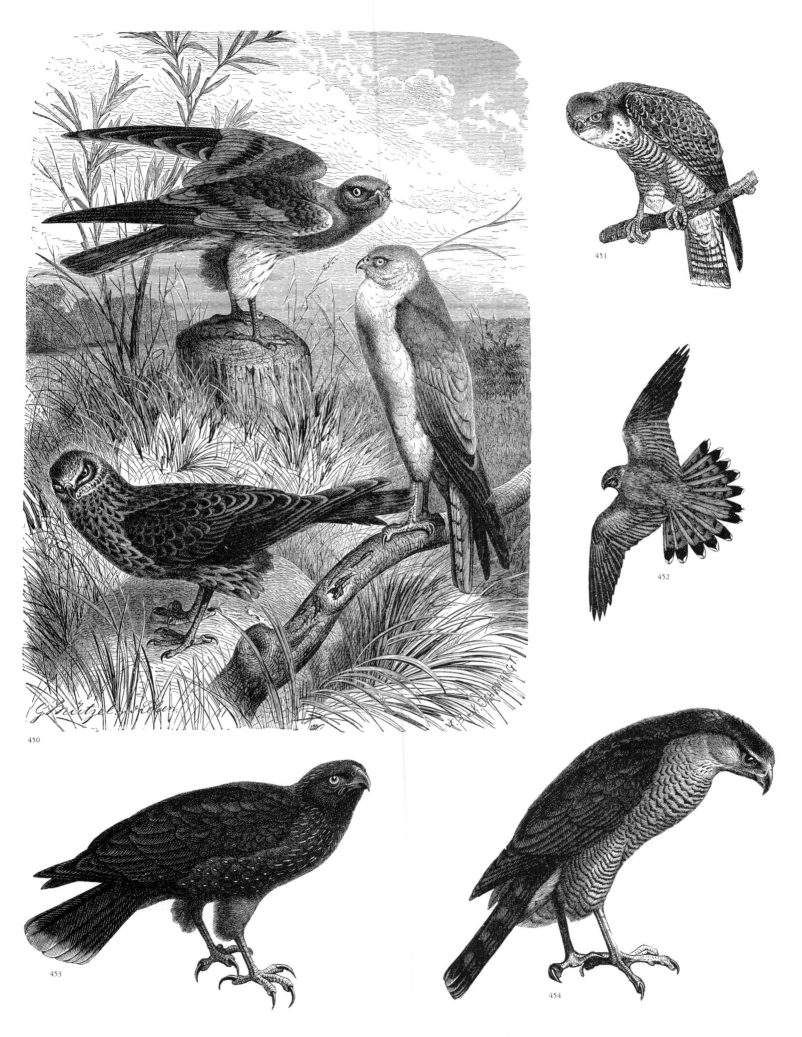

**BIRDS. 450:** Harriers (top, hen harrier; right, Montagu's harrier; bottom, pallid harrier). **451:** Species of hawk. **452, 454:** Sparrow hawk. **453:** Cara-cara.

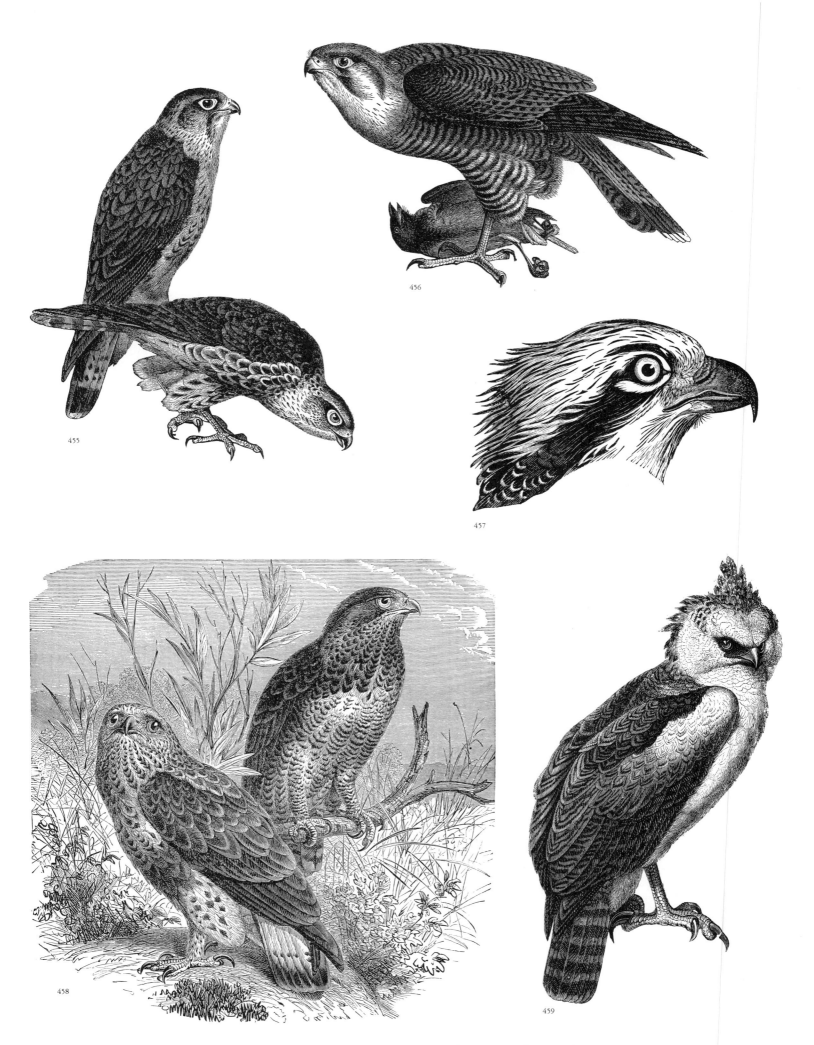

**BIRDS.** **455:** Merlin. **456:** Species of hawk. **457:** Osprey. **458:** Rough-legged buzzard. **459:** Crested eagle.

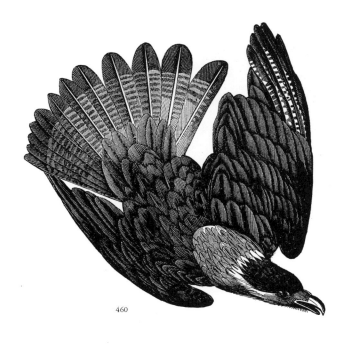

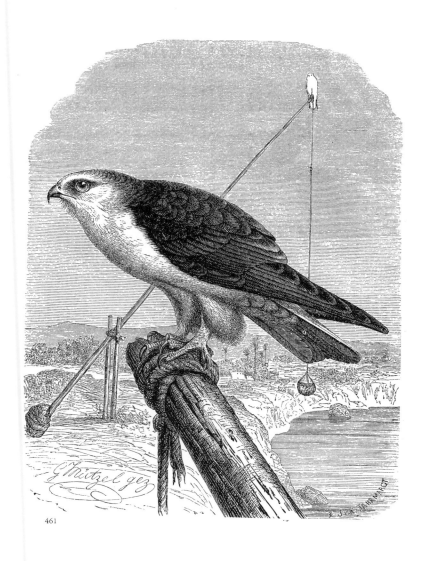

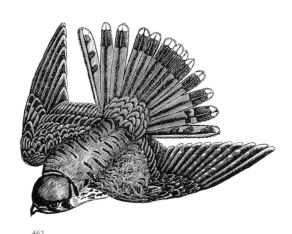

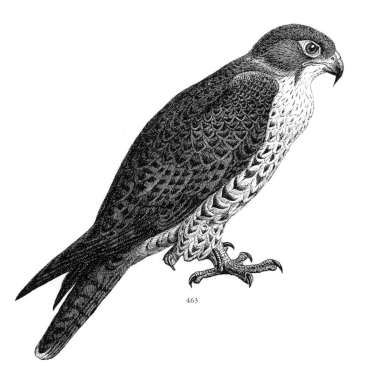

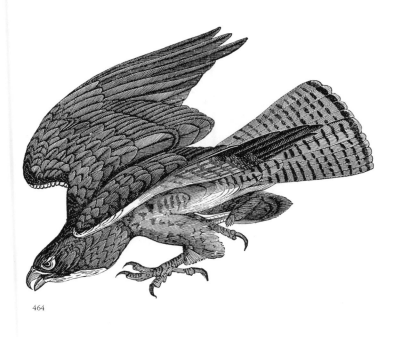

**BIRDS.** 460: Caracara. 461: Black-winged kite. 462: Sparrow hawk. 463:
A species of falcon. 464: Buzzard.

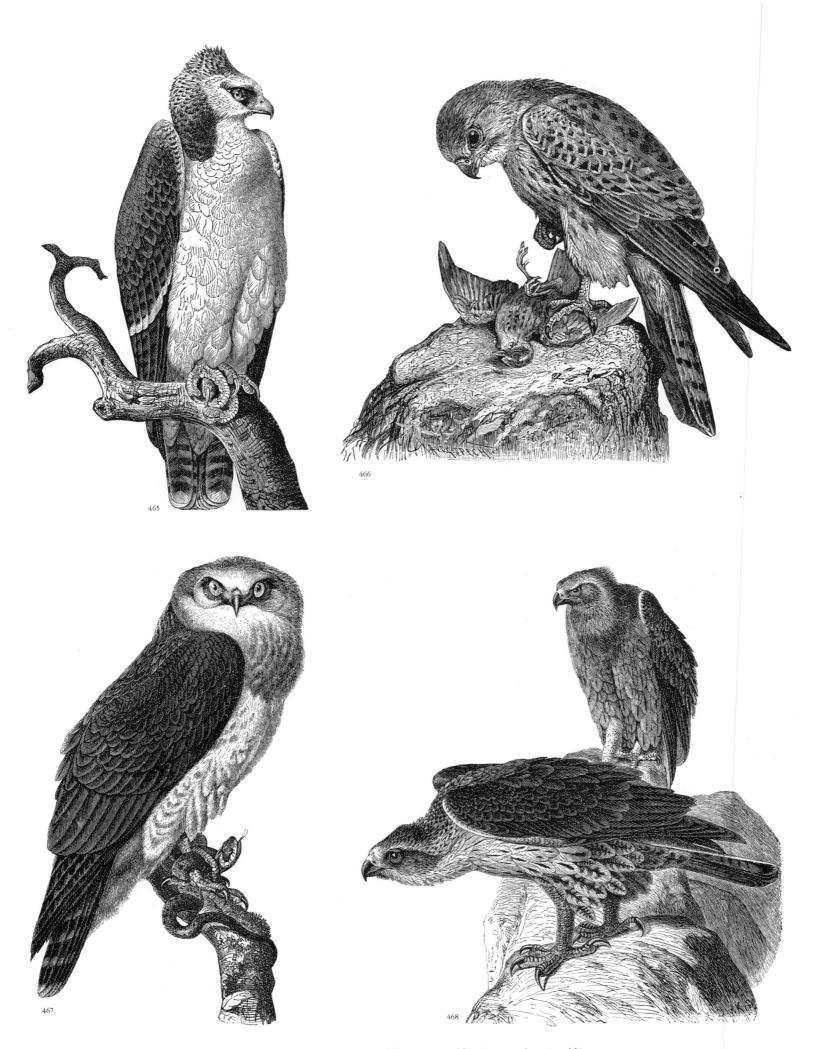

**BIRDS.** **465**: Type of eagle. **466.** Kestrel. **467**: Short-toed eagle. **468**: Bonelli's eagle.

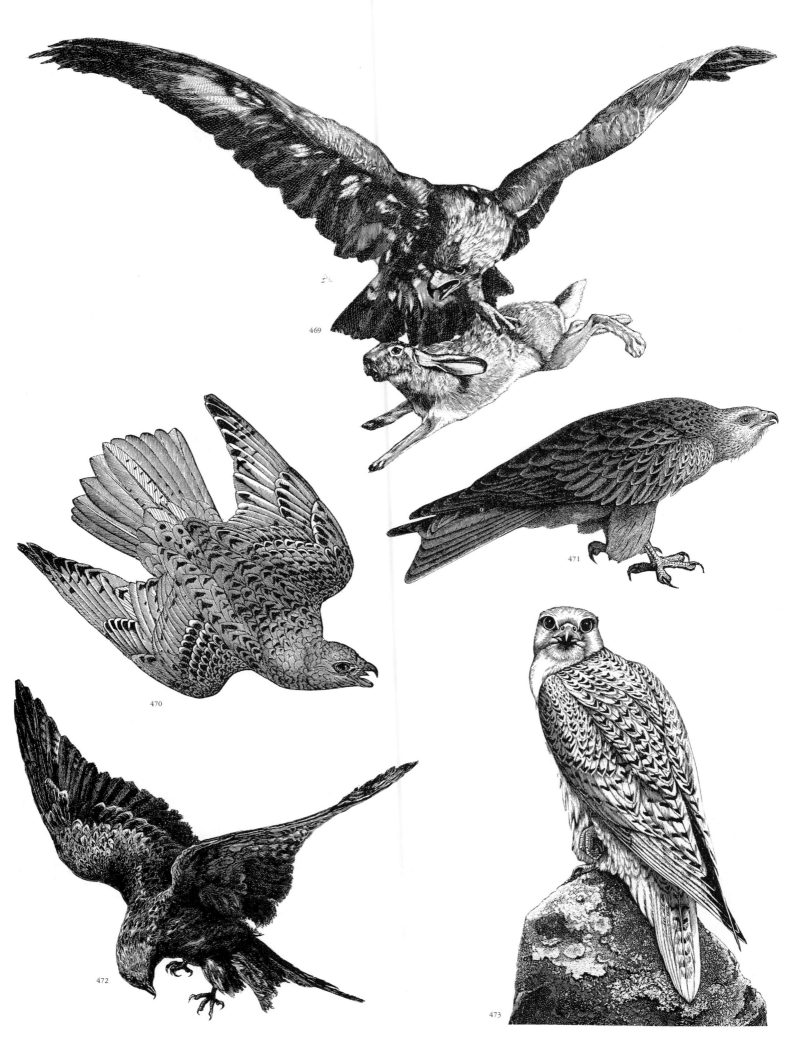

**BIRDS.** 469, 470, 472 : Birds of prey. **471:** Kite. **473:** Gyrfalcon.

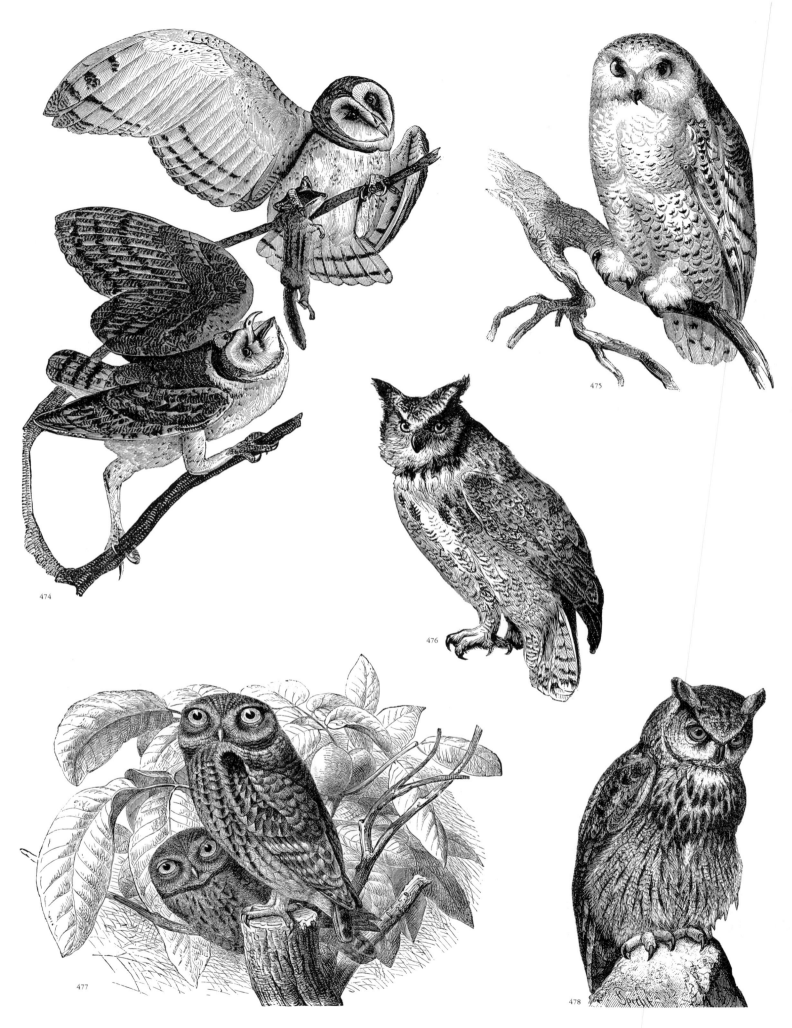

**BIRDS.** 474: American barn owls. 475: Snowy owl. 476: Horned owl.
477: Little owls. 478: Eagle owl.

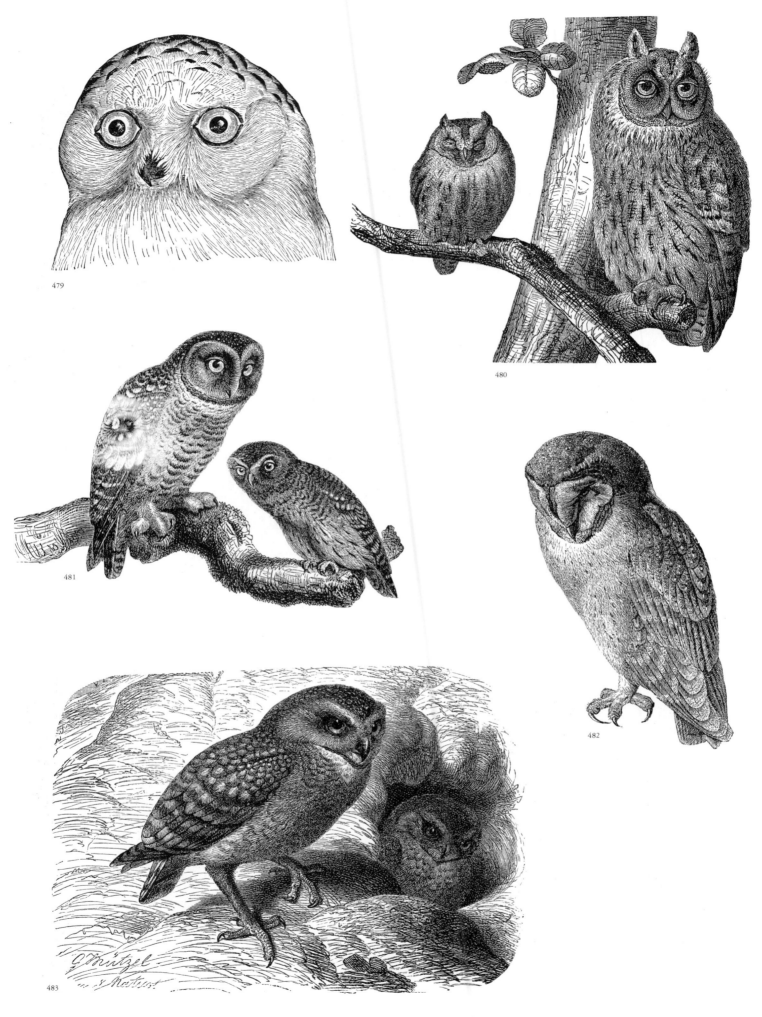

**BIRDS.** **479:** Snowy owl. **480:** Scops owl (left) and long-eared owl. **481:** Tengmalm's owl (left) and pygmy owl. **482:** European barn owl. **483:** Burrowing owls.

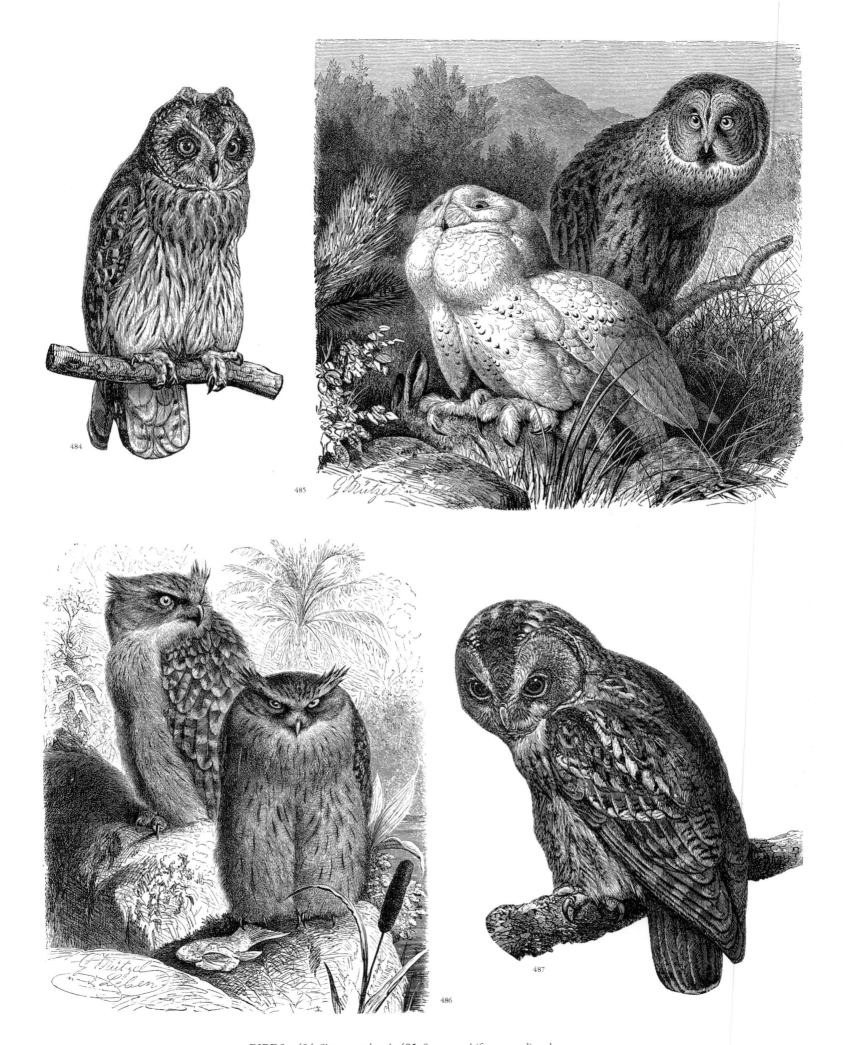

**BIRDS. 484:** Short-eared owl. **485:** Snowy owl (foreground) and great grey (or Lapland) owl. **486:** Indian fishing owls. **487:** Tawny owl.

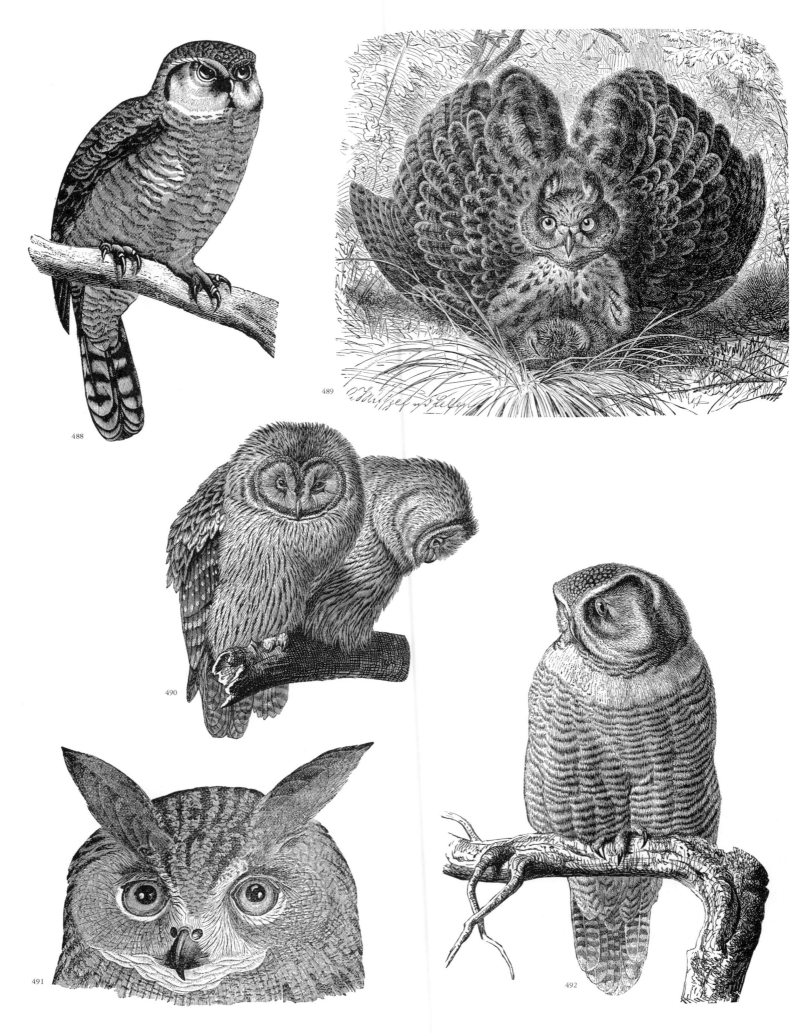

**BIRDS. 488:** Hawk owl (?). **489, 491:** Eagle owl. **490:** Ural owls. **492:** Hawk owl.

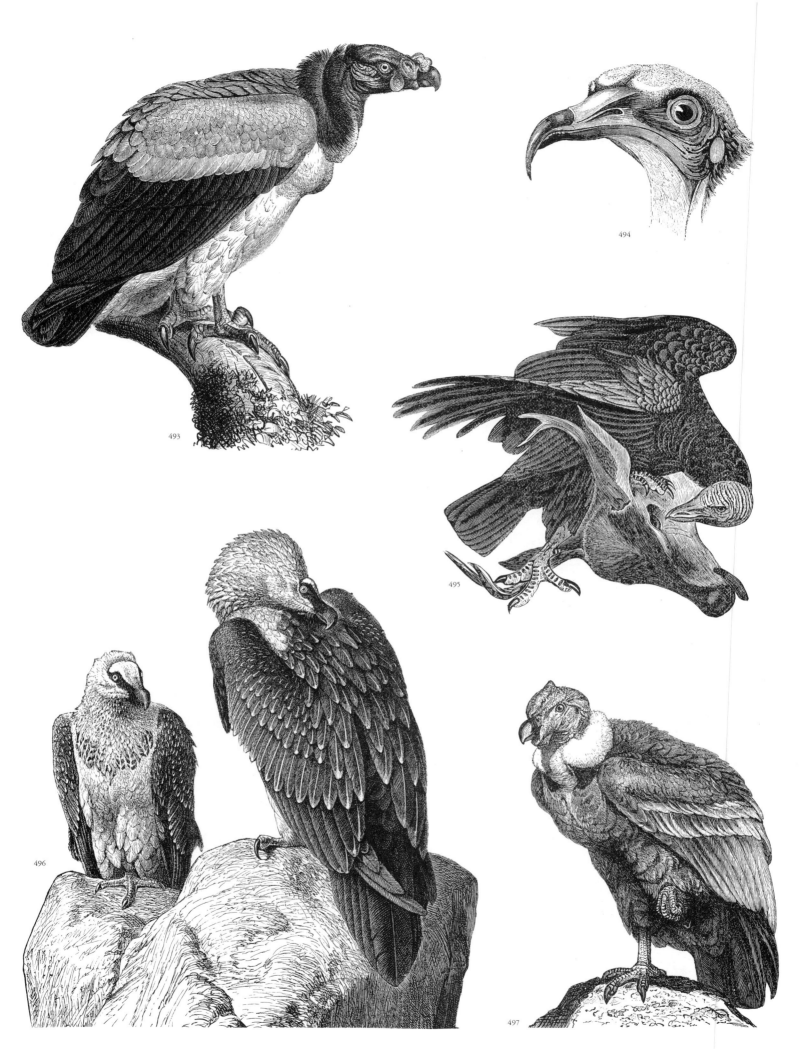

**BIRDS.** 493: King vulture. 494: Egyptian vulture. 495: American black vulture. 496: Bearded vultures (or lammergeyers). 497: Condor.

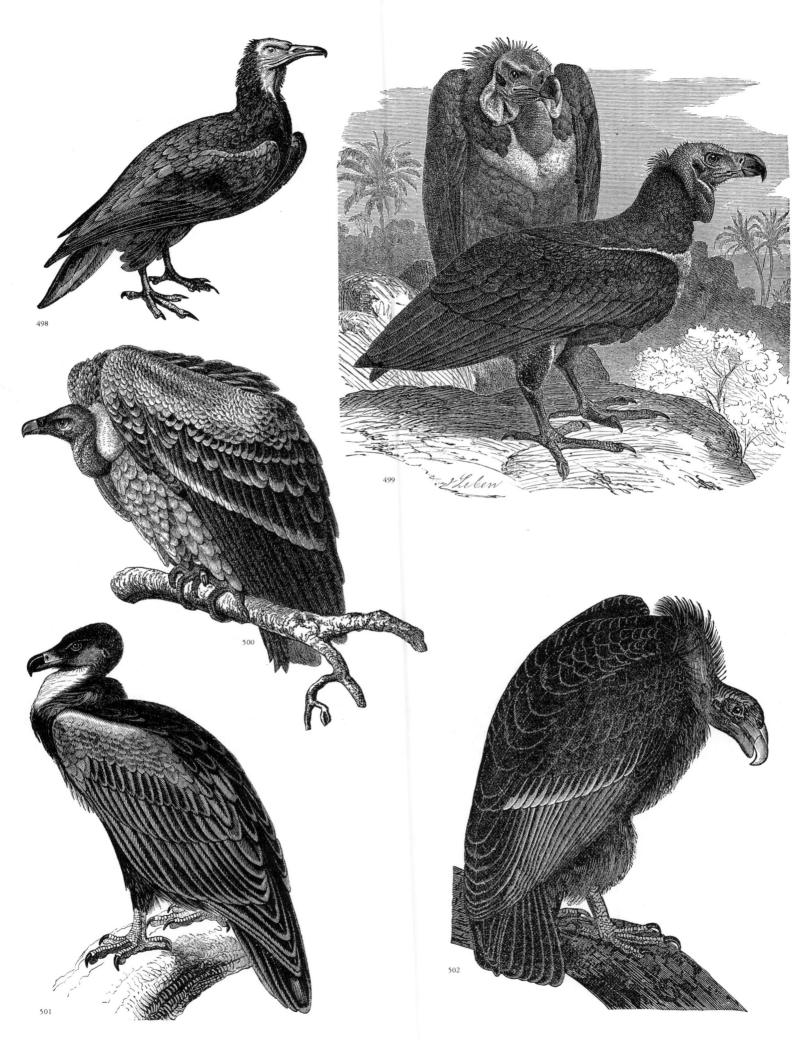

**BIRDS. 498:** Egyptian vulture. **499:** Pondicherry vultures. **500:** Rüppell's griffon. **501:** Type of vulture. **502:** California condor.

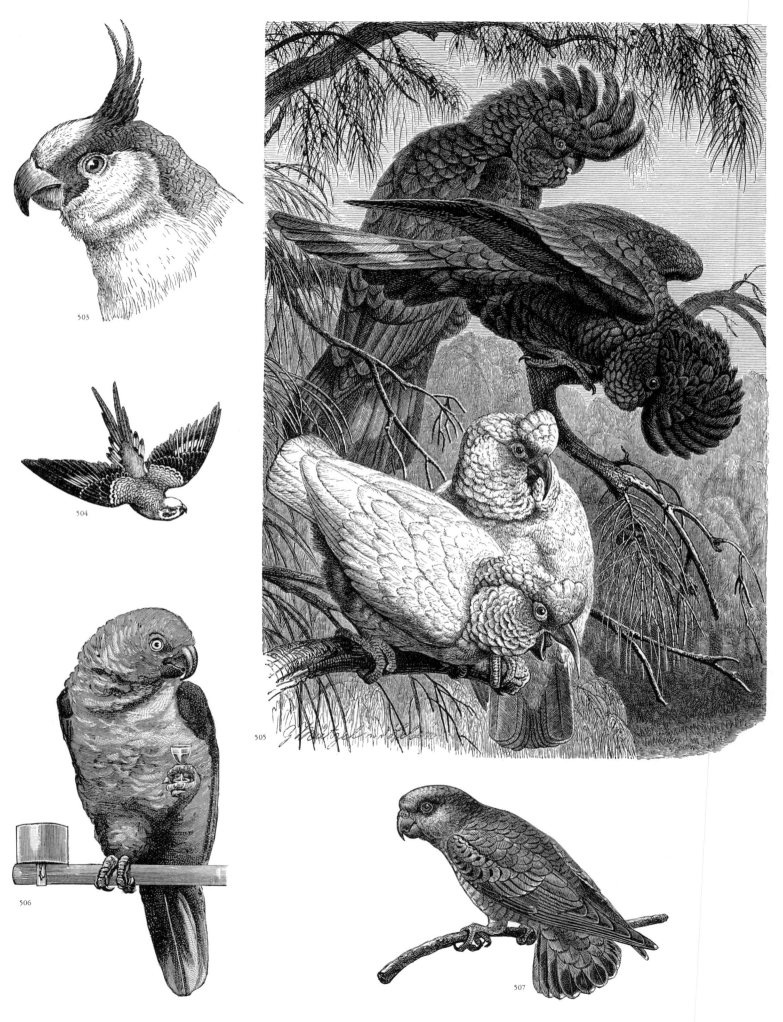

**BIRDS.** 503, 504: Types of parakeet. 505: Types of cockatoo (above, Banksian black cockatoos). 506, 507: Types of parrot.

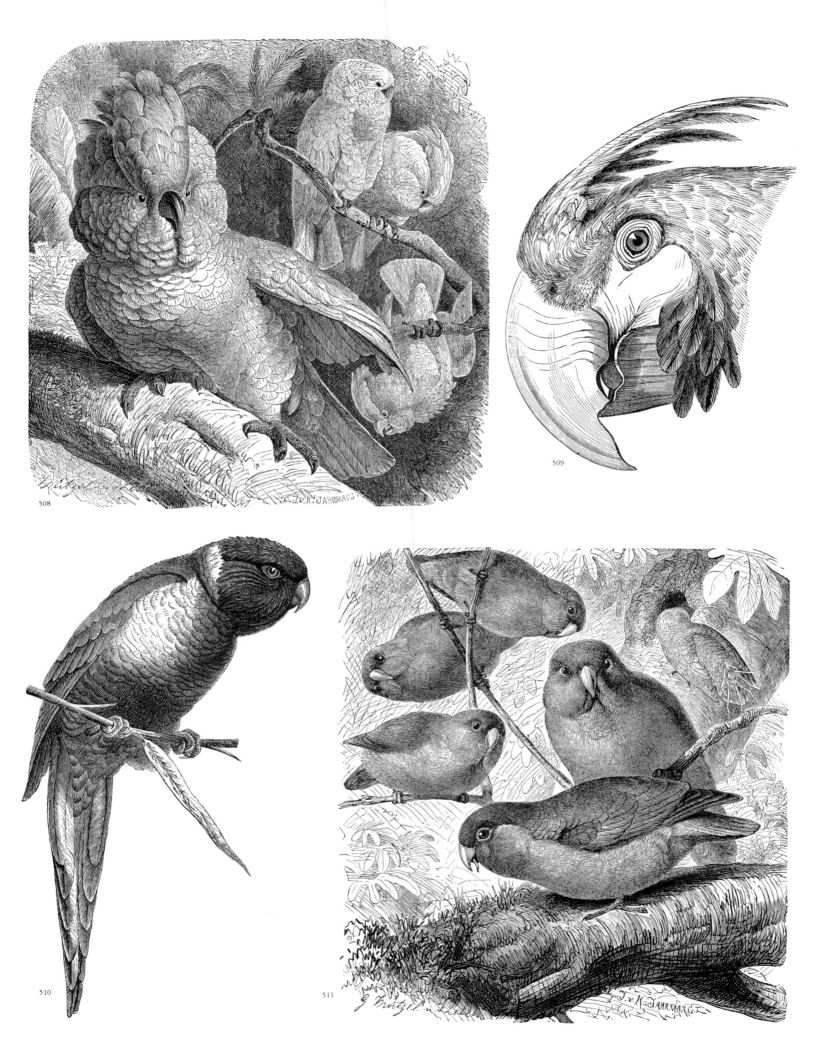

**BIRDS.** **508:** Roseate cockatoos (?). **509:** Macaw. **510:** Bird of the parrot family. **511:** Peach-faced lovebirds.

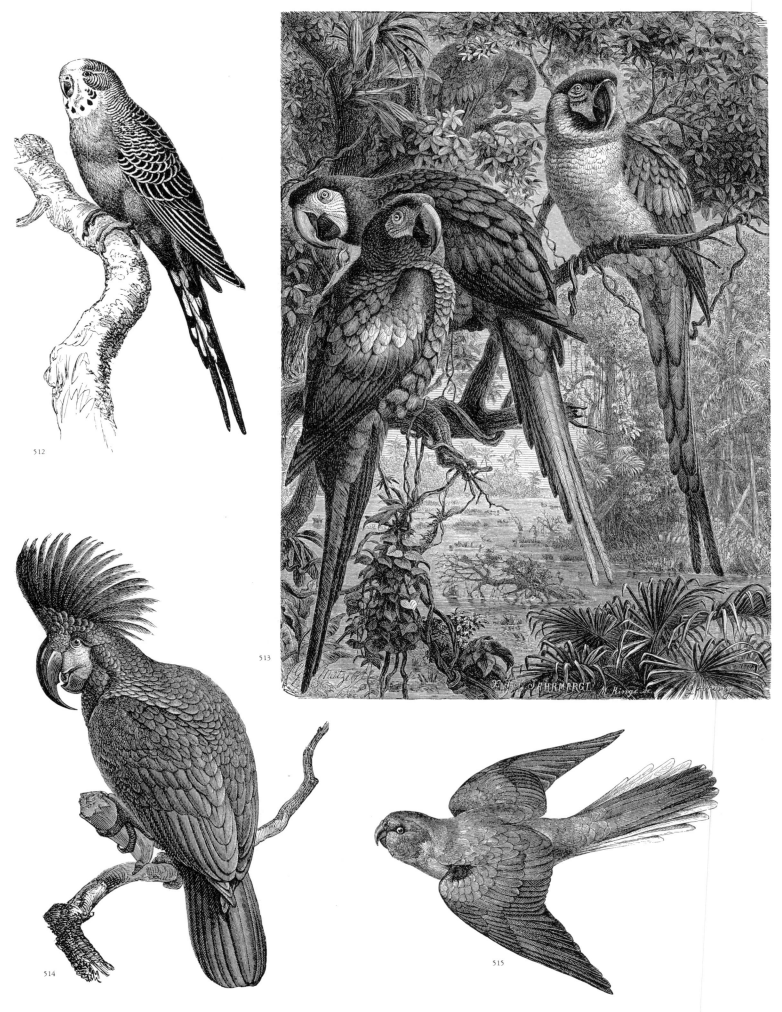

**BIRDS.** 512: Budgerigar. 513: Macaws. 514: Great black cockatoo. 515: Bird of the parrot family.

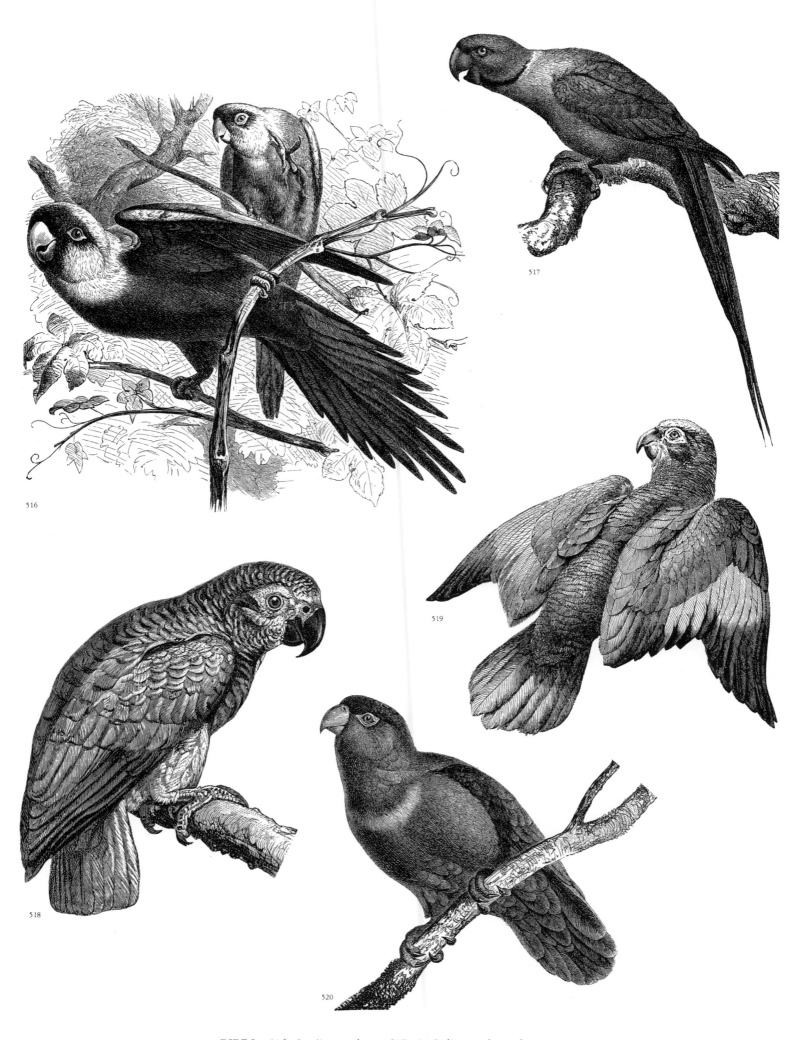

**BIRDS. 516:** Carolina parakeets. **517:** An Indian parakeet of the genus *Palaeornis*. **518:** Gray parrot. **519:** A species of Amazon parrot. **520:** Purple-capped lory.

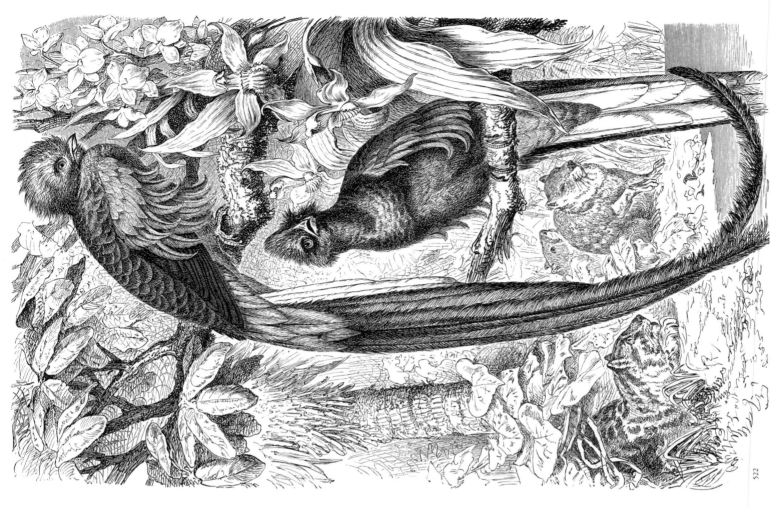

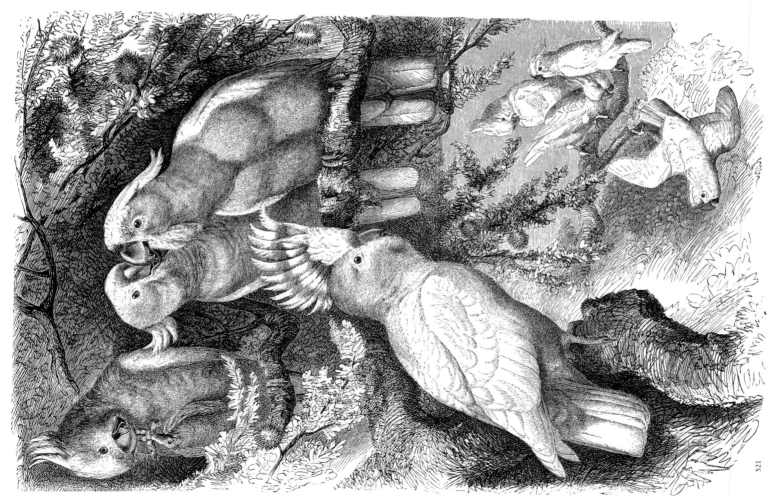

BIRDS. 521: Leadbeater's cockatoos. 522: Quetzals.

522

521

117

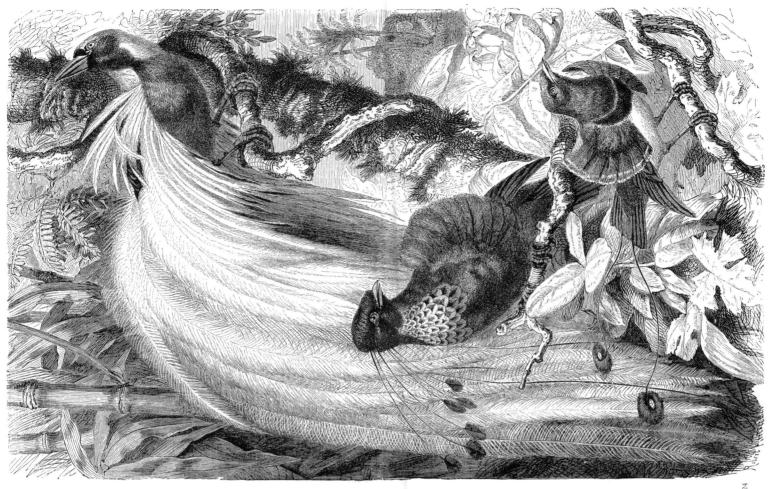

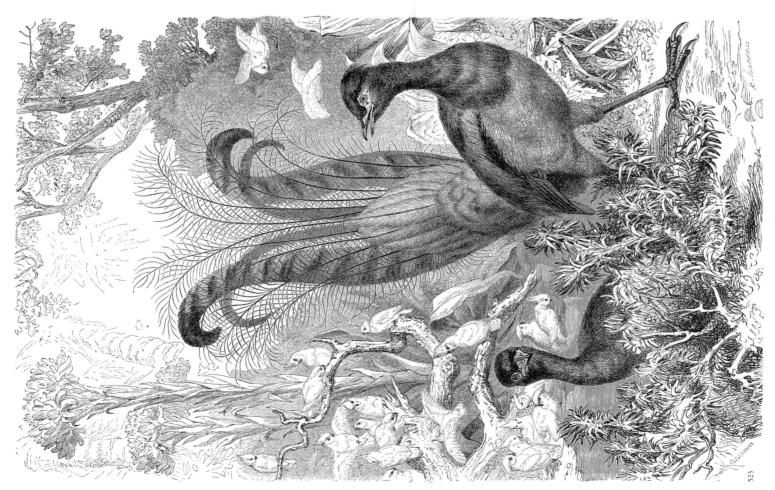

**BIRDS.** 523: Lyrebirds. 524: Birds of paradise (bottom, king bird of paradise).

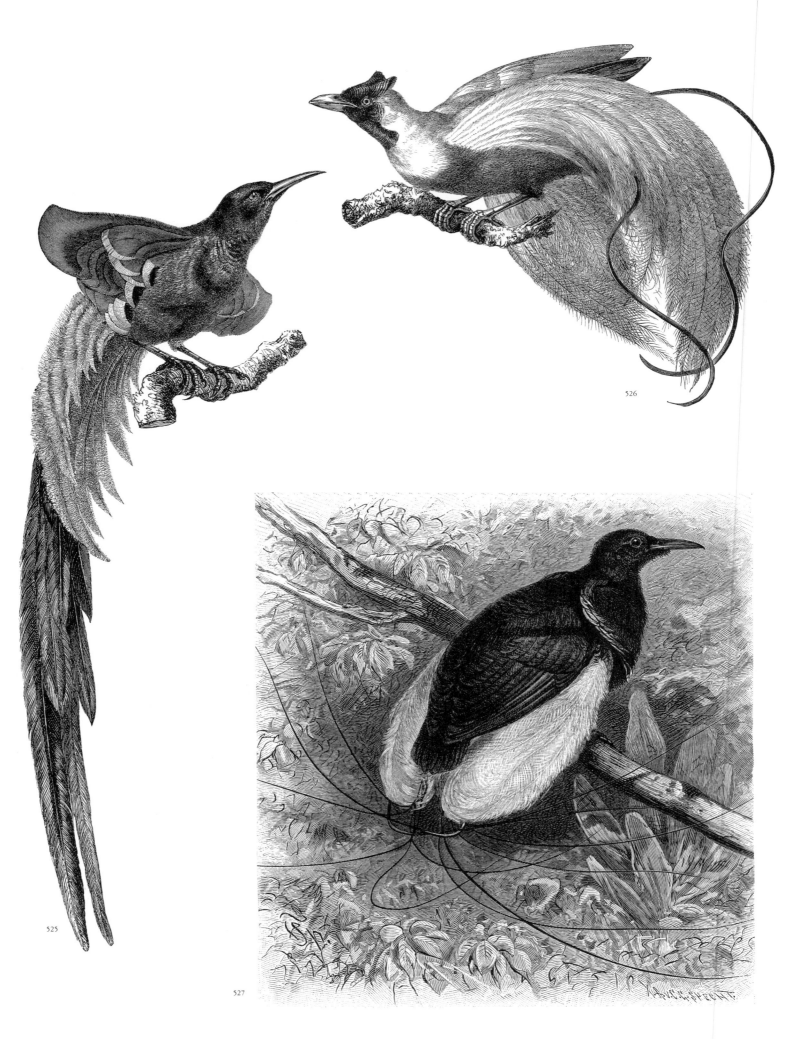

**BIRDS.  525, 527:** Types of bird of paradise. **526:** Red bird of paradise.

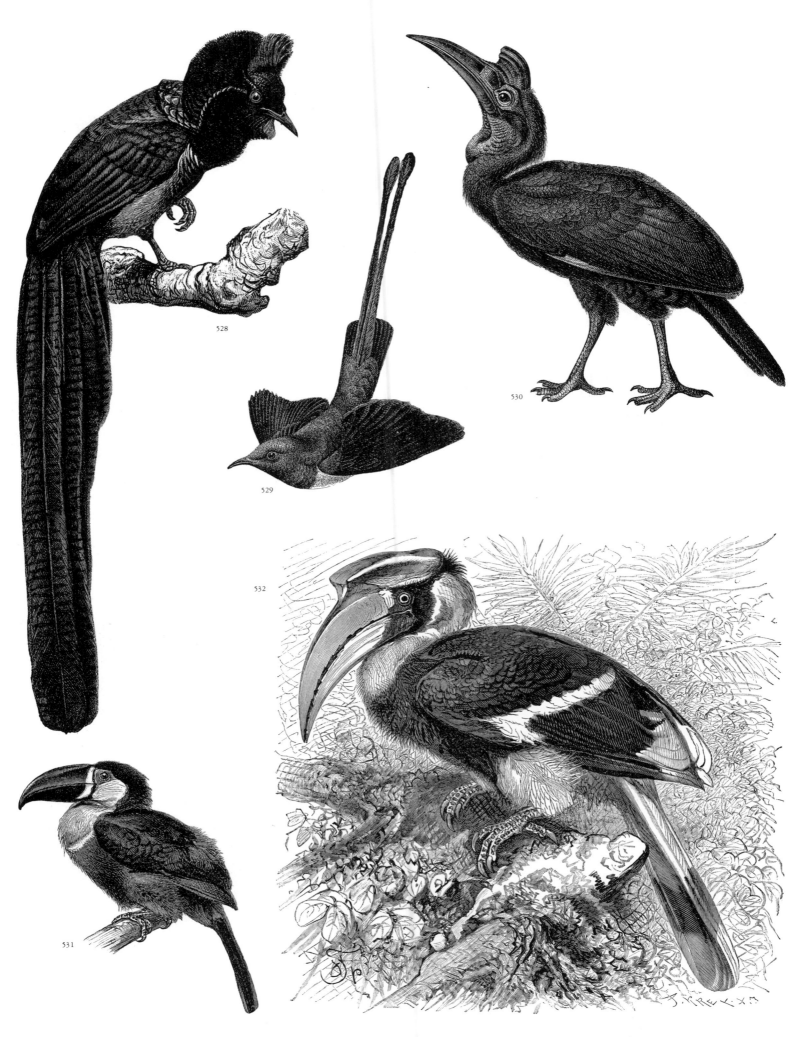

**BIRDS.** **528:** Type of bird of paradise. **529:** A species of sunbird. **530:** North African ground hornbill. **531:** A species of toucan. **532:** Concave-casqued hornbill.

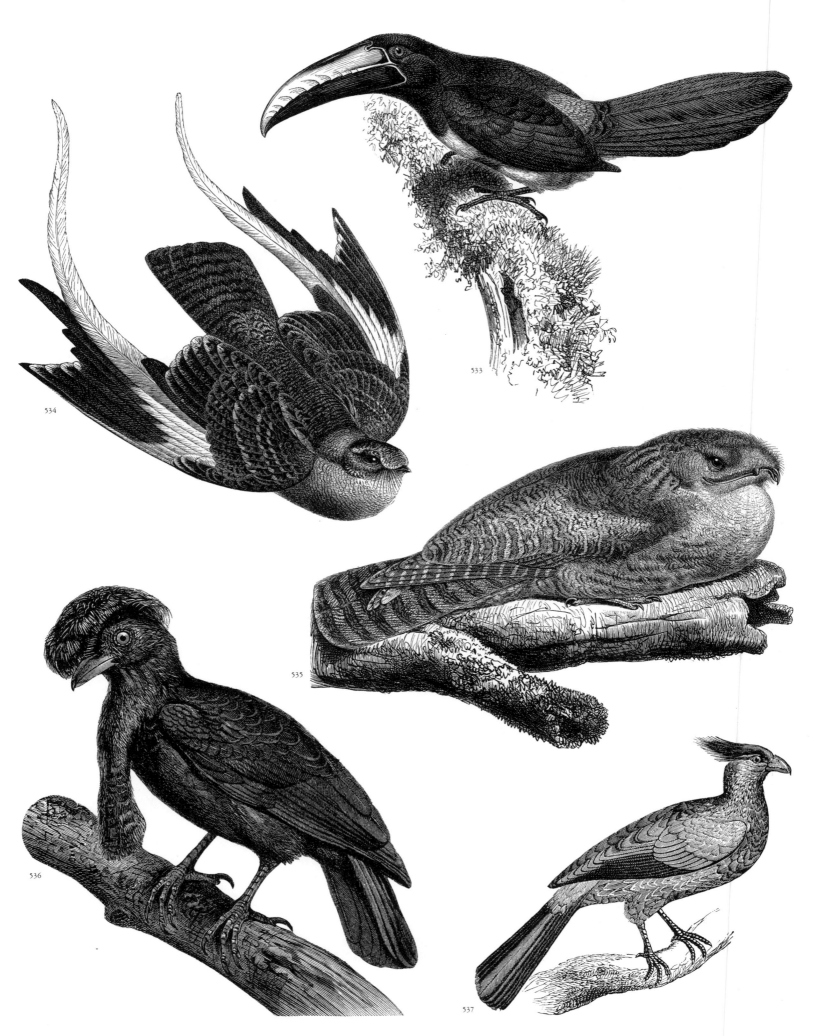

BIRDS. 533: A species of aracari. 534: Pennant-winged night jar. 535:
Great potoo. 536: Long-wattled umbrellabird. 537: A species of touraco.

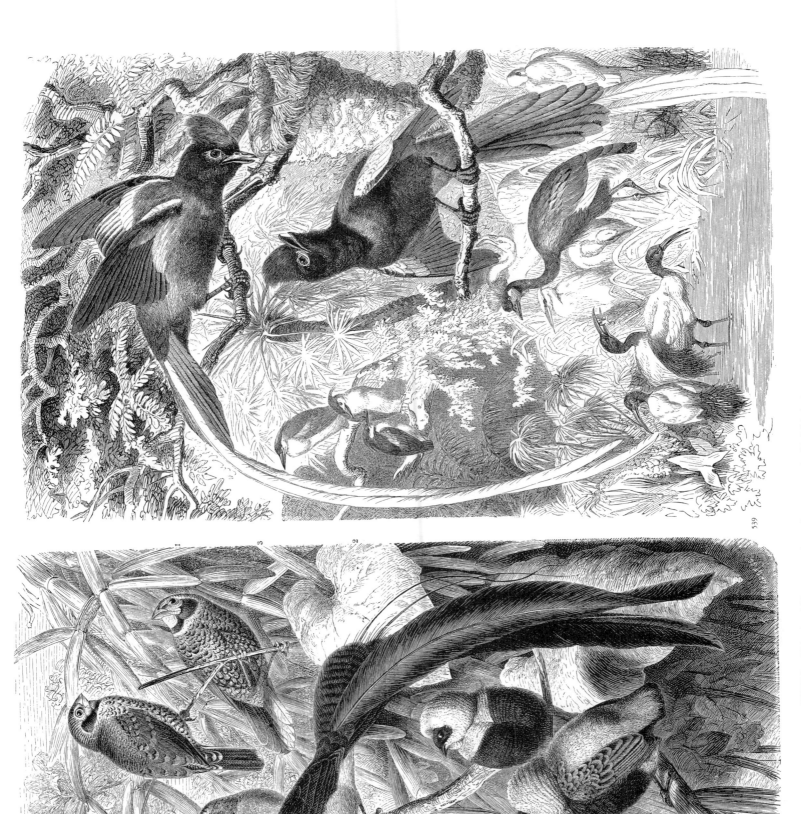

**BIRDS.** **538:** An African grouping of weavers and allied birds (center, paradise whydahs; bottom, orange weavers). **539:** A species of paradise flycatcher (foreground).

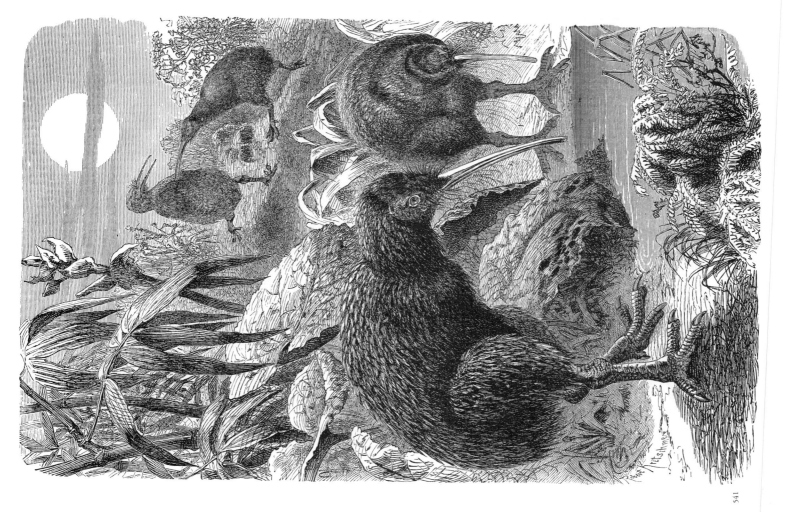

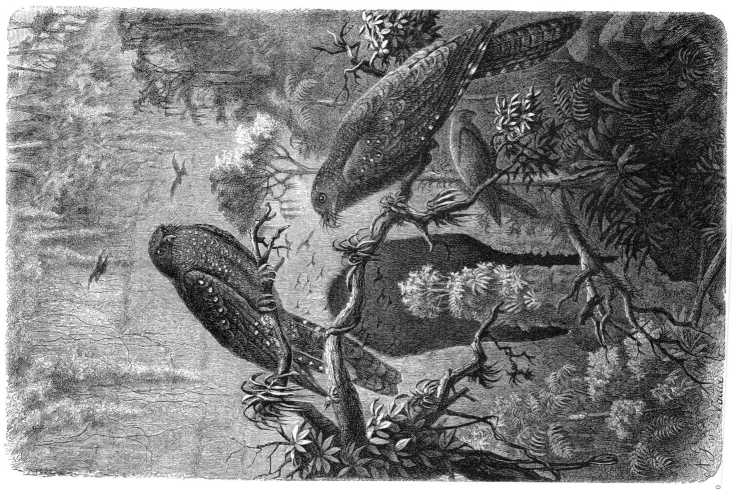

**BIRDS.** 540: Oilbirds. 541: Common kiwis.

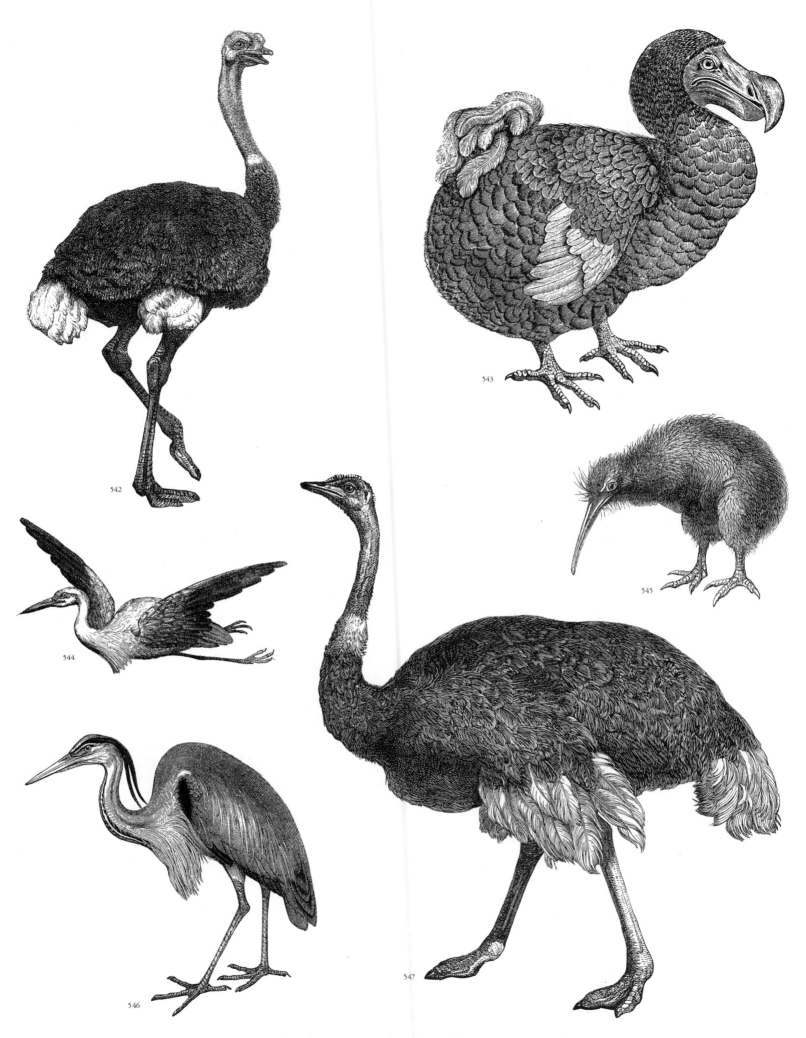

**BIRDS.** **542, 547**: Ostriches. **543**: Dodo. **544**: A type of stork. **545**: Common kiwi. **546**: Heron.

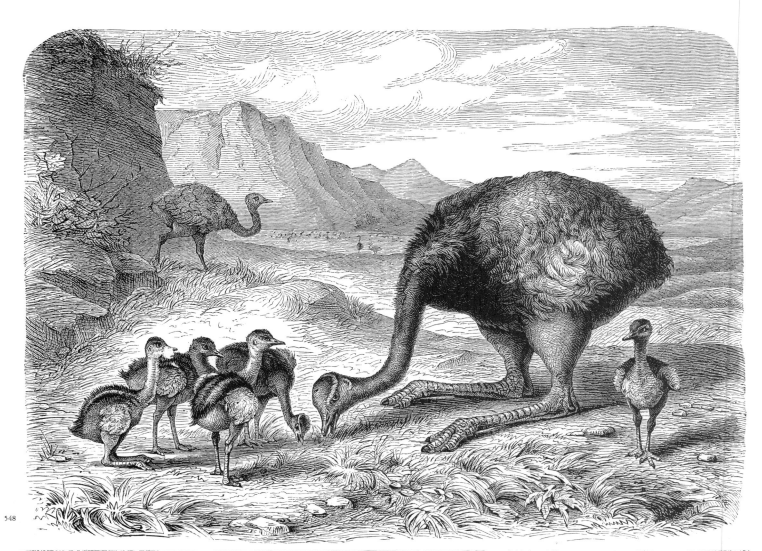

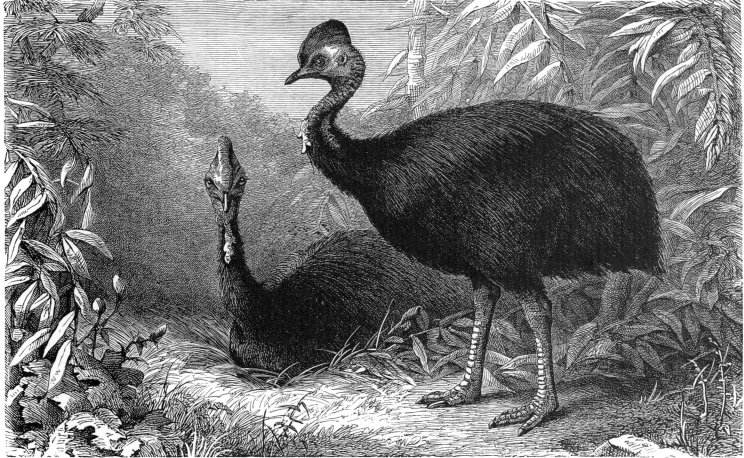

BIRDS. 548: Greater rheas. 549: Cassowaries.

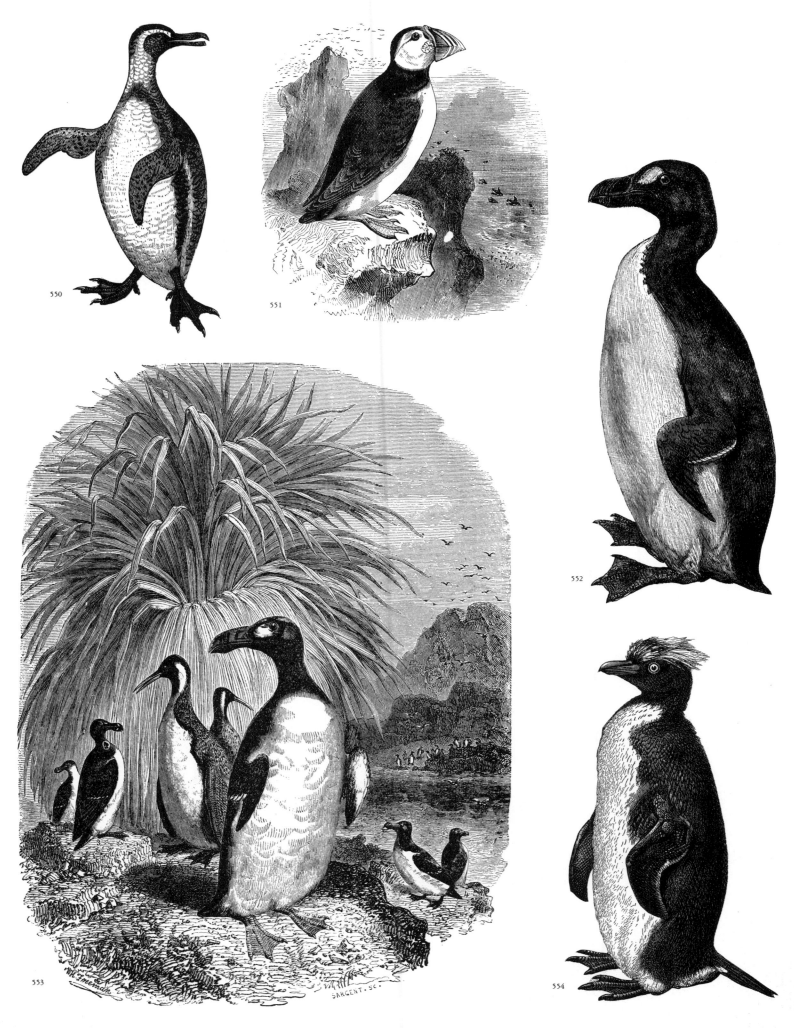

**BIRDS.** 550: Type of auk or penguin. 551: Atlantic puffin. 552: Great auk. 553: Great auk (foreground), razor-billed auks (with flat bills) and allied birds. 554: Rockhopper penguin.

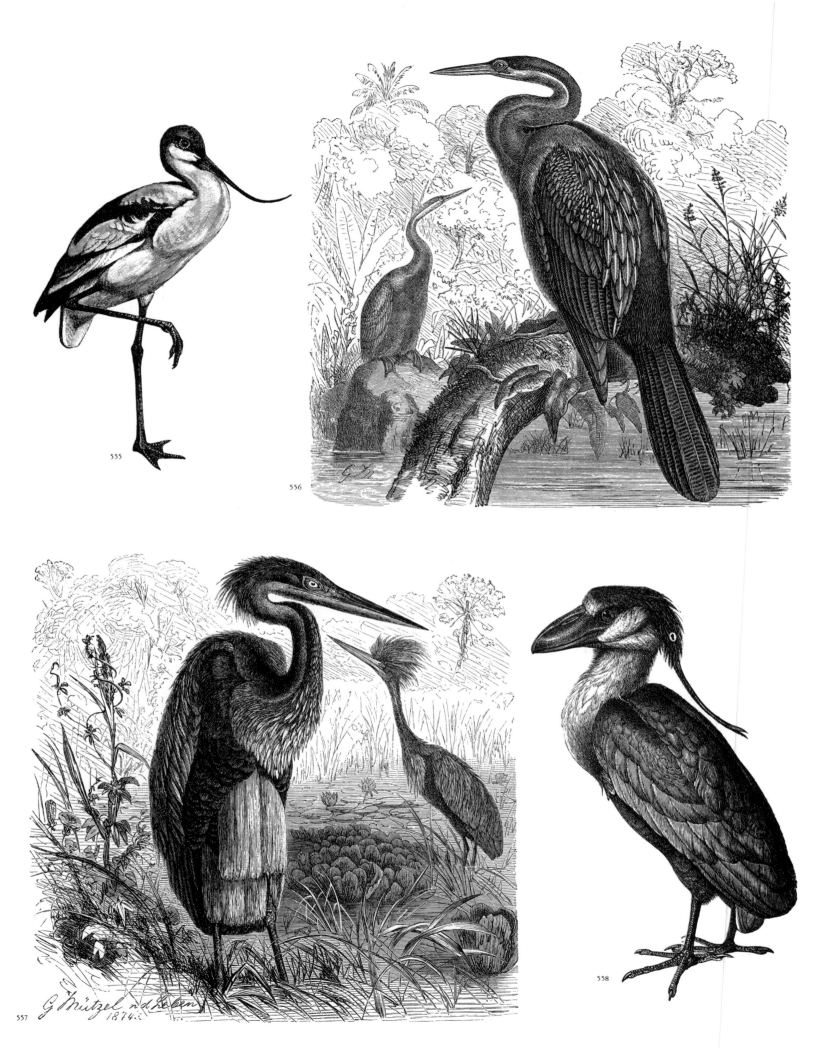

**BIRDS.** 555: European avocet. 556: African darter. 557: Goliath heron (?).
558: Boat-billed heron.

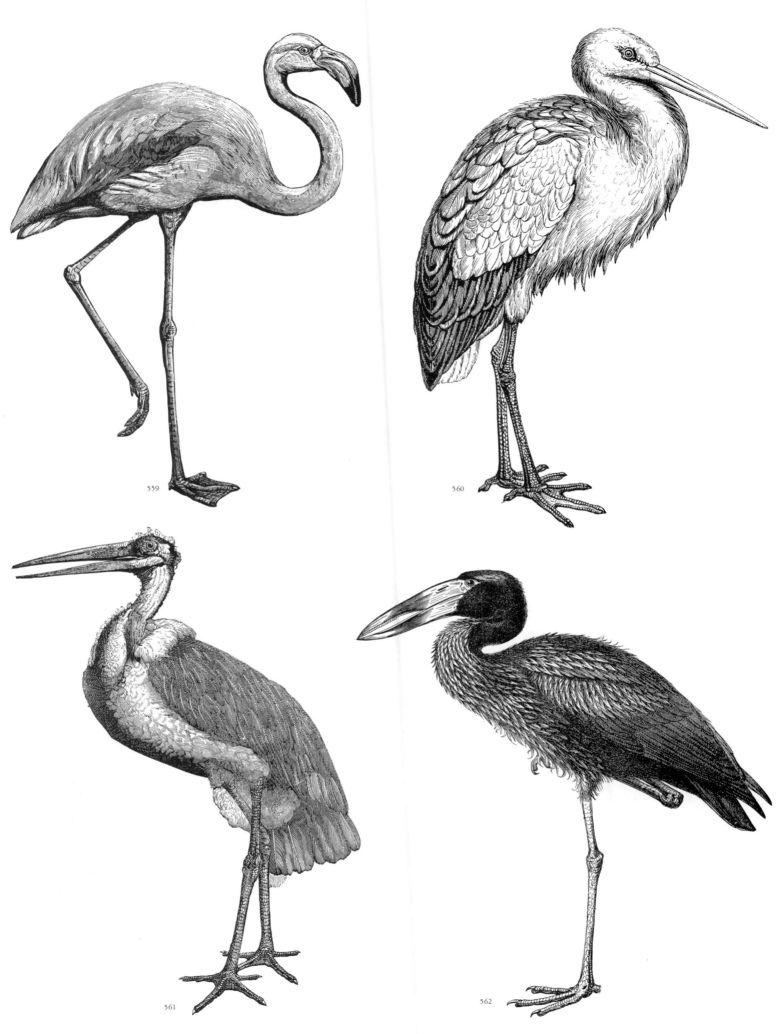

**BIRDS. 559:** Flamingo. **560:** White stork. **561:** Marabou stork. **562:** Openbill stork.

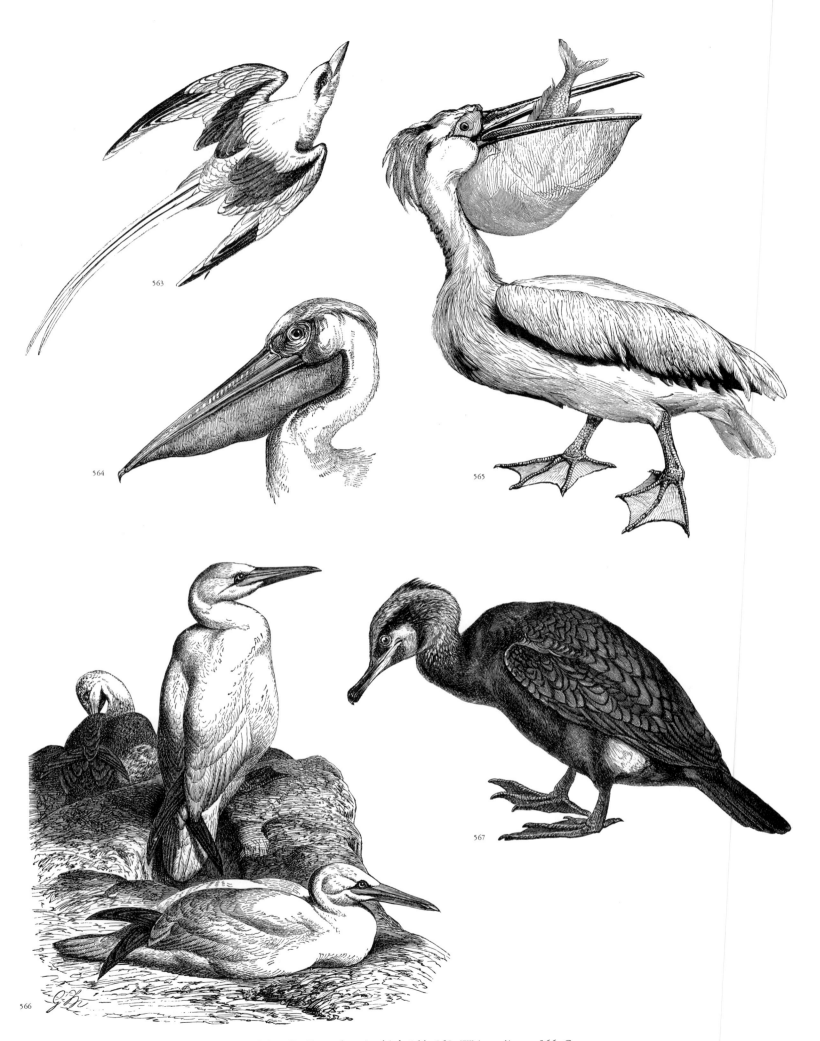

**BIRDS. 563:** Type of marine bird. **564, 565:** White pelicans. **566:** Gannets. **567:** Cormorant.

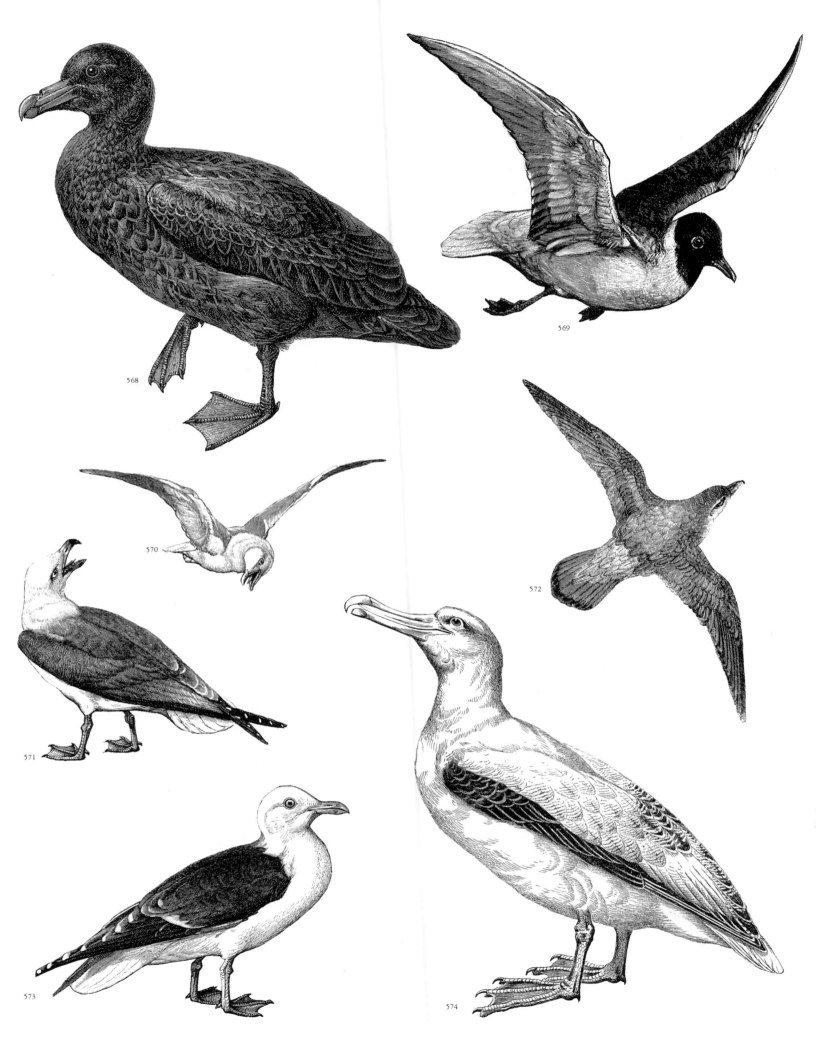

**BIRDS. 568:** Giant petrel. **569:** Black-headed gull. **570:** Common gull.
**571:** Herring gull. **572:** A species of petrel. **573:** Great black-backed gull.
**574:** Wandering albatross.

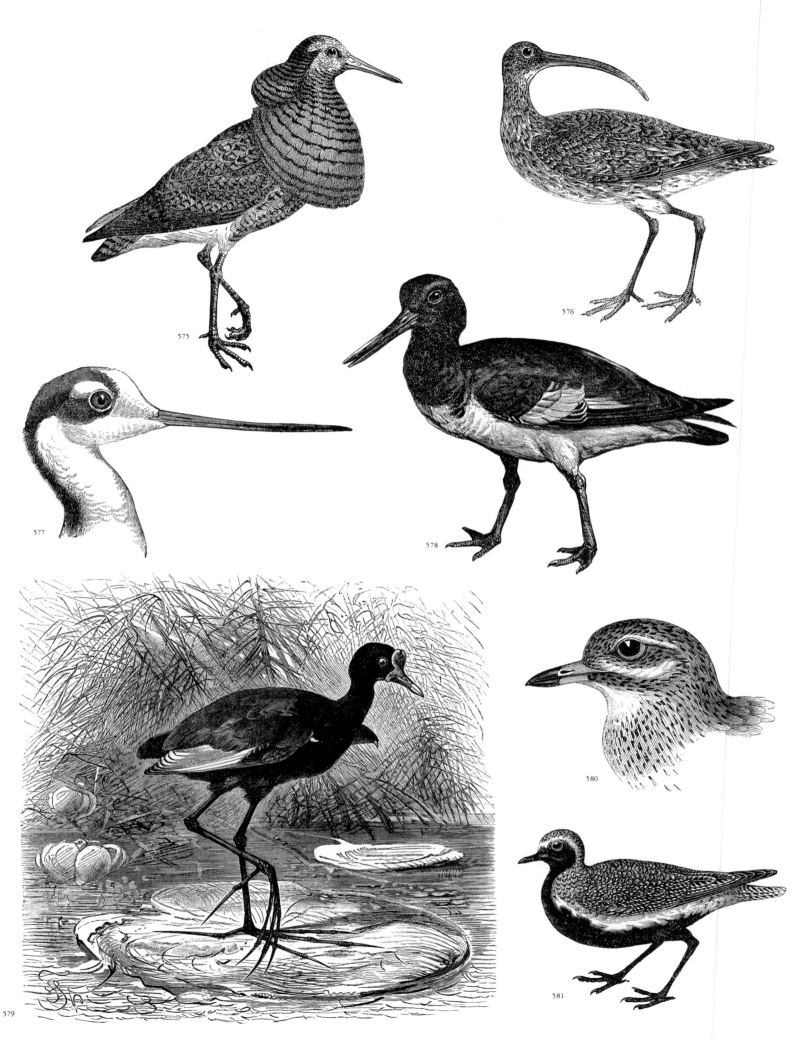

**BIRDS.** 575: Ruff. 576: Curlew. 577: Type of wading bird. 578: Oyster-catcher. 579: Jacana. 580: A species of thick-knee. 581: Golden plover.

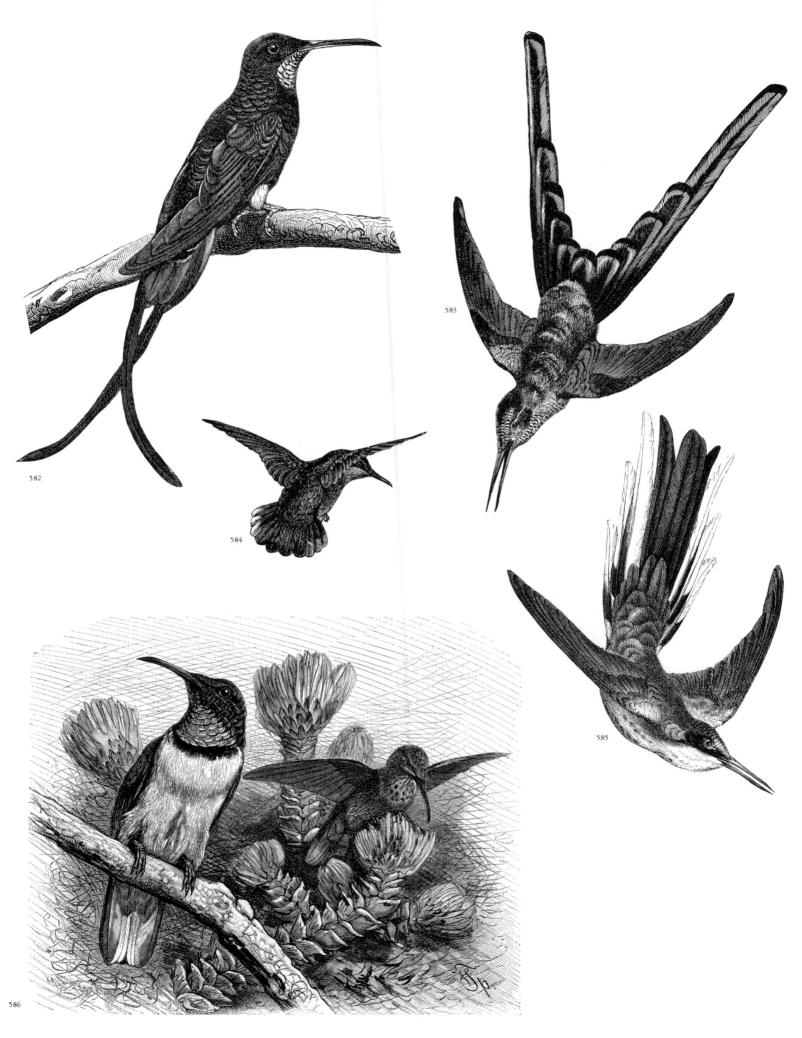

**BIRDS.** 582–586: Types of hummingbird (586, Pichincha hill star).

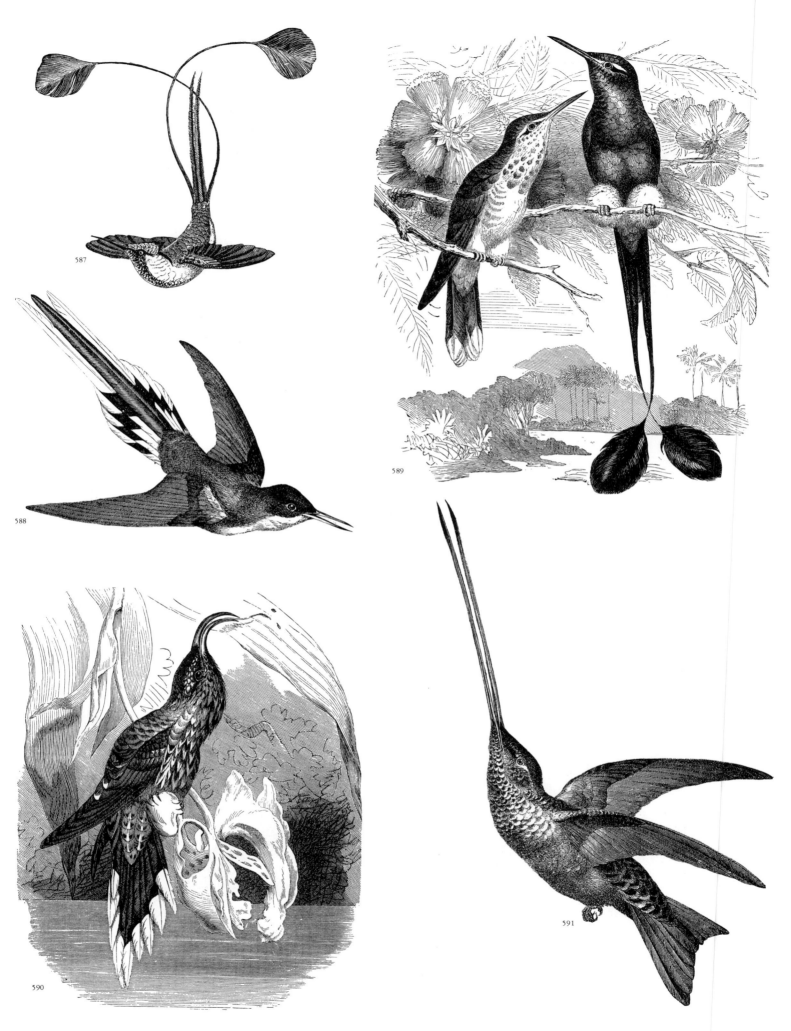

**BIRDS.** **587, 589:** Racket-tailed hummingbird. **588:** Type of hummingbird. **590:** Sickle-billed hummingbird. **591:** Sword-billed hummingbird.

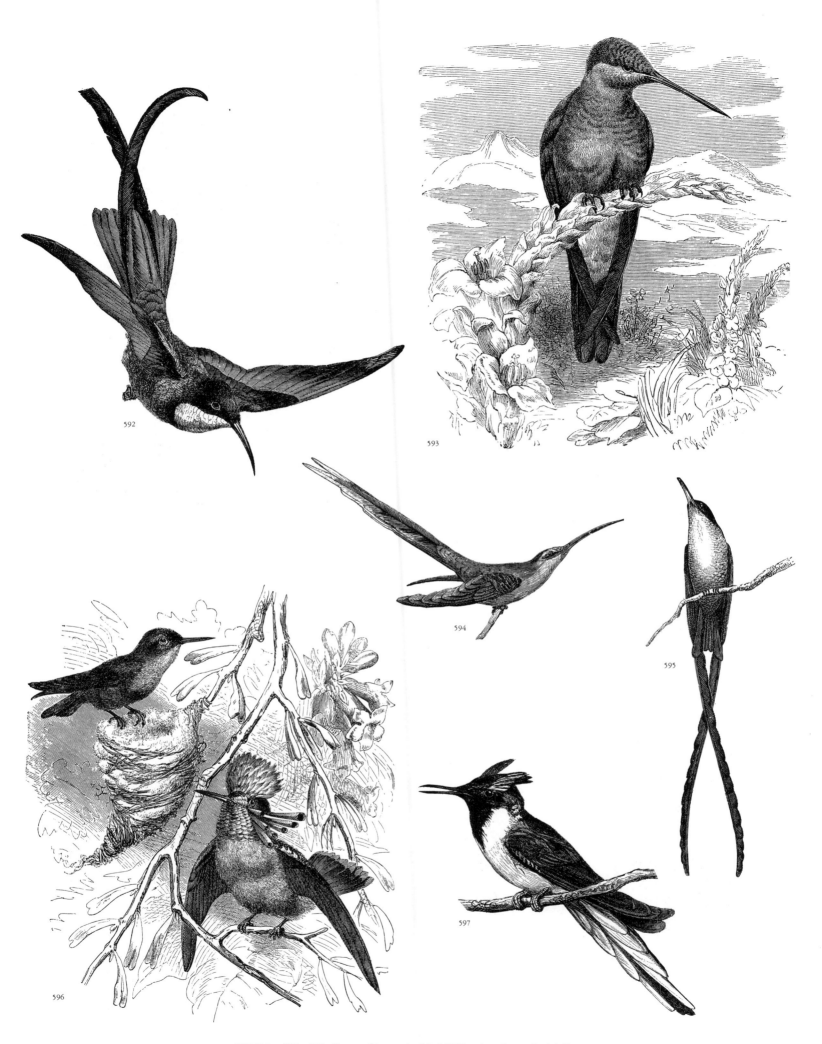

**BIRDS.  592–597:** Types of hummingbird (593, giant hummingbird).

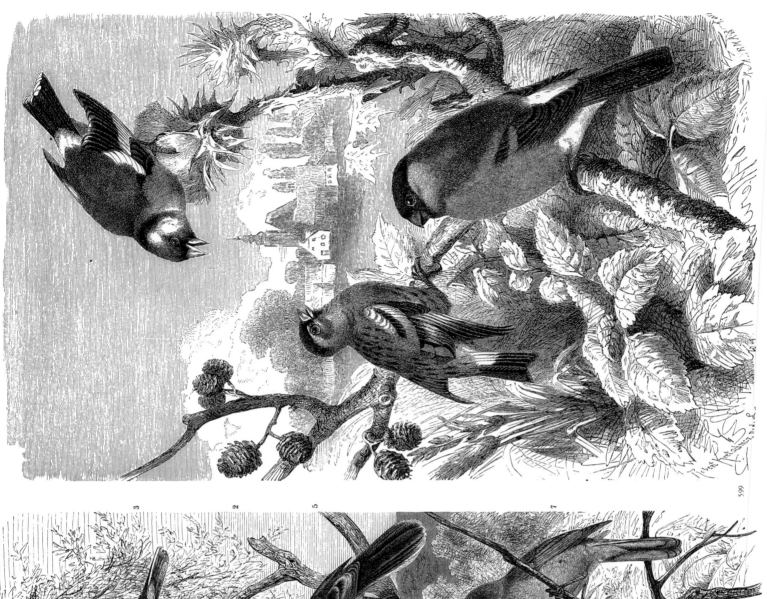

**BIRDS. 598:** Southern European warblers (1, Dartford warbler; 4, Marmora's warbler; 5, spectacled warbler; 7, subalpine warbler). **599:** Goldfinch (above), siskin (below, left) and bullfinch (below, right).

598

599

135

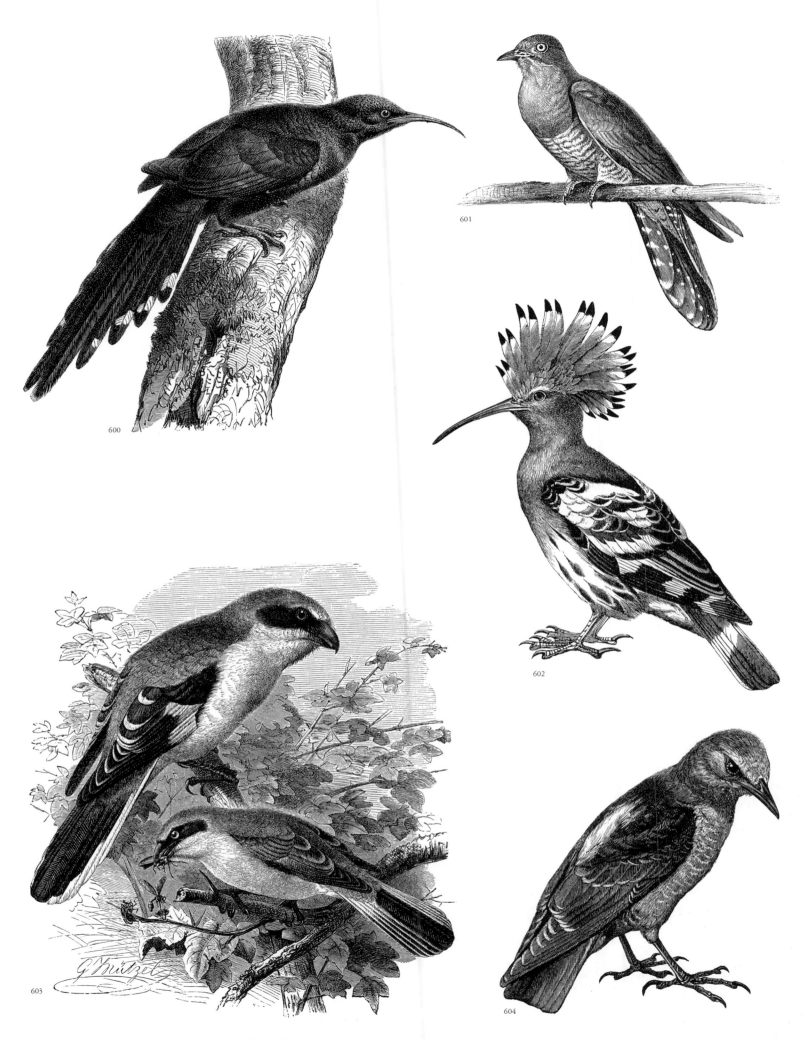

**BIRDS.** **600:** A species of wood hoopoe. **601:** Cuckoo. **602:** European hoopoe. **603:** Great grey shrike (above) and red-backed shrike. **604:** Rock thrush.

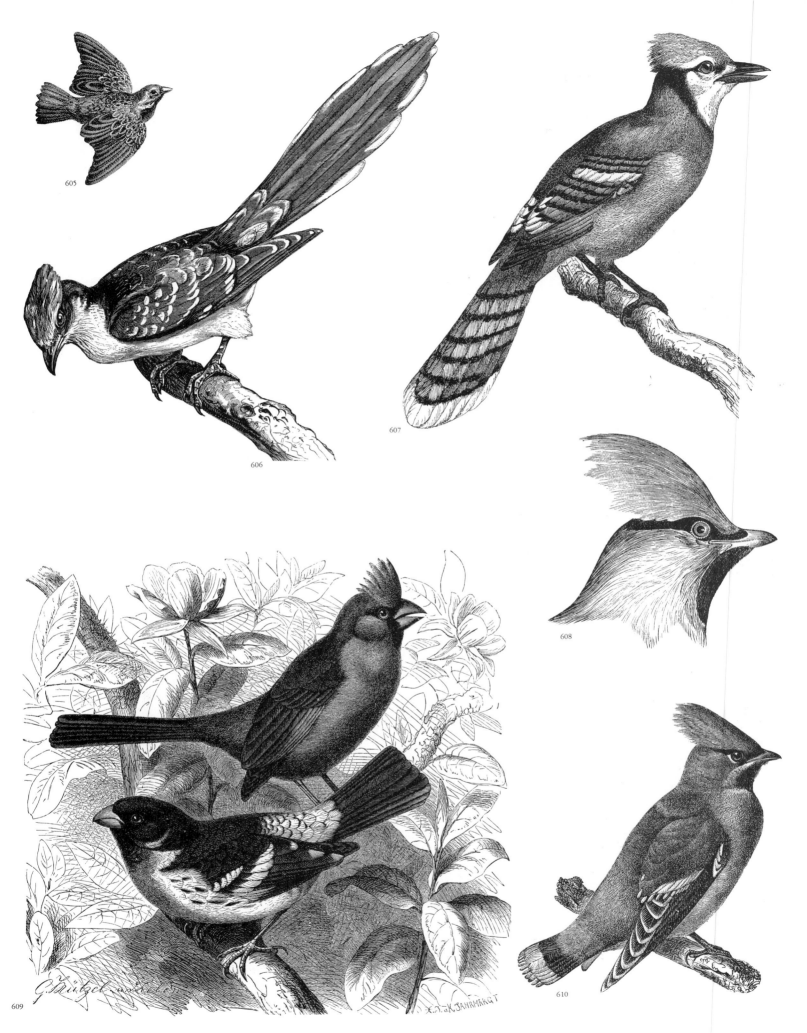

**BIRDS. 605, 608:** Unidentified birds. **606:** Great spotted cuckoo. **607:** Blue jay. **609:** Cardinal (above) and rose-breasted grosbeak. **610:** Bohemian waxwing.

137

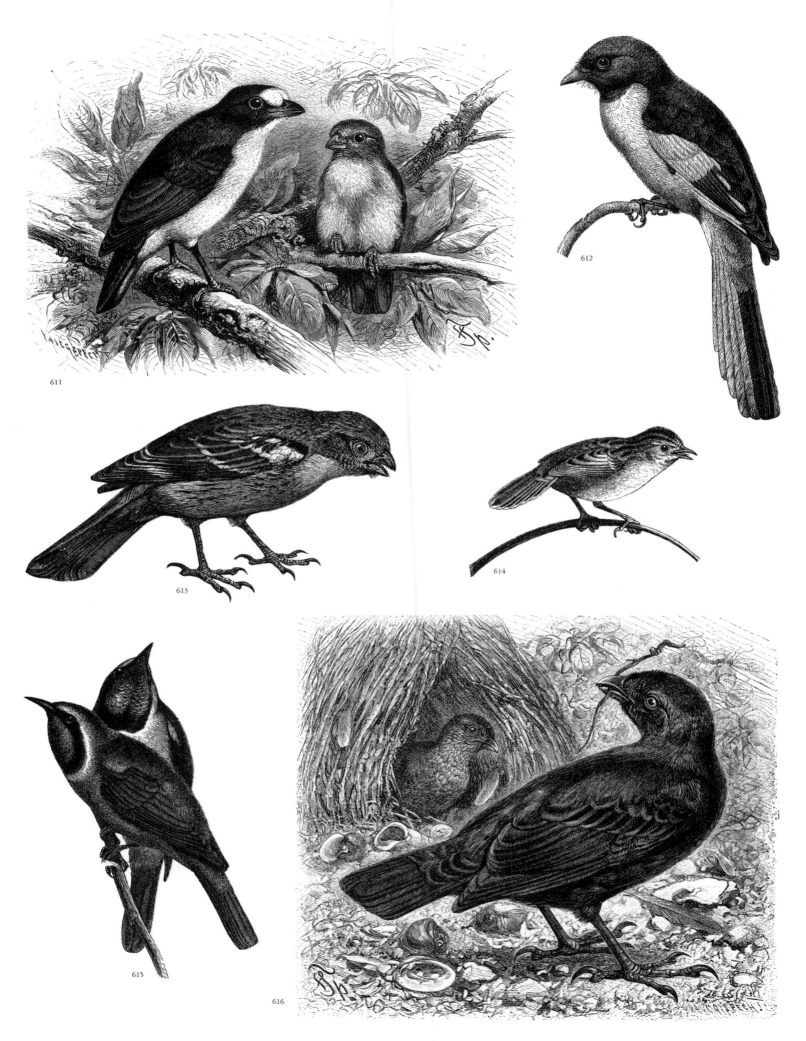

**BIRDS.** 611: Violet euphonia. 612: A species of minivet. 613: Chilean plantcutter. 614: Sedge warbler. 615: Golden-fronted leafbird (or green bulbul). 616: Satin bowerbird.

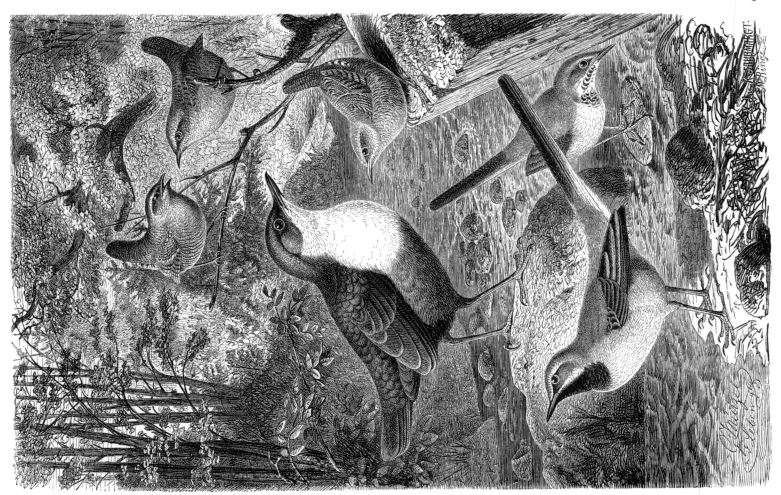

**BIRDS.** 617: Wrens (top), dipper (center) and grey wagtails (bottom). 618: Thrushes found in Germany (song thrush, mistle thrush, fieldfare and blackbird).

618

617

139

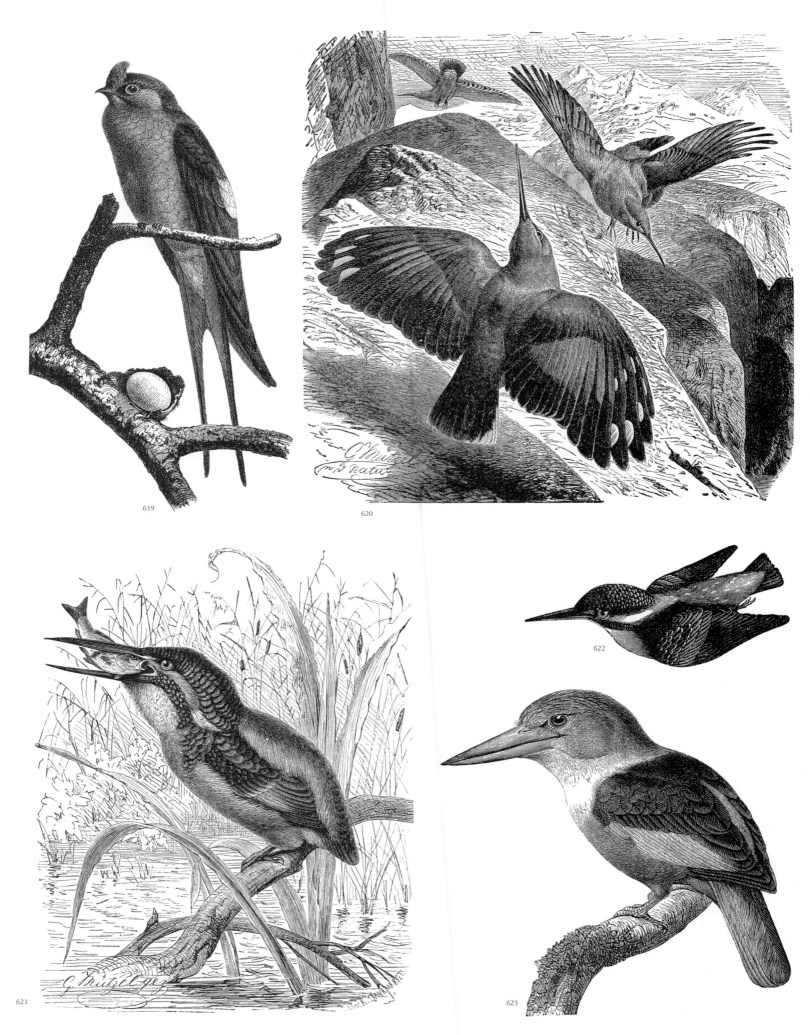

**BIRDS.** 619: A species of crested (or tree) swift. 620: Wall creepers. 621,
622: European kingfisher. 623: An African species of kingfisher.

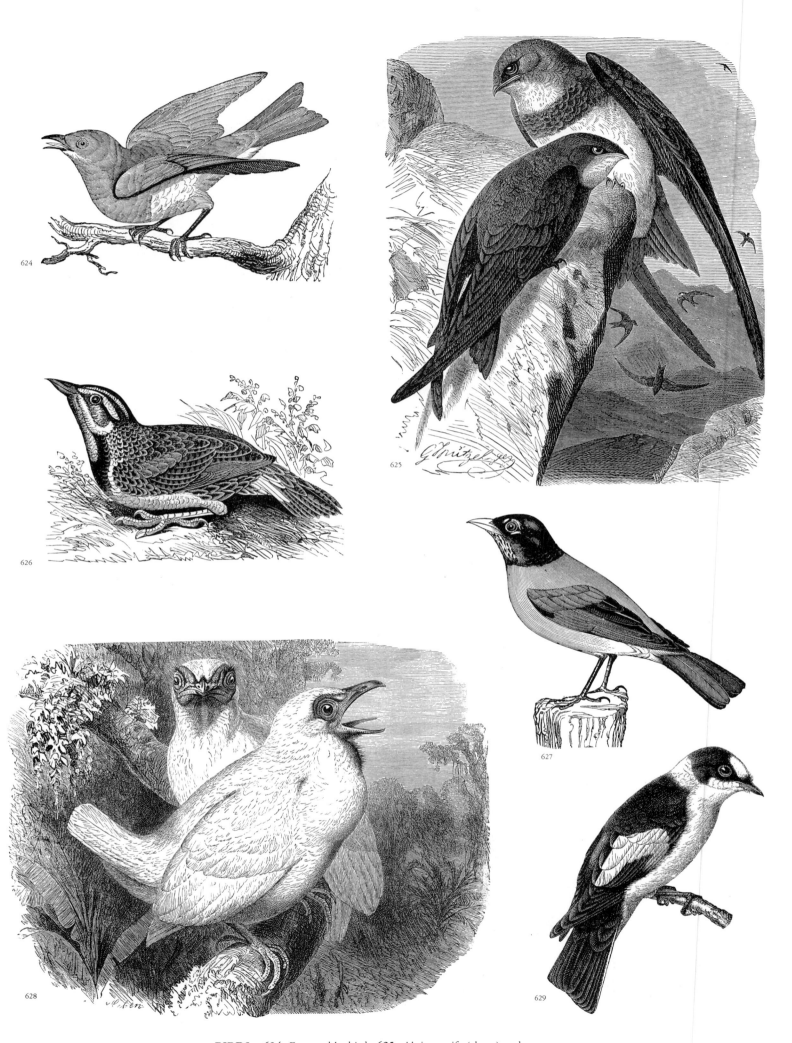

**BIRDS. 624:** Eastern bluebird. **625:** Alpine swift (above) and common European swift. **626:** Meadowlark. **627:** American robin. **628:** Bare-throated bellbird. **629:** Collared flycatcher.

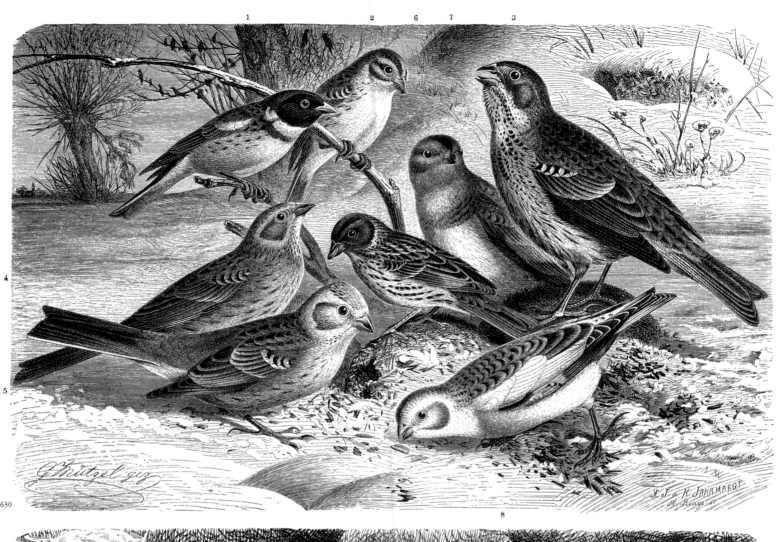

630

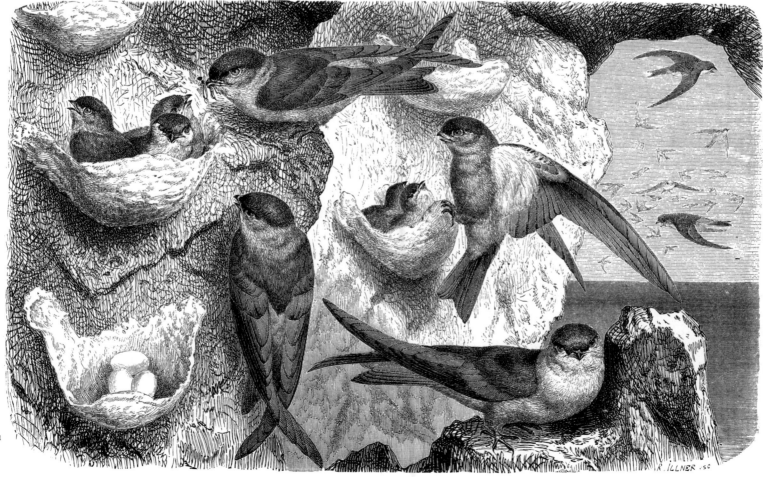

631

**BIRDS. 630:** Buntings (1 & 2, yellow-breasted buntings; 3, corn bunting;
4 & 5, yellowhammers; 6, little bunting; 7 & 8, snow buntings). **631:**
Swiftlets of southern Asia that build edible nests.

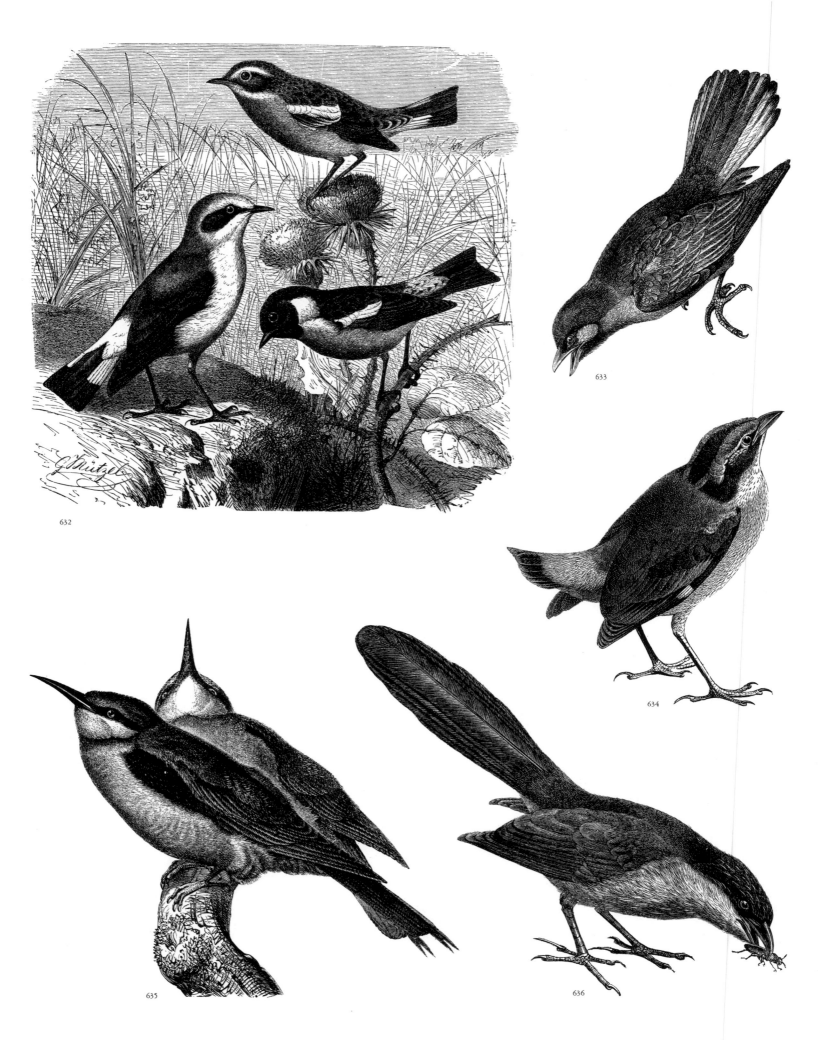

**BIRDS. 632:** Whinchat (top), wheatear (below, left) and stonechat (below, right). **633:** Greater honeyguide. **634:** A species of pitta. **635:** European bee-eater. **636:** Senegal coucal.

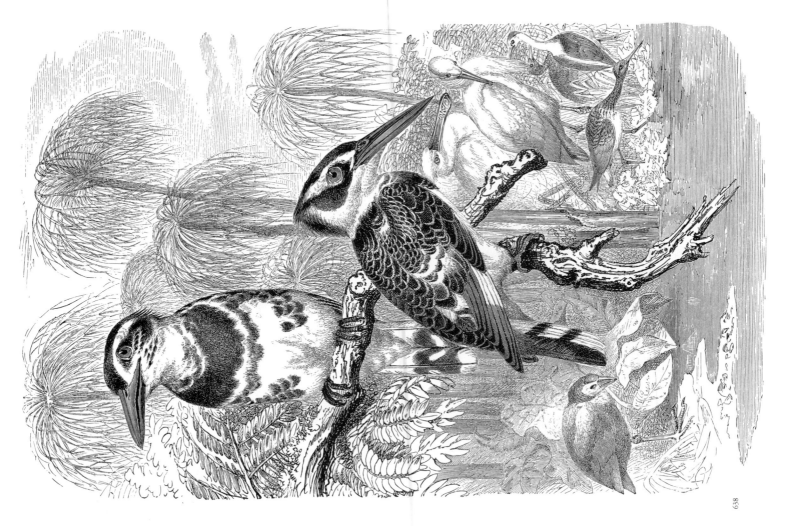

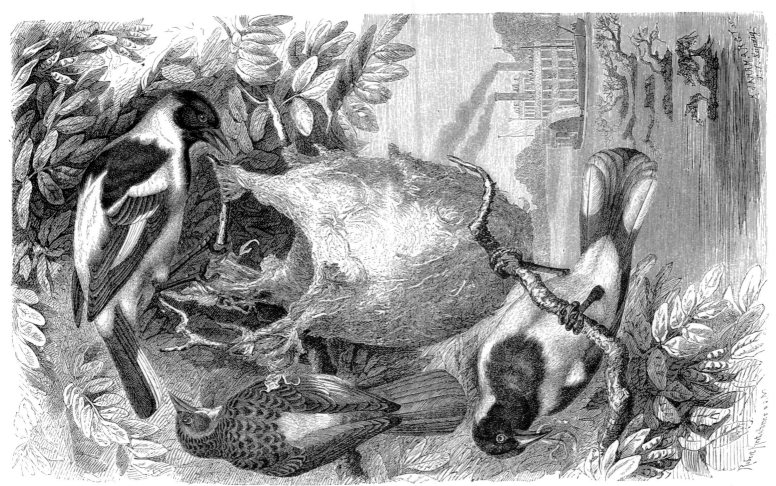

**BIRDS.** 637: Baltimore orioles. 638: Pied kingfishers (foreground).

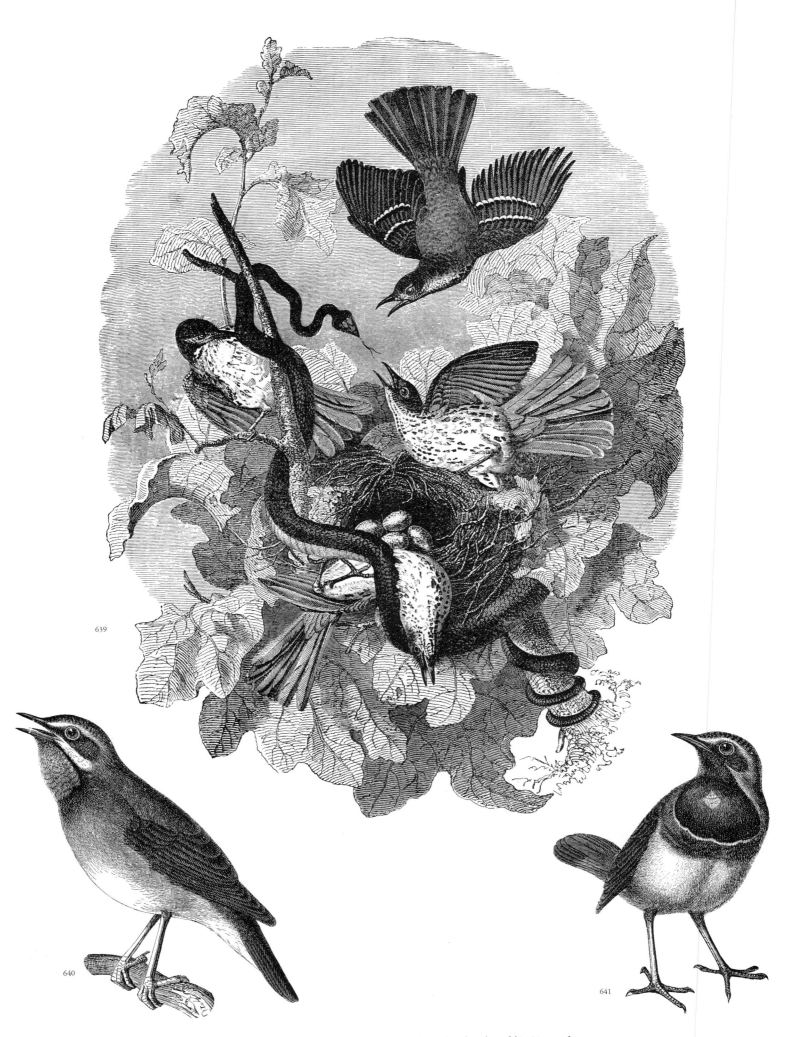

**BIRDS.** **639:** Brown thrashers attacked by a blacksnake. **640:** Type of Siberian songbird. **641:** Bluethroat.

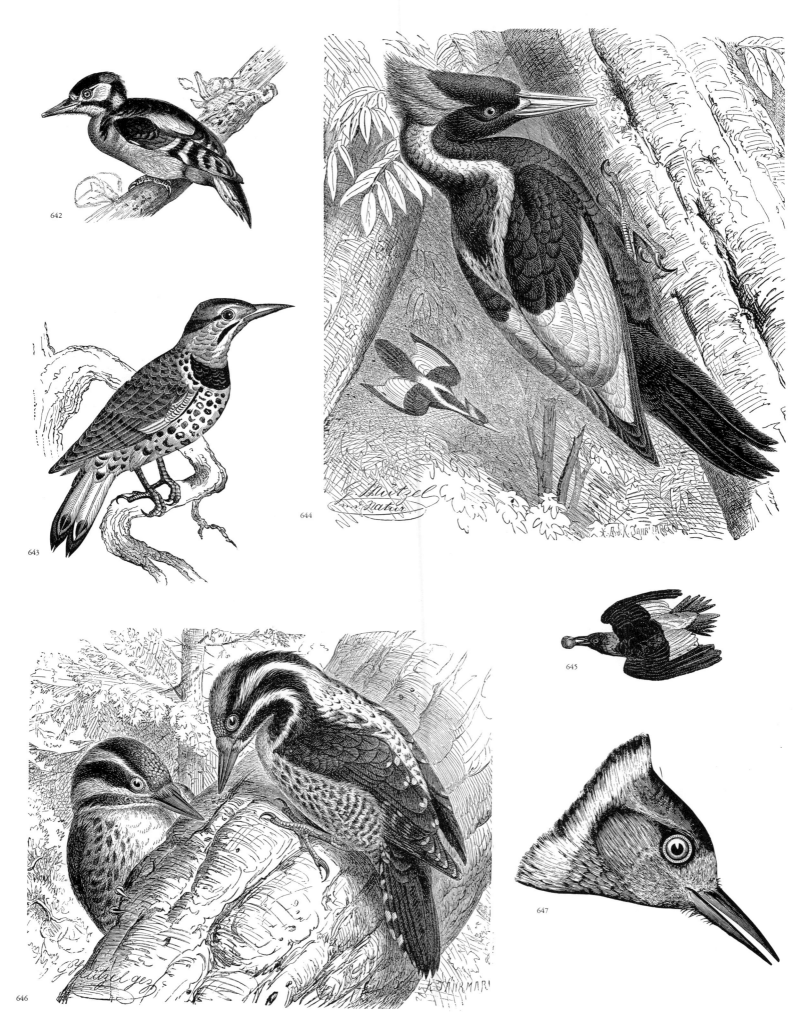

**BIRDS.** 642: Great spotted woodpecker. 643: Flicker. 644: Ivory-billed woodpecker. 645: Red-headed woodpecker. 646: Three-toed woodpecker. 647: Lewis's woodpecker.

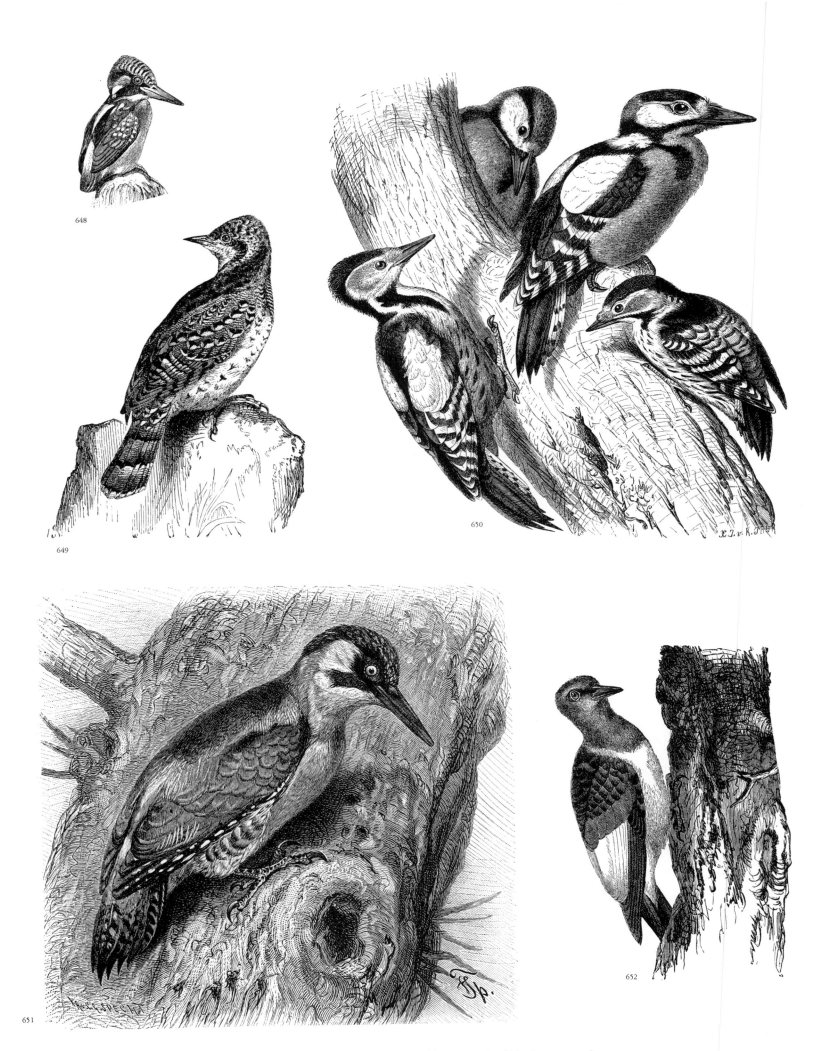

**BIRDS.** **648:** European kingfisher. **649:** Wryneck. **650:** Great spotted, middle spotted and lesser spotted woodpeckers. **651:** Green woodpecker. **652:** Red-headed woodpecker.

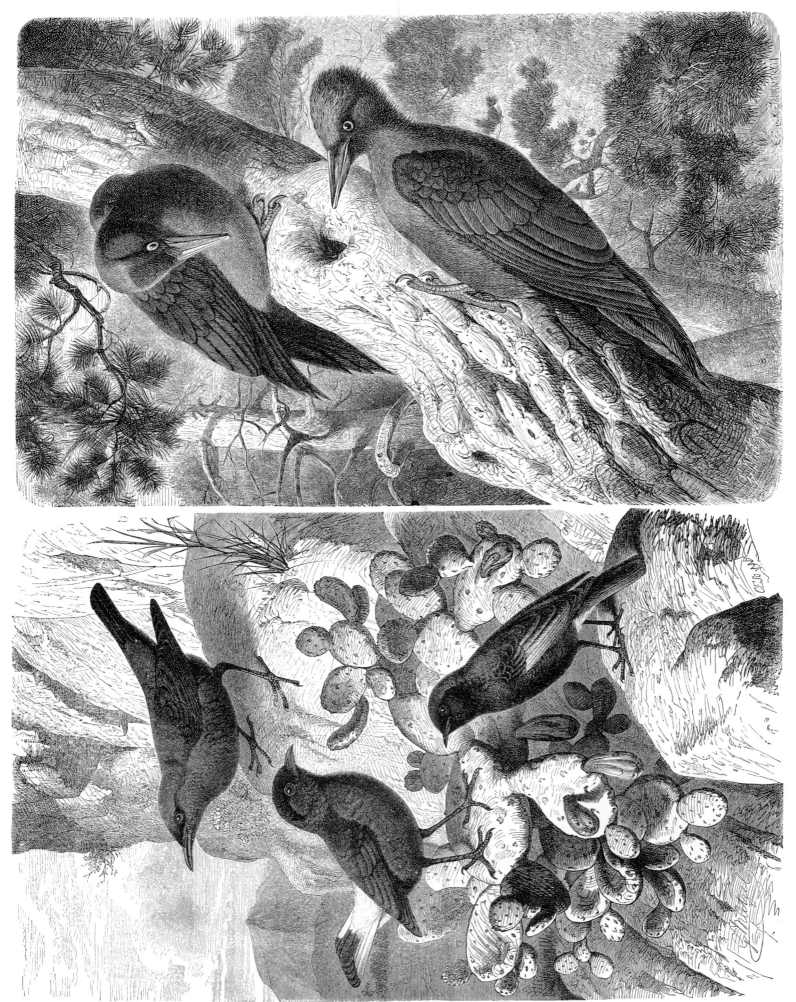

654

**BIRDS.** **653:** (top to bottom) Blue rock thrush, black wheatear and black redstart. **654:** Black woodpeckers.

653

148

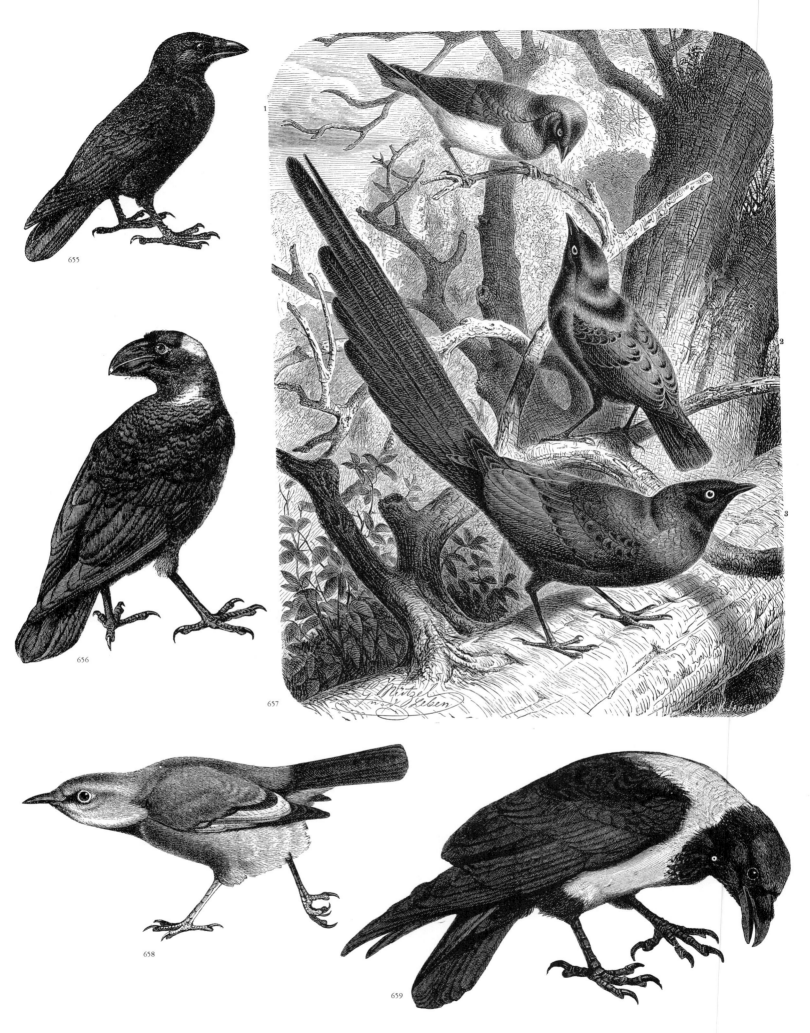

**BIRDS. 655:** Carrion crow. **656, 659:** Two African species of raven. **657:** Three species of glossy starling. **658:** Type of jay.

149

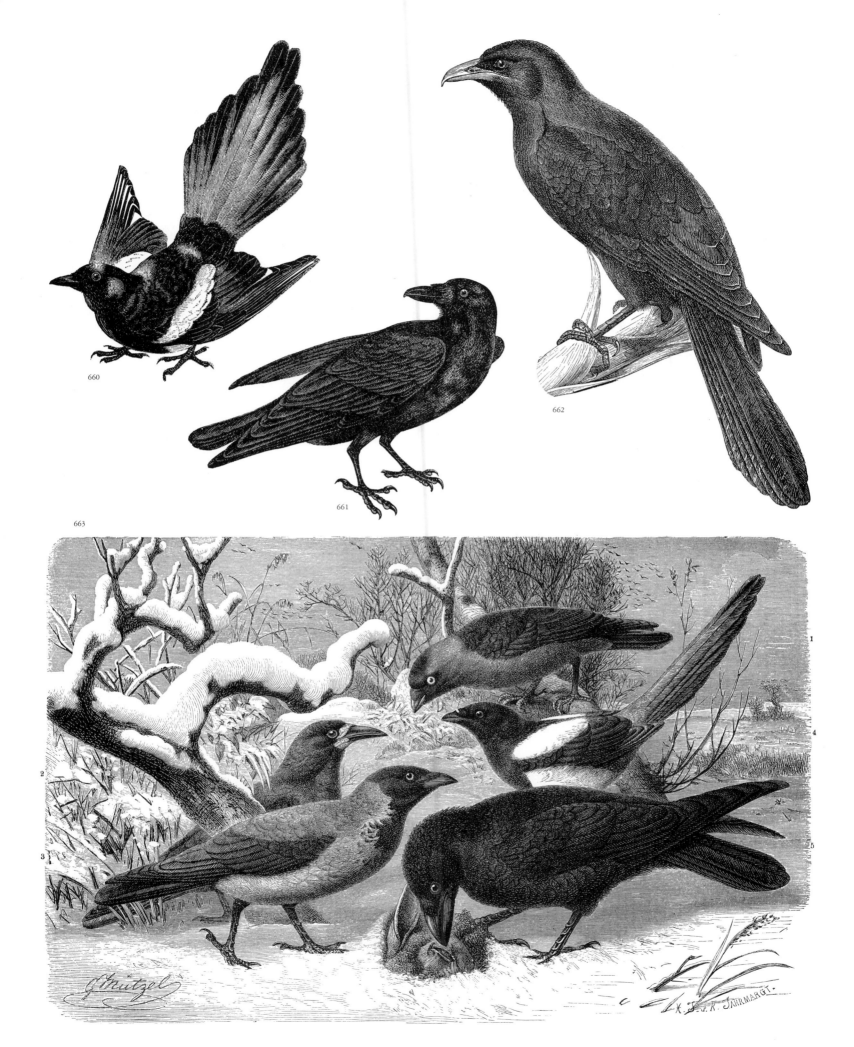

**BIRDS.** 660: Magpie. 661: Raven. 662: Koel. 663: European birds of the crow family (1, jackdaw; 2, rook; 3, hooded crow; 4, magpie; 5, raven).

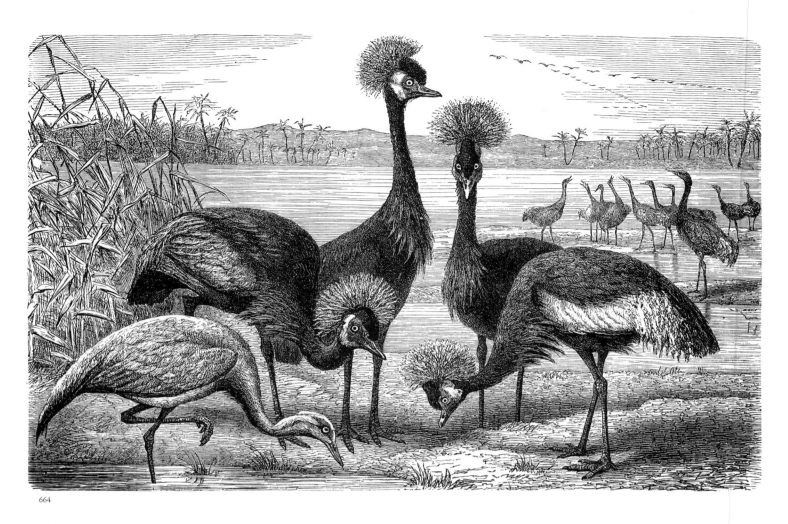

664

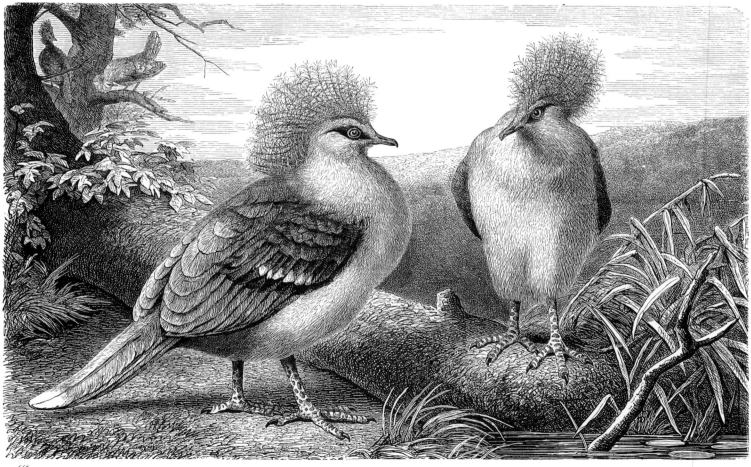

665

**BIRDS.** **664:** Demoiselle cranes and crowned cranes. **665:** Victoria crowned pigeons.

151

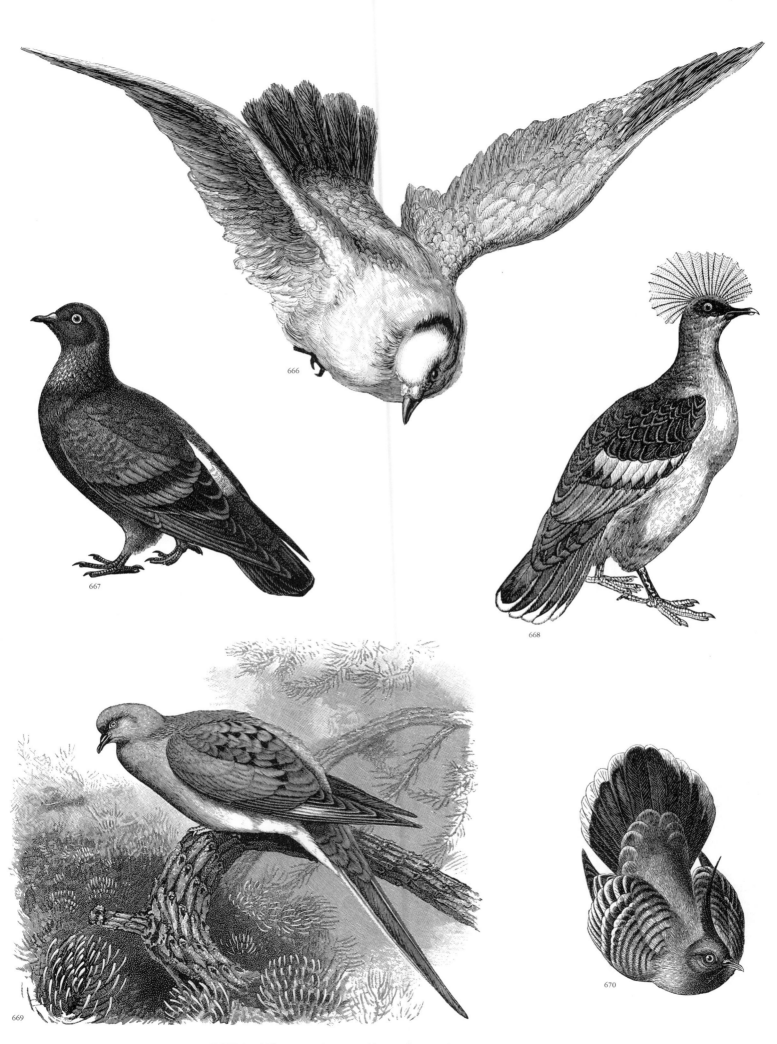

**BIRDS.** **666:** A type of pigeon. **667:** Rock dove. **668:** A species of crowned pigeon. **669:** Passenger pigeon. **670:** A type of dove.

BIRDS. 671: Domestic pigeon.

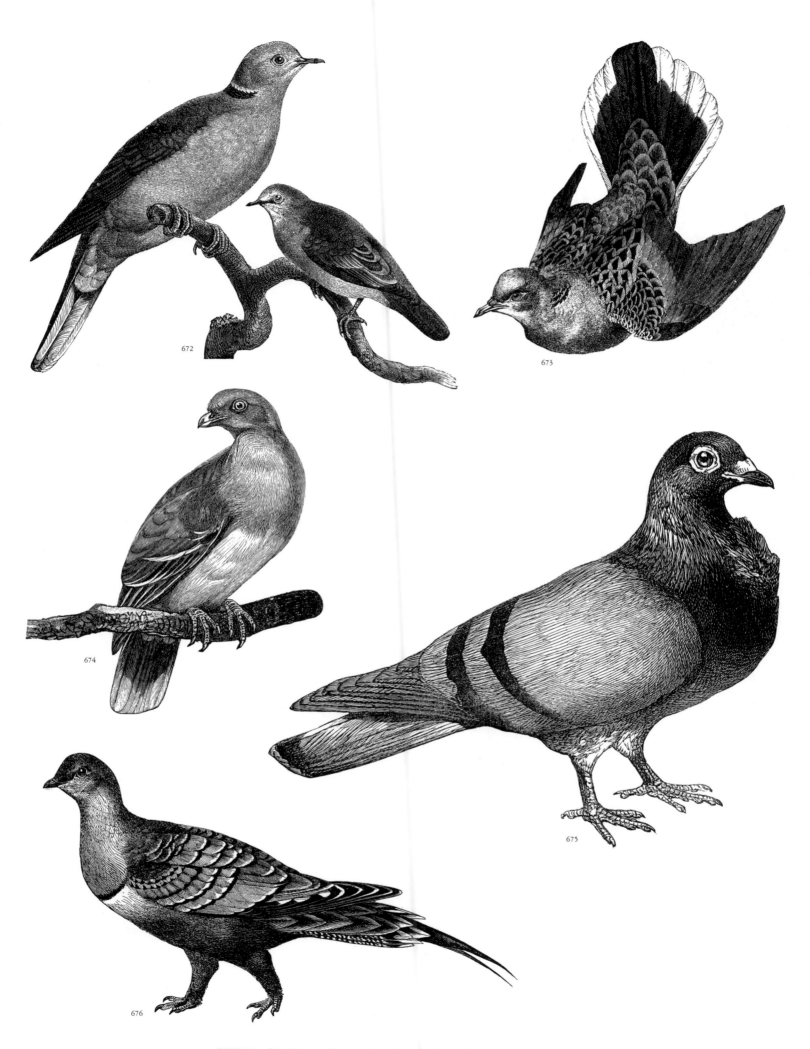

**BIRDS. 672:** Doves (above, collared turtle dove). **673:** Turtle dove. **674:** An African species of pigeon. **675:** Domestic pigeon. **676:** Black-bellied sandgrouse.

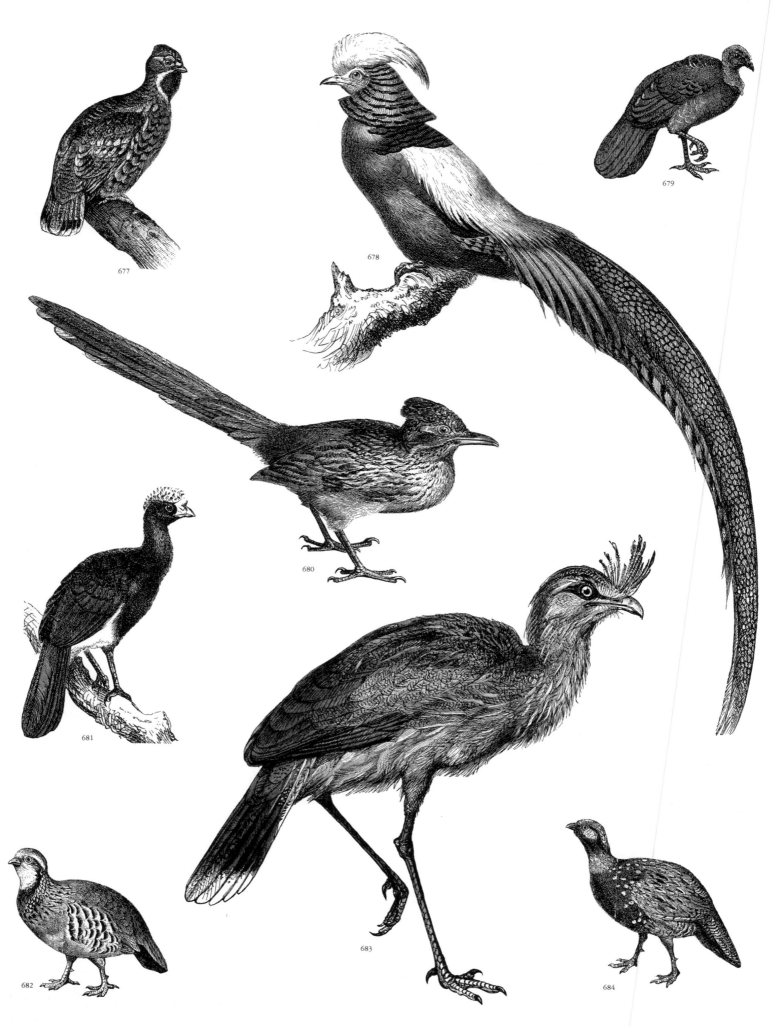

**BIRDS.** **677:** Hazel hen. **678:** Golden pheasant. **679:** A species of brush turkey. **680:** Roadrunner. **681:** A species of curassow or allied birds. **682:** Red-legged partridge. **683:** Crested seriema. **684:** A species of grouse or allied birds.

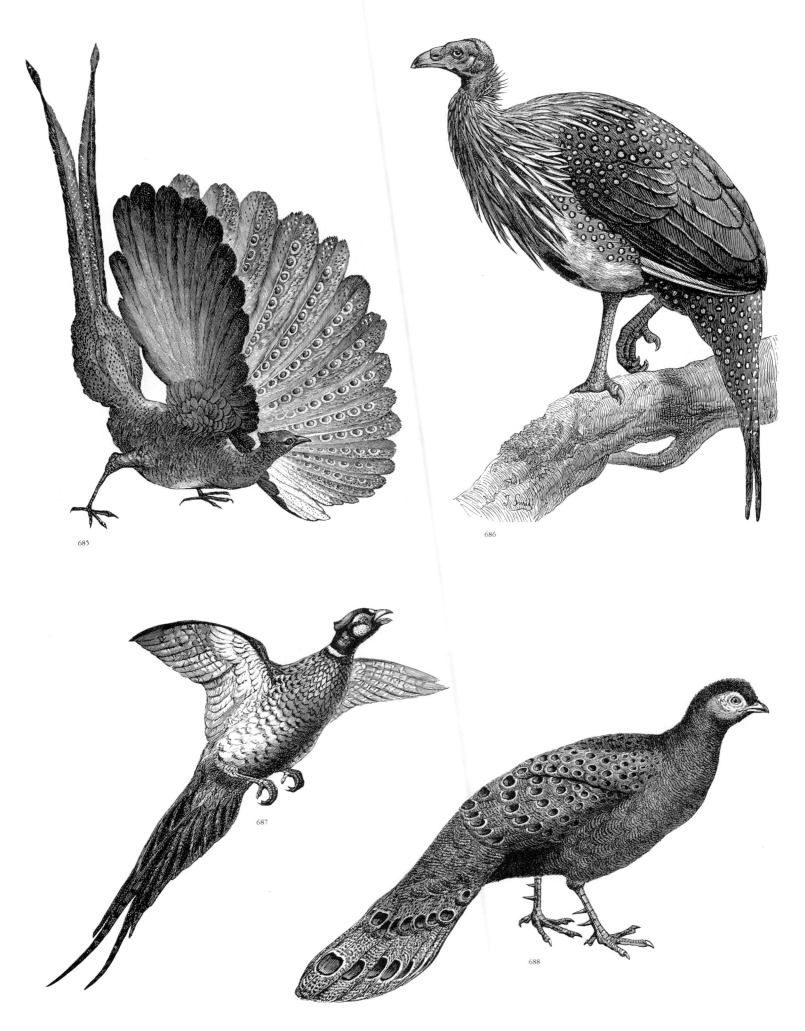

**BIRDS. 685:** Great argus pheasant. **686:** Vulturine guineafowl. **687:** A type of pheasant. **688:** Gray peacock pheasant.

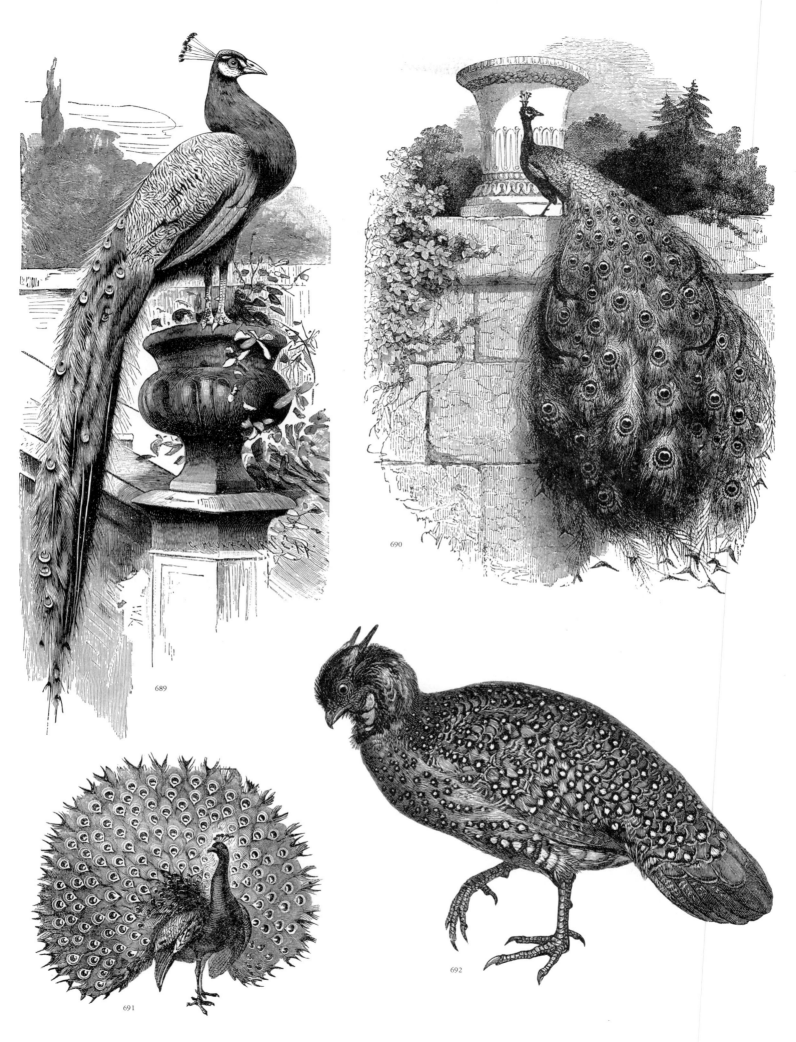

**BIRDS.** **689–691:** Indian peafowl (peacock). **692:** A species of tragopan.

157

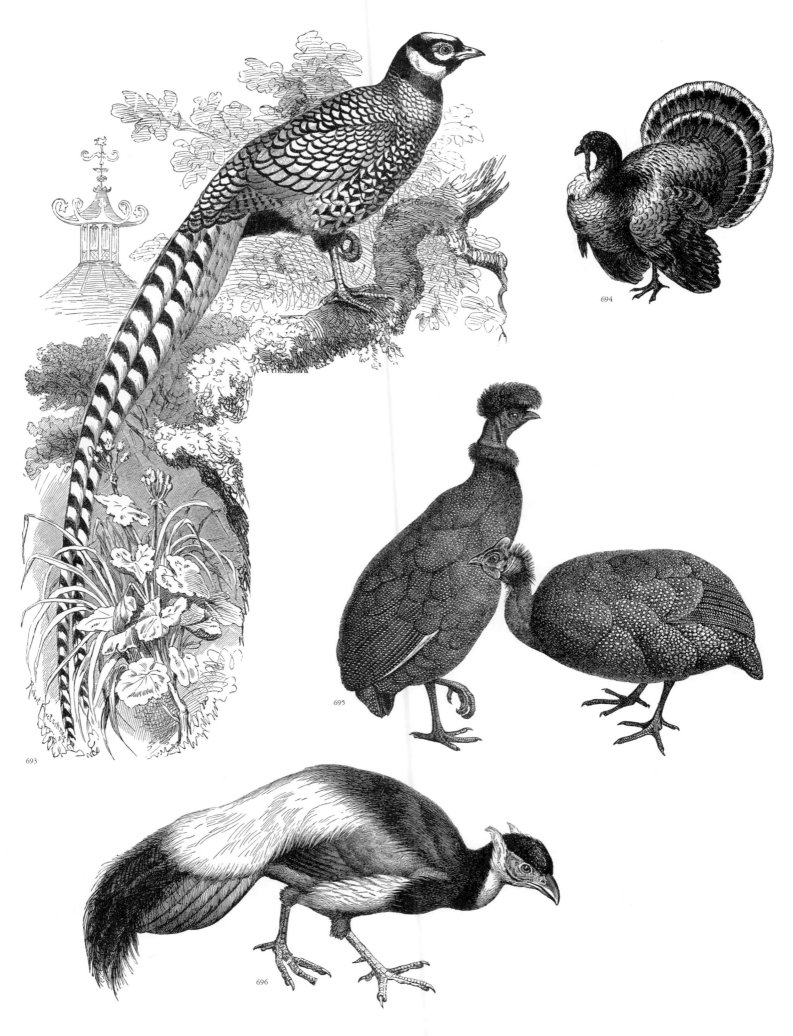

**BIRDS.** 693: Reeves's pheasant. 694: Turkey. 695: Crested and common guineafowl. 696: Brown eared pheasant.

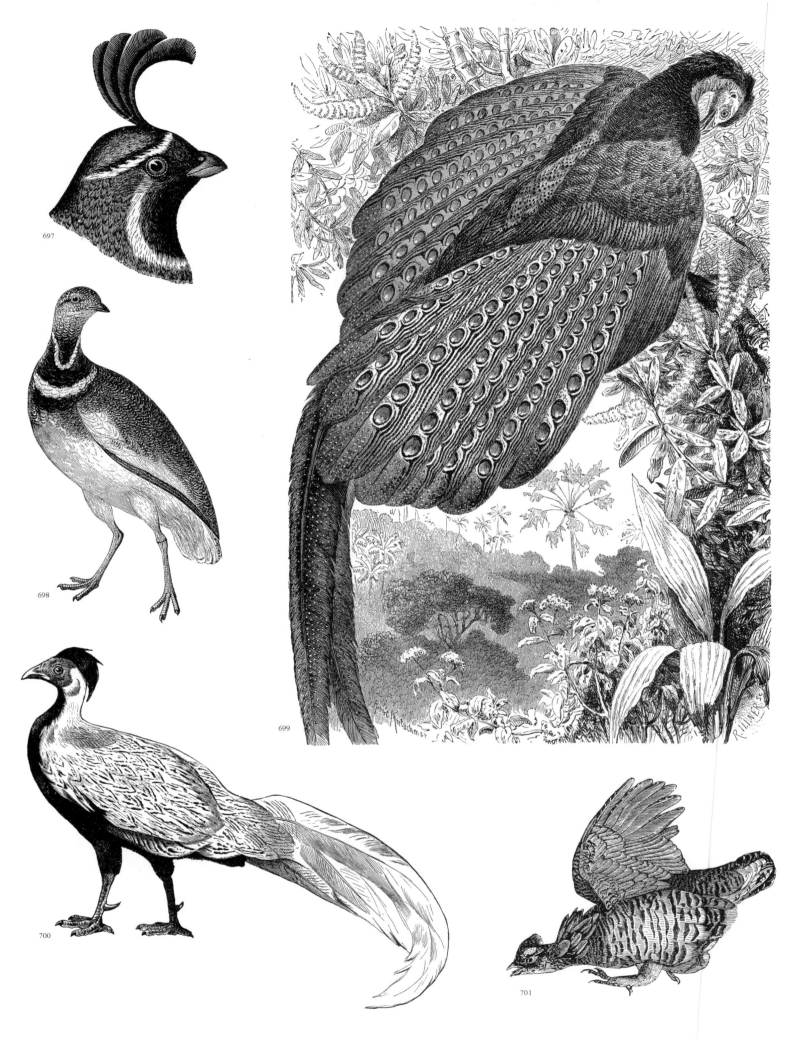

**BIRDS.** 697: California quail. 698: Little bustard. 699: Great argus pheasant. 700: Silver pheasant. 701: Prairie chicken.

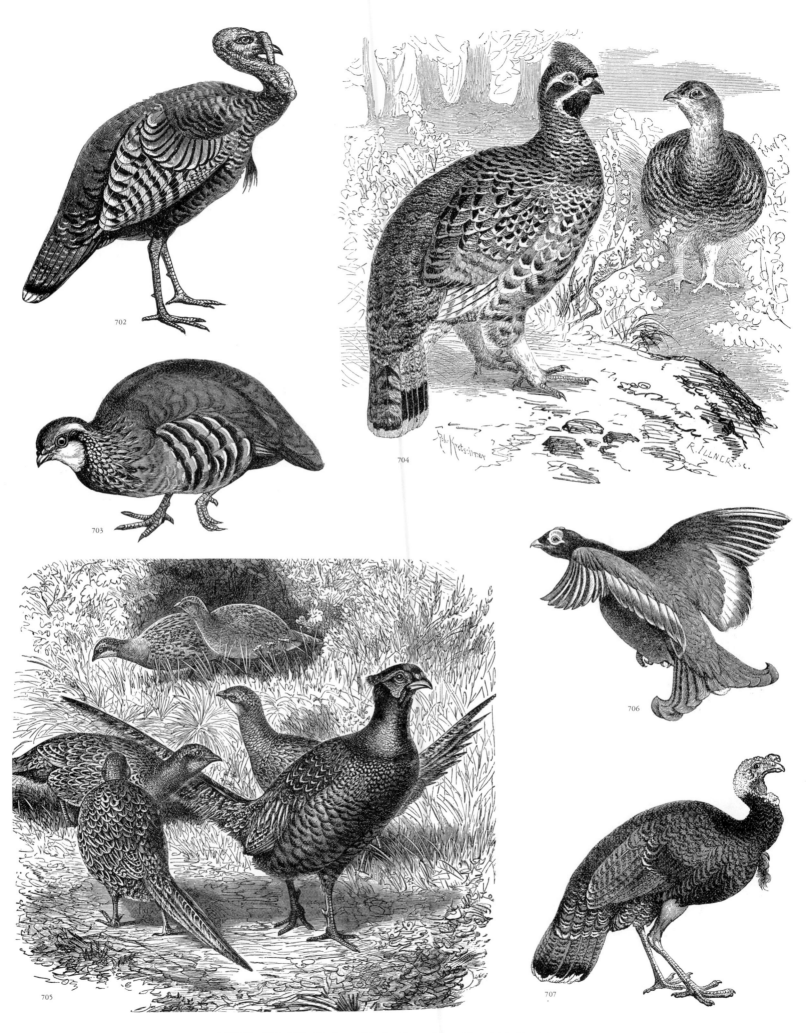

**BIRDS.** 702, 707: Turkey. 703: Red-legged partridge. 704: Hazel hen.
705: Common European pheasants. 706: Black grouse.

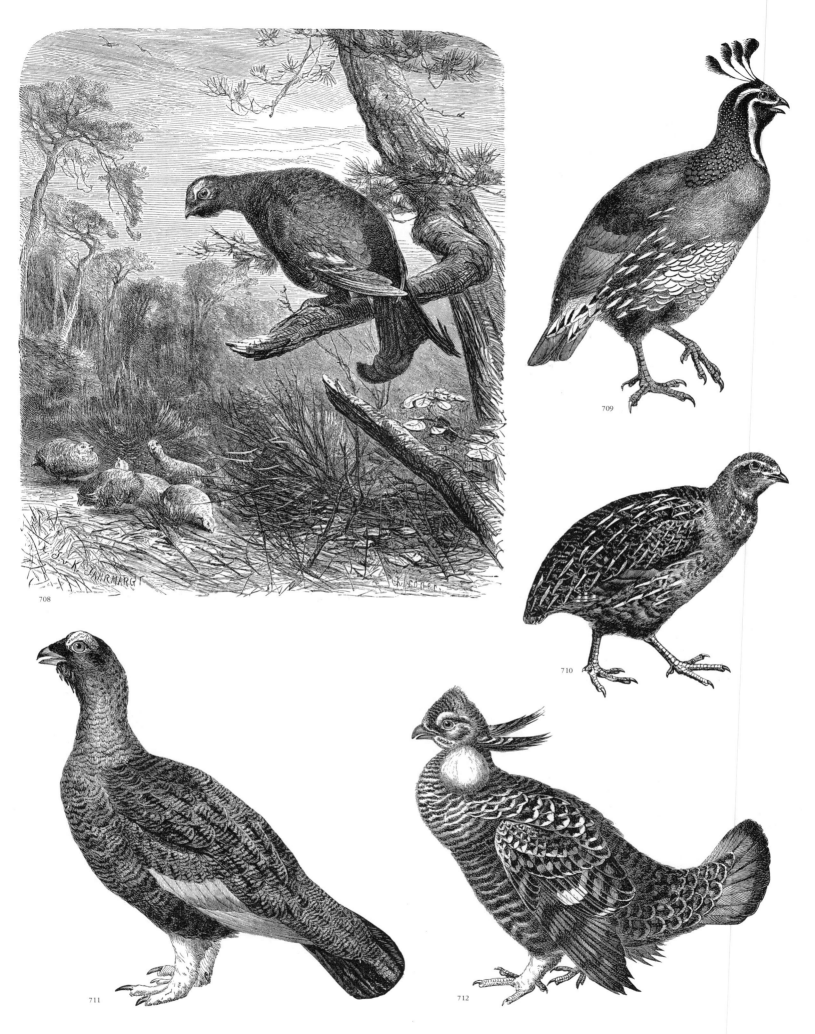

**BIRDS.** **708:** Black grouse. **709:** California quail. **710:** Quail. **711:** Ptarmigan. **712:** Greater prairie chicken.

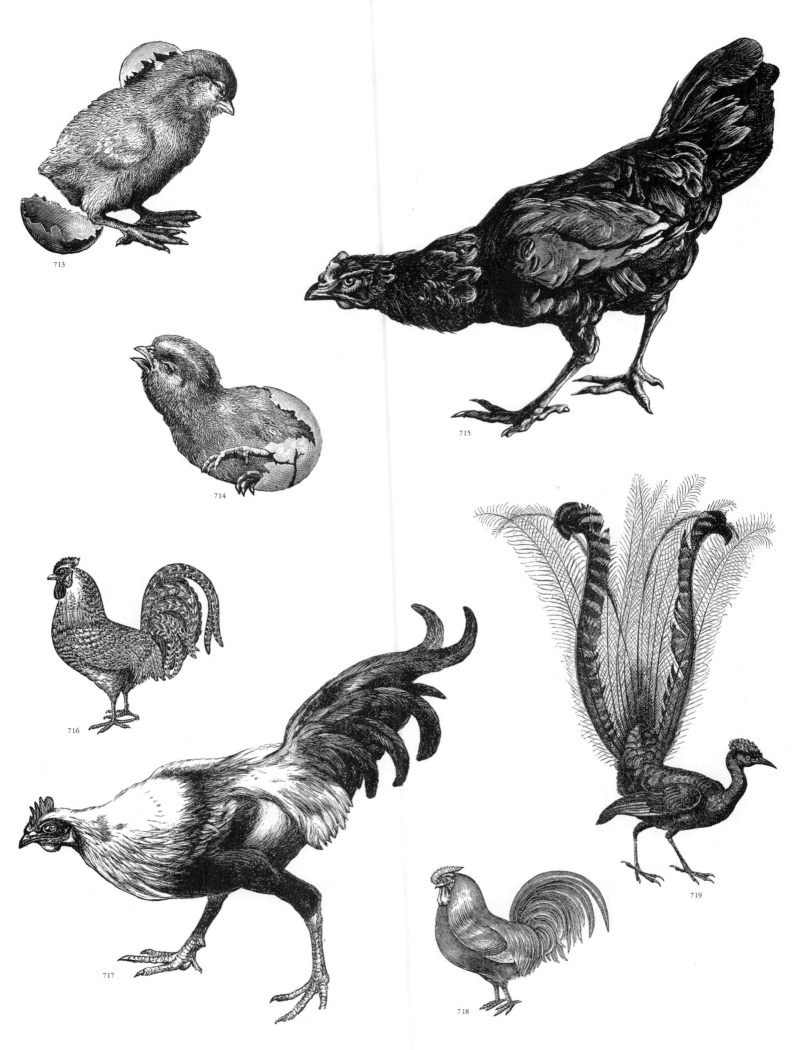

**BIRDS.** 713–718: Domestic fowl. 719: Lyrebird.

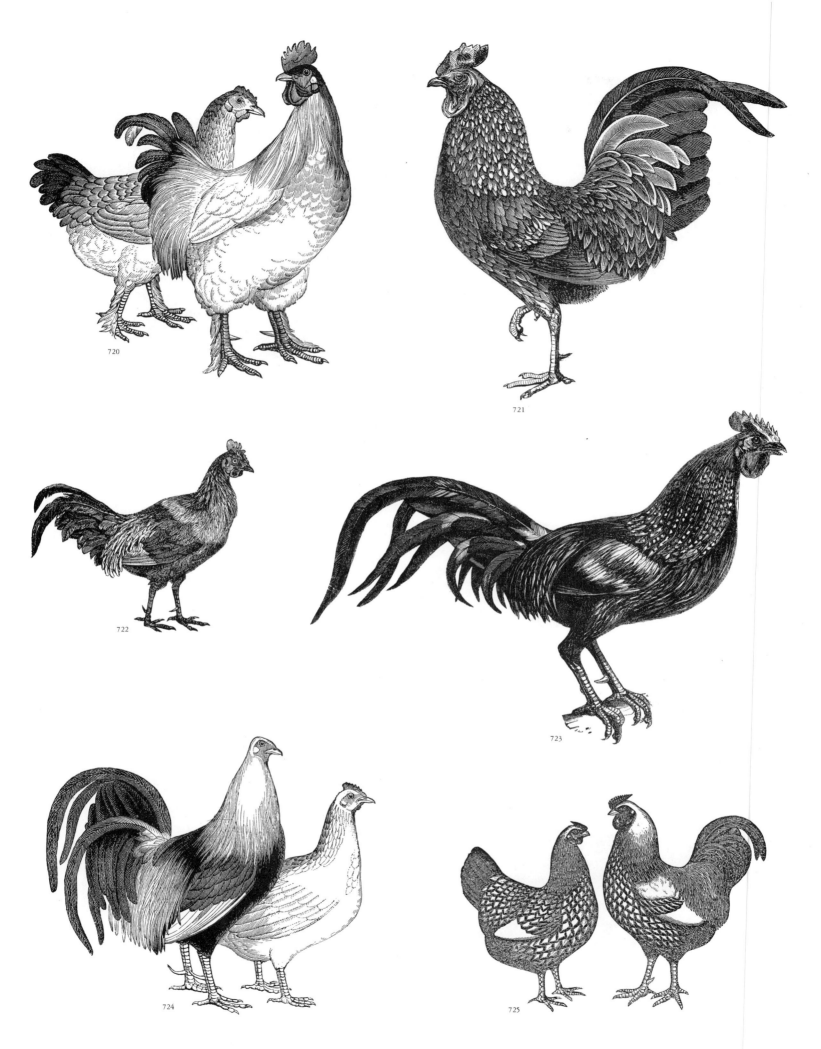

**BIRDS.** **720–725:** Domestic fowl (720, Cochin Chinas; 725, Wyandottes).

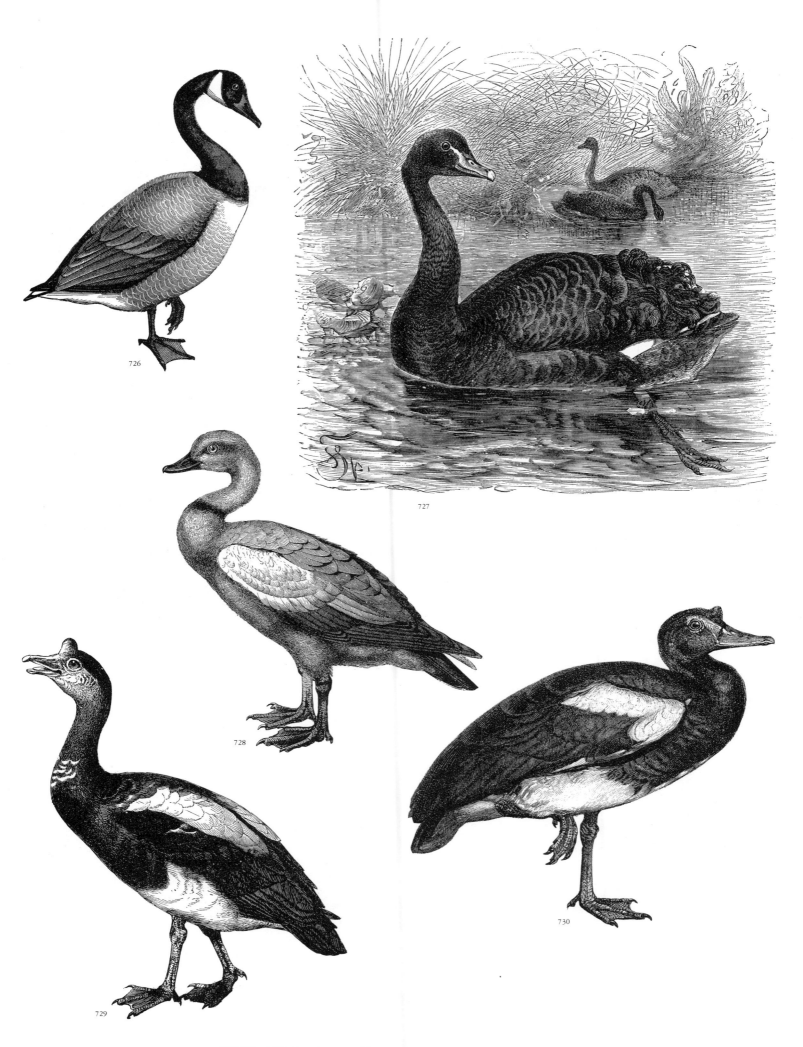

**BIRDS.** **726:** Canada goose. **727:** Black swan. **728:** Ruddy shelduck. **729, 730:** Two species of spurwinged goose.

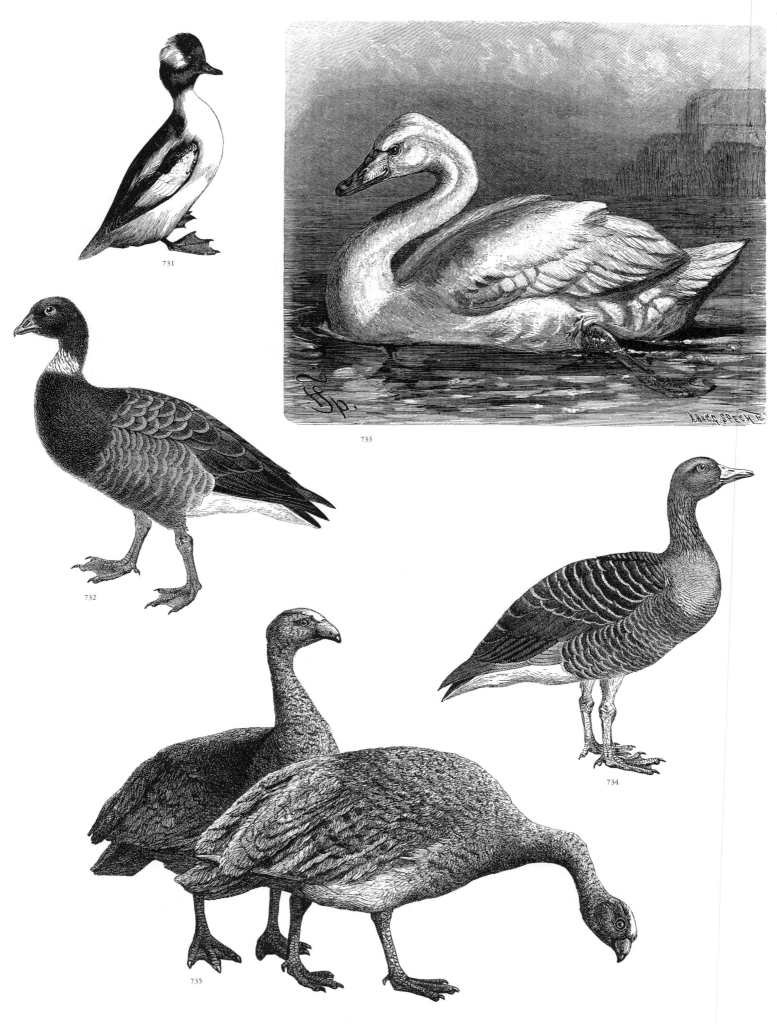

**BIRDS.** **731**: Bufflehead. **732**: Brent goose. **733**: Whooper swan. **734**: Grey lag goose. **735**: Cereopsis geese.

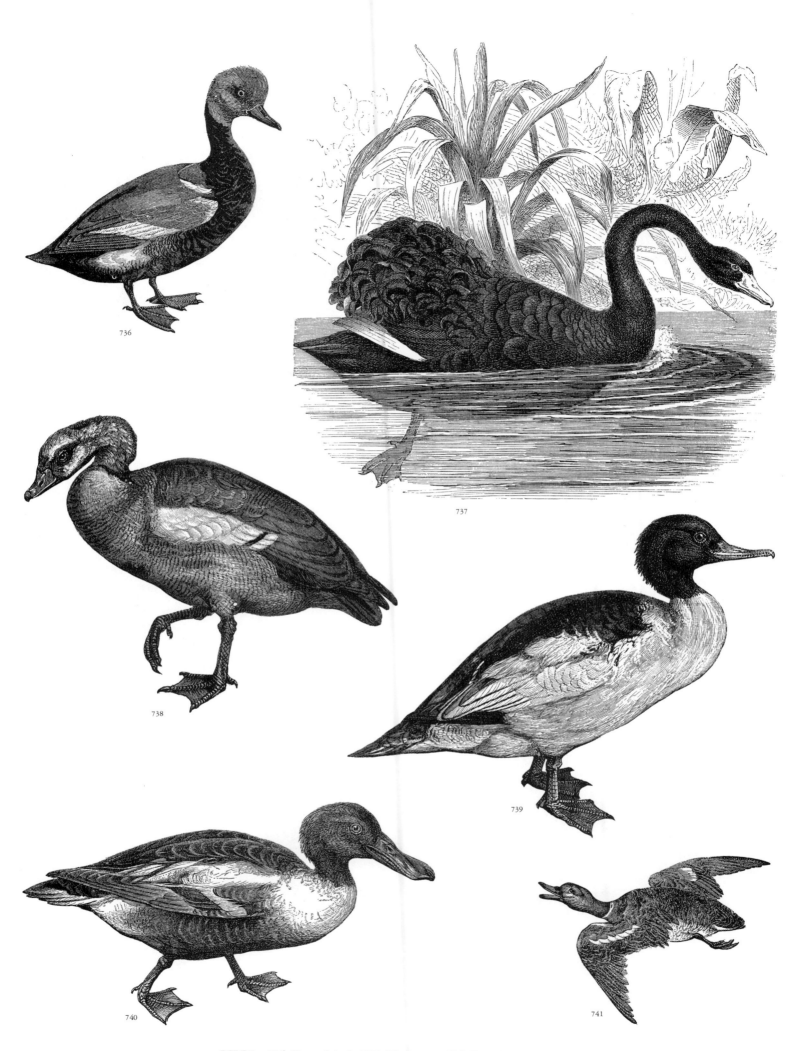

**BIRDS.** **736:** Type of duck. **737:** Black swan. **738:** Egyptian goose. **739:** Goosander. **740:** Common shoveller. **741:** Mallard.

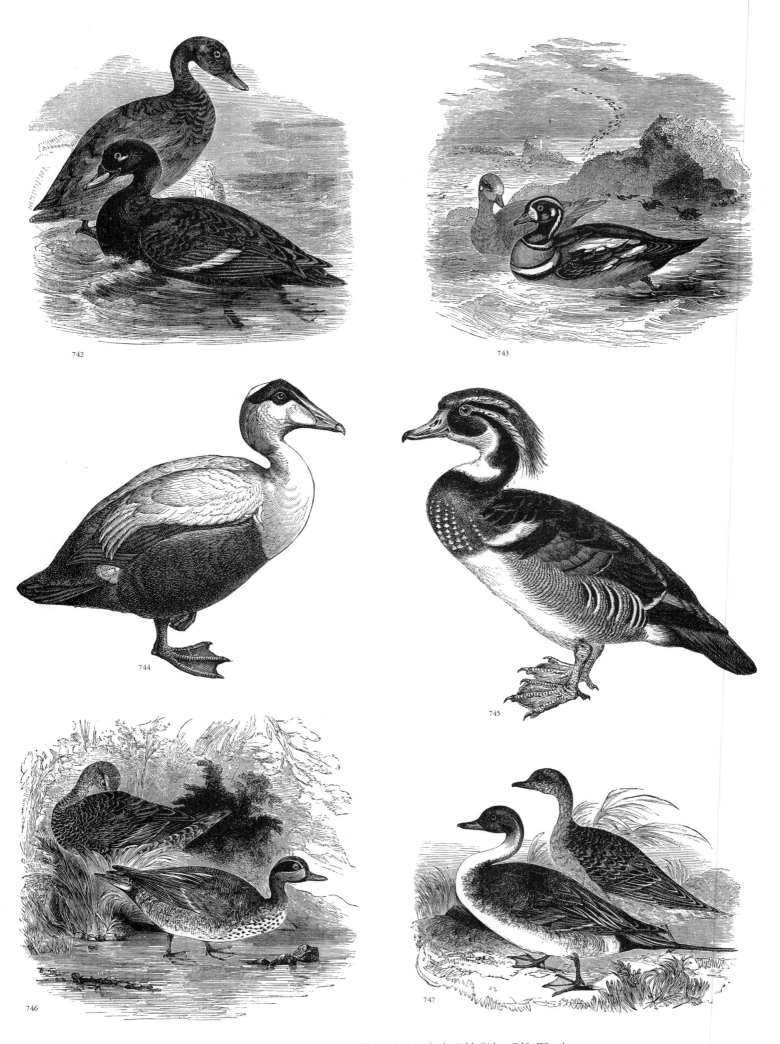

**BIRDS.** 742: Velvet scoter. 743: Harlequin duck. 744: Eider. 745: Wood duck. 746: Teal. 747: Pintails.

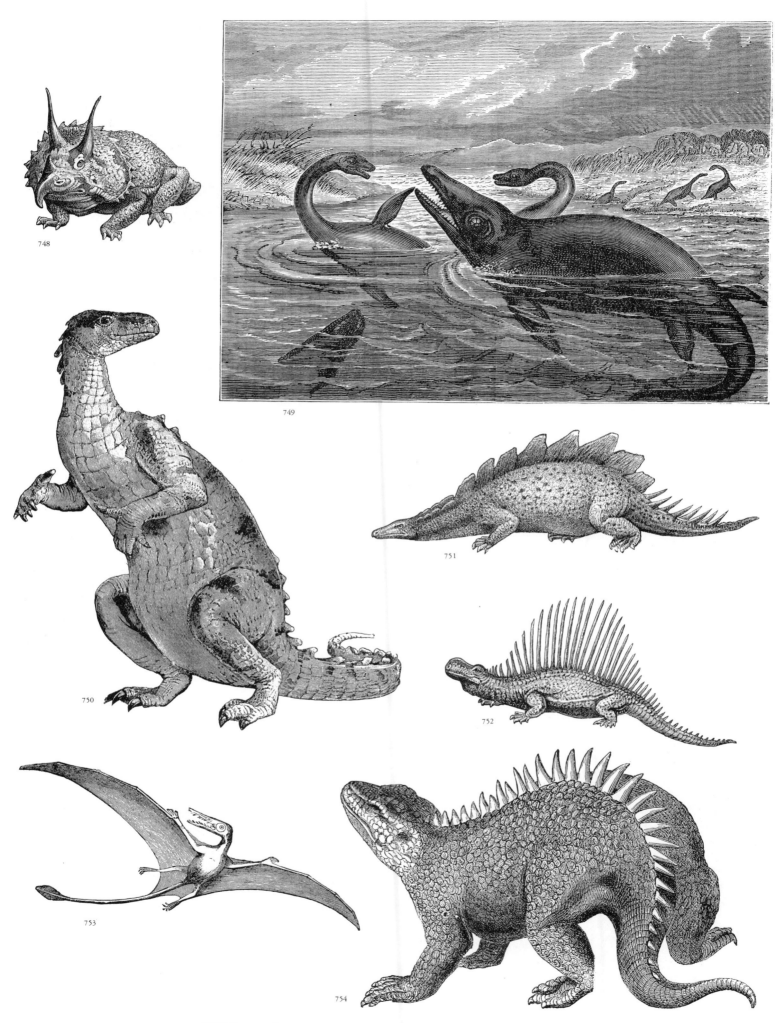

**REPTILES. 748:** Triceratops. **749:** Plesiosaurus and ichthyosaurus. **750:** Iguanodon. **751:** Stegosaurus. **752, 754:** Types of dinosaur. **753:** Pterodactyl.

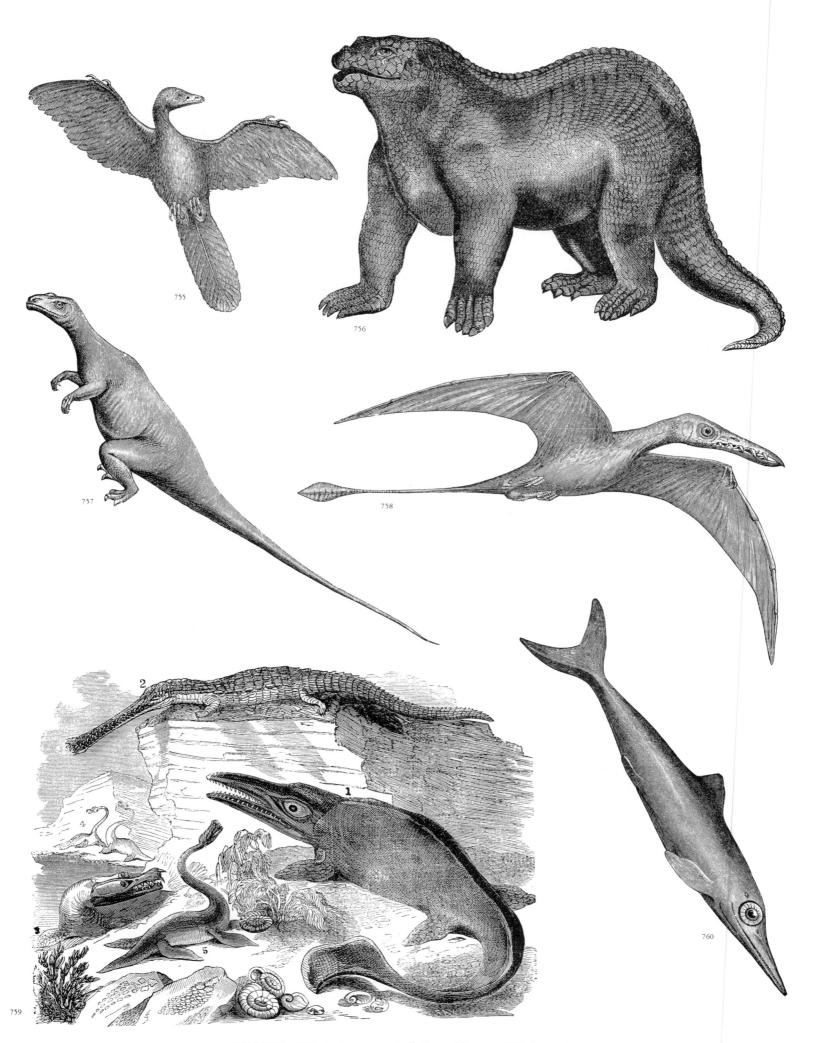

**REPTILES.** 755: Archaeopteryx. 756: Type of dinosaur. 757: Iguanodon. 758: Rhamphorhyncus. 759: A group of dinosaurs (1, ichthyosaurus; 2, teleosaurus; 3–5, plesiosaurus). 760: Ichthyosaurus.

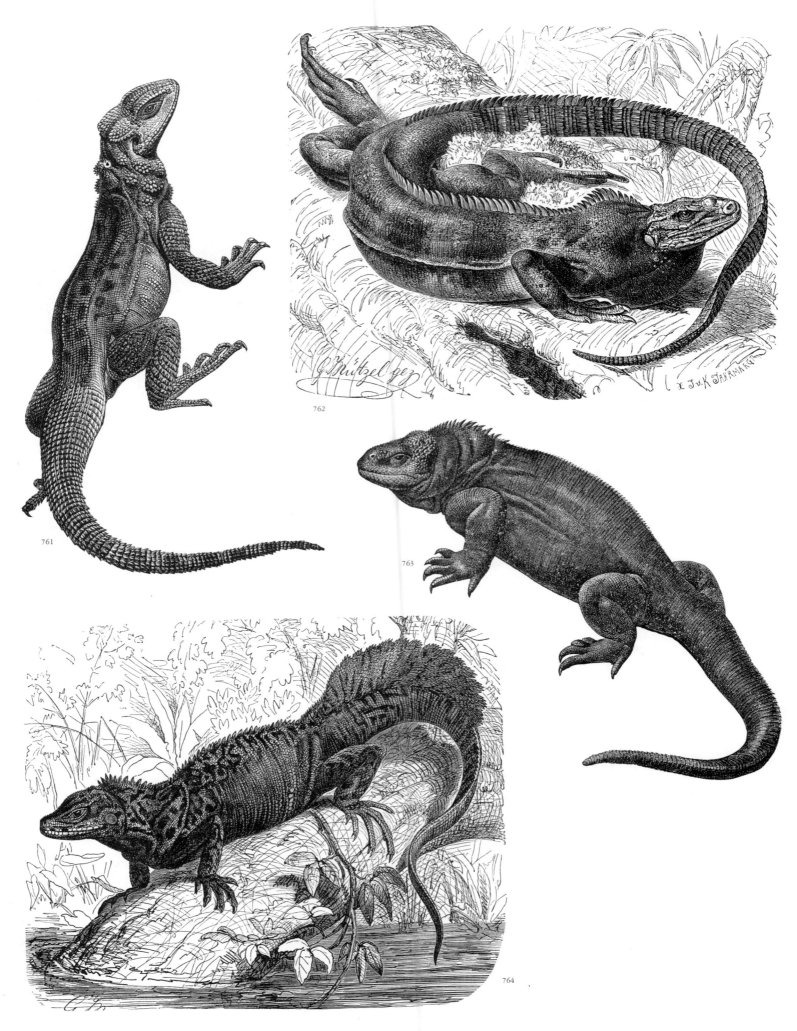

**REPTILES.** 761: Lizard of the agamid type. 762: An iguana of the West Indies. 763: Galápagos land iguana. 764: East Indian water lizard.

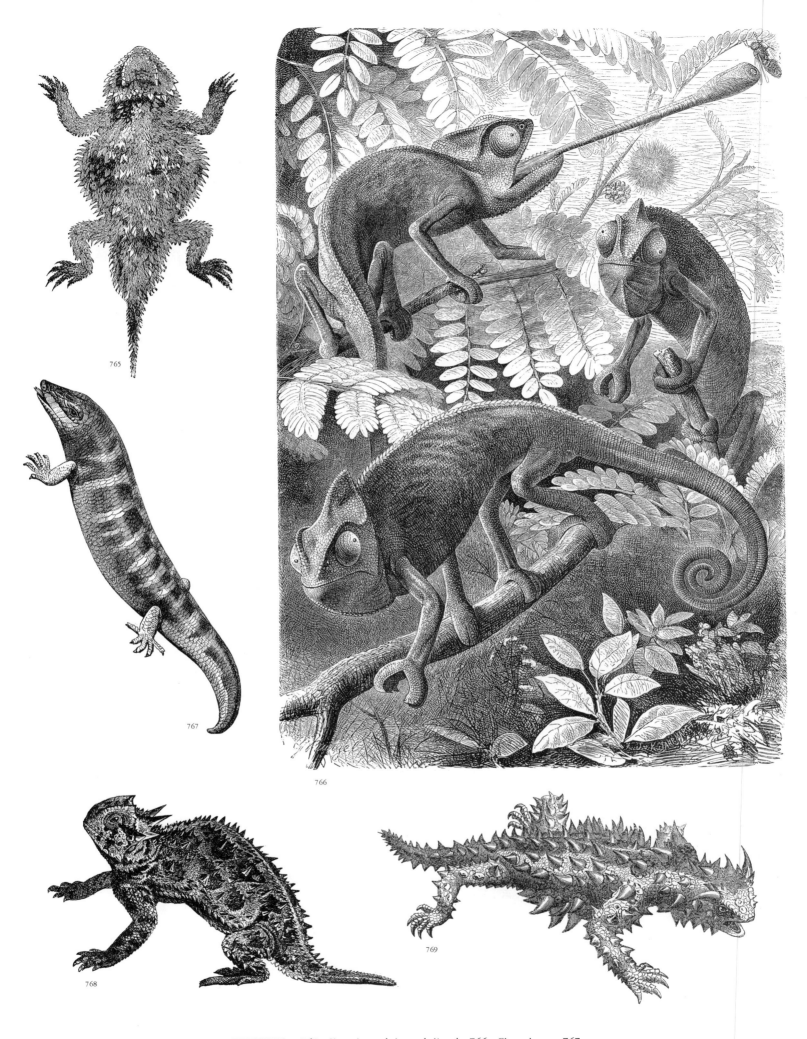

**REPTILES.** **765:** Short-horned horned lizard. **766:** Chameleons. **767:** Skink. **768:** Horned lizard ("horned toad"). **769:** Moloch lizard.

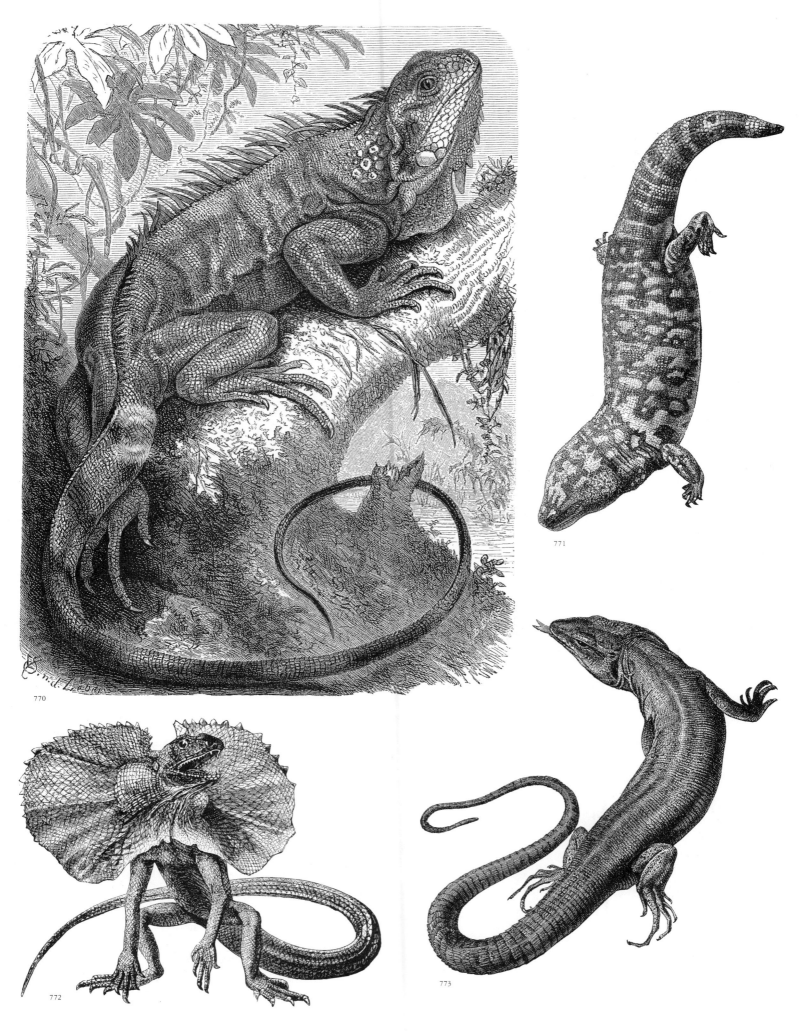

**REPTILES.** 770: South American iguana. 771: Gila monster. 772: Frilled lizard. 773: Green lizard.

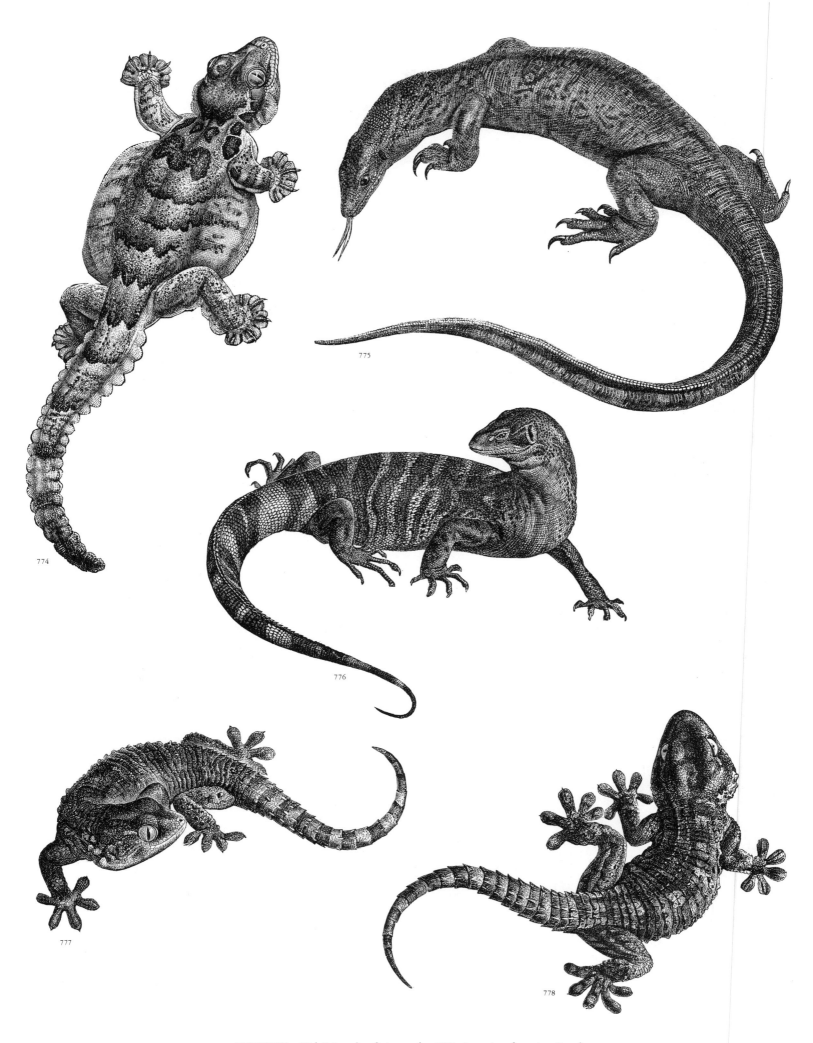

**REPTILES.** 774: Fringed or flying gecko. 775: A species of monitor lizard.
776: A monitor lizard from South Africa. 777 & 778: Wall geckos.

173

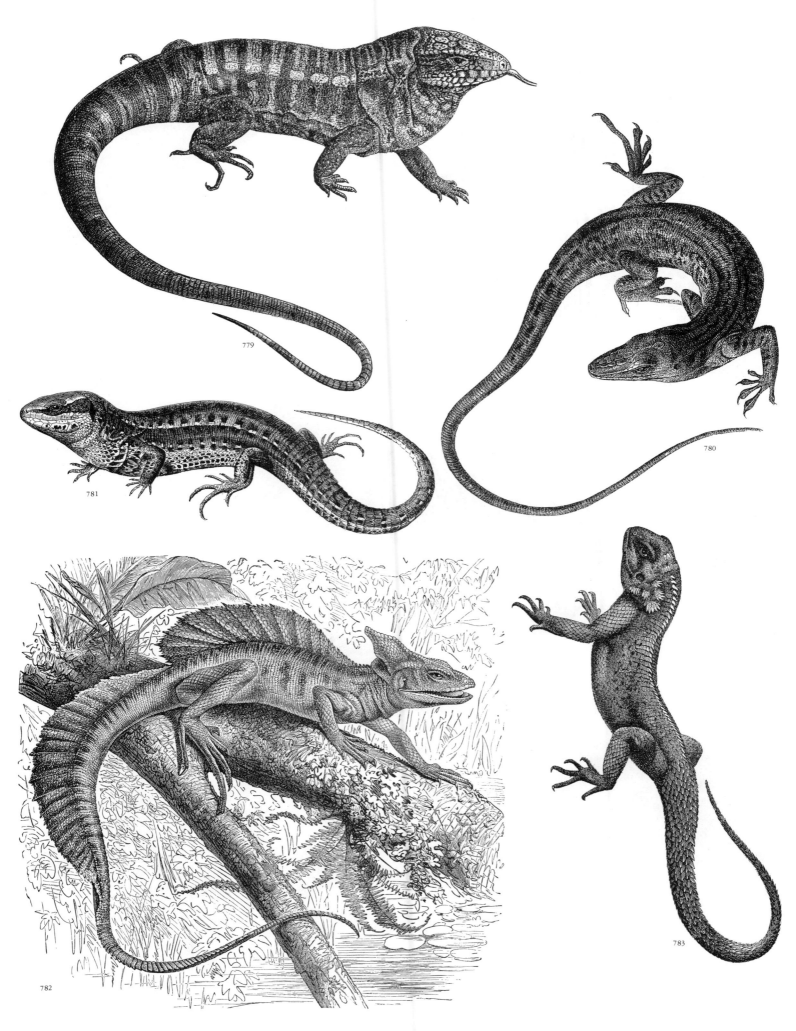

**REPTILES.** 779: Tegu. 780: Green anole. 781: European fence lizard.
782: A species of basilisk. 783: A lizard of the agamid type.

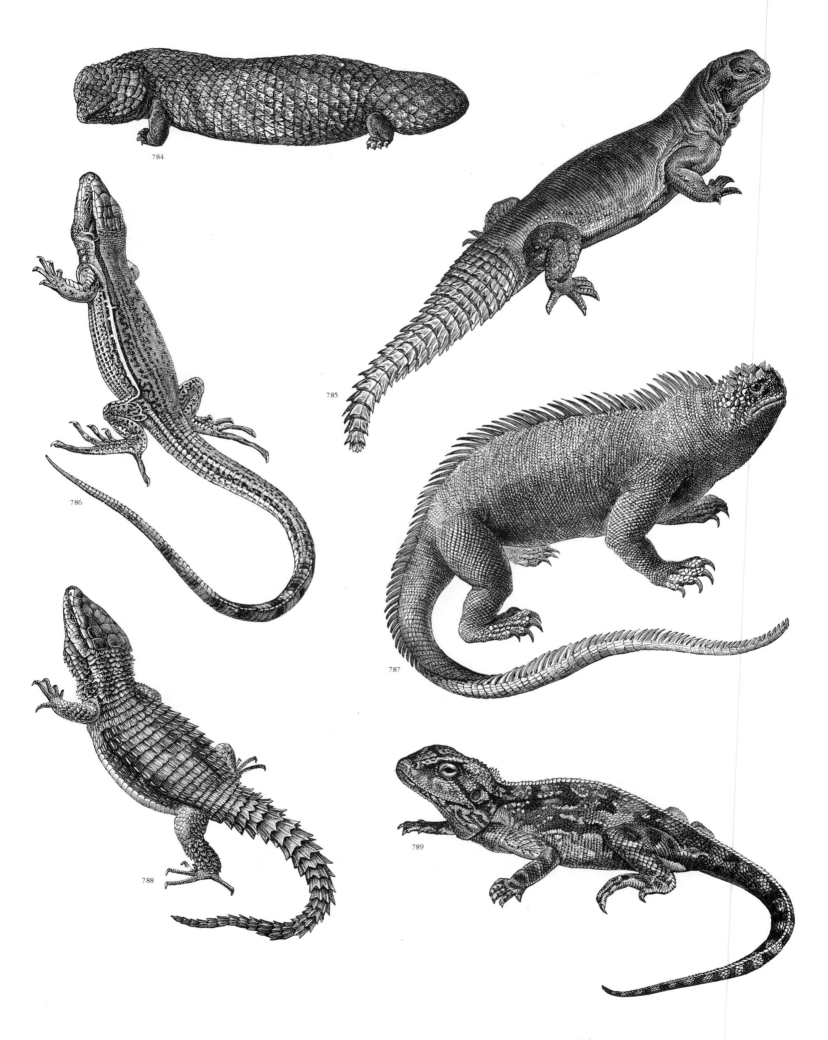

**REPTILES.** **784:** Stump-tailed lizard. **785:** A species of spiny-tailed agamid lizard. **786:** A lizard of the genus *Ameiva*. **787:** Marine iguana. **788:** A species of girdle-tailed lizard. **789:** An agamid.

175

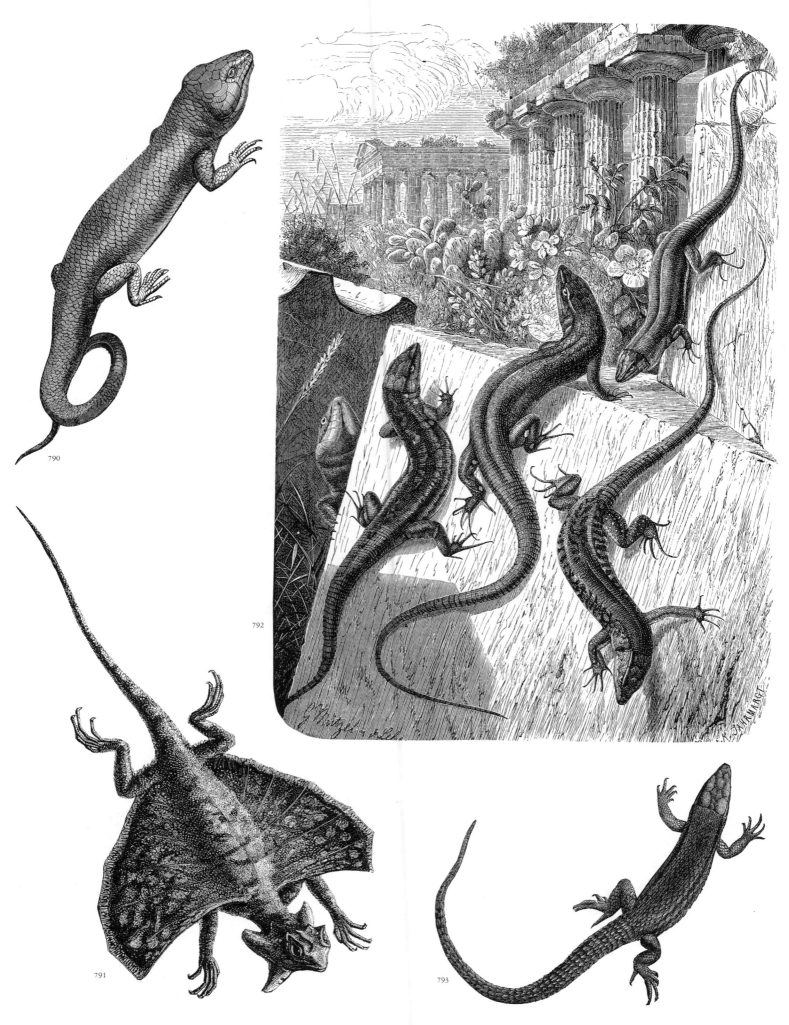

**REPTILES.** 790, 793: Types of lizard. 791: (Flying) dragon, a lizard of the genus *Draco*. 792: Wall lizards.

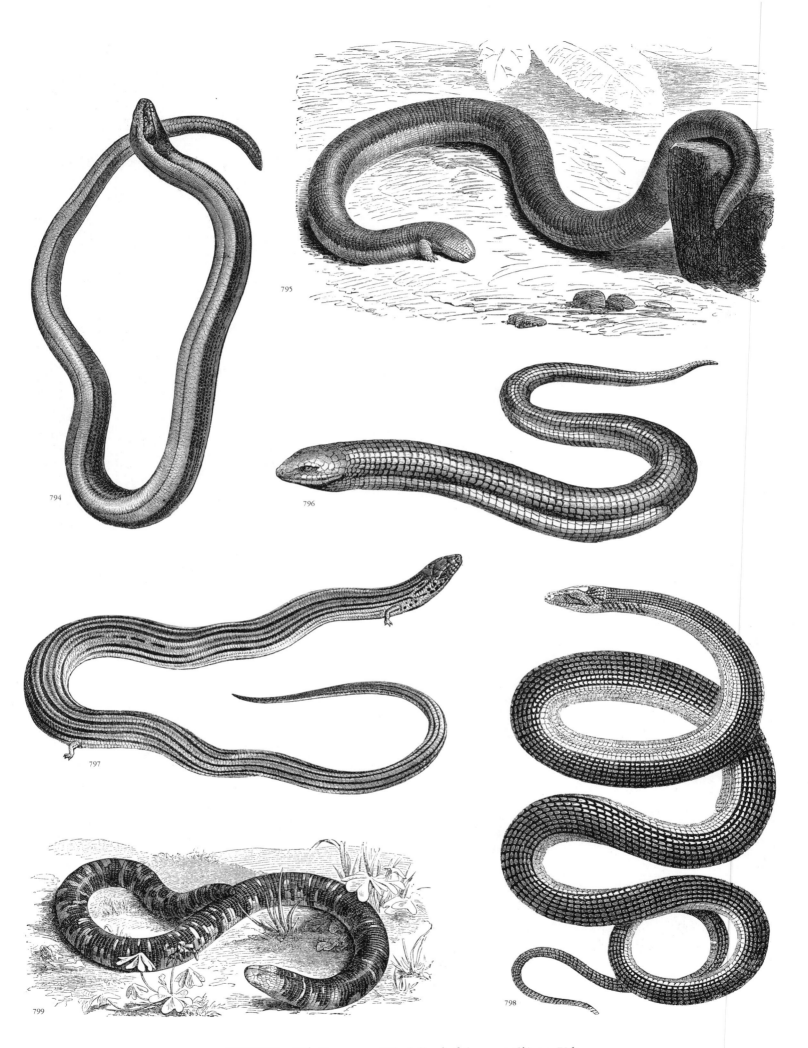

**REPTILES.** 794: Slow-worm. 795: A lizard of the genus *Chirotes*. 796: Glass lizard. 797: Type of lizard. 798: Eastern glass snake. 799: A species of worm lizard.

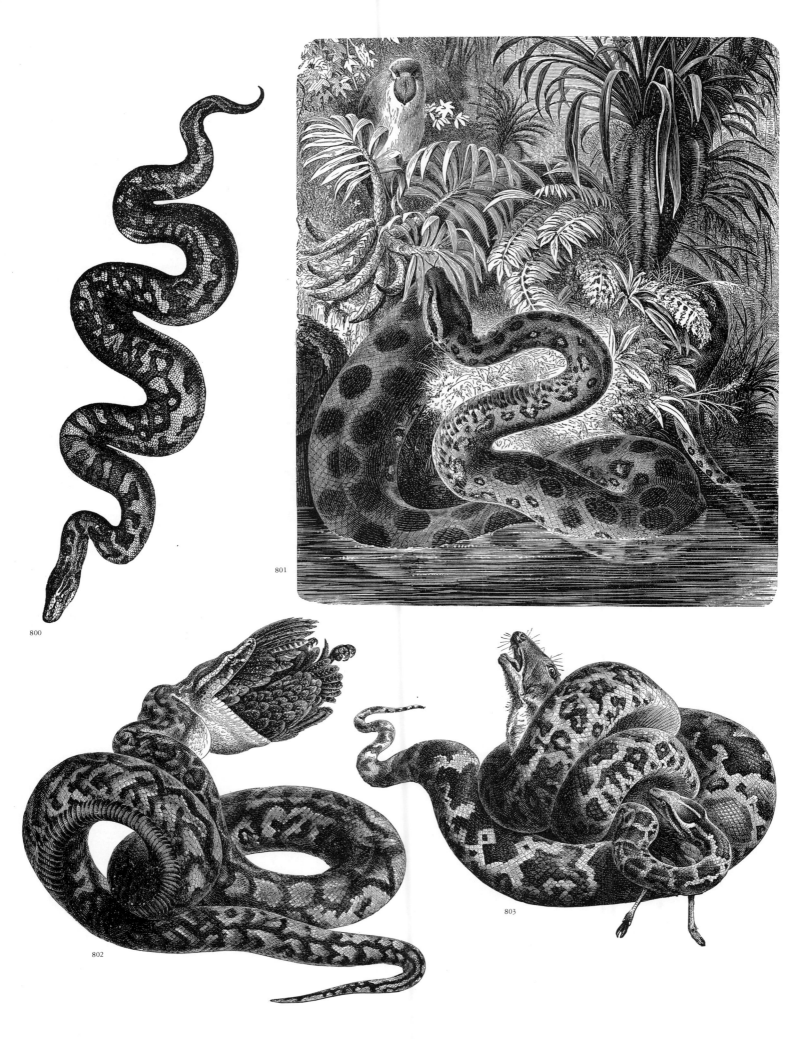

**REPTILES. 800:** A South African species of rock python. **801:** Anaconda.
**802:** African rock python. **803:** Indian python.

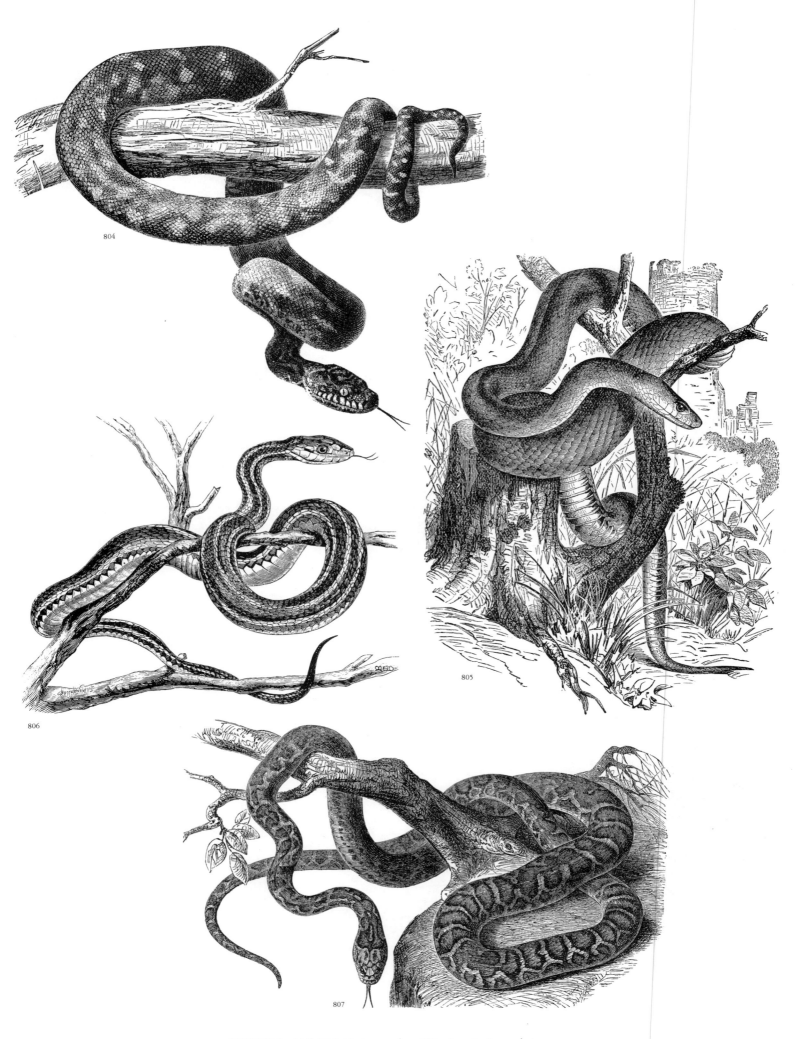

**REPTILES.** 804–807: Various snakes (805, Aesculapian snake).

179

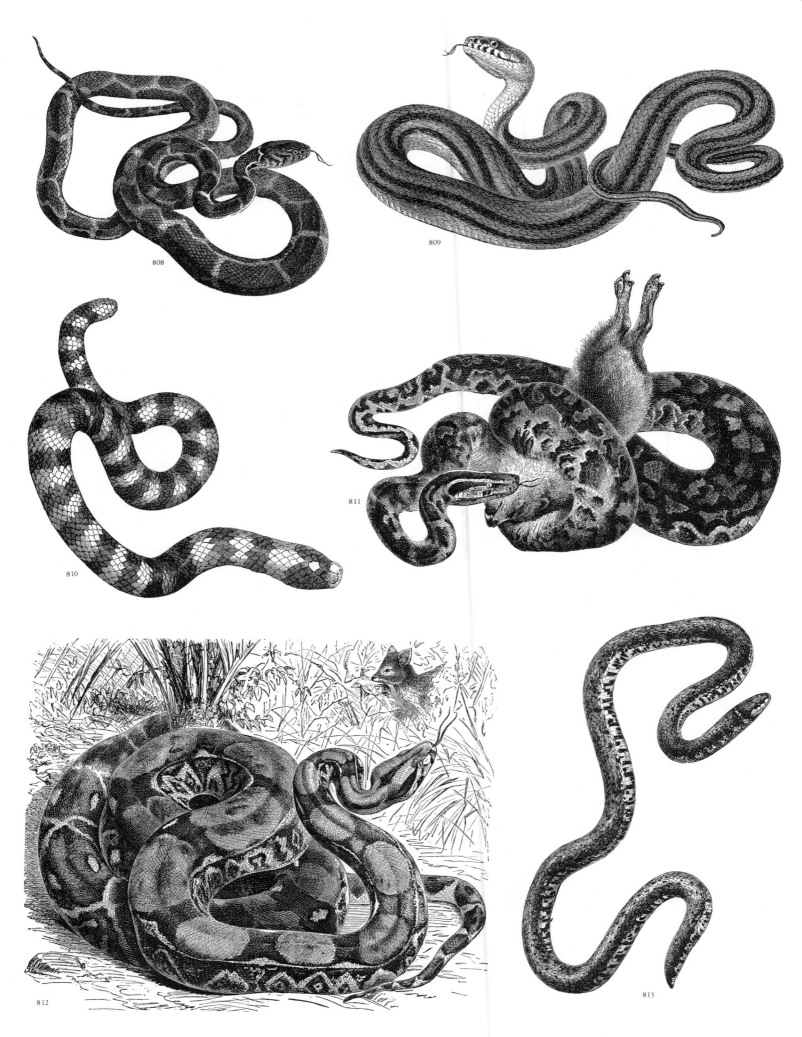

**REPTILES.** **808, 809, 813:** Unidentified snakes. **810:** A South American coral snake of the genus *Ilysia*. **811:** A South African species of rock python. **812:** Boa constrictor.

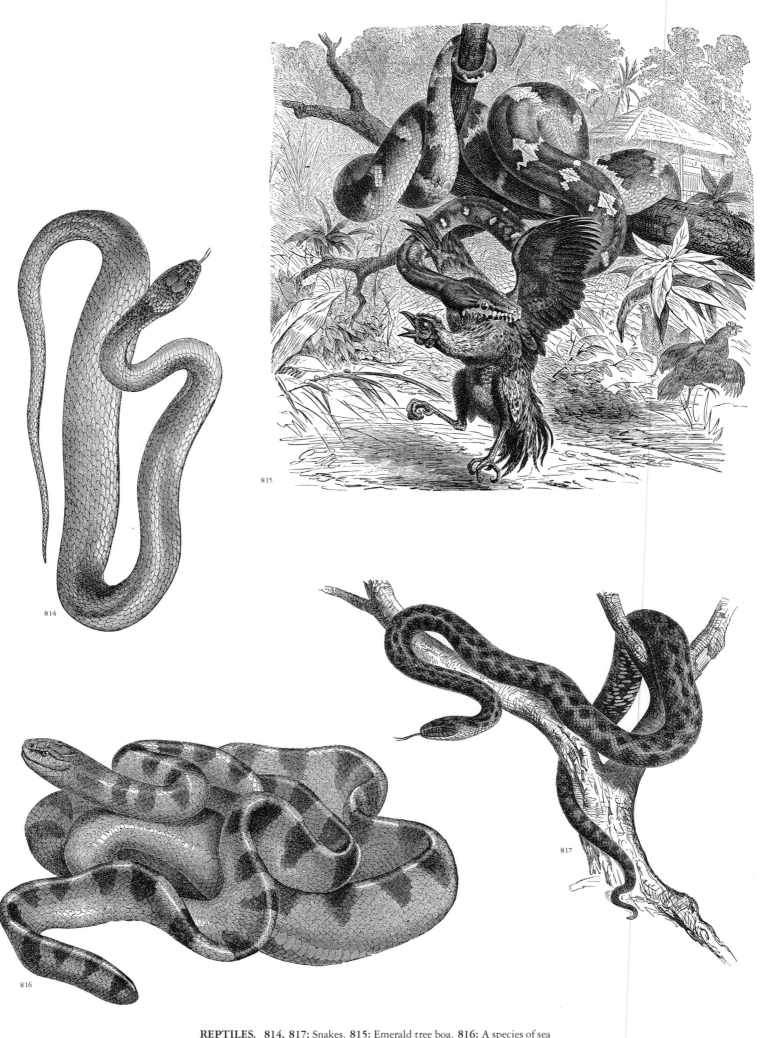

**REPTILES. 814, 817:** Snakes. **815:** Emerald tree boa. **816:** A species of sea snake of the genus *Hydrophis*.

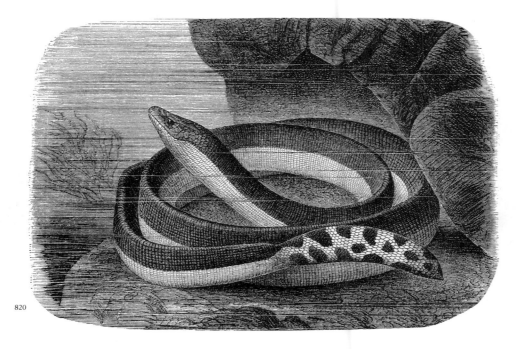

**REPTILES.** **818:** Java wart snake. **819:** European grass snake. **820:** Yellow-bellied sea snake.

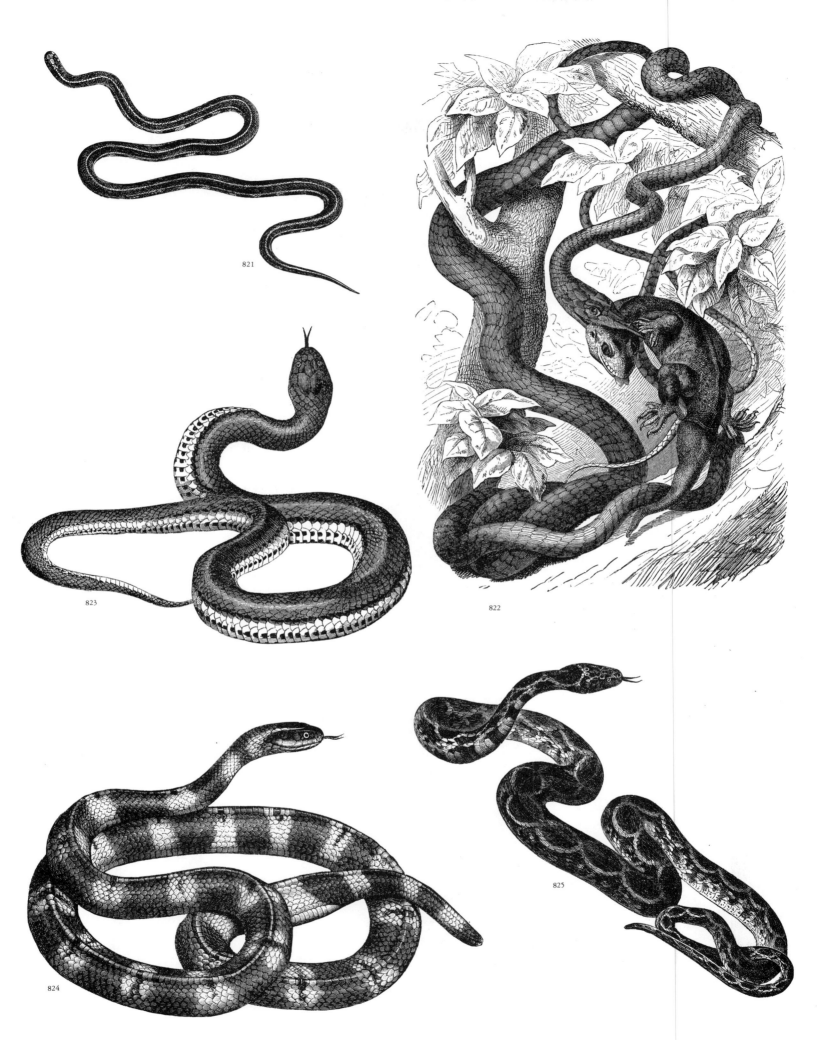

**REPTILES. 821, 823, 825:** Snakes. **822:** A longnosed tree snake from Ceylon of the genus *Dryophis*. **824:** A species of krait.

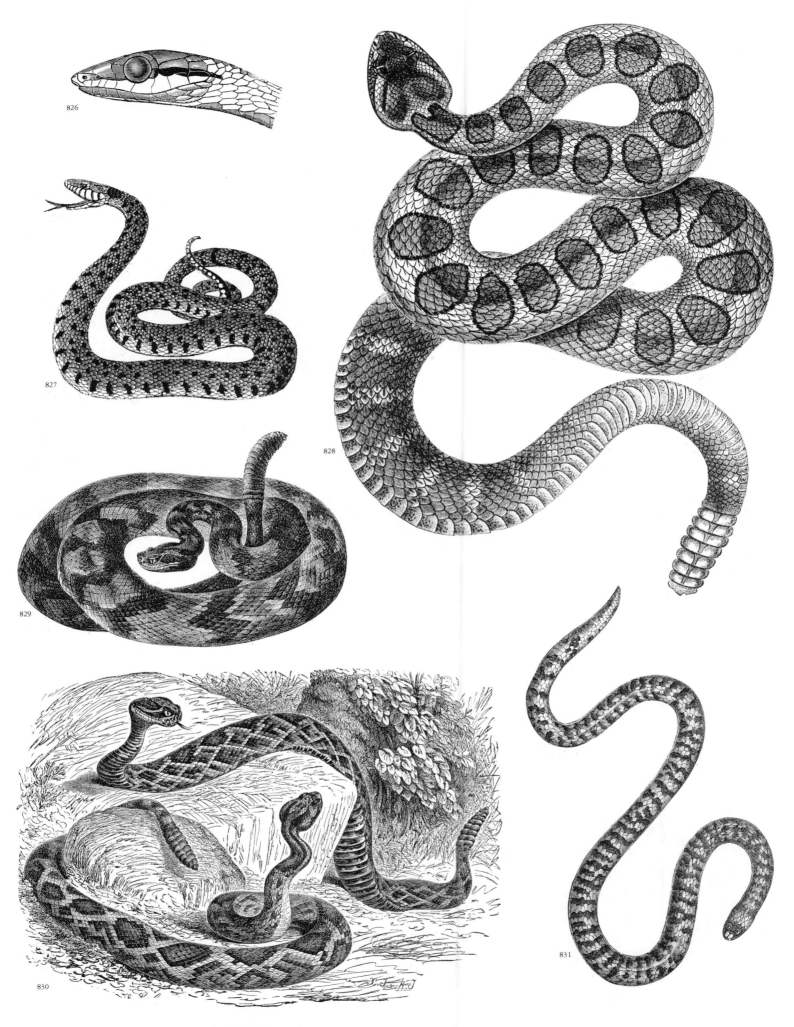

**REPTILES.** 826, 827: Snakes. 828, 829: Species of rattlesnake. 830: Eastern and Western diamondback rattlesnakes. 831: A species of coral snake.

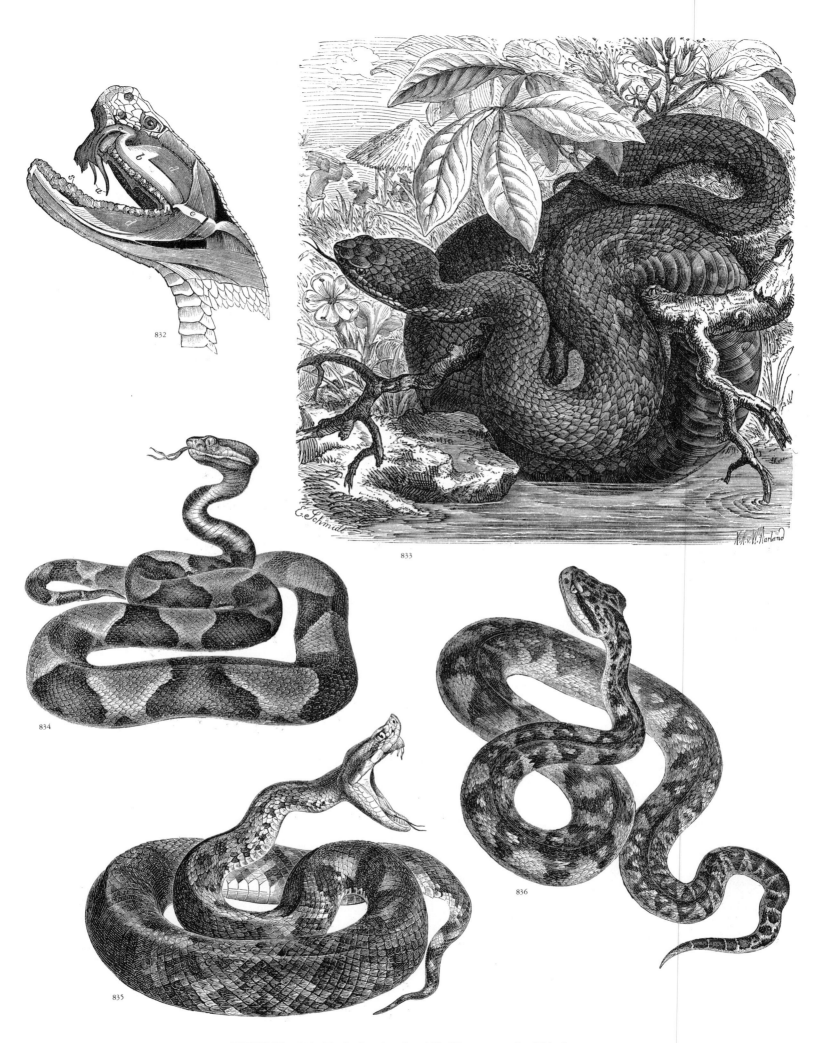

**REPTILES.  832:** Head of rattlesnake. **833:** Water moccasin. **834:** Cop-
perhead. **835:** Fer-de-lance. **836:** Bushmaster.

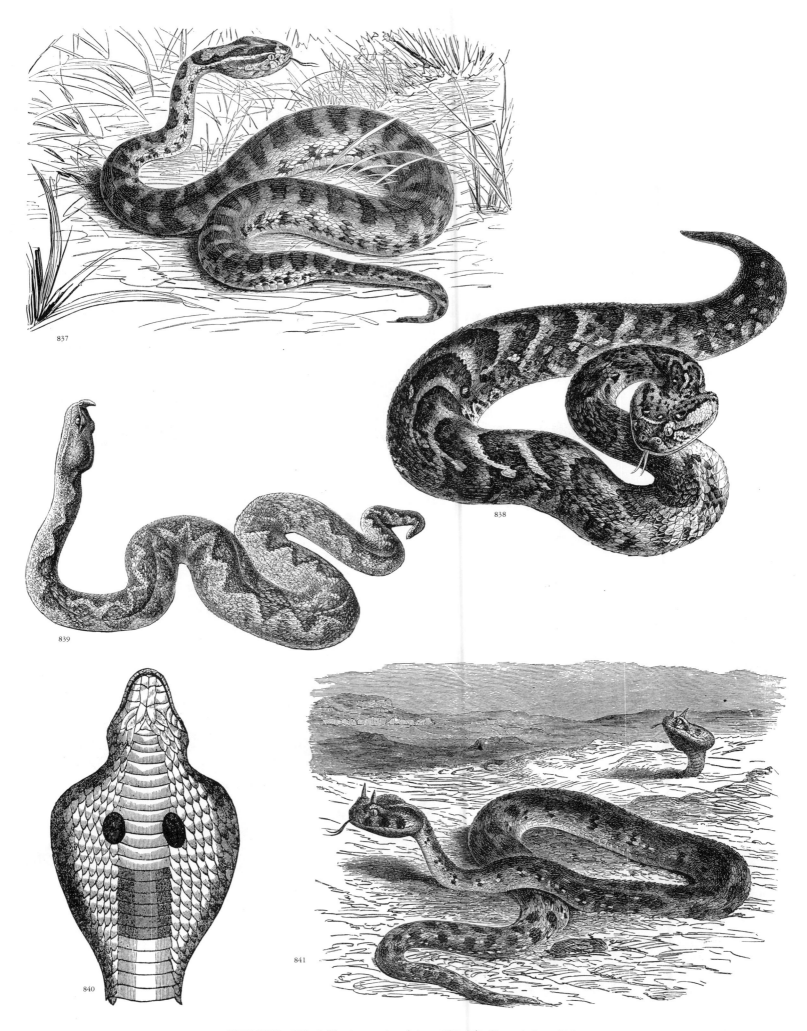

**REPTILES.**  837: A Siberian species of viper. 838, 841: Horned viper. 839:
Puff adder. 840: Hood of cobra.

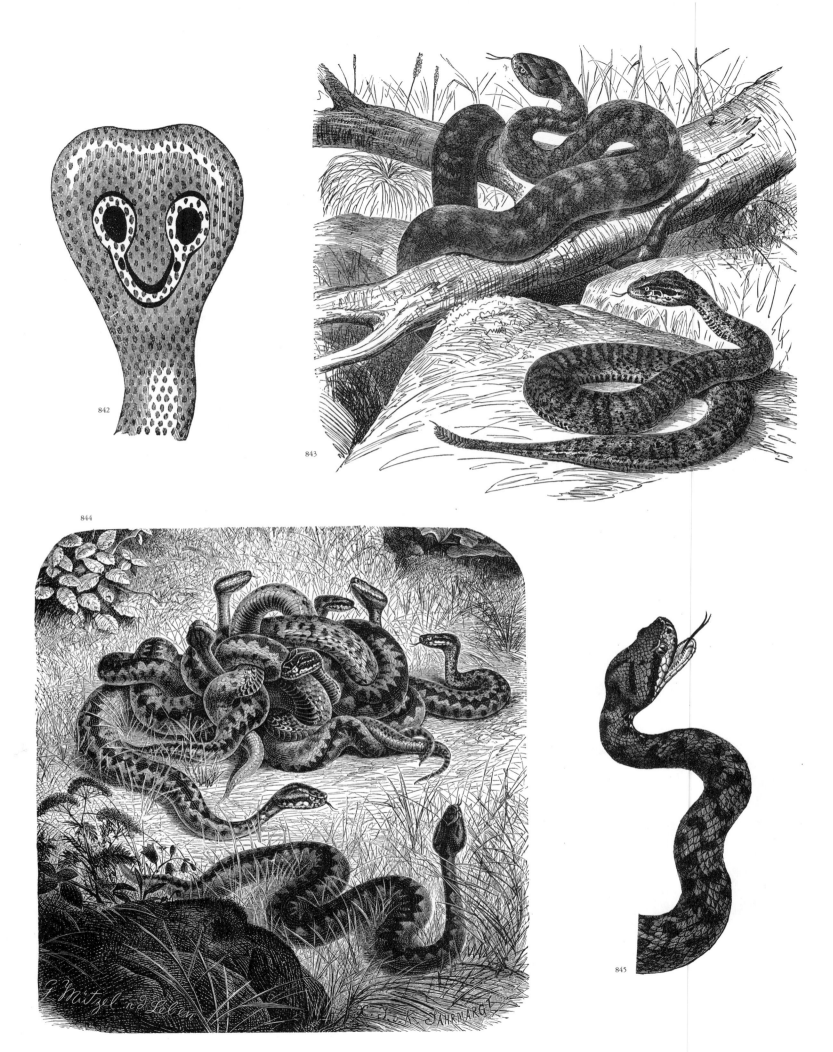

**REPTILES.** **842:** Hood of spectacled cobra. **843:** Two species of adder (below, death adder). **844:** European viper. **845:** Asp viper.

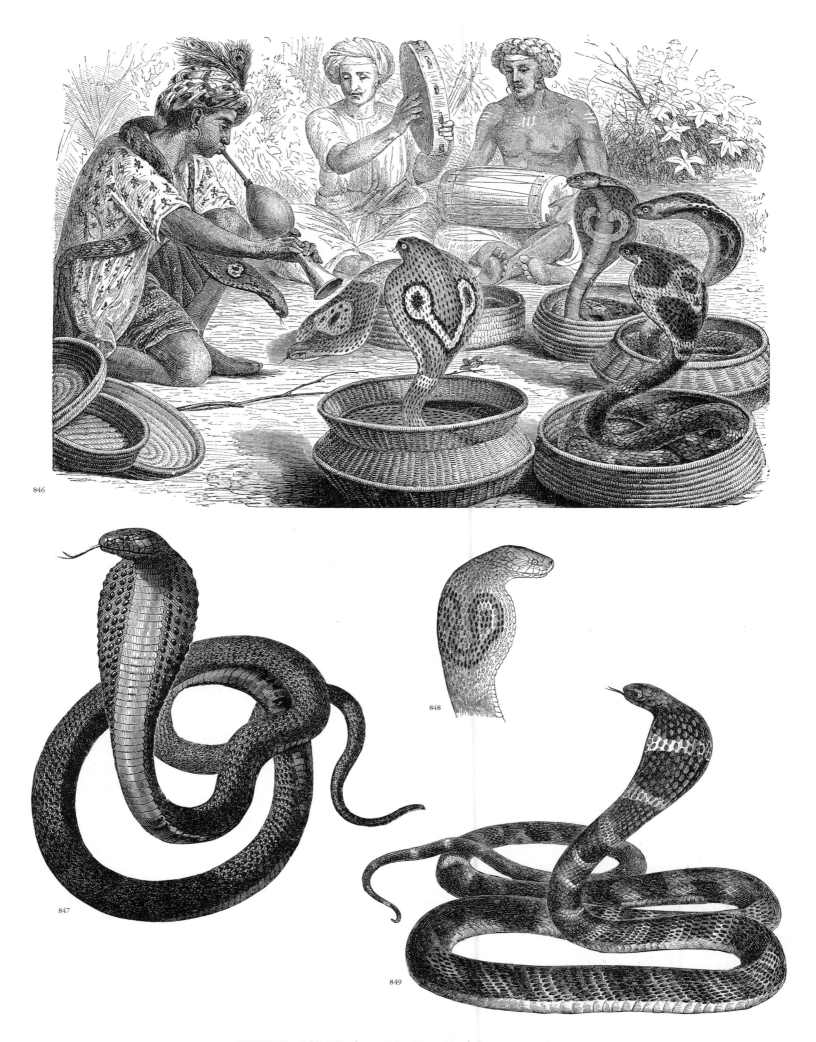

**REPTILES.** **846, 848:** Spectacled cobra. **847:** Egyptian cobra. **849:** King cobra.

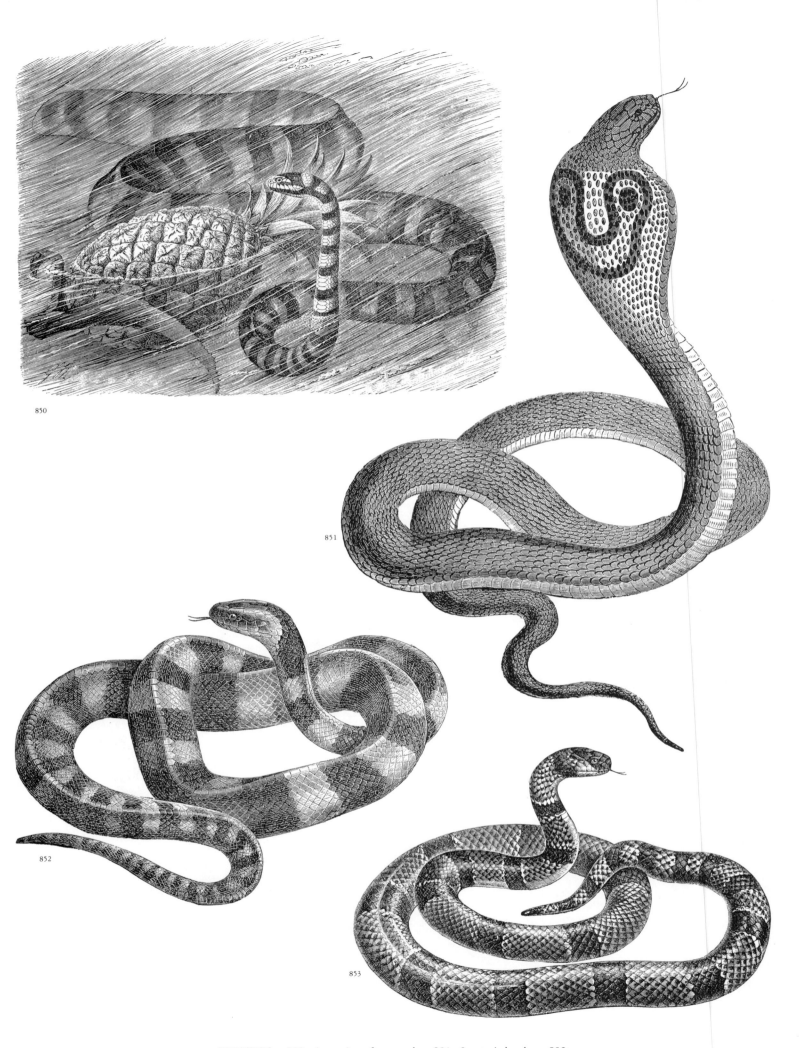

**REPTILES.** 850: A species of sea snake. 851: Spectacled cobra. 852: Banded krait. 853: A species of coral snake.

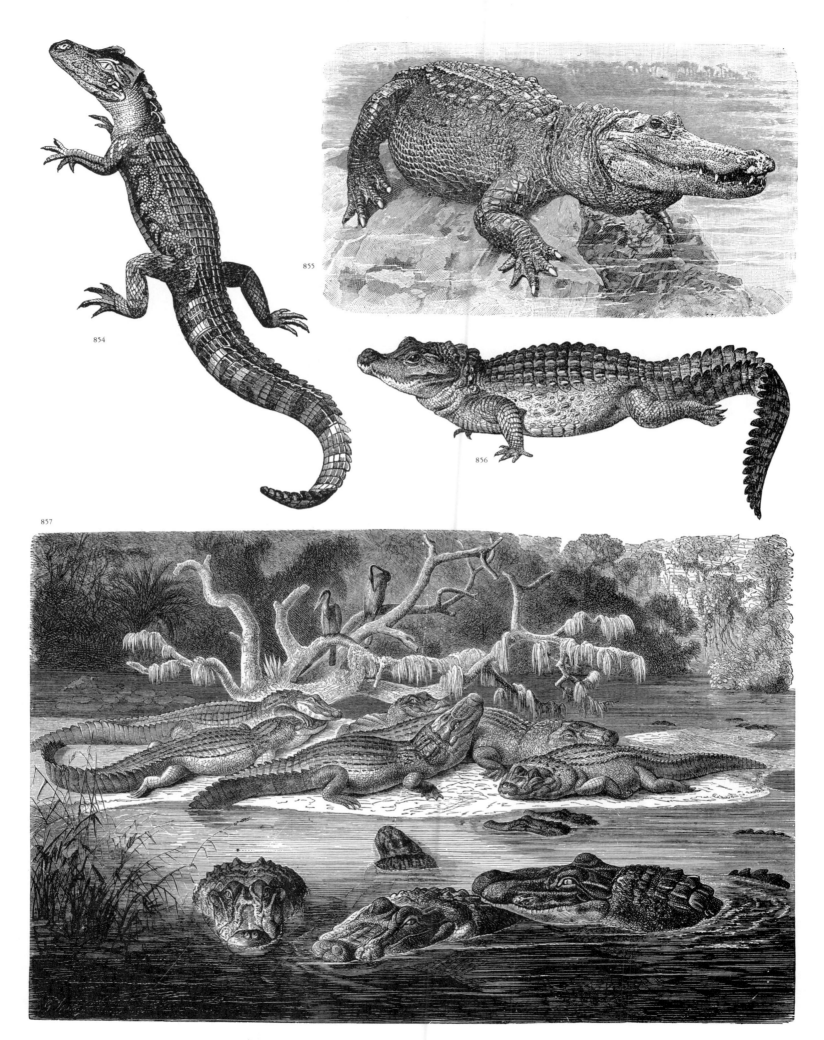

**REPTILES.** **854**: A young American alligator. **855, 856**: Species of crocodile. **857**: Black caimans.

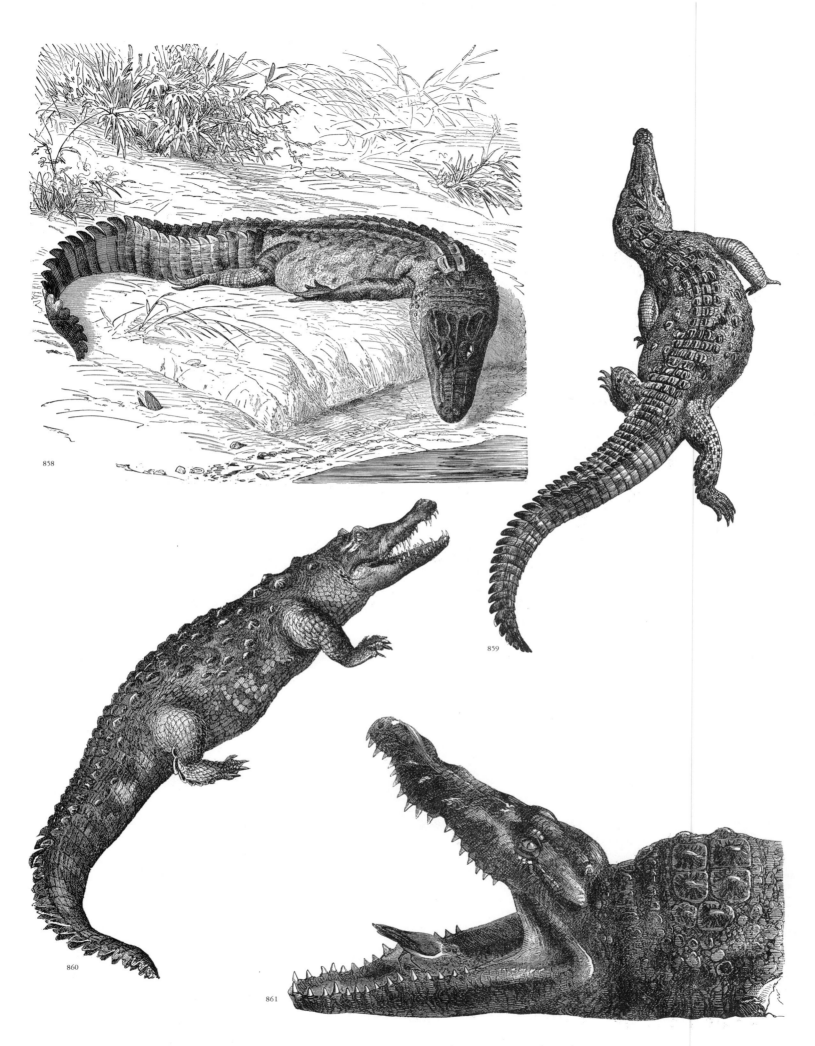

**REPTILES. 858:** American alligator. **859, 860:** American crocodile. **861:** A species of crocodile.

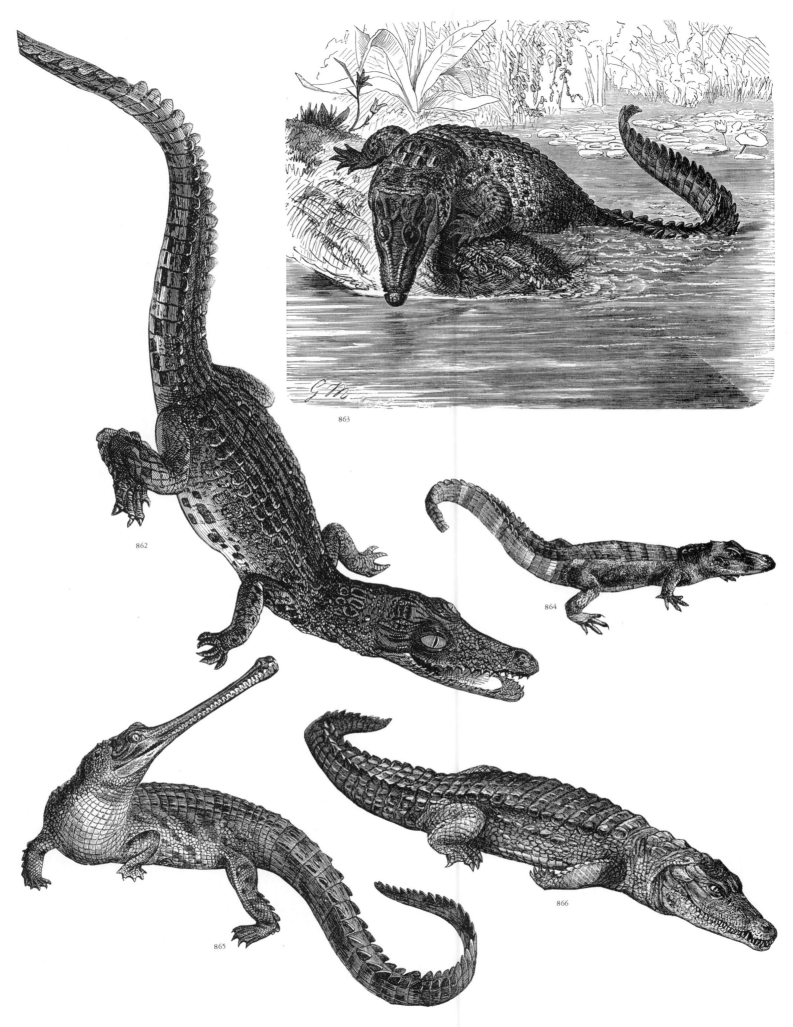

**REPTILES. 862, 866:** Species of crocodile. **863:** Salt-water crocodile. **864:** A young American alligator. **865:** Indian gavial.

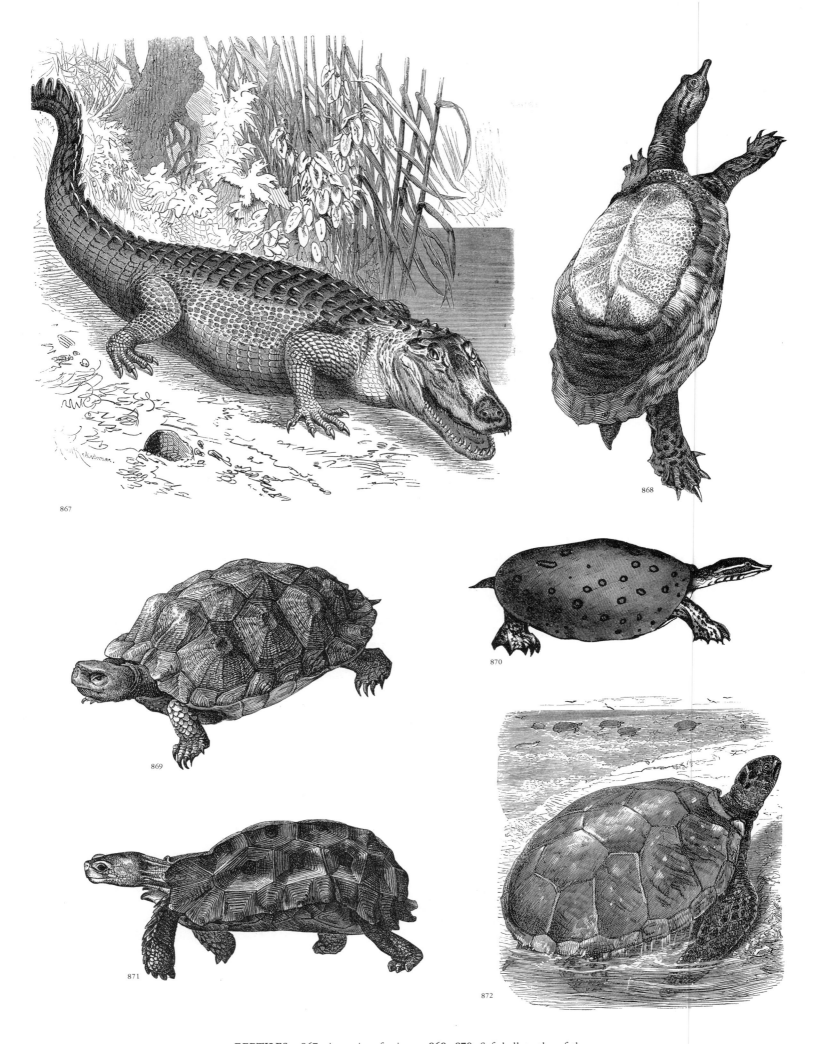

**REPTILES.** **867:** A species of caiman. **868, 870:** Softshell turtles of the genus *Trionyx*. **869:** Wood turtle. **871:** Hinged tortoise. **872:** Green turtle.

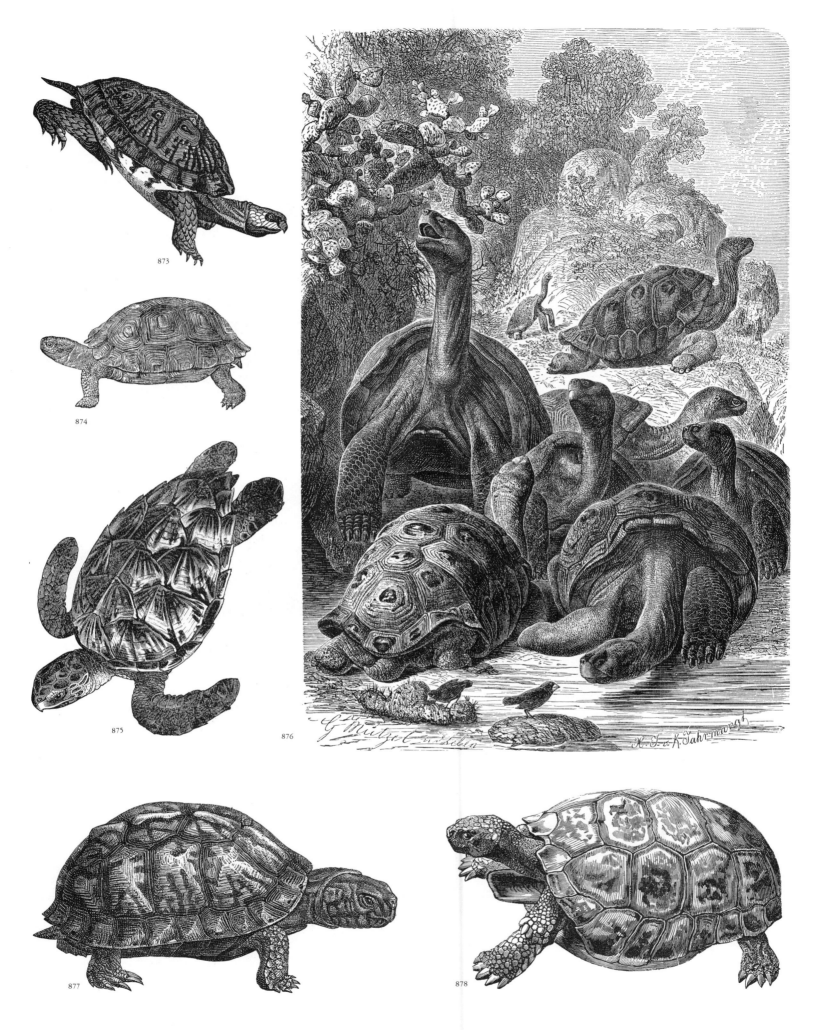

**REPTILES.** **873:** A species of box turtle. **874, 878:** Species of tortoise. **875:** Hawksbill turtle. **876:** Galápagos giant tortoises. **877:** Eastern box turtle.

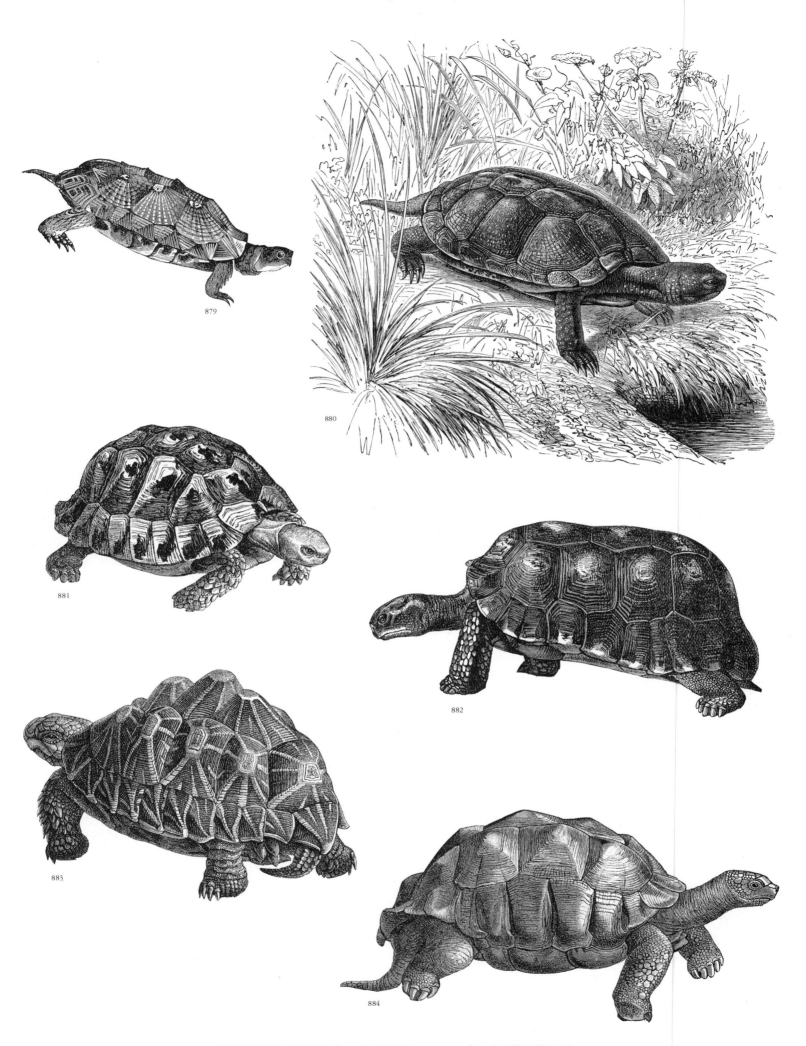

**REPTILES.** **879:** Wood turtle. **880:** European pond turtle. **881:** Moorish tortoise. **882–884:** Species of tortoise.

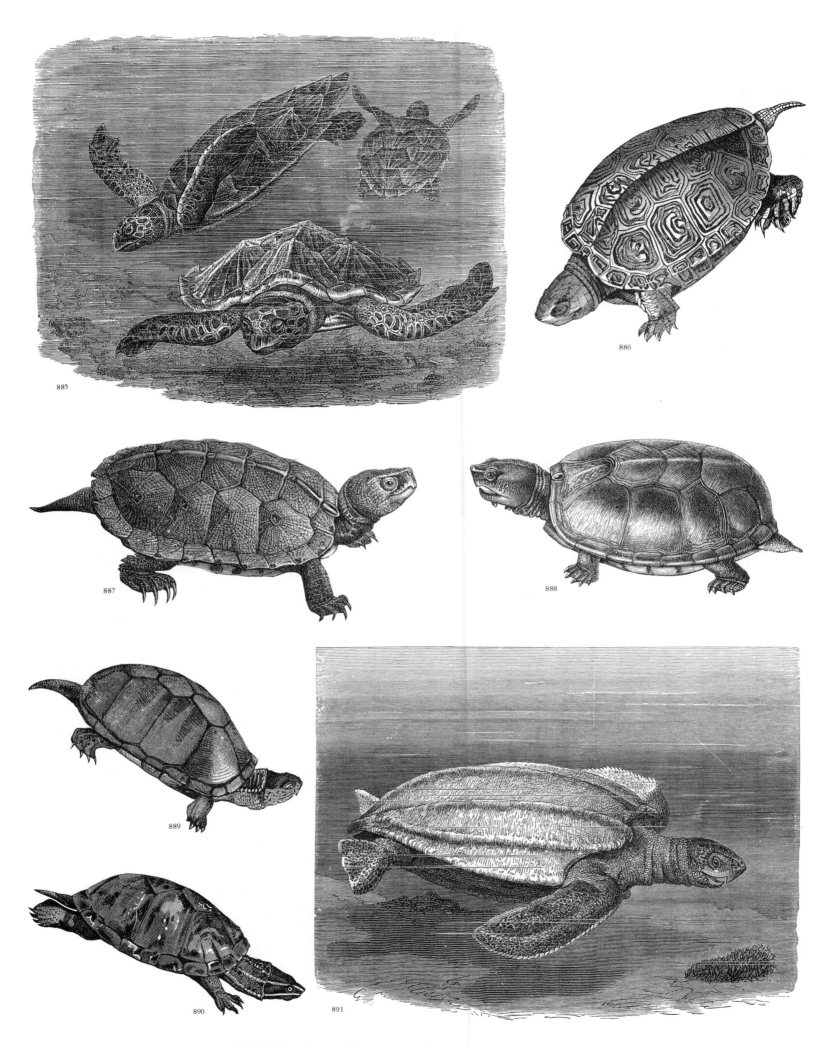

**REPTILES.** **885:** Hawksbill turtles. **886, 888:** Turtles. **887:** Wood turtle.
**889:** A species of mud turtle. **890:** A species of musk turtle. **891:** Leather-
back turtle.

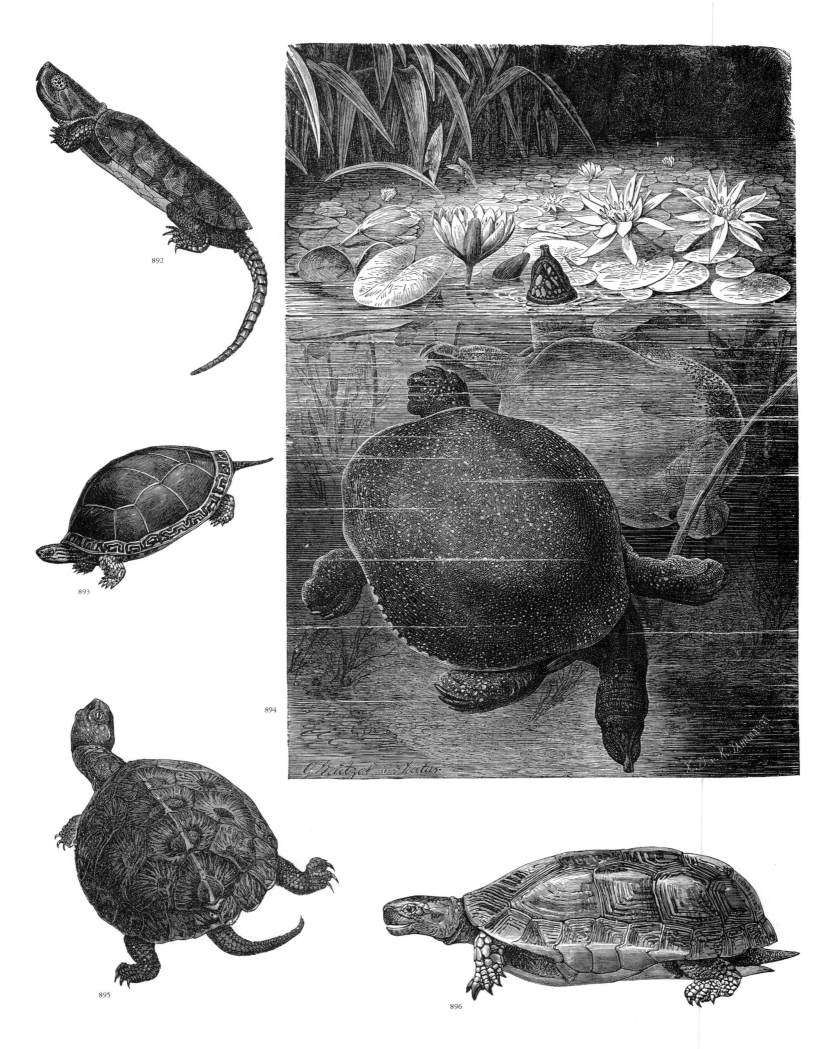

**REPTILES.** 892: Bigheaded turtle. 893: Painted turtle. 894: A species of softshell turtle. 895, 896: Turtles.

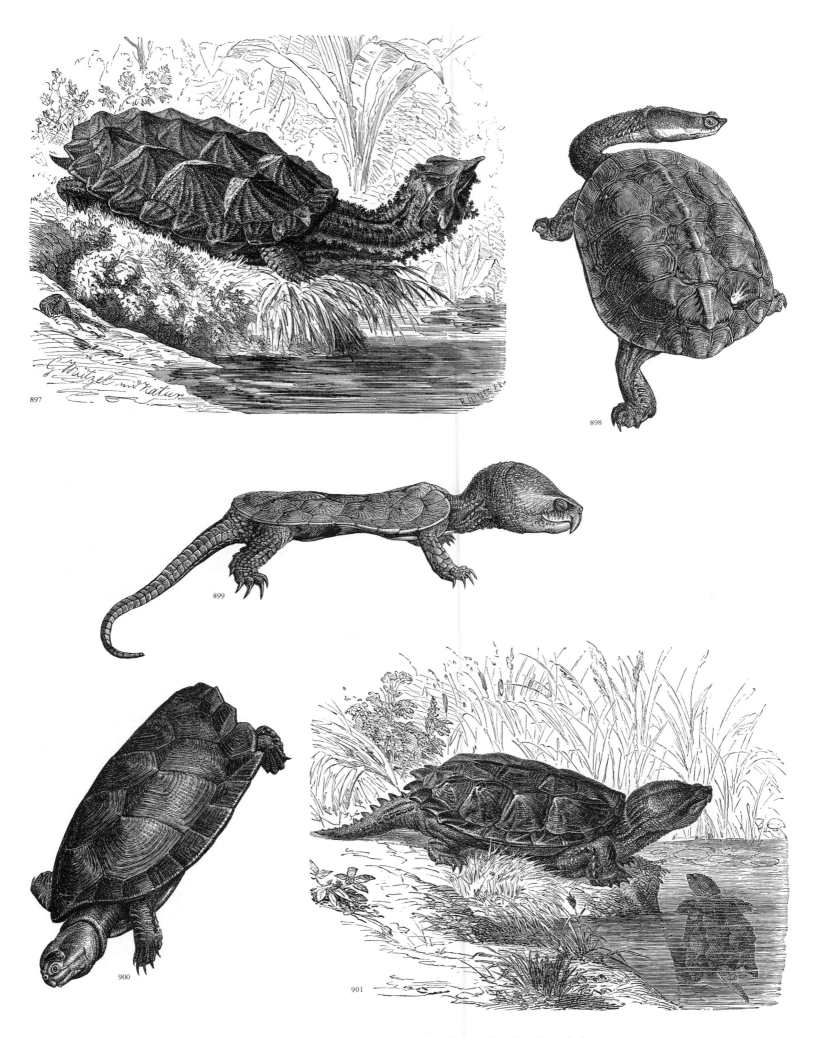

**REPTILES.** **897:** Matamata. **898:** A Brazilian species of snake-necked turtle. **899:** Bigheaded turtle. **900:** Giant side-necked turtle. **901:** Alligator snapping turtle.

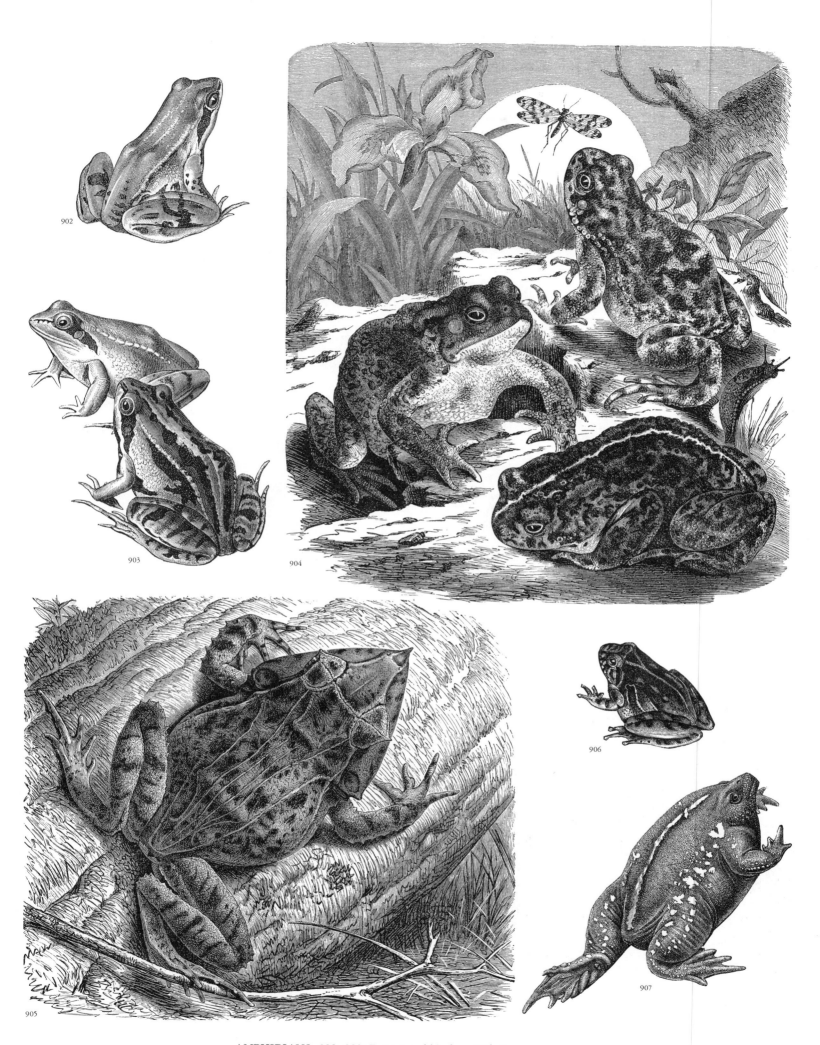

**AMPHIBIANS. 902, 903:** European edible frog. **904:** European common toad, European green toad and natterjack toad. **905–907:** Various frogs and toads.

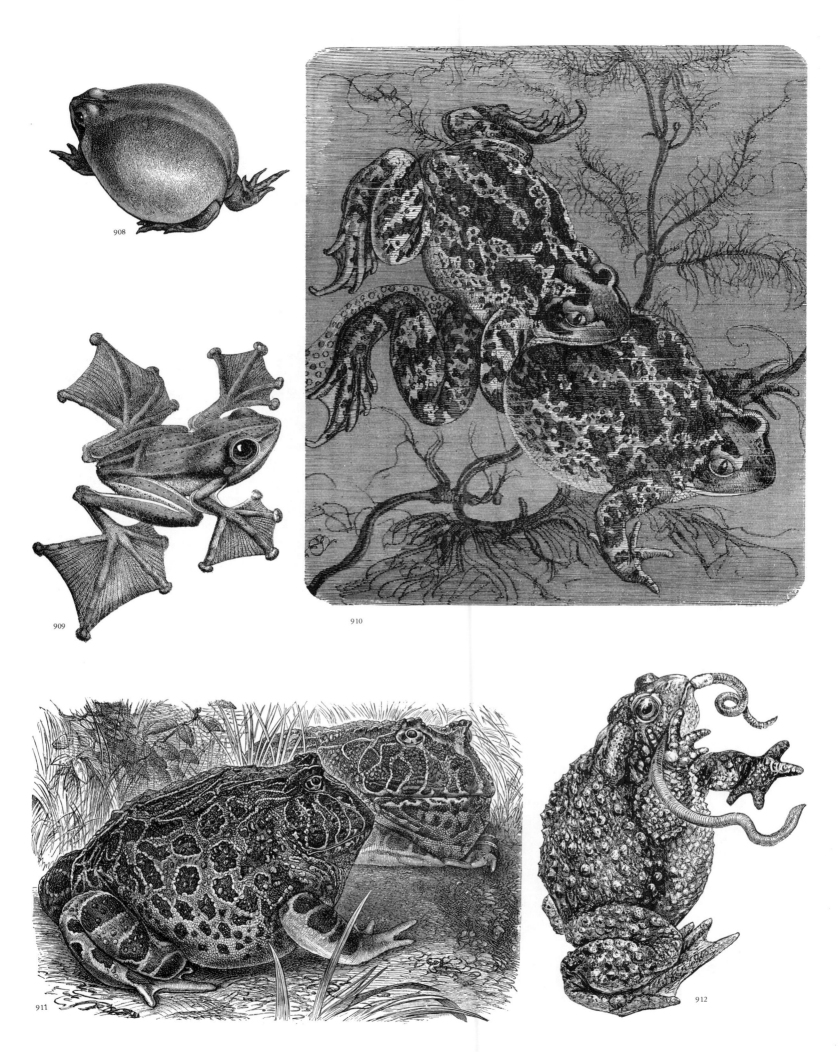

**AMPHIBIANS.** 908: Rain frog of the genus *Breviceps*. 909: Reinwardt's gliding frog. 910: European spadefoot. 911: Escuerzo (horned frog from Argentina). 912: European common toad.

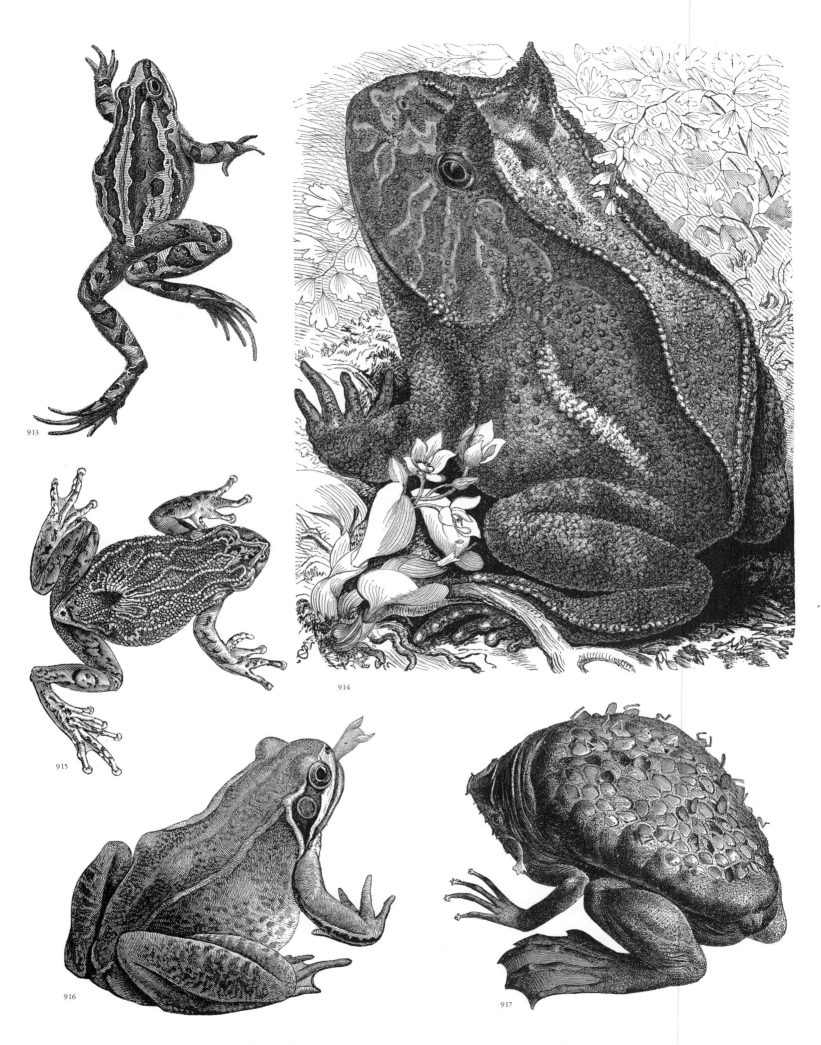

**AMPHIBIANS.** 913, 916: Frogs. 914: Brazilian horned frog. 915: A marsupial frog of the genus *Nototrema*. 917: Surinam toad.

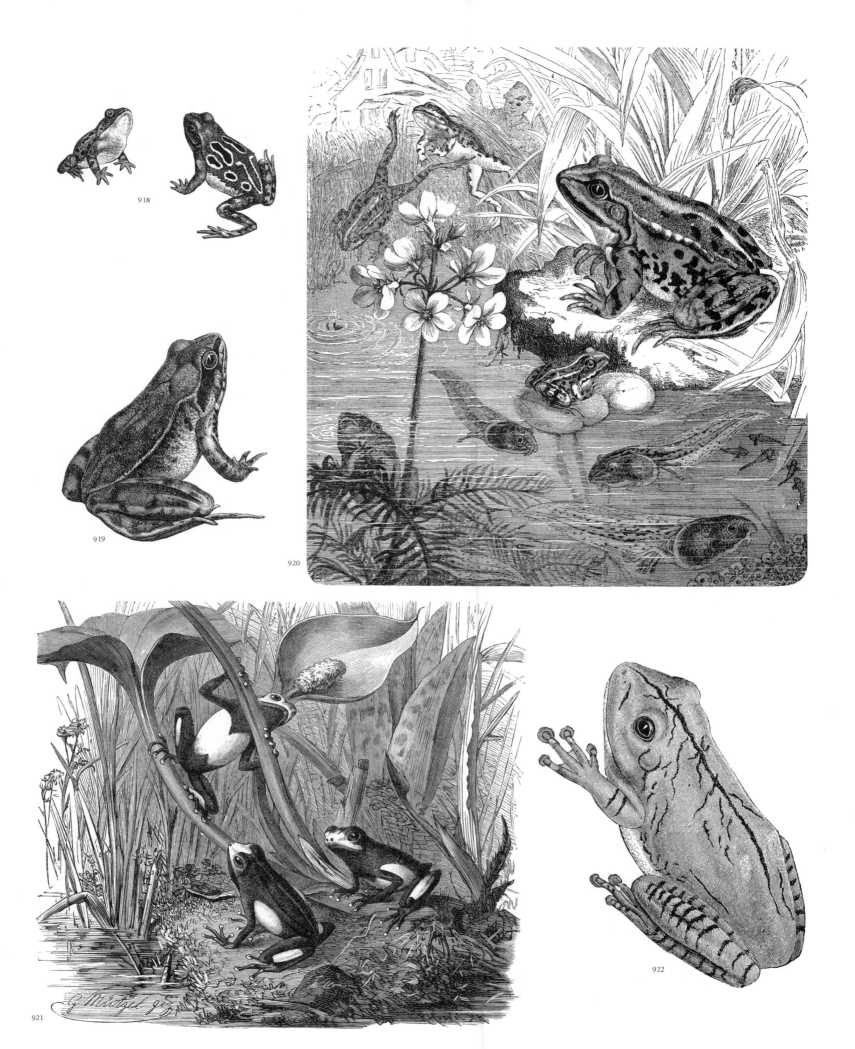

**AMPHIBIANS. 918:** A pair of ornate chorus frogs. **919:** A species of frog. **920:** European edible frog. **921:** South American poison frog. **922:** A Brazilian species of treefrog.

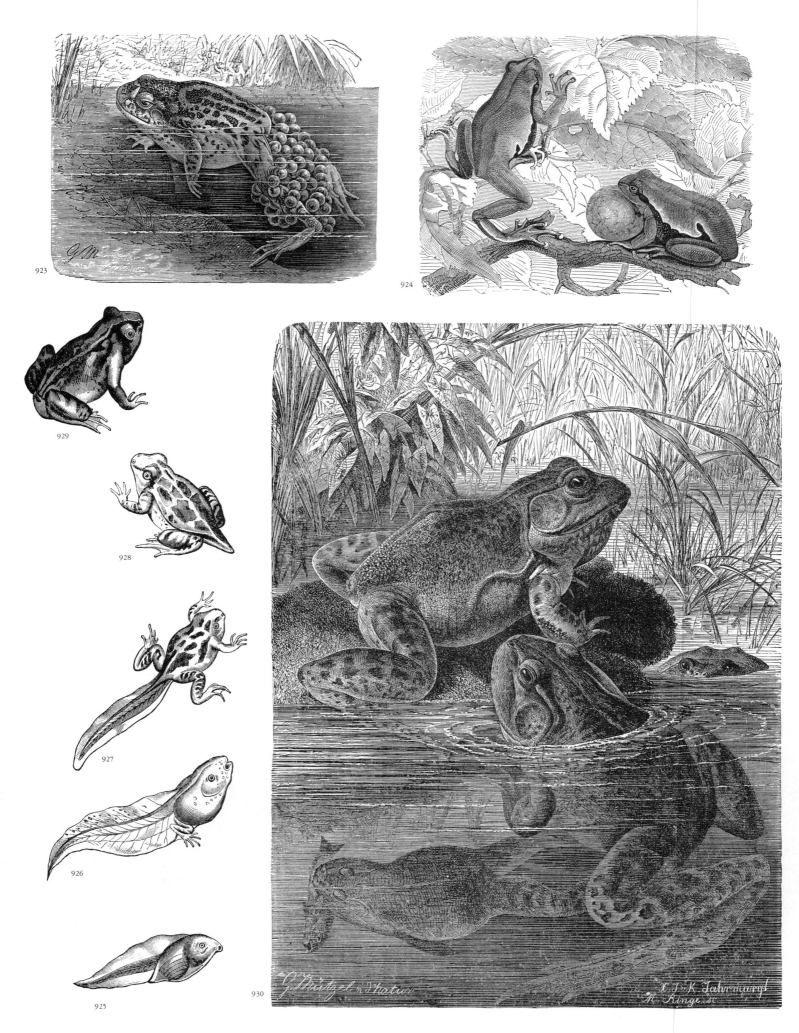

**AMPHIBIANS.** 923: Midwife toad. 924: European green treefrog. 925–929: Development of a frog from tadpole to adult. 930: Bullfrogs.

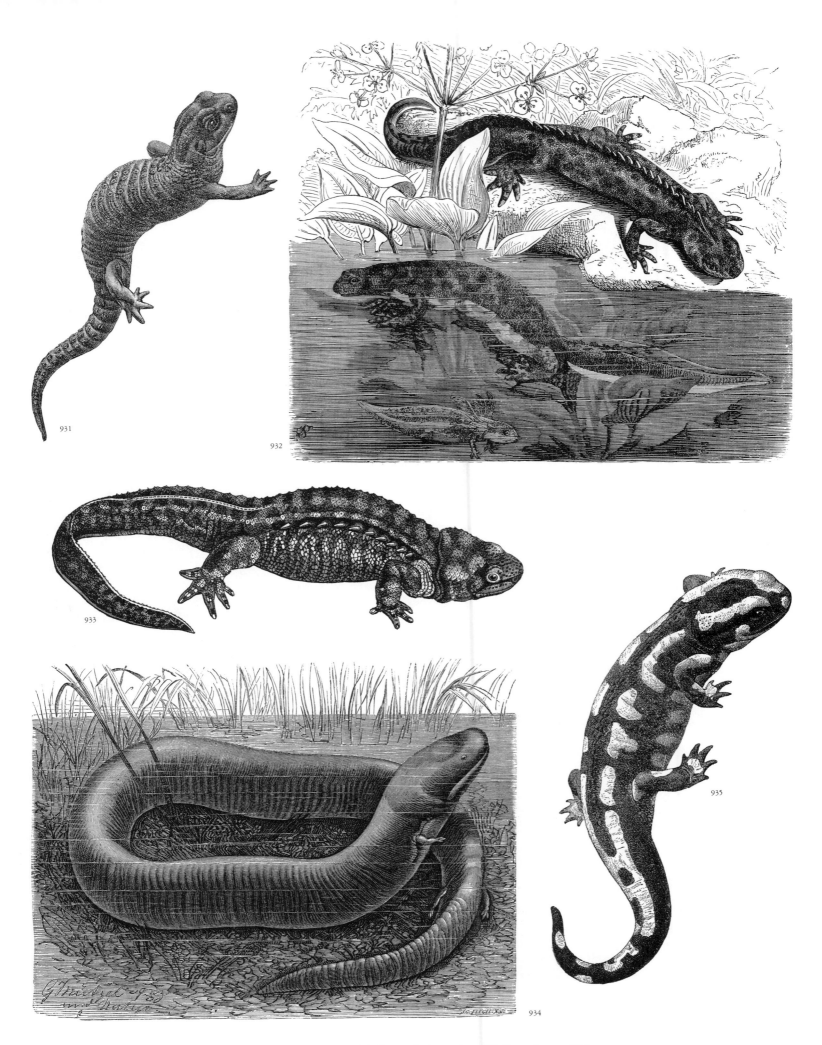

**AMPHIBIANS.** **931, 933:** Types of salamander. **932:** Crested newt. **934:** Three-toed amphiuma. **935:** Spotted salamander.

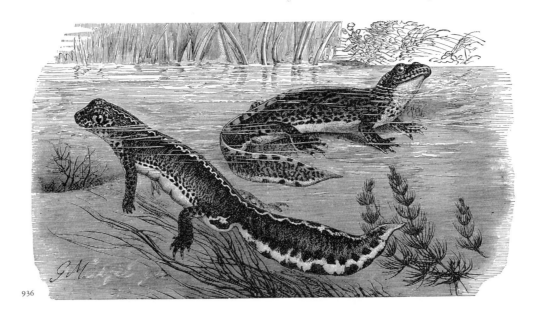

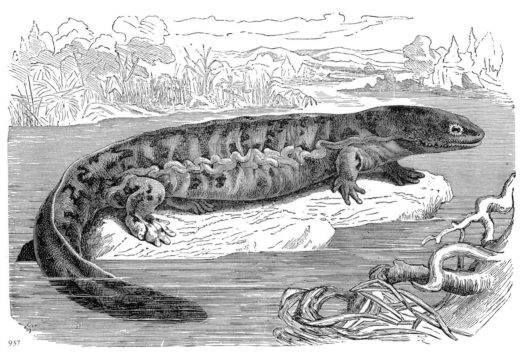

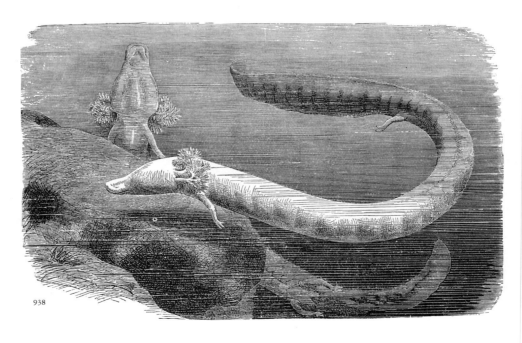

**AMPHIBIANS.** 936: Alpine newt. 937: Hellbender. 938: Olm, or European blind salamander.

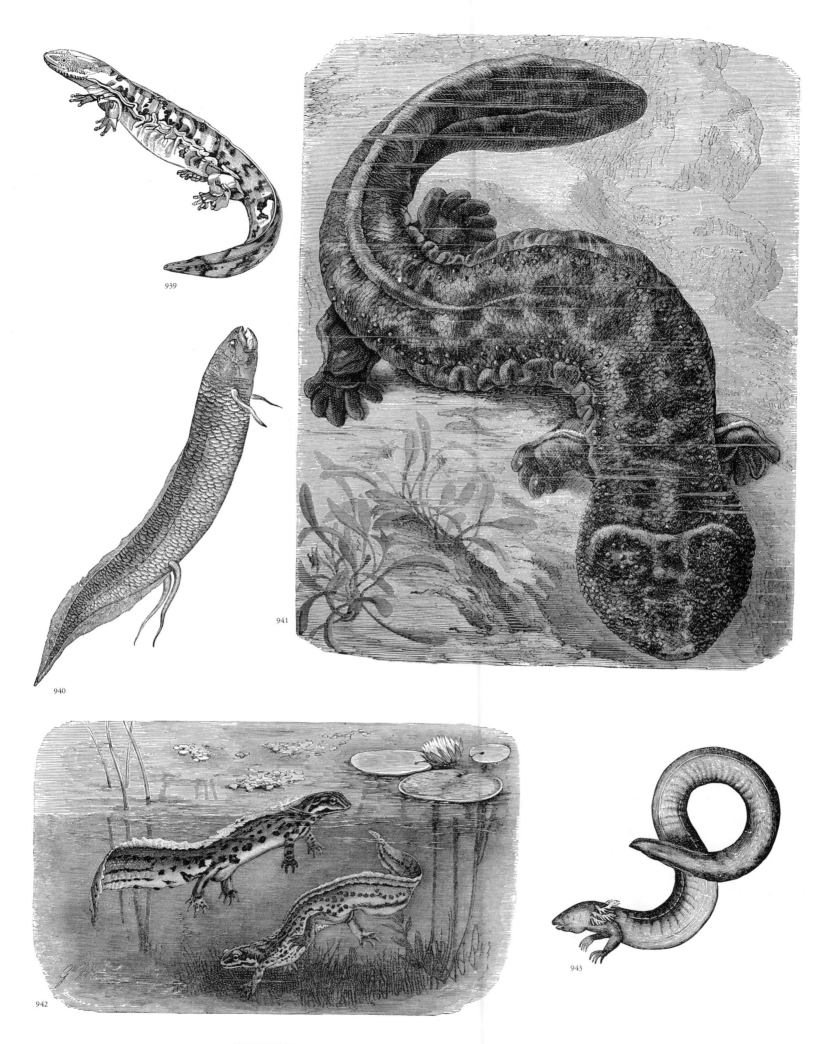

**AMPHIBIANS. 939:** Hellbender. **940:** A species of lungfish. **941:**
Japanese giant salamander. **942:** Smooth newt (?). **943:** A species of siren.

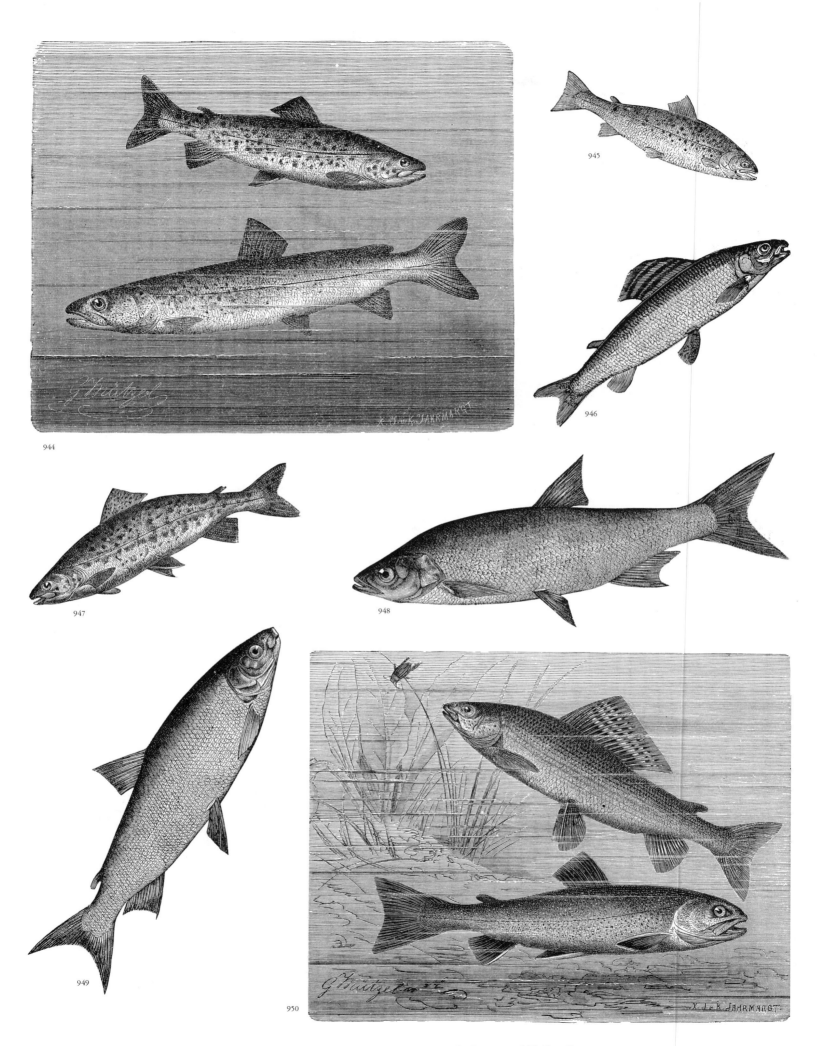

**FISH. 944:** European lake trout and huchen. **945:** Sea trout. **946:** Grayling.
**947:** European lake trout. **948:** Blue char. **949:** A species of char or trout.
**950:** Grayling and a species of char.

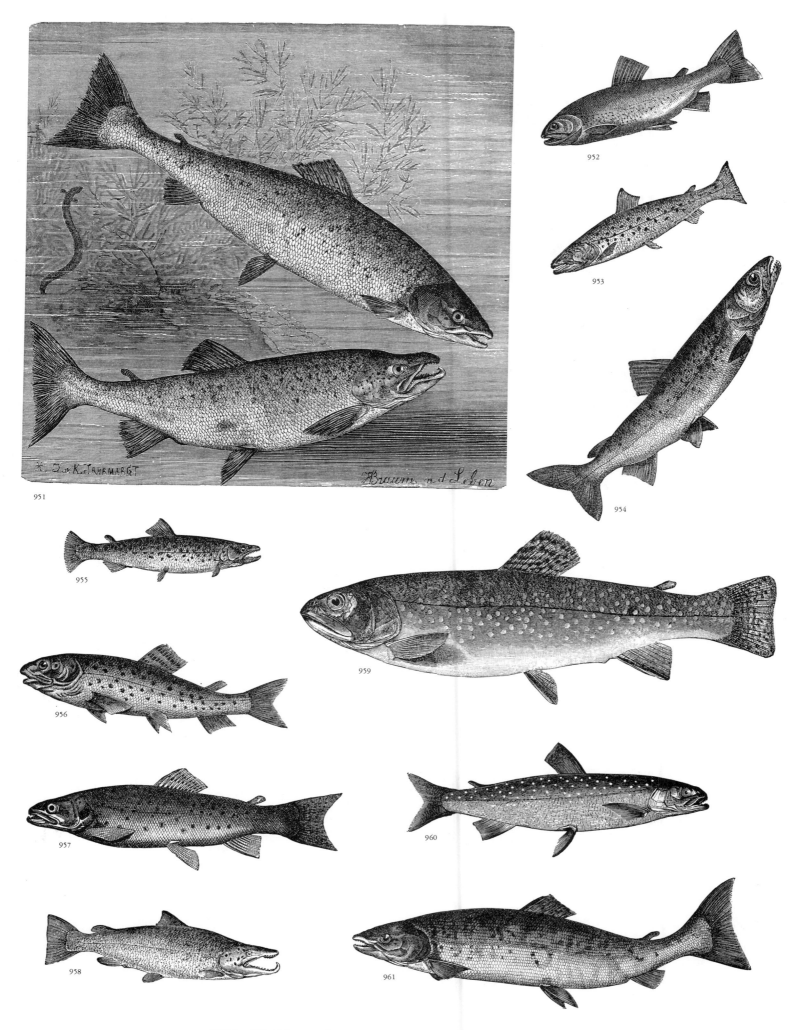

**FISH.** 951: Salmon and sea trout. 952, 953, 955–957, 960: Species of trout or char. 954: Huchen. 958: Sea trout. 959: Brook trout. 961: Salmon.

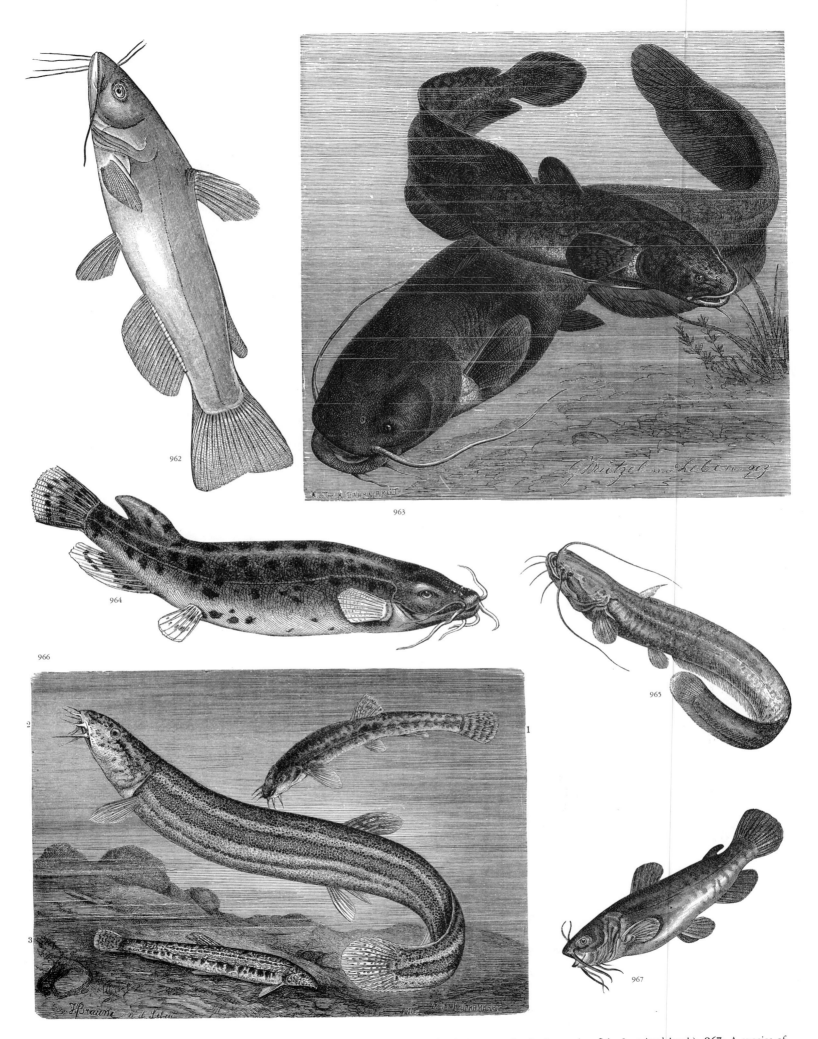

**FISH. 962:** Brown bullhead. **963:** Burbot and European catfish, or wels. **964:** Electric catfish. **965:** European catfish, or wels. **966:** Fishes of the loach family (1, stone loach; 2, weather-fish; 3, spined loach). **967:** A species of catfish.

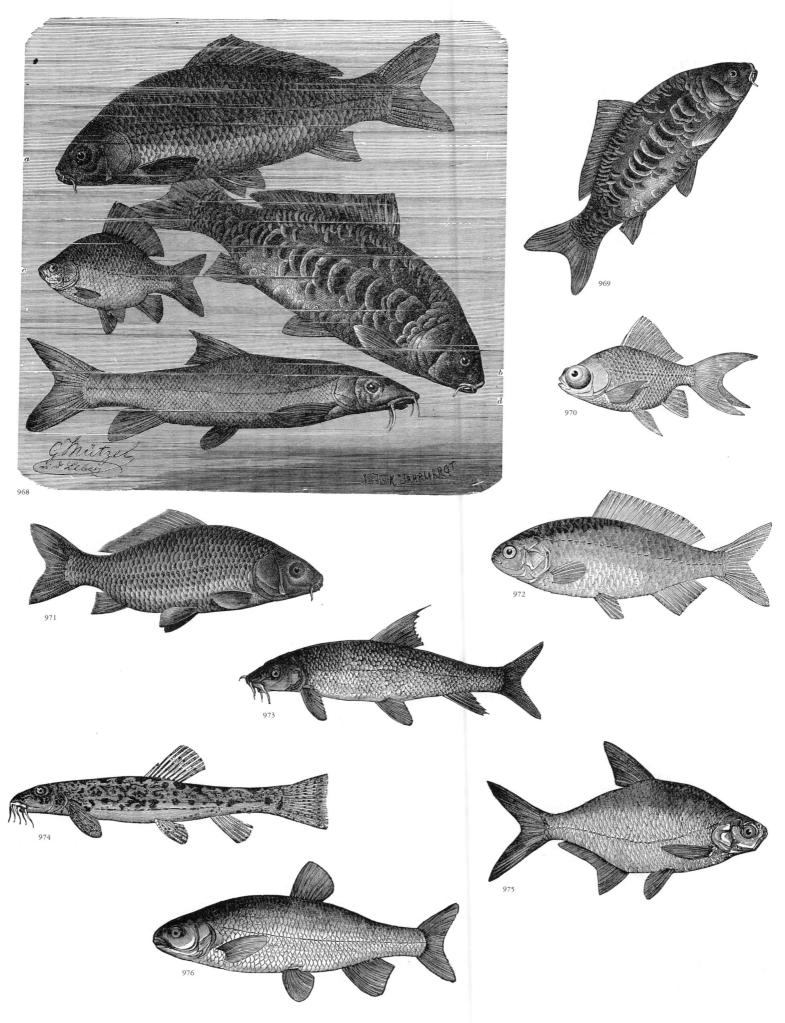

**FISH. 968:** Carps and other fish (*a*, carp; *b*, mirror carp; *c*, crucian carp, *d*, barbel). **969:** Mirror carp. **970:** A breed of goldfish. **971:** Carp. **972:** Golden carp. **973:** Barbel. **974:** Stone loach. **975:** Common bream. **976:** Chub.

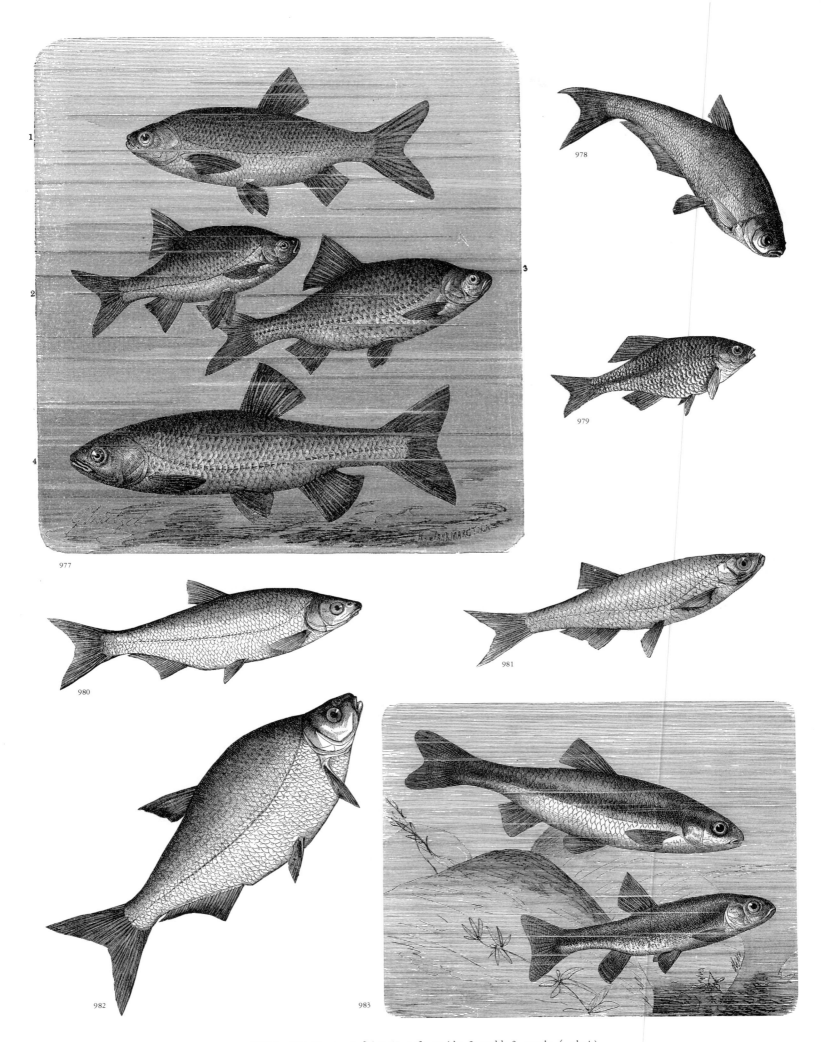

**FISH.** **977:** European fishes (1, orfe, or ide; 2, rudd; 3, roach; 4, chub).
**978:** Zope. **979:** Bitterling. **980 & 981:** Species of sea bream. **982:** Common
bream. **983:** A fish of the genus *Leuciscus*, and a minnow.

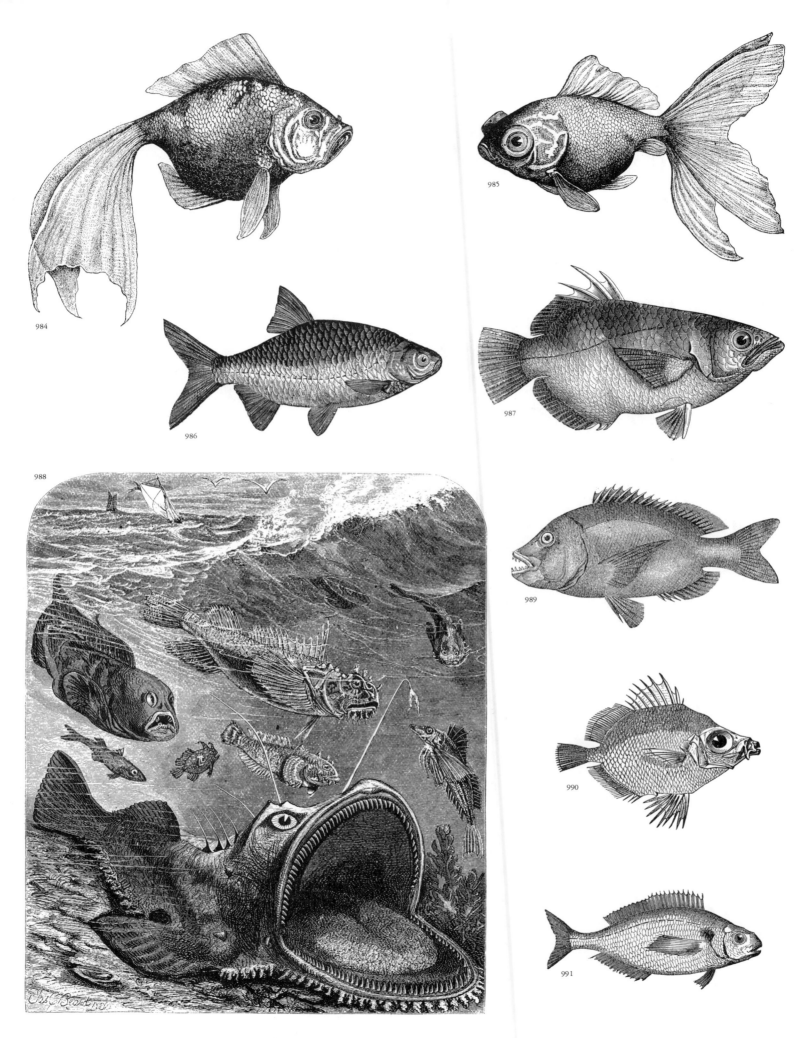

**FISH. 984 & 985:** Breeds of goldfish. **986, 989–991:** Unidentified. **987:** Archerfish. **988:** Various fishes (bottom, angler, or monkfish.)

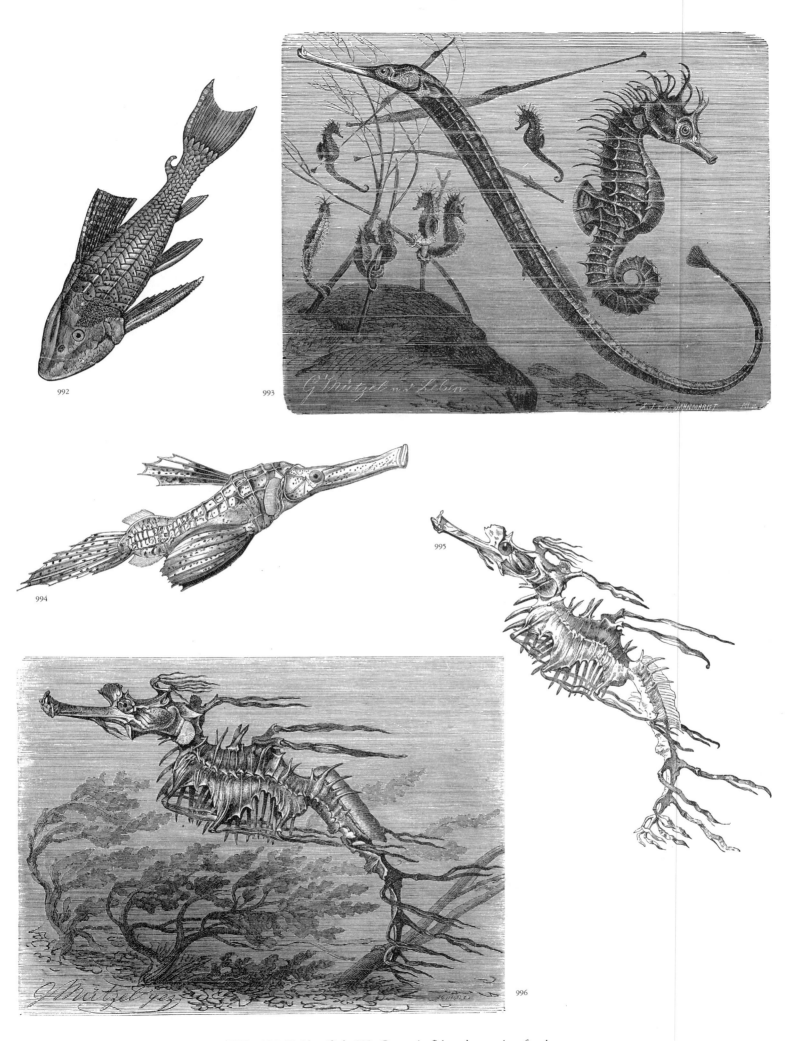

**FISH.** 992: Unidentified. 993: Great pipefish and a species of seahorse.
994–996: Allies of the seahorse.

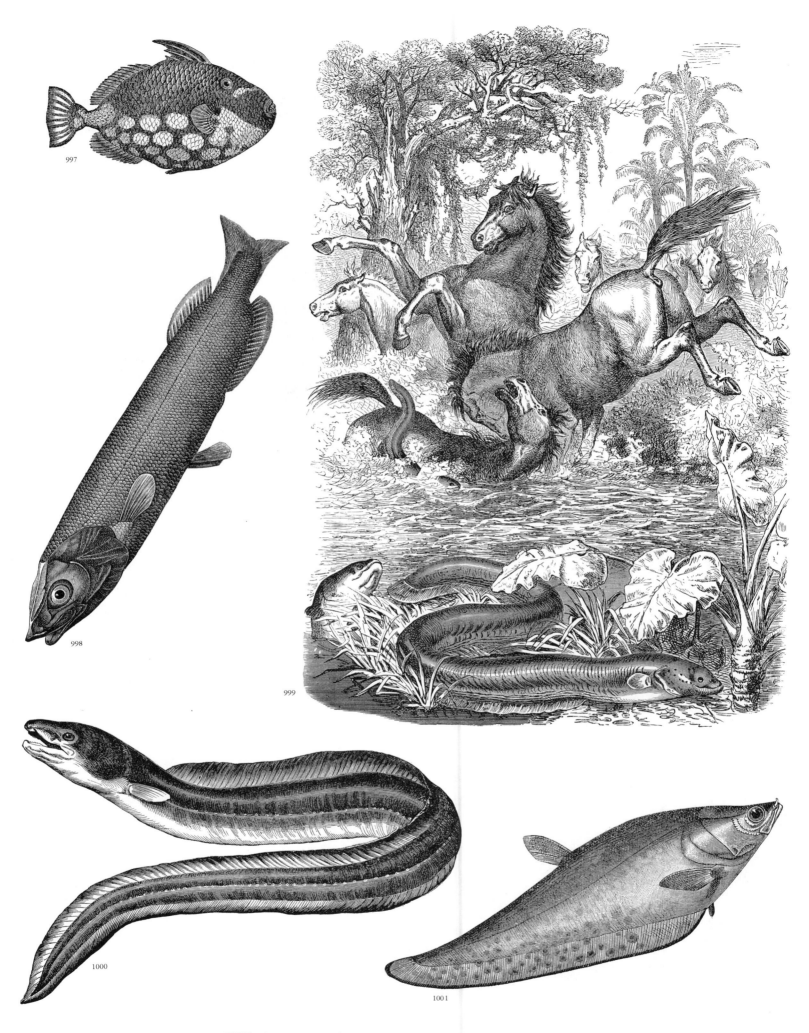

**FISH.** 997: A species of triggerfish. 998, 1001: Unidentified. 999: Electric
eel. 1000: Conger eel.

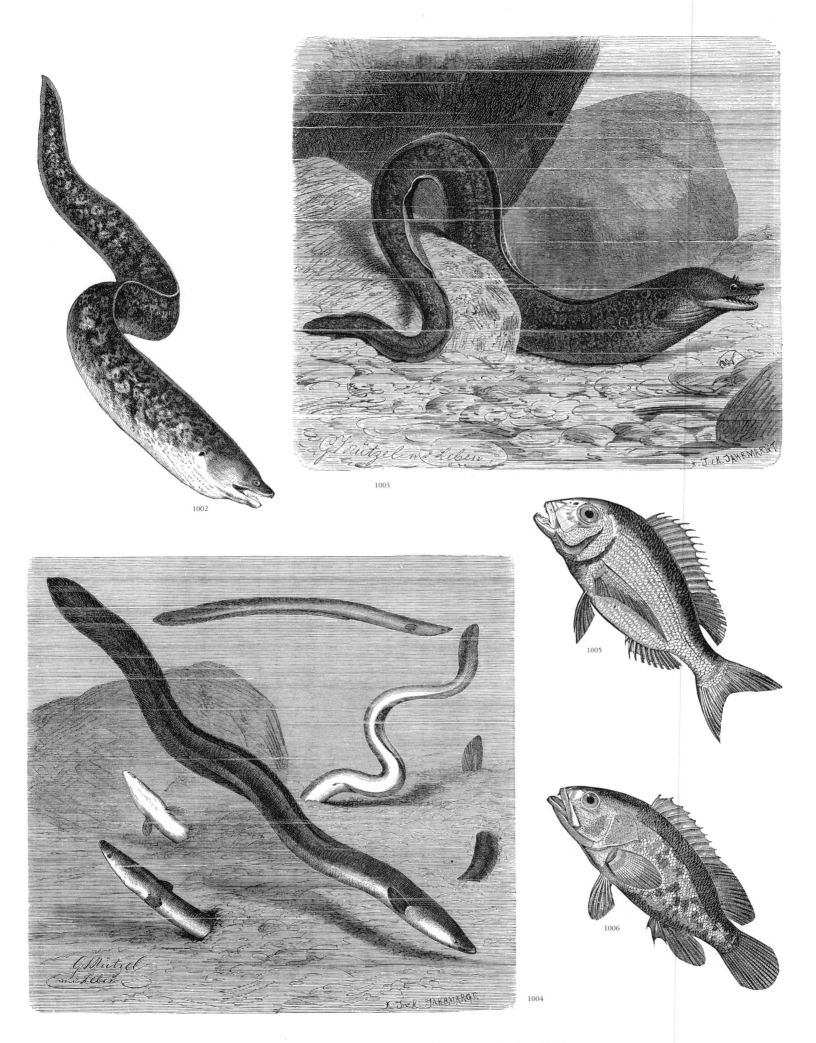

**FISH.** 1002 & 1003: Common moray. 1004: European eel. 1005: Unidentified. 1006: A fish of the family Serranidae.

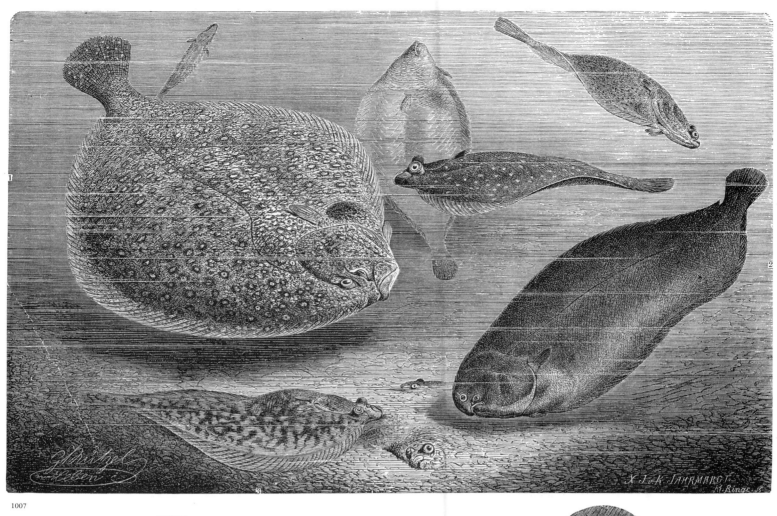

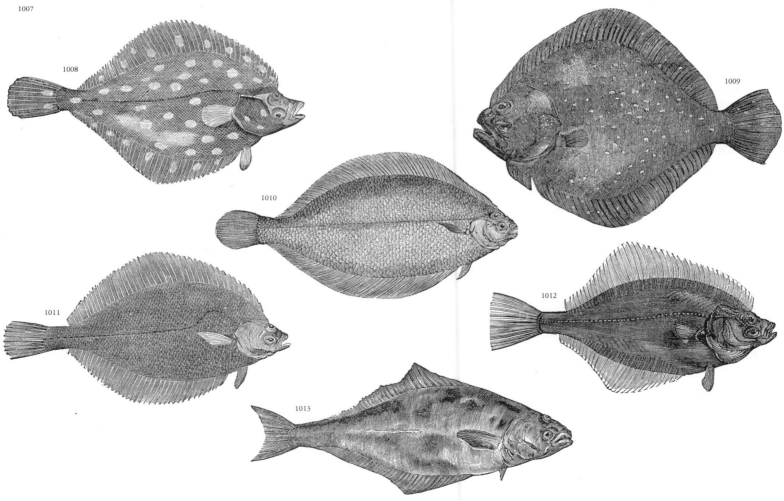

**FISH.** 1007: Flatfishes (1, turbot; 2, sole; 3, plaice). 1008: Plaice. 1009: Turbot. 1010: A Type of flatfish. 1011: Dab. 1012: Flounder. 1013: Halibut.

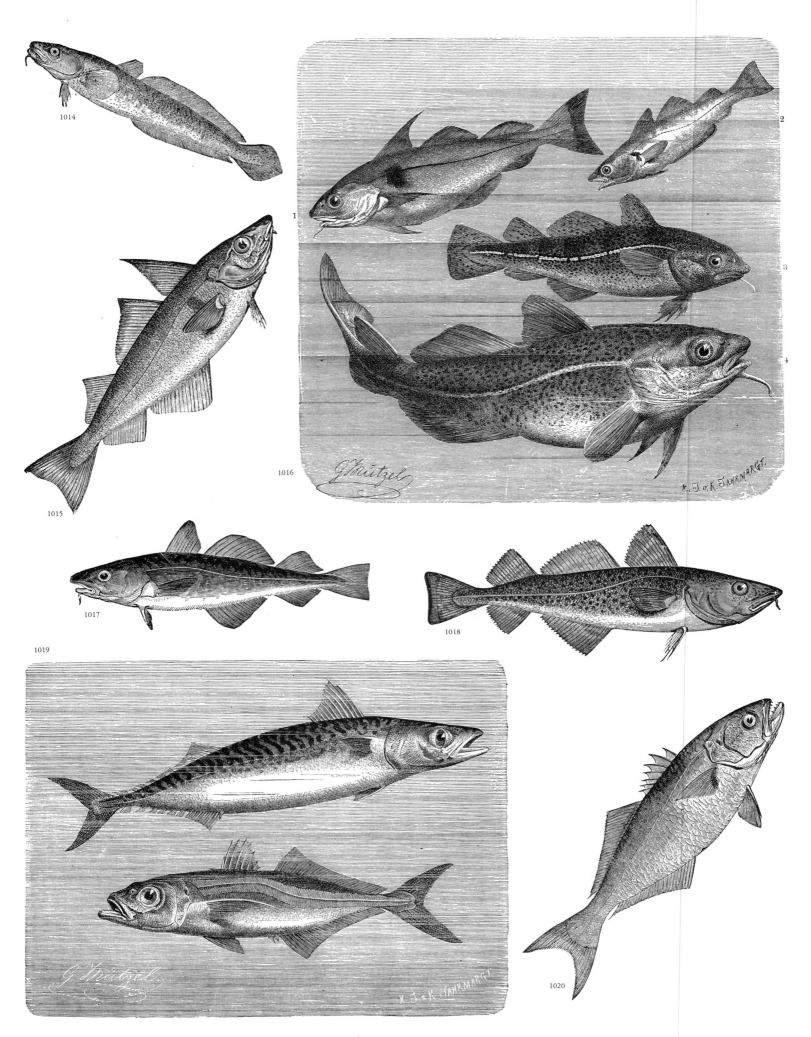

**FISH.** 1014: Burbot. 1015: Haddock. 1016: Major food fishes of the cod
family (1, haddock; 2, whiting; 3 & 4, cod). 1017: Fish of the cod family.
1018: Cod. 1019: Common mackerel and a species of saurel. 1020: Bluefish.

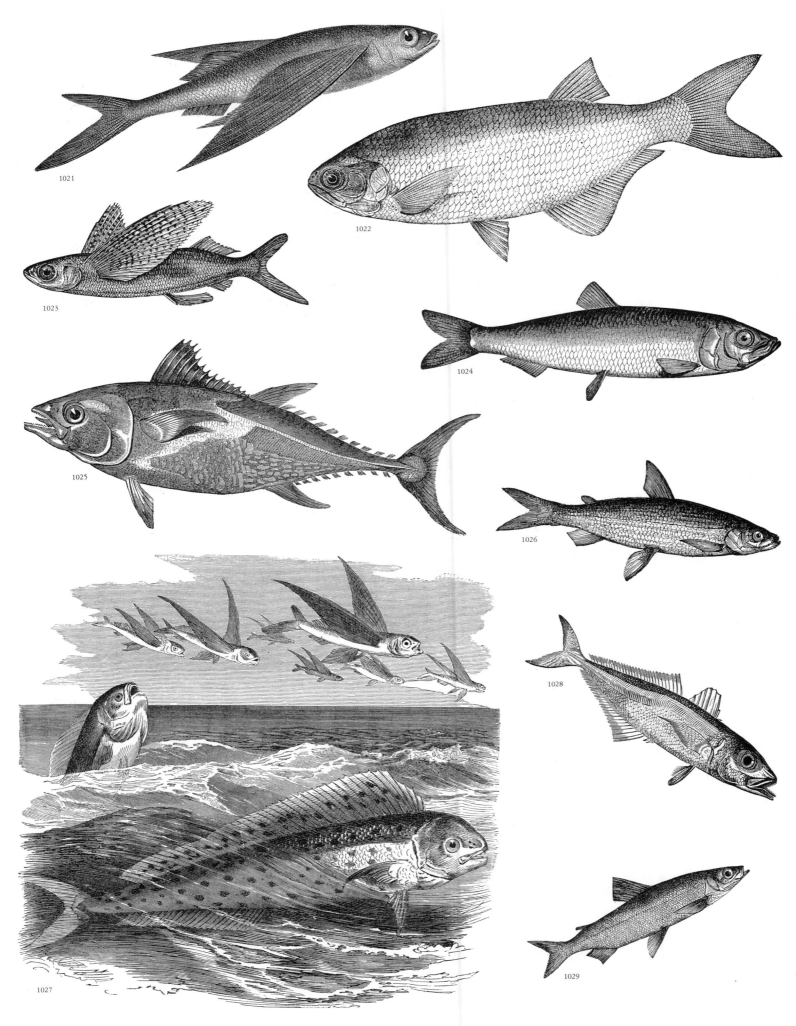

**FISH. 1021:** Atlantic flying fish. **1022:** Unidentified. **1023:** A species of flying fish. **1024:** Herring. **1025:** Tuna. **1026, 1029:** Fishes of the species *Coregonus*. **1027:** A species of gilthead, or sea bream. **1028:** Scad, or horse mackerel.

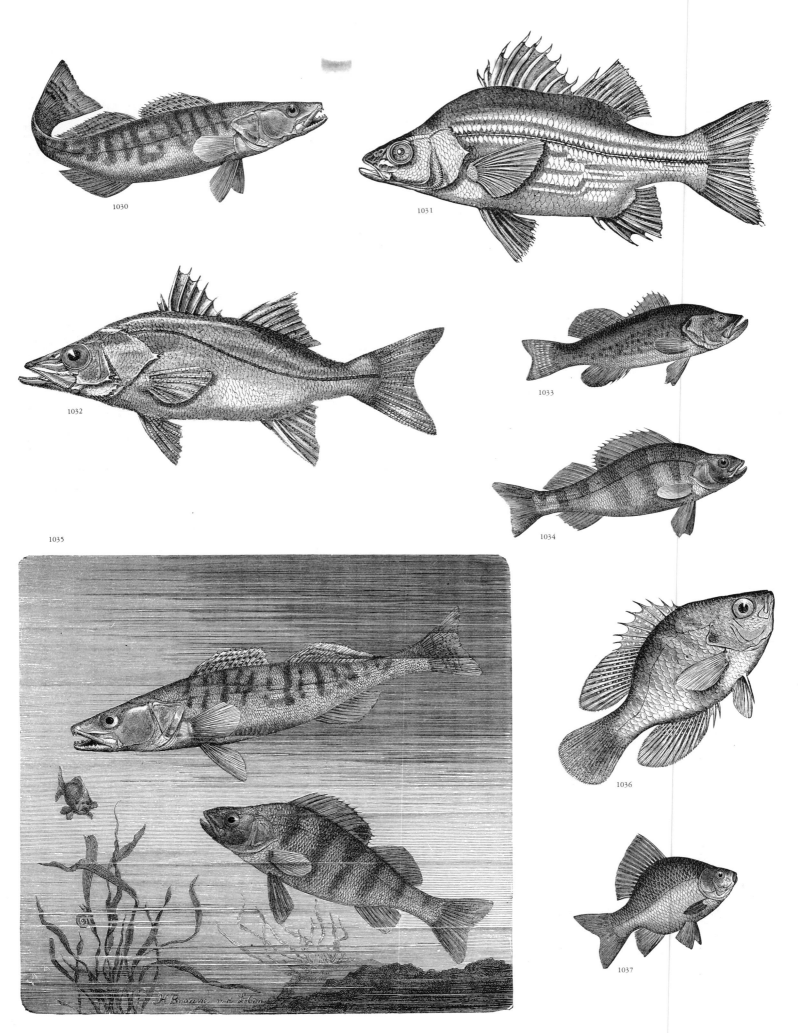

**FISH.** 1030: Pike-perch. 1031: A freshwater bass of the genus *Morone*. 1032: Fish of the bass family. 1033: Largemouth, or black bass. 1034: Common perch. 1035: Pike-perch and common perch. 1036: Pumpkinseed sunfish. 1037: Crucian carp.

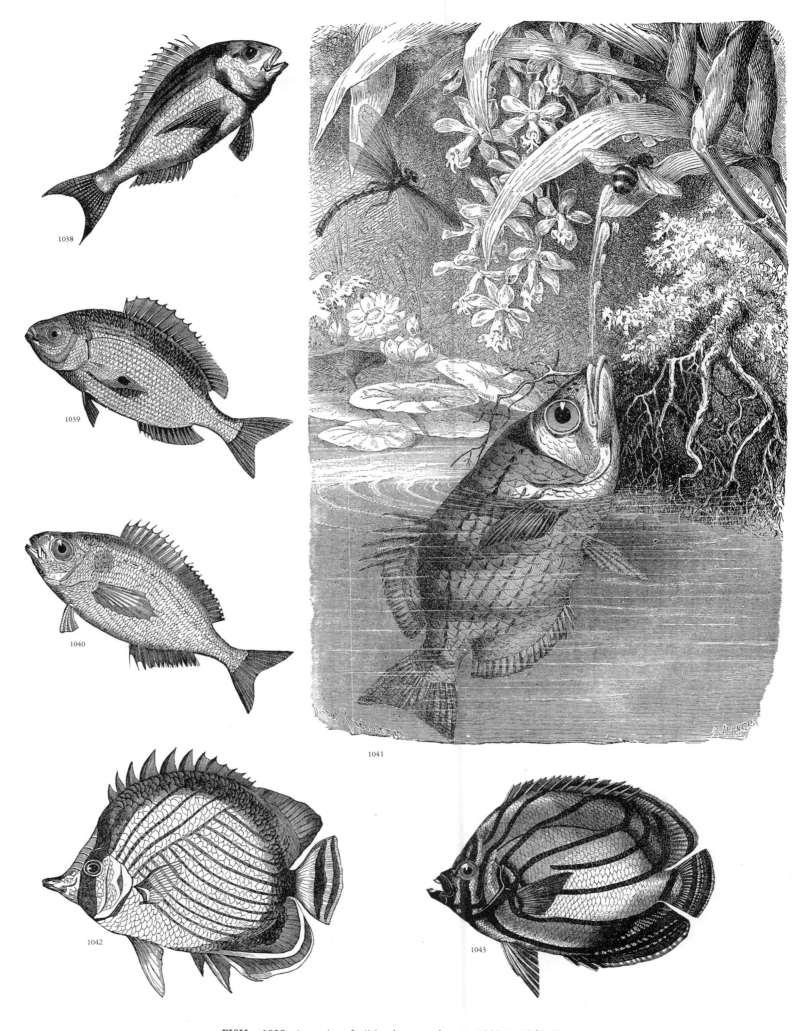

**FISH.** 1038: A species of gilthead, or sea bream. 1039 & 1040: Two species of sea bream. 1041: A species of archerfish. 1042: Criss-cross butterfly-fish. 1043: Another species of butterfly-fish.

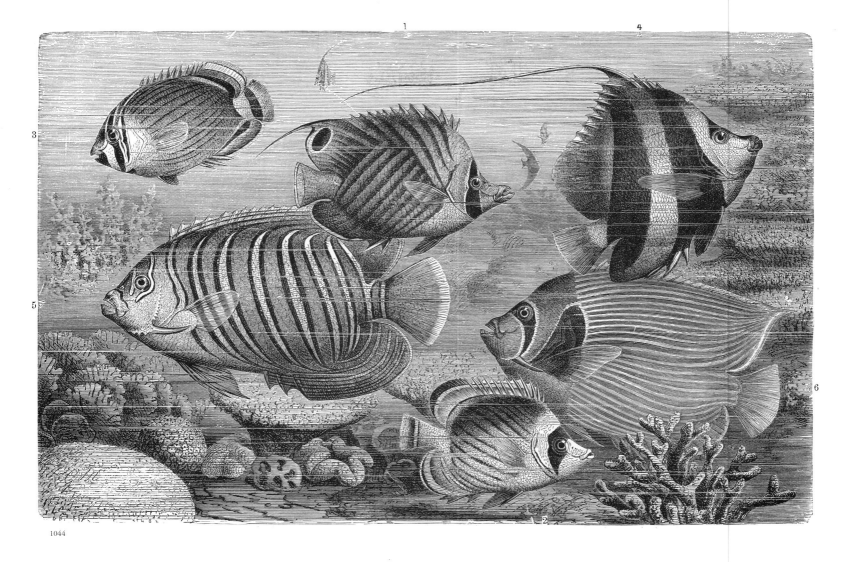

1044

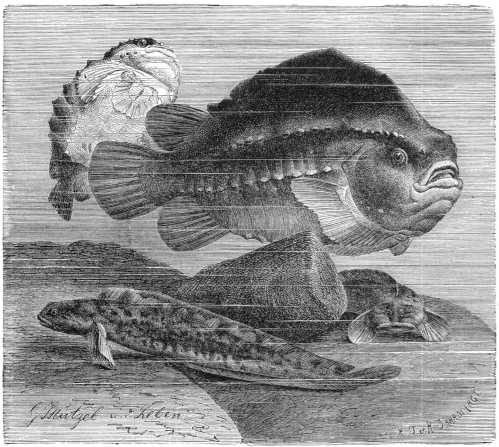

1045

1046

**FISH.** 1044: Various species of butterfly-fish (1–4; 3 is a three-striped butterfly-fish) and angelfish (5 & 6). 1045: Lumpsucker (also called sea hen, hen-fish and lump) and eelpout, or viviparous blenny. 1046: Unidentified.

221

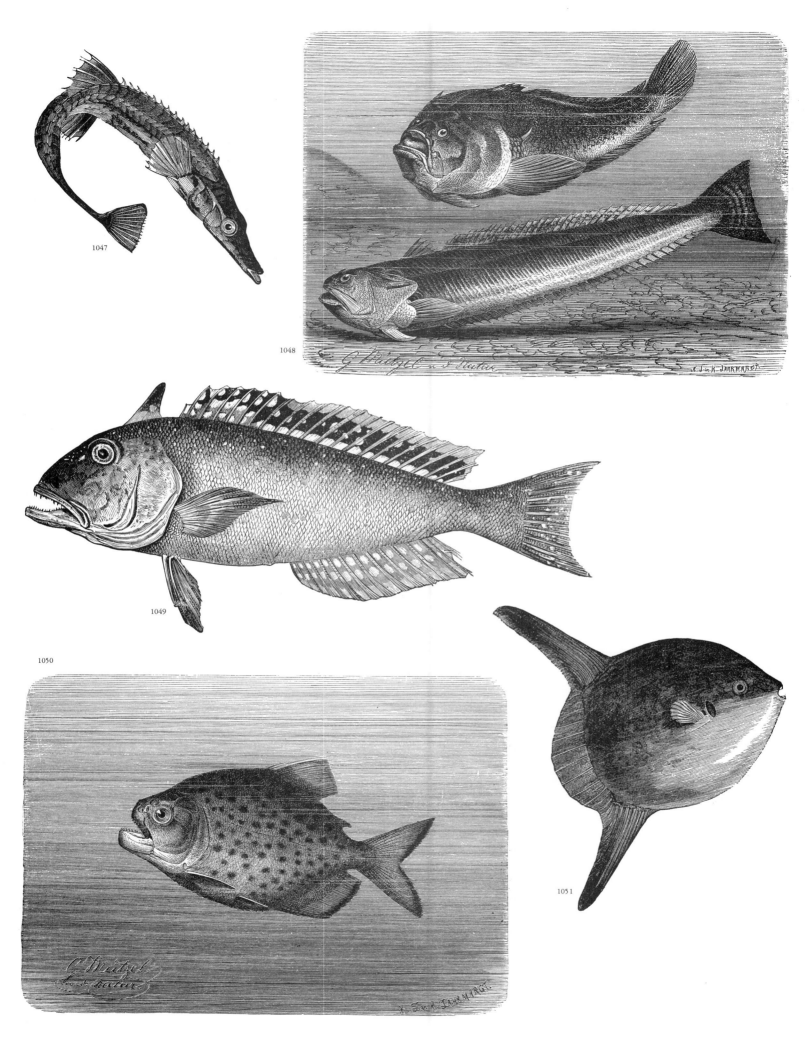

**FISH.** 1047: A species of stickleback. 1048: A species of stargazer, and a greater weever. 1049: Tilefish. 1050: Piraya. 1051: Sunfish.

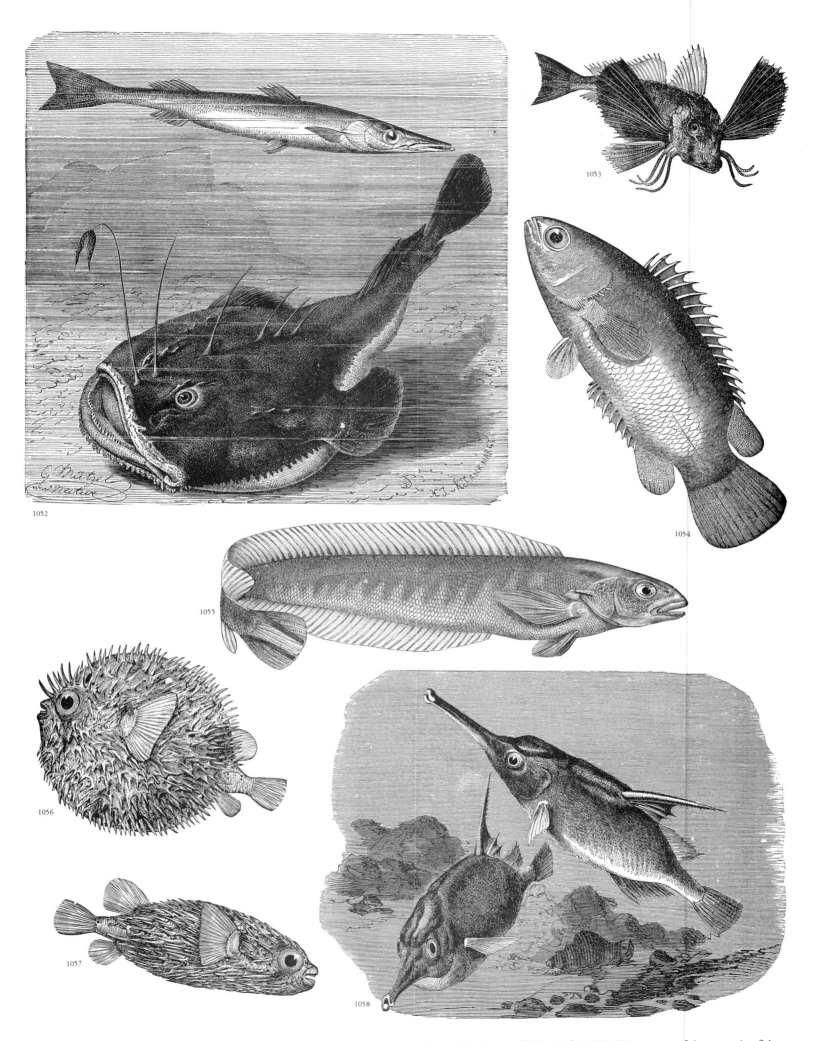

**FISH.** 1052: European barracuda and angler, or monkfish. 1053: Tub gurnard, or saphirine gurnard. 1054: A climbing fish of the family Anaban-tidae. 1055: Unidentified. 1056 & 1057: Two aspects of the porcupine-fish (there are various species). 1058: Bellows fish, or snipefish.

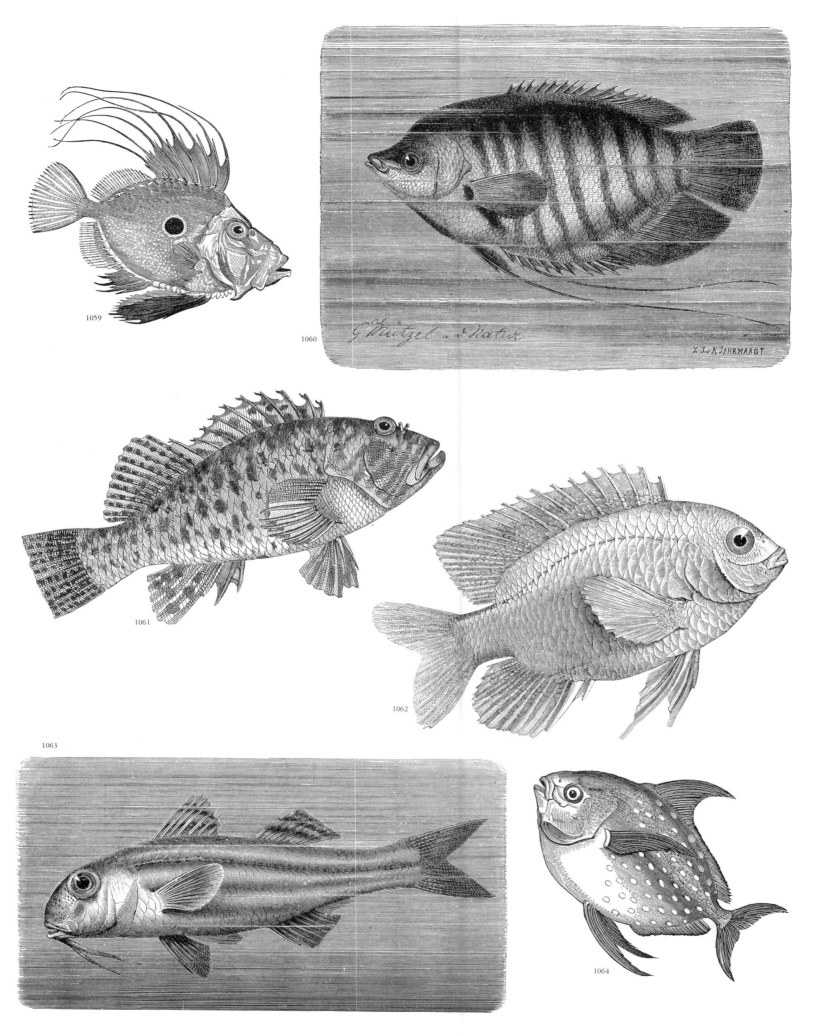

**FISH.** 1059: John Dory. 1060: A species of gourami. 1061: Unidentified. 1062: A demoiselle of the genus *Pomacentrus*. 1063: Red mullet. 1064: Opah.

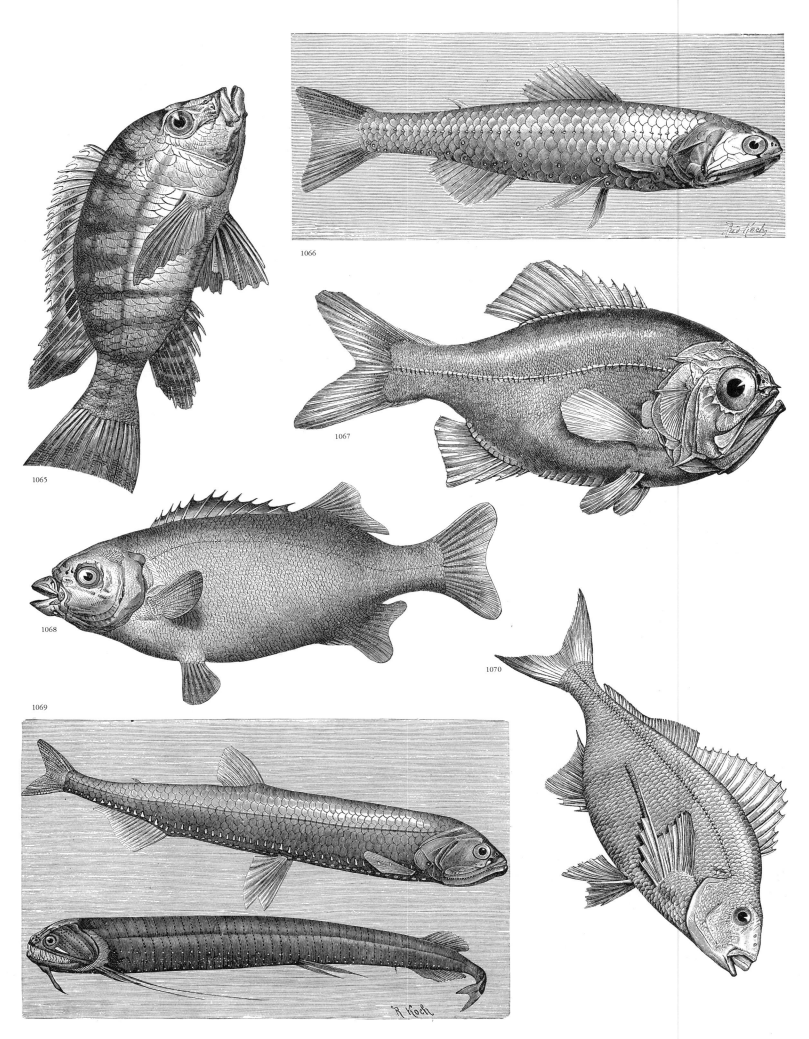

1066

1067

1065

1068

1069

1070

**FISH.** 1065–1070: Unidentified.

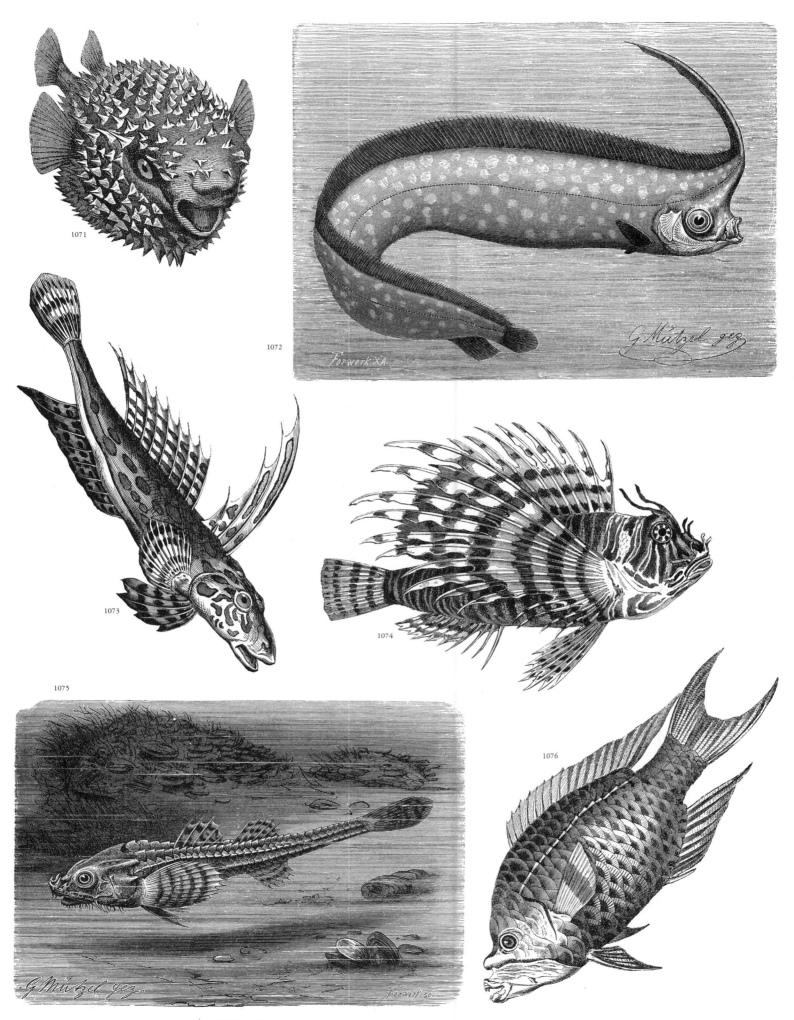

**FISH.** 1071: A species of porcupine-fish. 1072, 1075, 1076: Unidentified.
1073: Dragonet. 1074: Red firefish.

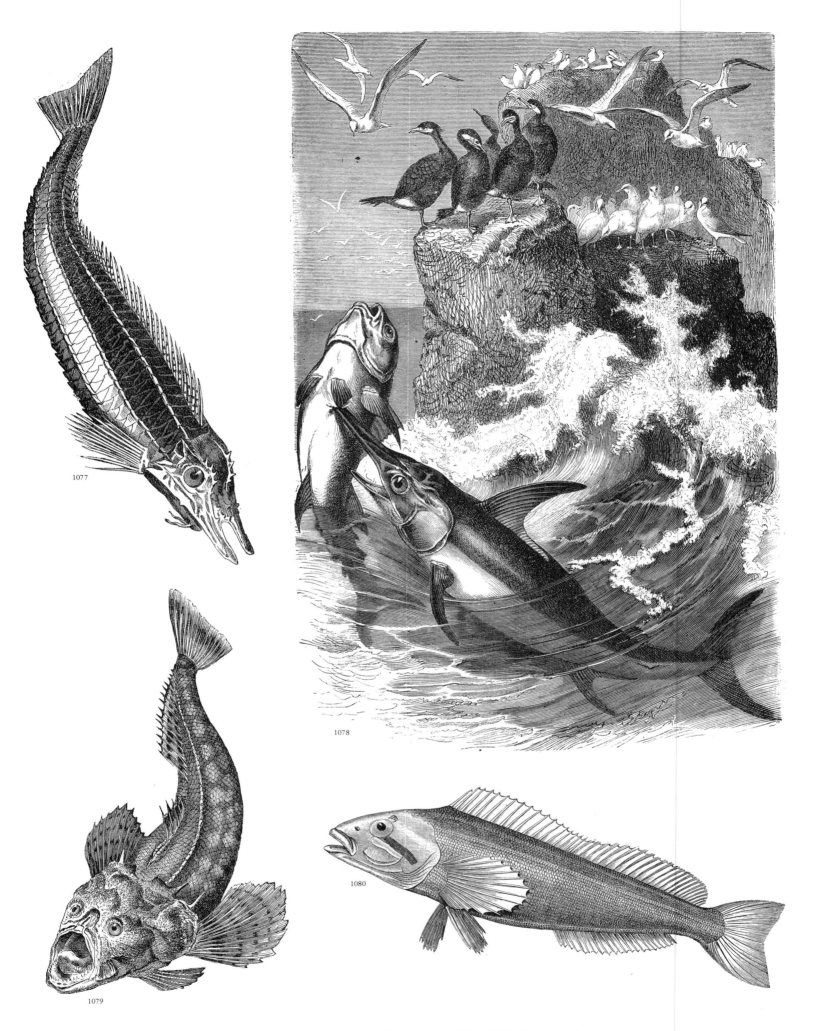

**FISH. 1077, 1080:** Unidentified. **1078:** Swordfish. **1079:** A species of stargazer.

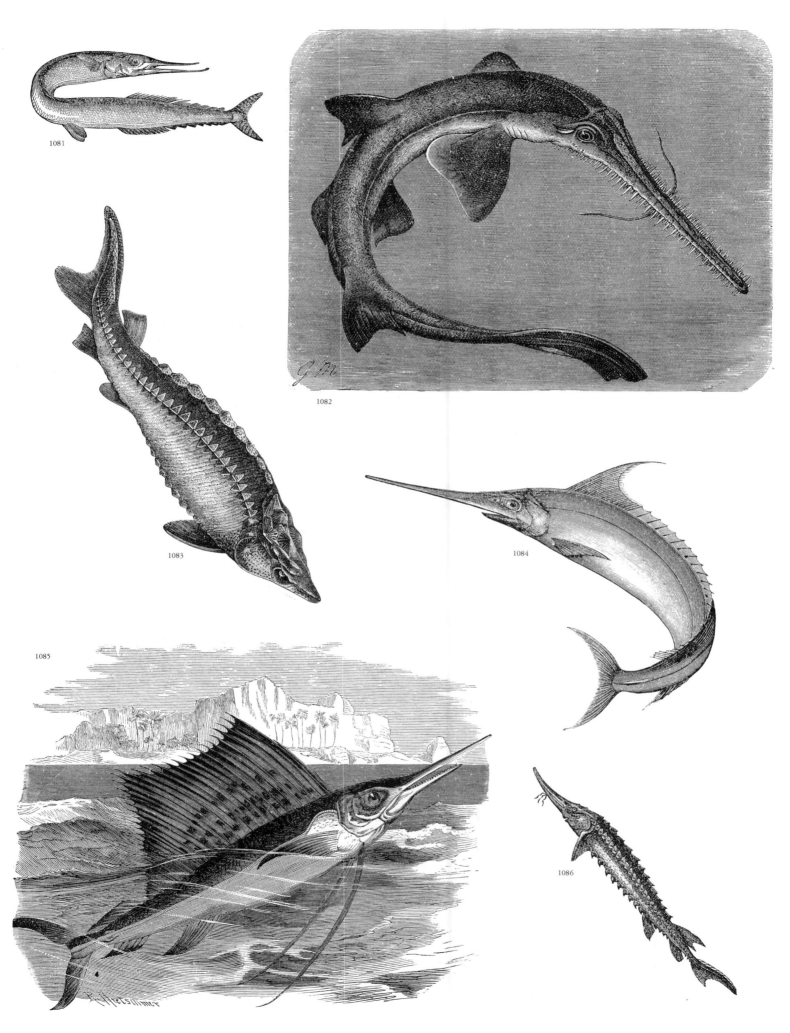

**FISH. 1081:** Saury (?) **1082:** A species of sawfish. **1083:** Common sturgeon. **1084:** Swordfish. **1085:** A species of sailfish. **1086:** A species of sturgeon.

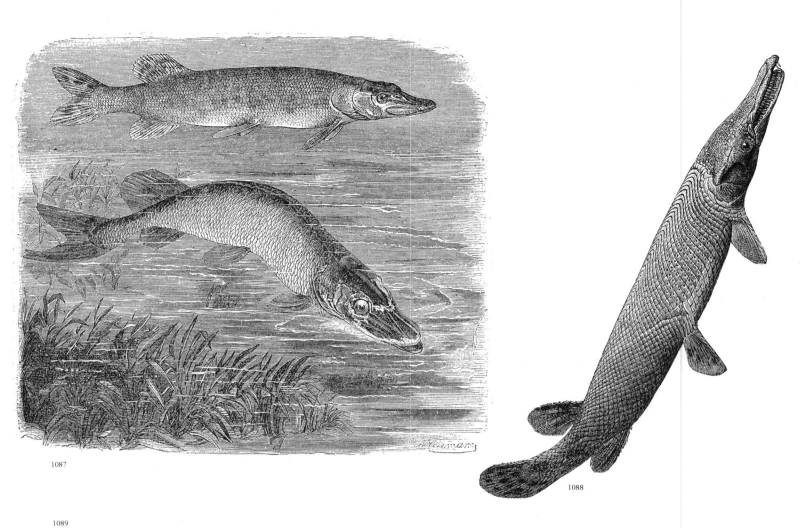

1087

1088

1089

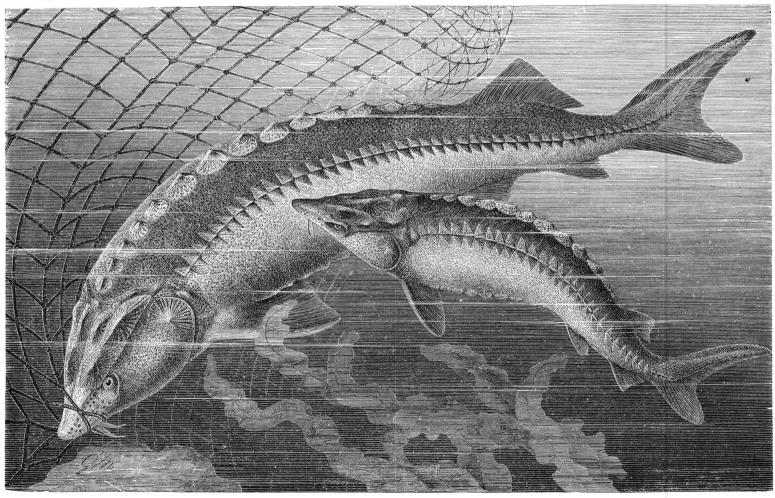

**FISH.** 1087: Pike. 1088: Longnose gar. 1089: Beluga and common sturgeon.

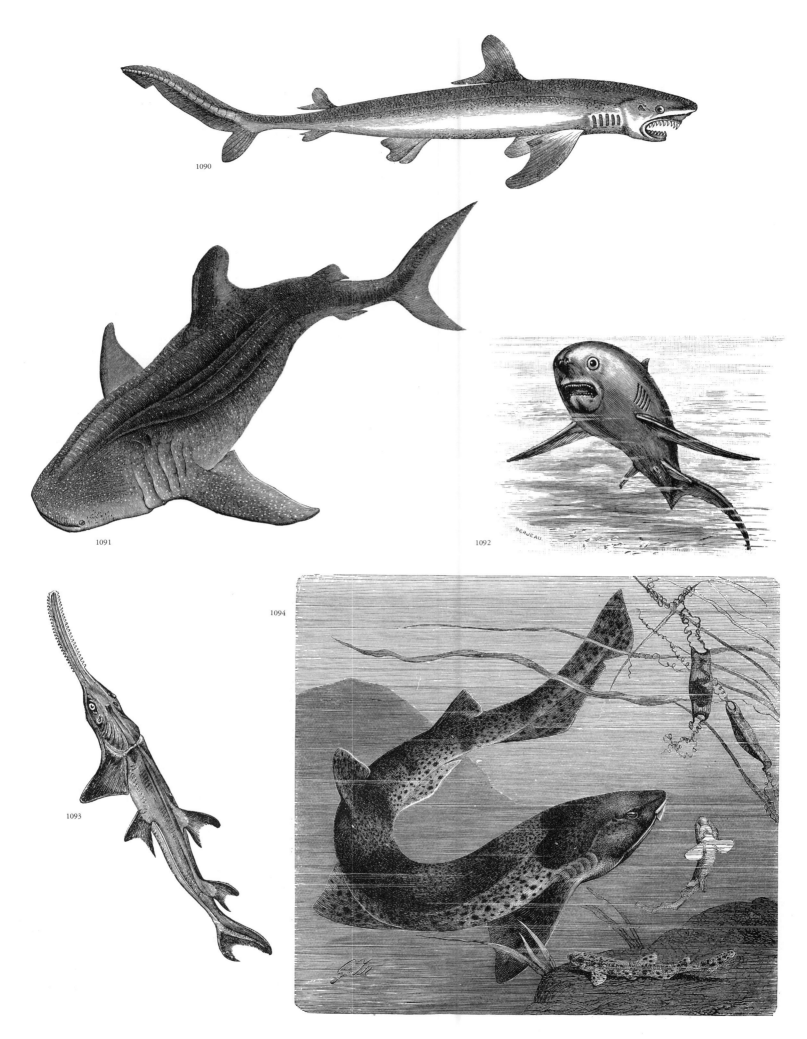

**FISH.** 1090: Blue shark. 1091: A shark found in the Indian and Pacific Oceans. 1092: A species of shark. 1093 A species of sawfish. 1094: A species of dogfish.

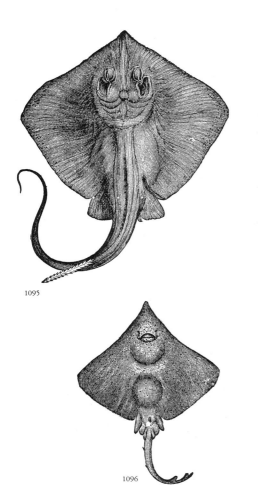

1095

1096

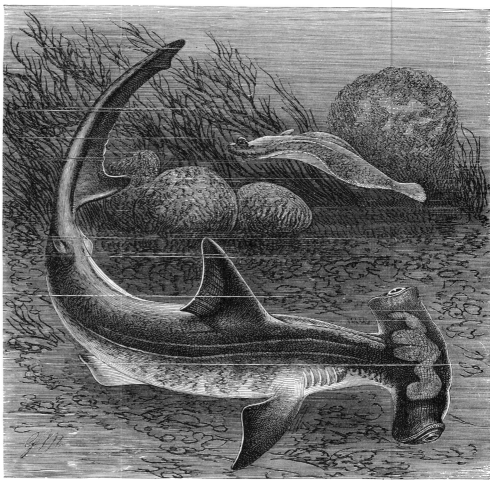

1097

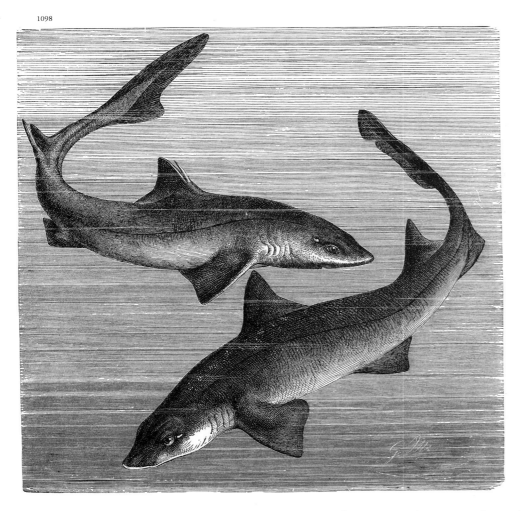

1098

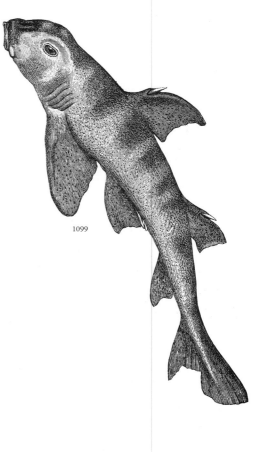

1099

**FISH.** 1095: A species of stingray. 1096: A species of ray. 1097: Hammerhead shark. 1098: Spur dog and smooth hound. 1099: Port Jackson shark.

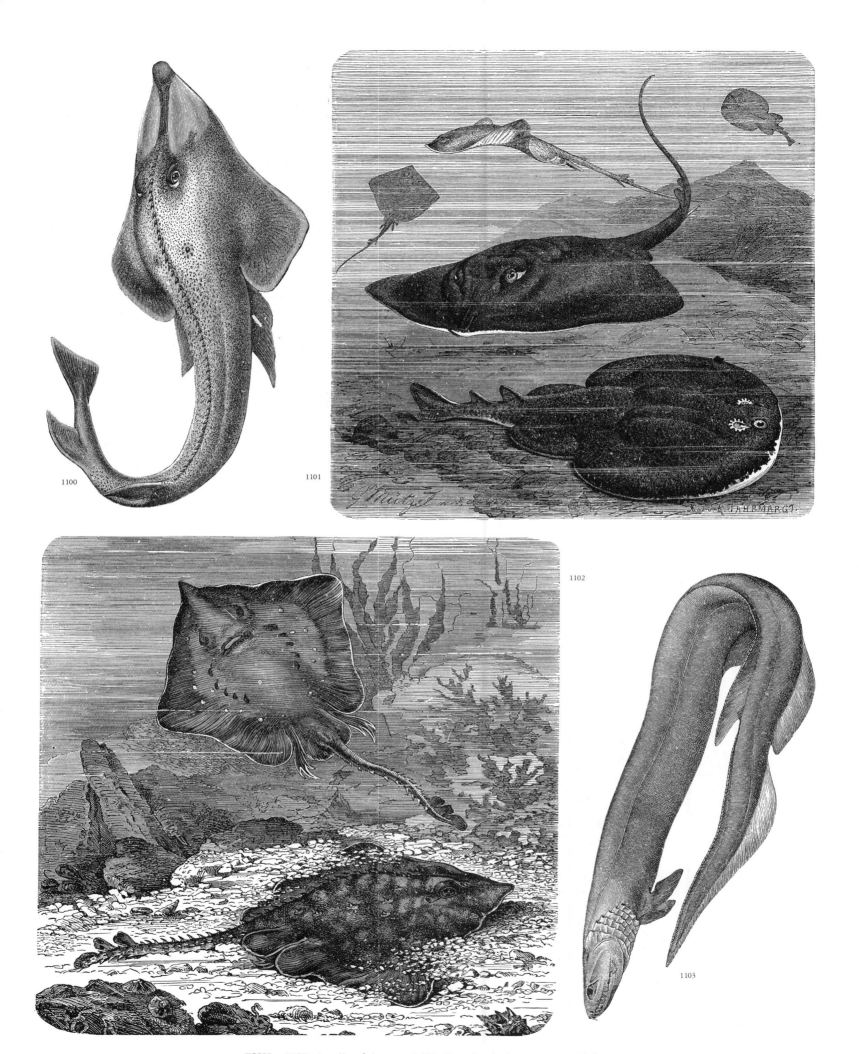

**FISH.** 1100: An ally of the rays. 1101: Rays (at the bottom, a marbled electric ray). 1102: Thornback rays. 1103: Frilled shark (?).

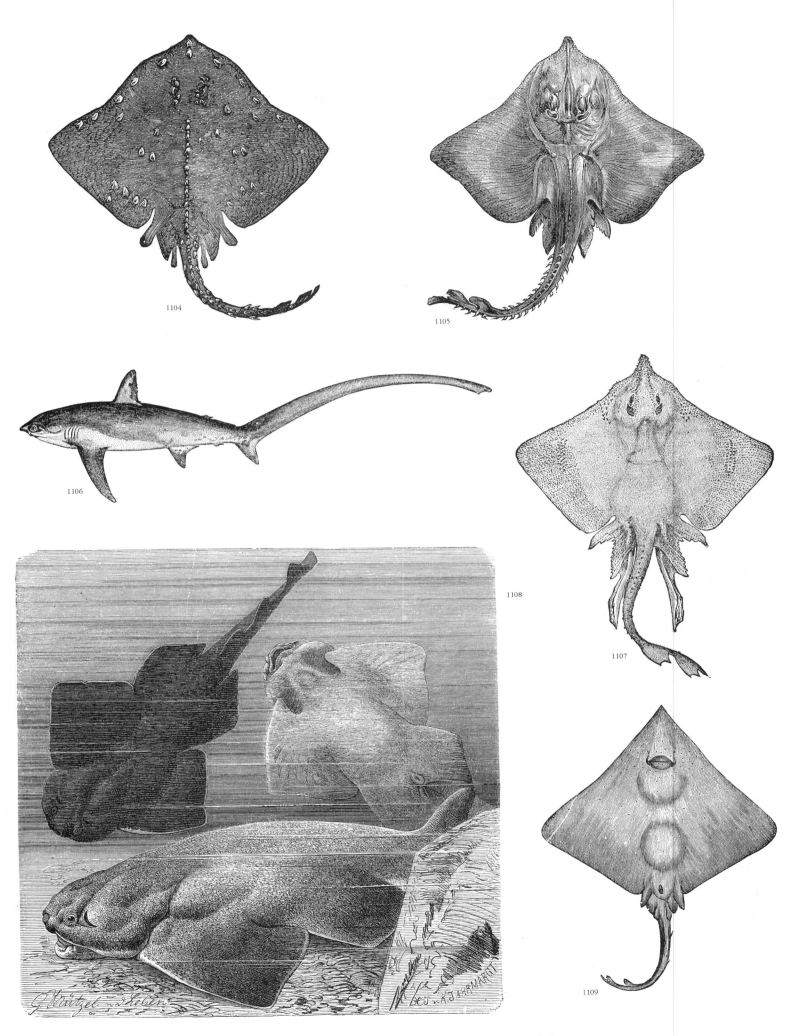

**FISH.** 1104: Thornback ray. 1105, 1107–1109: Species of rays and allies.
1106: Fox shark, or thresher shark.

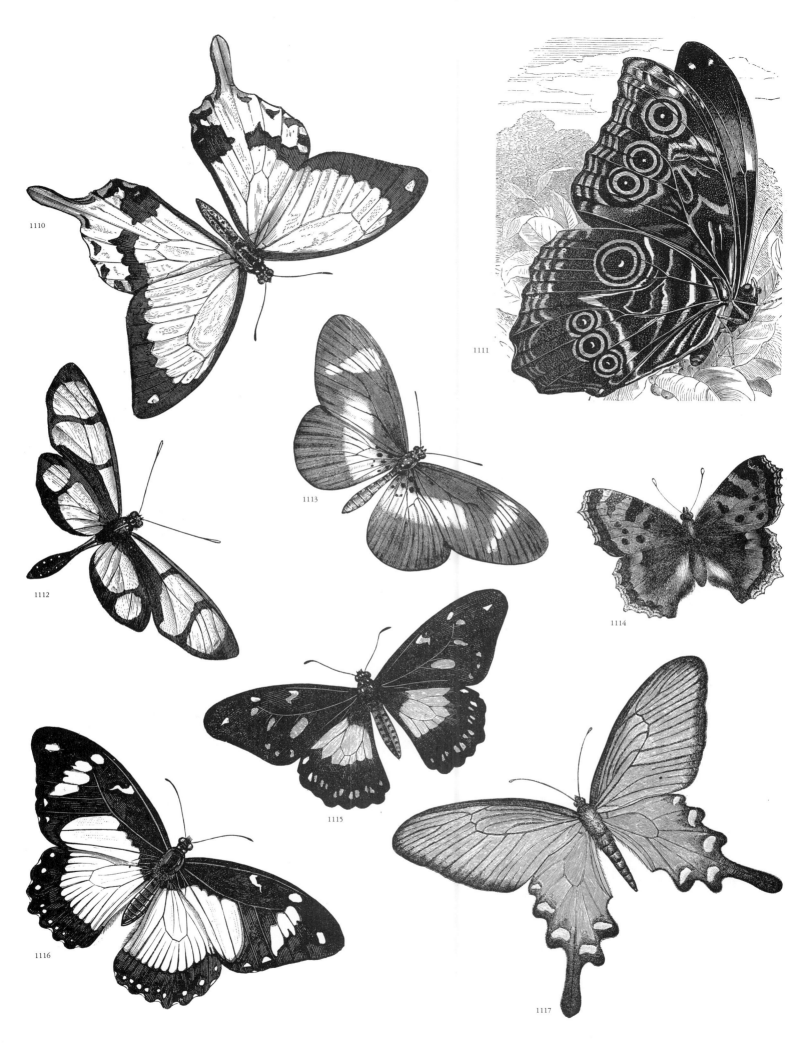

INSECTS. 1110–1117: Butterflies (1111, of the family Morphidae).

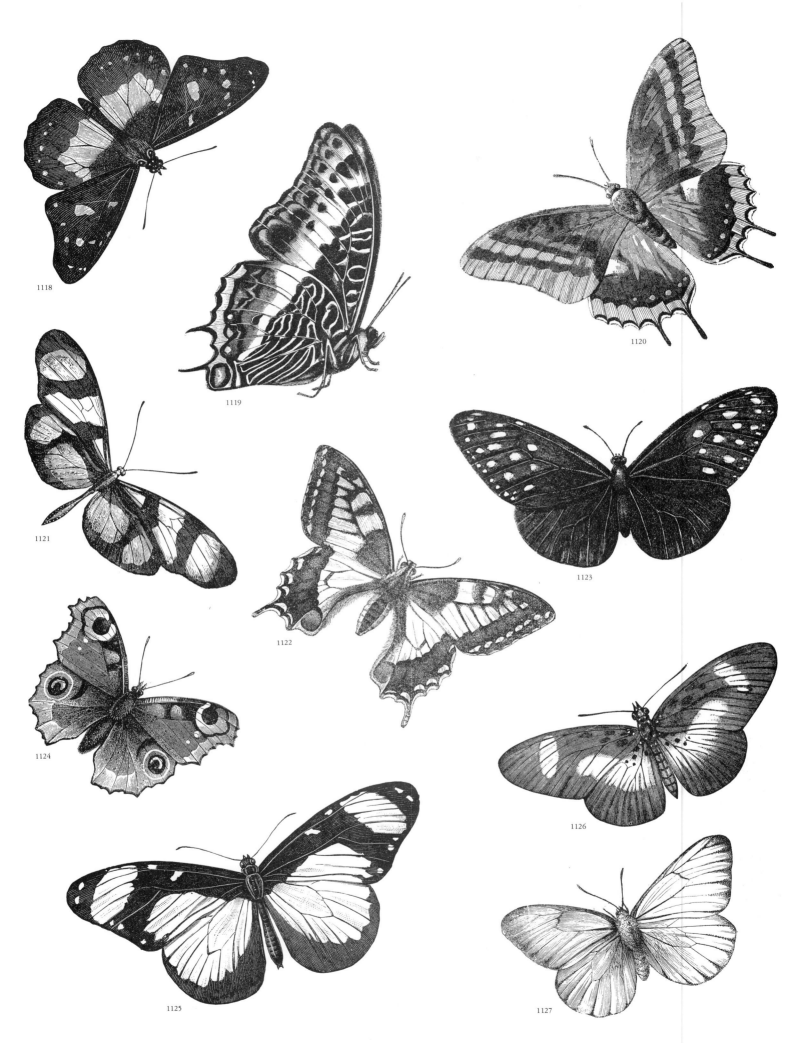

**INSECTS.** 1118–1121, 1123, 1125, 1126: Unidentified butterflies.
1122: Swallowtail. 1124: Peacock butterfly. 1127: A butterfly of the family
Pieridae.

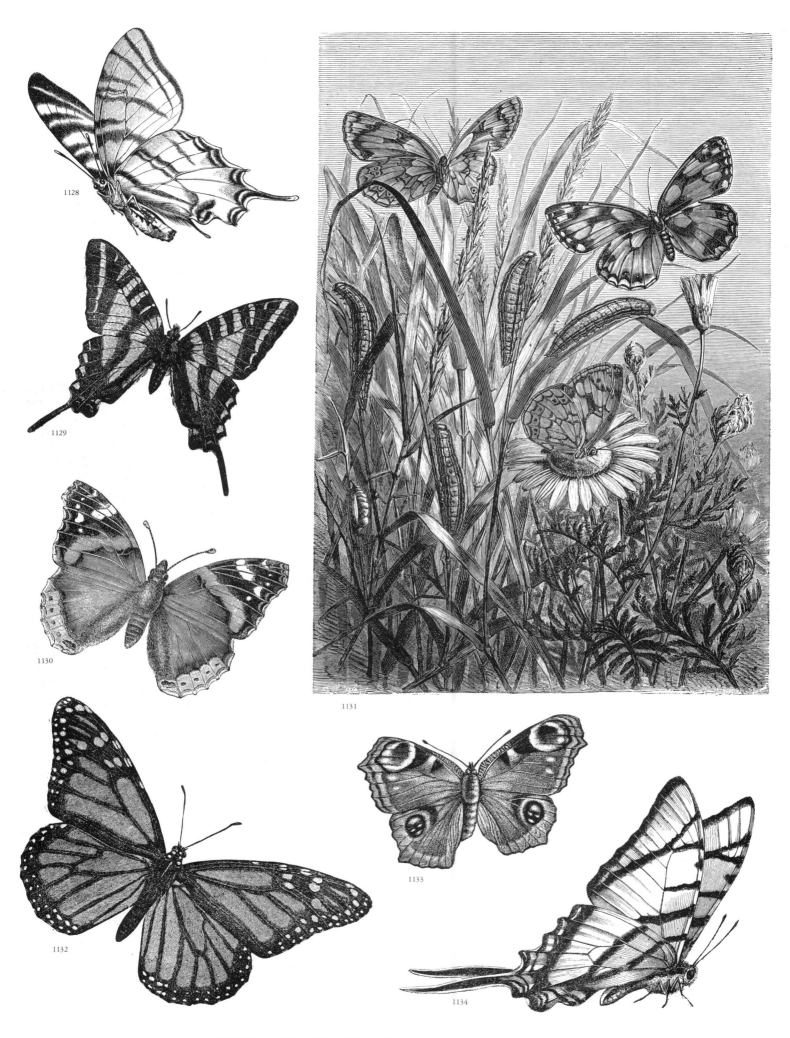

**INSECTS.** 1128–1130, 1132, 1134: Unidentified butterflies. 1131: Metamorphosis of the marbled white butterfly. 1133: Peacock butterfly.

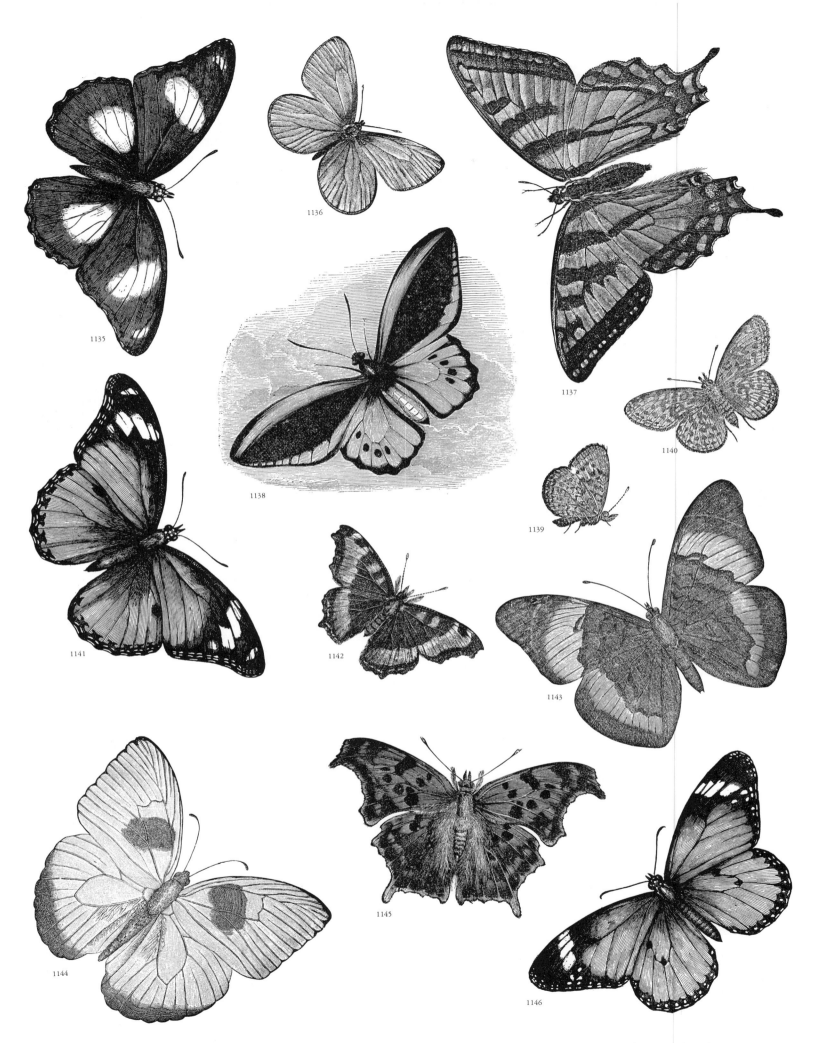

**INSECTS.** 1135: Male *Hypolimnas missippus*. 1136: A butterfly of the family Pieridae. 1137, 1138, 1142–1145: Unidentified butterflies. 1139 & 1340: A butterfly of the fritillary group. 1141: Female *Hypolimnas missippus*. 1146: *Danaus chrysippus*.

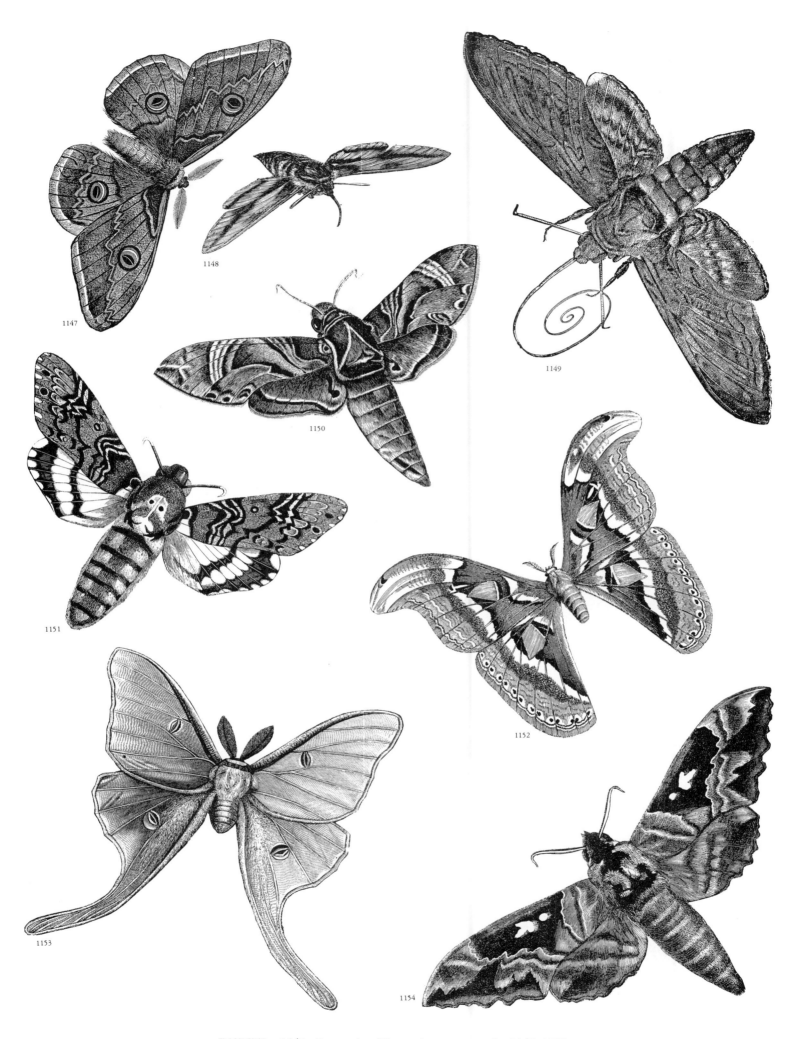

**INSECTS.** 1147: Greater (or, Viennese) emperor moth. 1148–1150, 1152–1154: Unidentified moths. 1151: Death's-head hawk-moth.

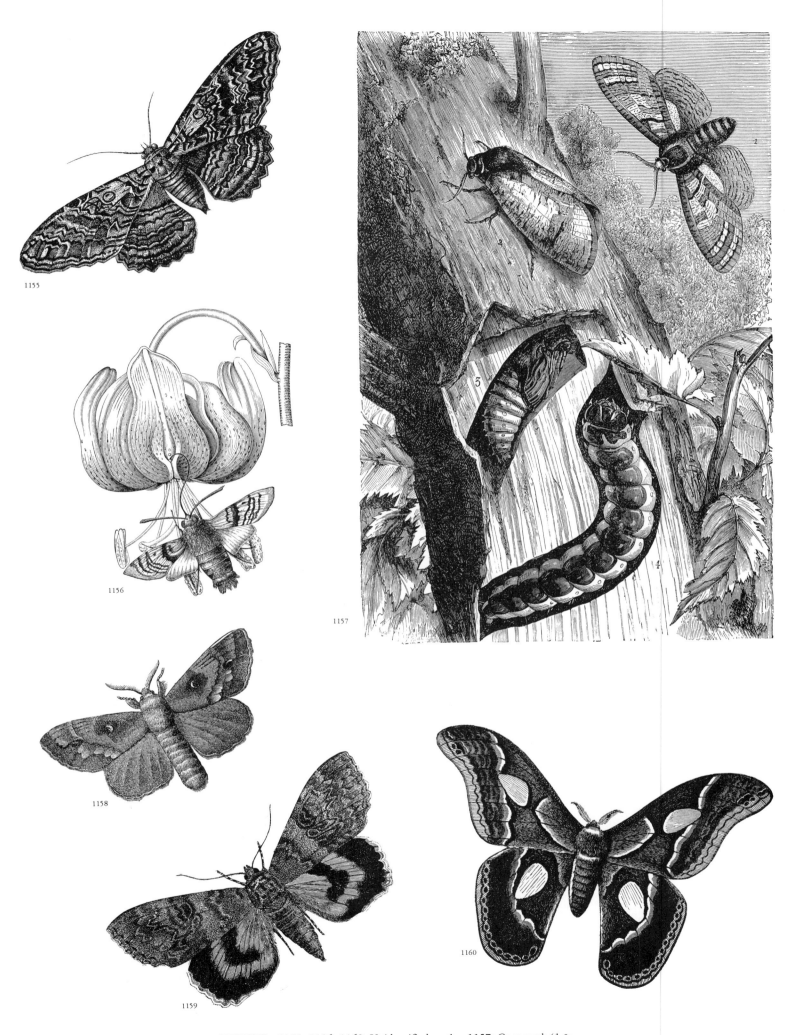

**INSECTS.** 1155, 1156, 1160: Unidentified moths. 1157: Goat moth (1 & 2, adult; 3, pupa; 4, larva). 1158: Pine lappet (?). 1159: Poplar (or else, dark) crimson underwing.

239

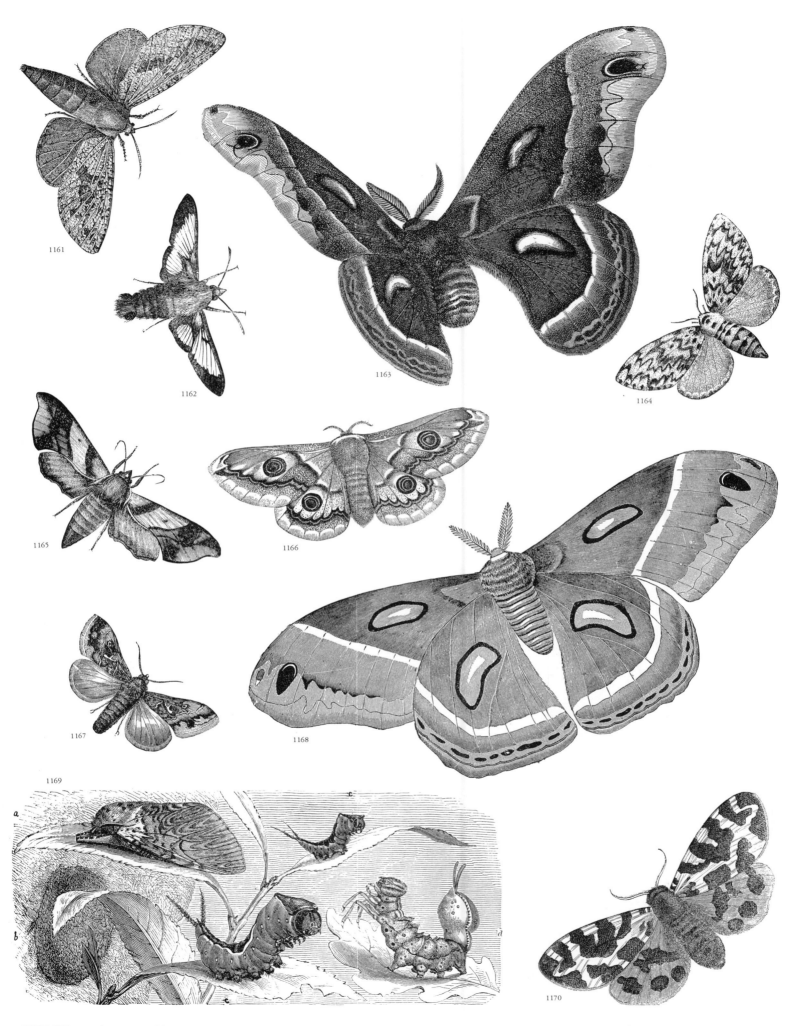

**INSECTS.** 1161: A wood-borer moth of the family Cossidae. 1162: Broad-bordered hawk-moth. 1163, 1168: Cecropia moth. 1164, 1165, 1167: Unidentified moths. 1166: Lesser emperor moth. 1169: Life stages of two moths (*a*, adult; *b*, cocoon; *c*, two stages of larval growth, all of one species; and *d*, larva of another species). 1170: Garden tiger-moth.

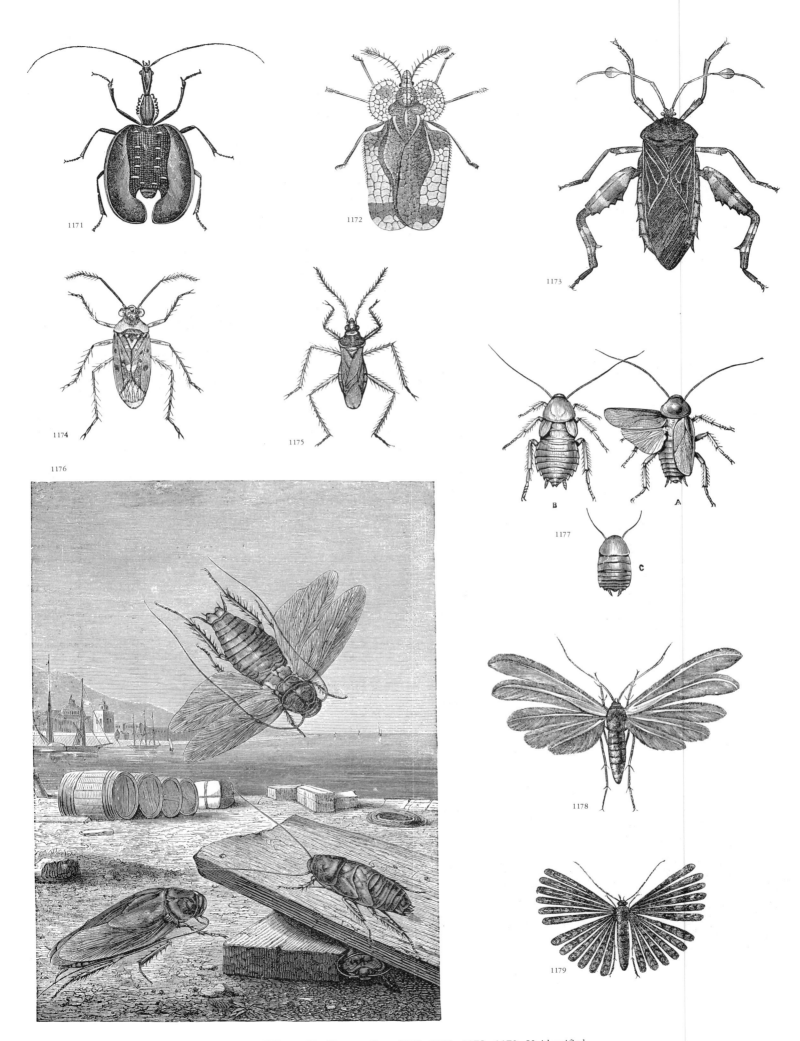

**INSECTS.** 1171: Ghost walker. 1172–1175, 1178, 1179: Unidentified insects. 1176: American cockroach. 1177: Cockroaches (A, male; B, female; C, nymph).

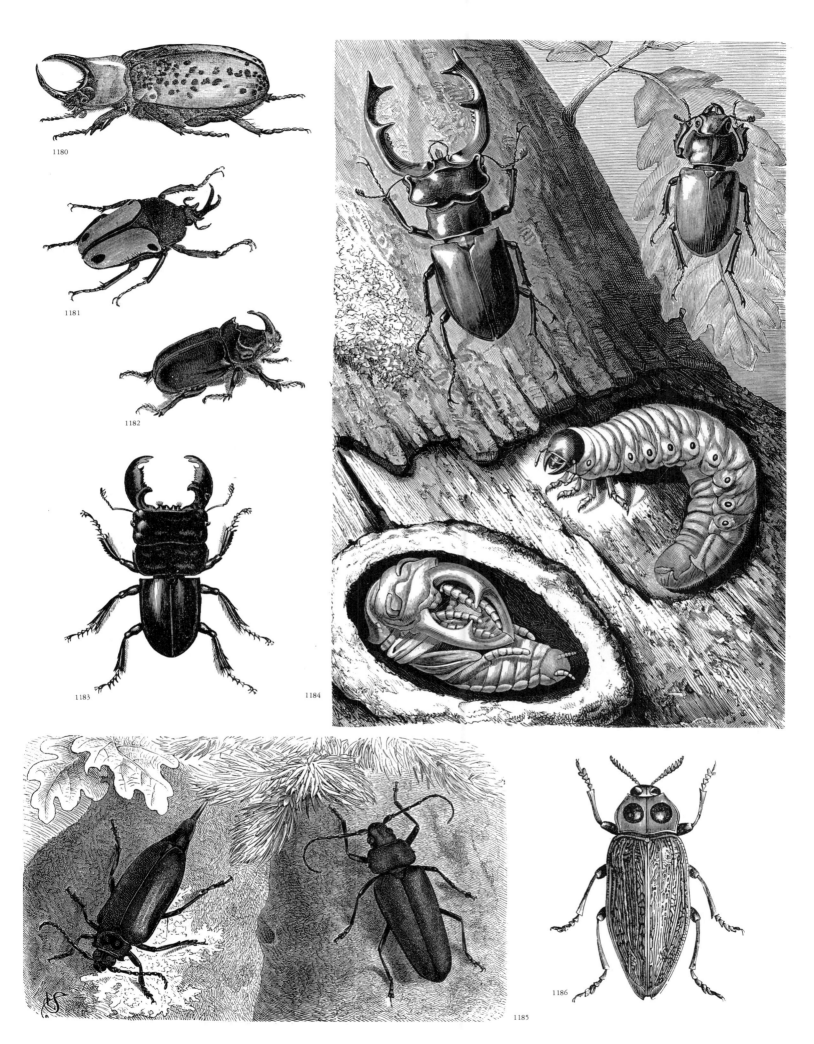

**INSECTS.** **1180:** A rhinoceros beetle of the family Dynastinae. **1181,**
**1183:** Unidentified beetles. **1182:** Common rhinoceros beetle. **1184:** Stag
beetles. **1185:** Female tanner, or sawyer longhorn, and male compost long-
horn, or carpenter longhorn. **1186:** *Euchroma gigantea,* a species of splen-
dour beetle.

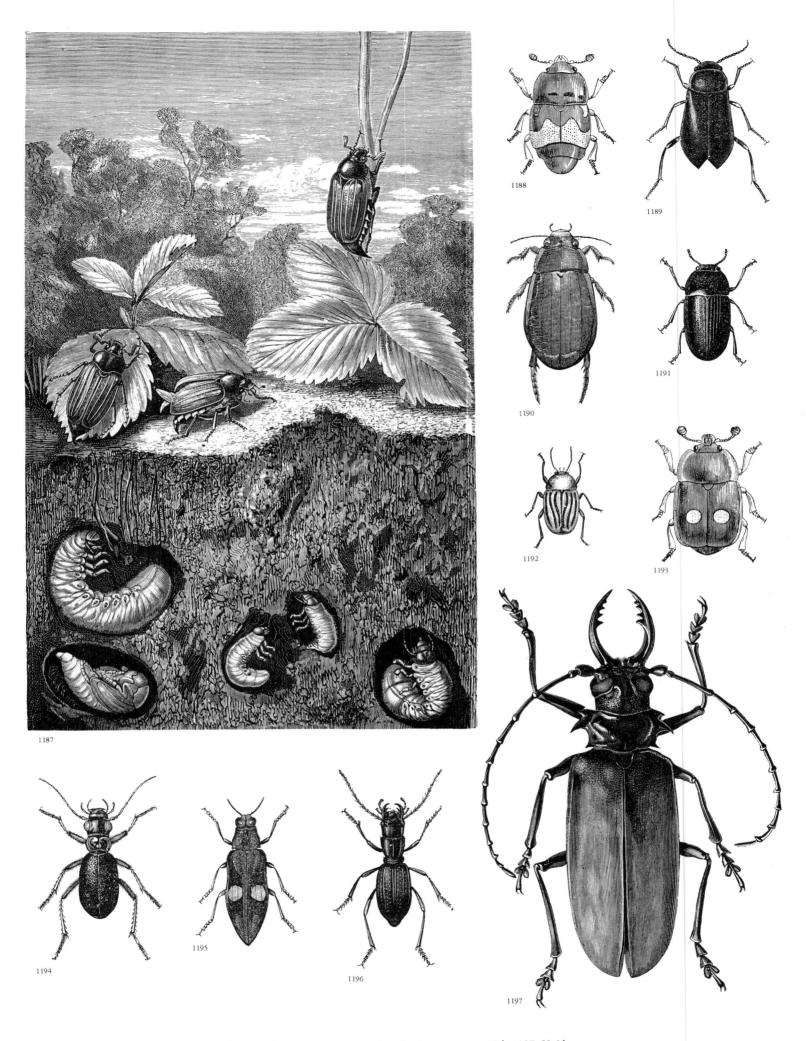

**INSECTS.** 1187: Common cockchafer. 1188–1191, 1194–1197: Unidentified beetles. 1192: A leaf beetle of the genus *Cryptocephalus*. 1193: A gloss beetle of the family Nitidulidae.

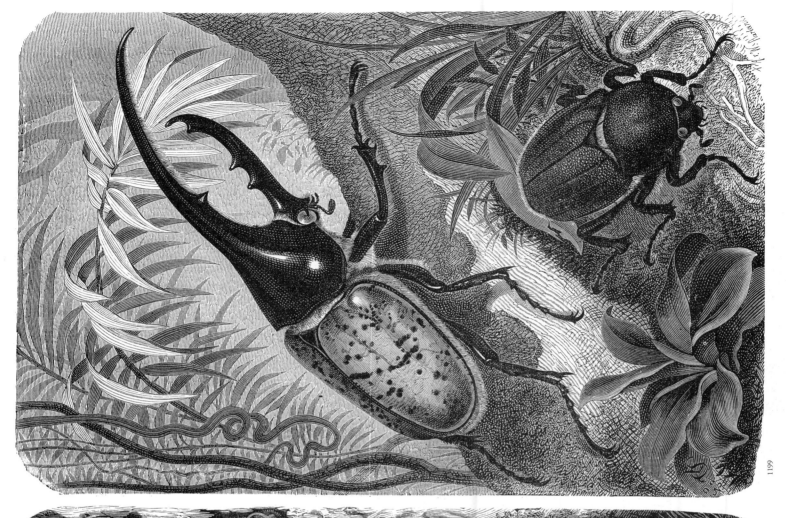

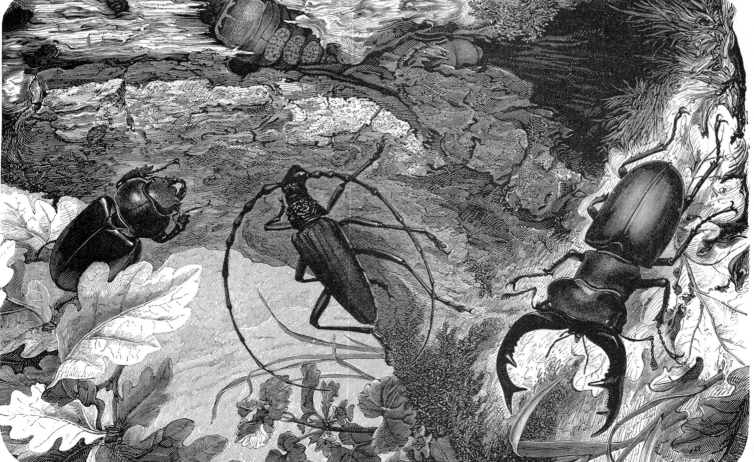

INSECTS. 1198: Stag beetles, and great oak (or, hero) longhorn. 1199: Hercules beetles.

1199

1198

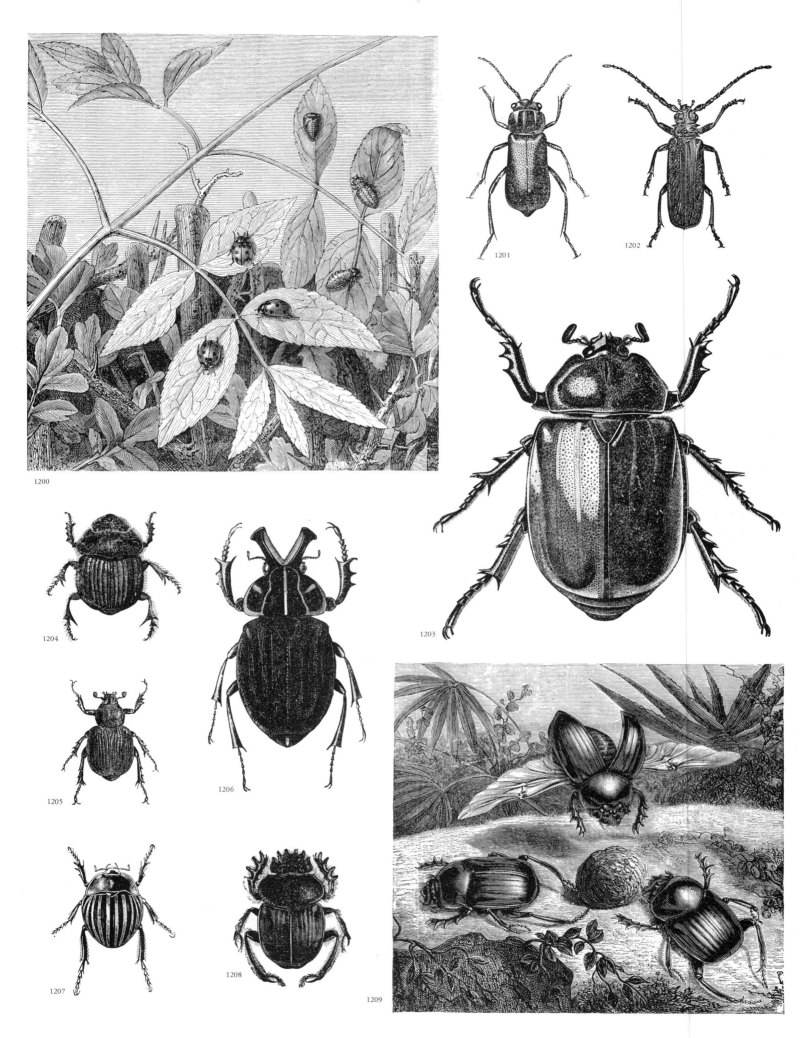

**INSECTS.** 1200: Seven-spot ladybirds. 1201, 1202, 1204–1207: Uniden-tified beetles. 1203: *Megasoma elephas*, a species of rhinoceros beetle. 1208 & 1209: Dung-pushers.

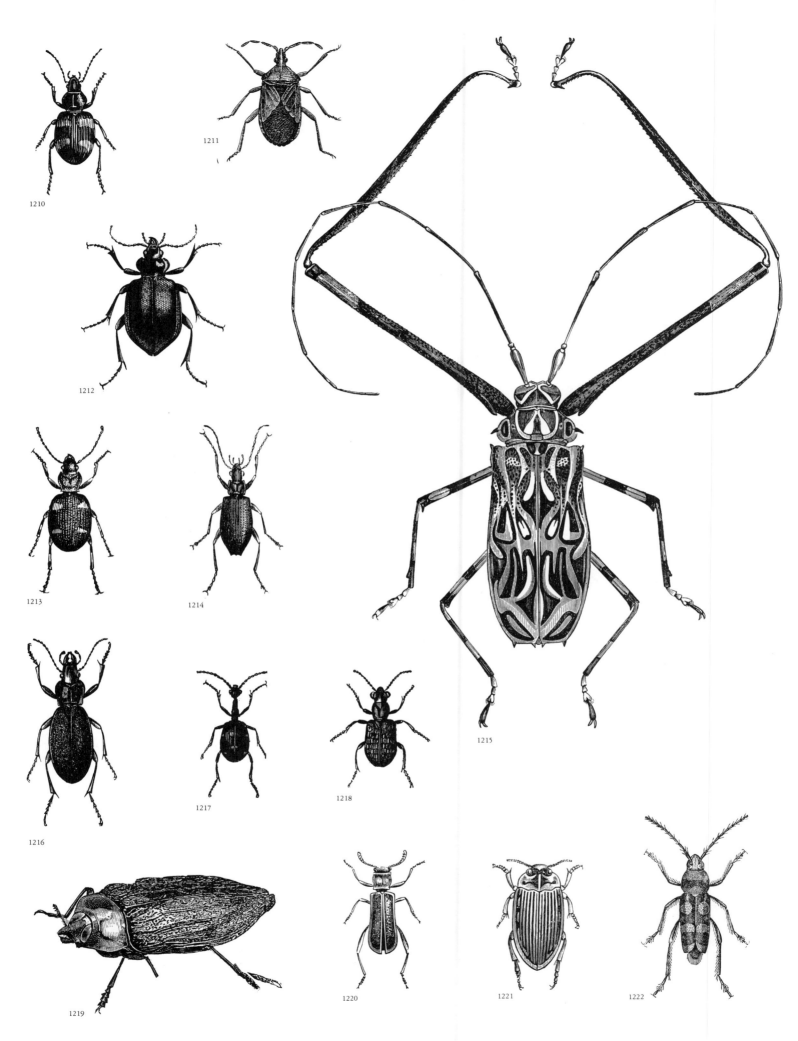

**INSECTS.** 1210, 1211, 1213, 1214, 1216–1218, 1220–1222: Unidentified insects. **1212:** Pupa-predator. **1215:** Harlequin longhorn. **1219:** *Euchroma gigantea*, a species of splendour beetle.

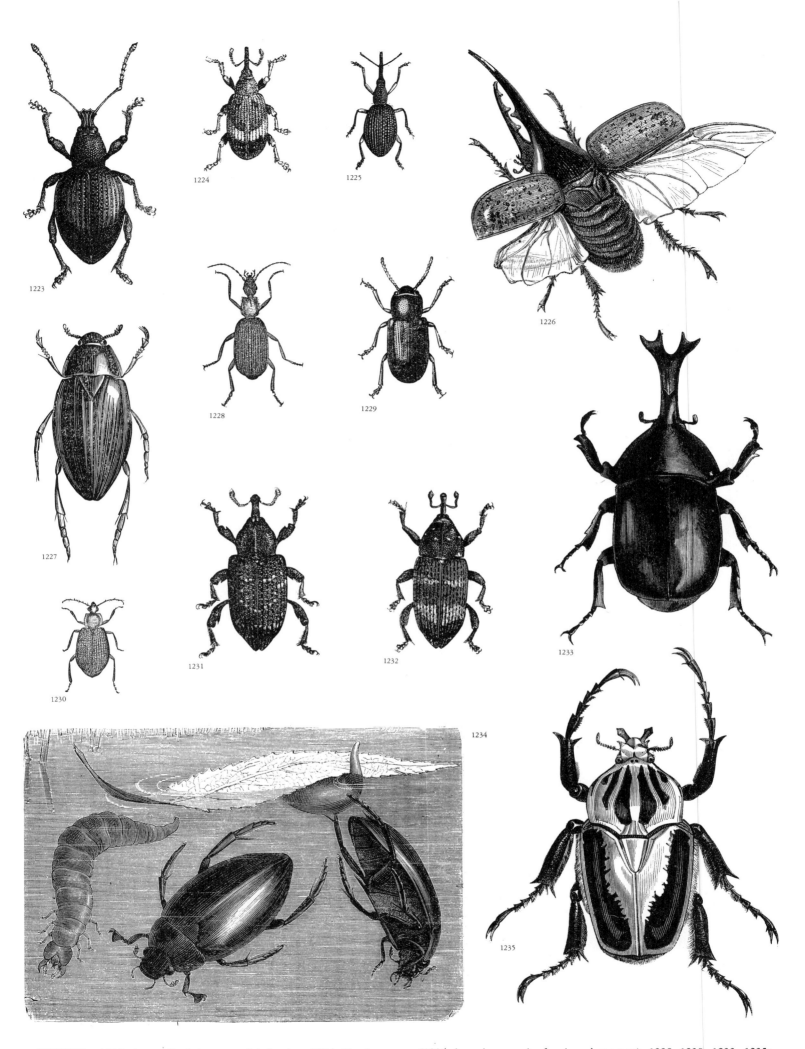

**INSECTS.** 1223: A weevil of the genus *Otiorhynchus*. 1224: Hazel-nut weevil. 1225, 1232: Other species of weevils. 1226: A species of rhinoceros beetle. 1227, 1234: Water-scavenger beetles of the family Hydrophilidae (1234 shows larva, male, female and egg nest). 1228–1230, 1233, 1235: Unidentified insects. 1231: Great brown weevil.

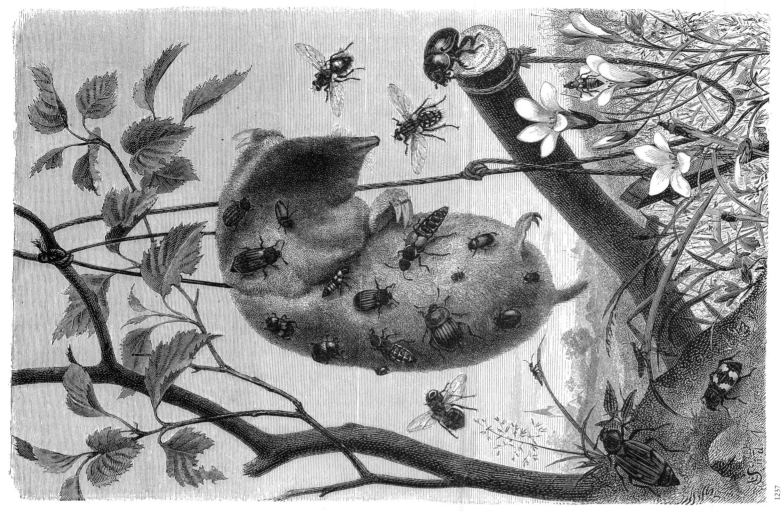

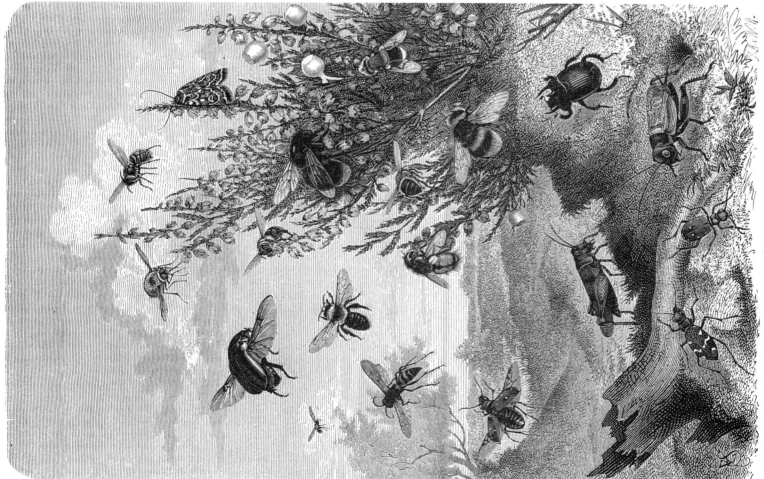

**INSECTS.** 1236: Insects among the heather: bees, bumblebees, moth, beetles, cricket, grasshopper. 1237: Insect scavengers on a dead mole.

248

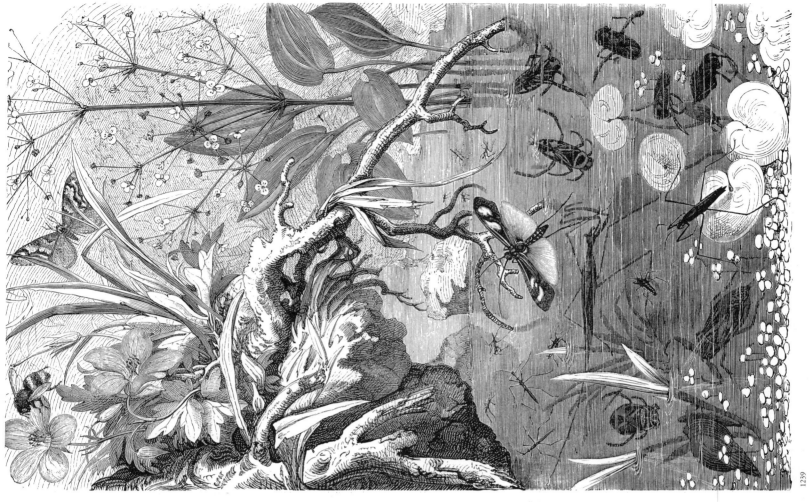

1239

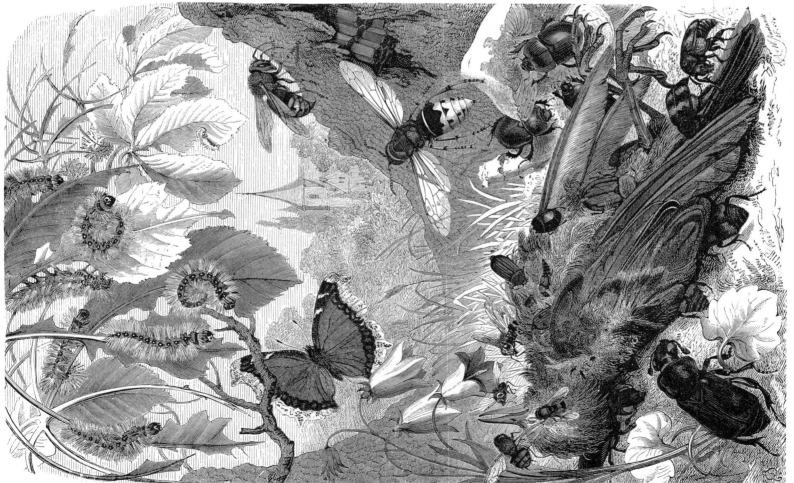

1238

**INSECTS. 1238:** Insect communal labor: burying beetles, moth larvae, hornets, spring dor beetles. **1239:** Aquatic insects found in Germany.

249

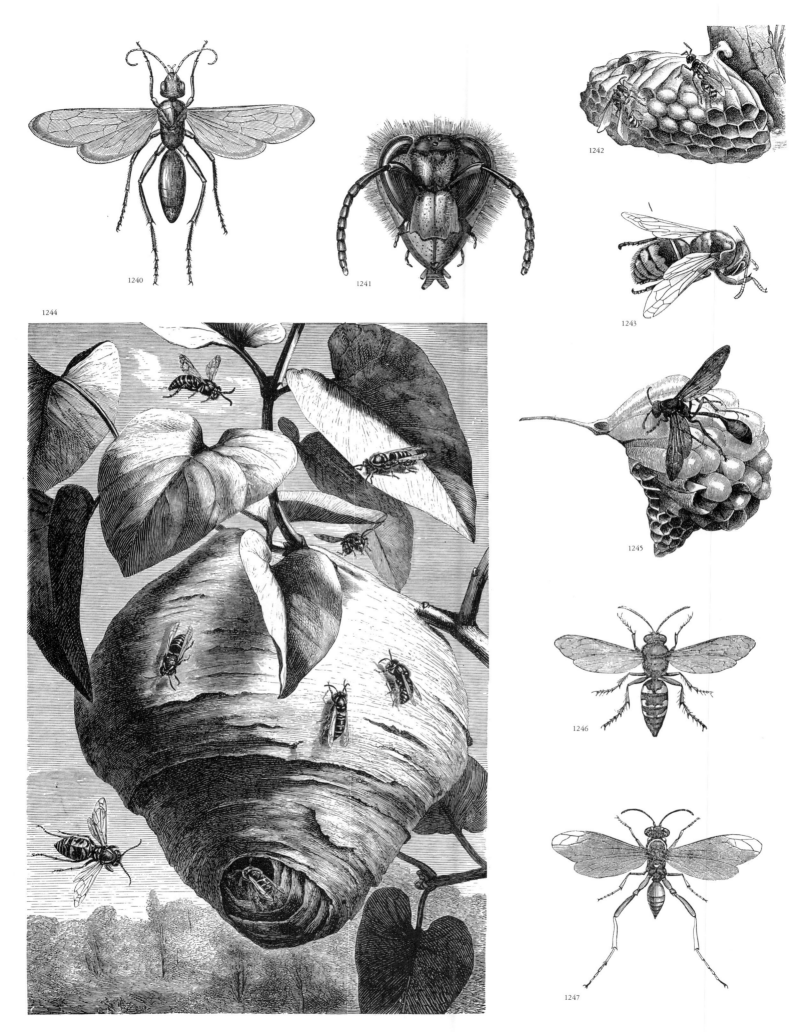

**INSECTS.** **1240:** Type of winged ant (?). **1241:** Head of a hornet. **1242:** Female wasps of the genus *Polistes* at their nest. **1243:** Hornet. **1244:** Types of wasps at their nest. **1245–1247:** Wasps or allies.

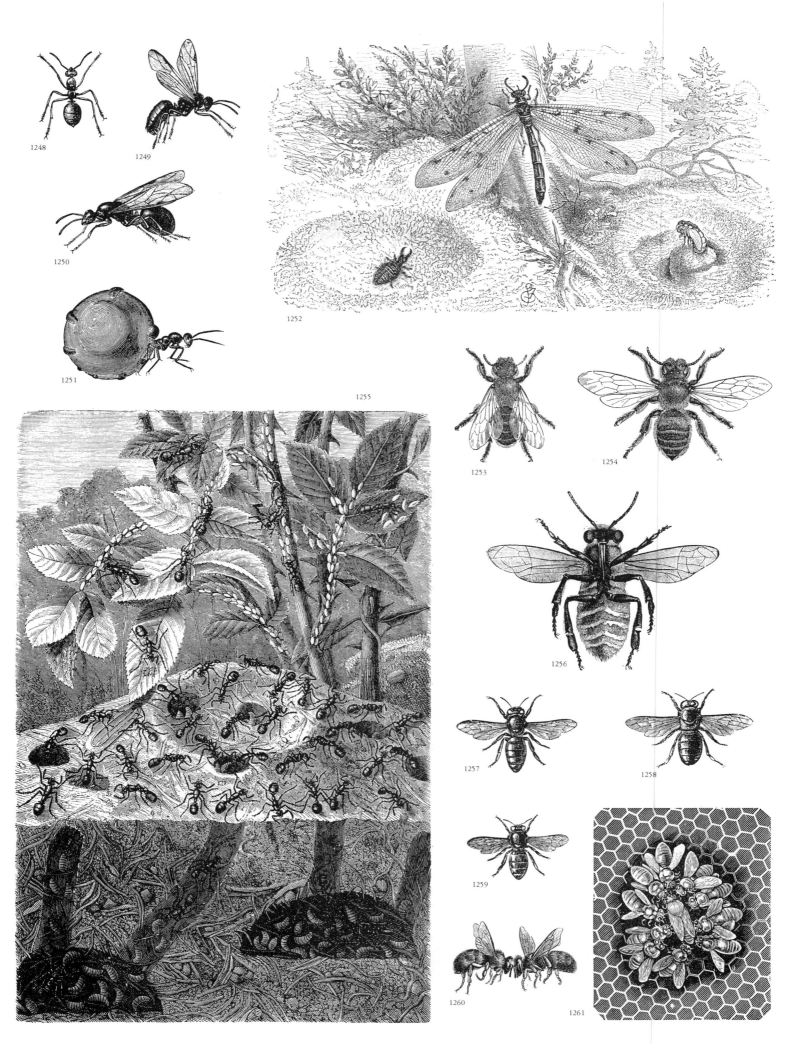

**INSECTS. 1248–1250:** Red wood ant (worker, male and female, respectively). **1251:** Type of ant. **1252:** Spotted ant-lion. **1253 & 1254:** Leaf-cutter bees (male and female, respectively). **1255:** Section of an ant hill. **1256:** A species of bee. **1257–1261:** Honey-bees (1257–1259 show queen, male and worker, respectively).

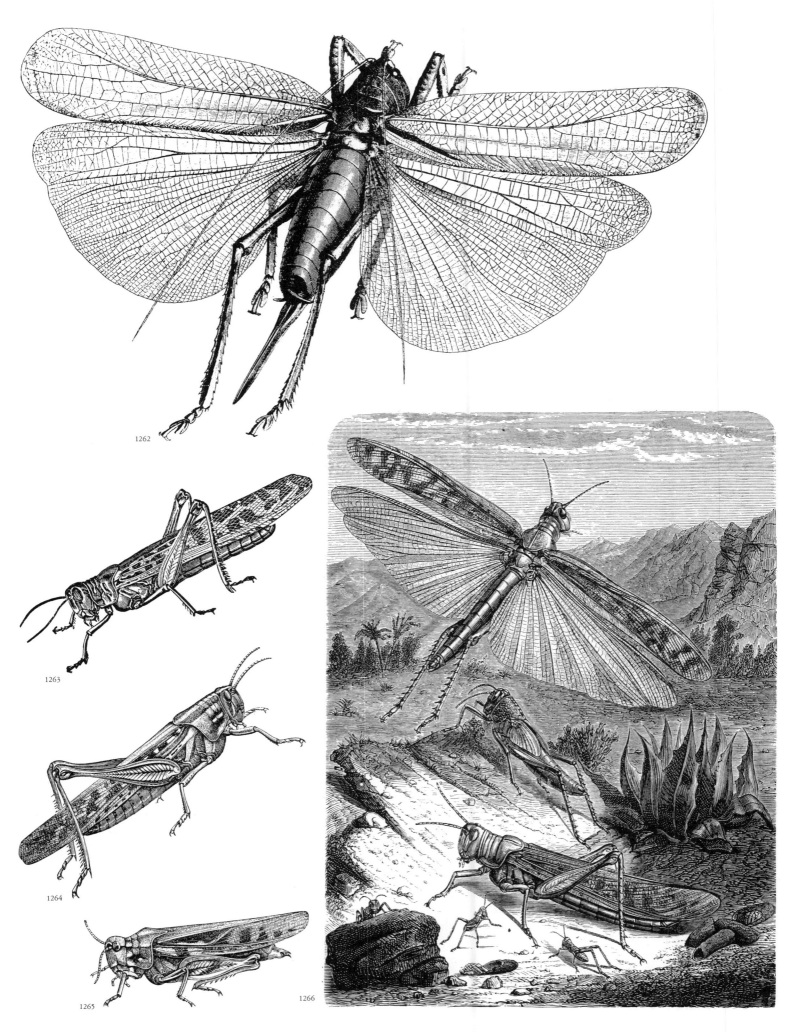

**INSECTS.** 1262–1266: Locusts and grasshoppers.

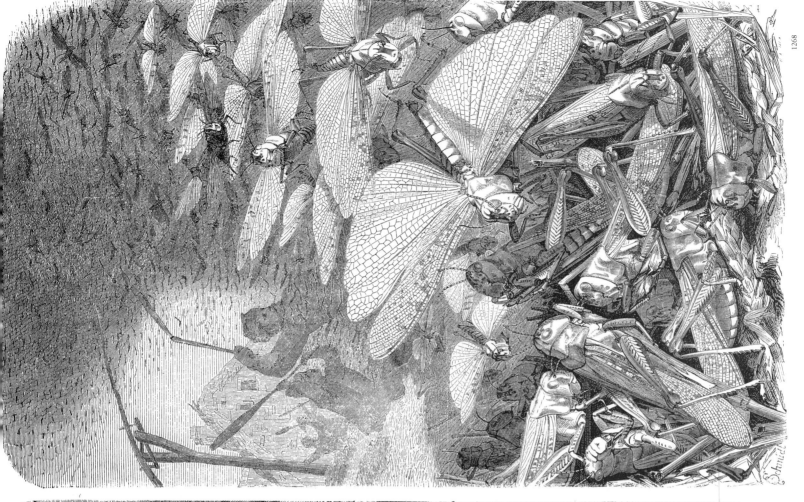

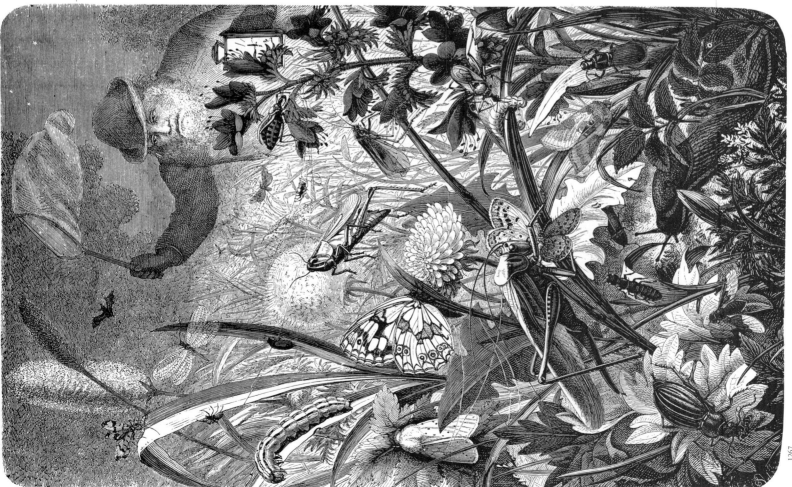

INSECTS. 1267: Nocturnal activity of insects. 1268: Swarm of locusts.

1268

1267

253

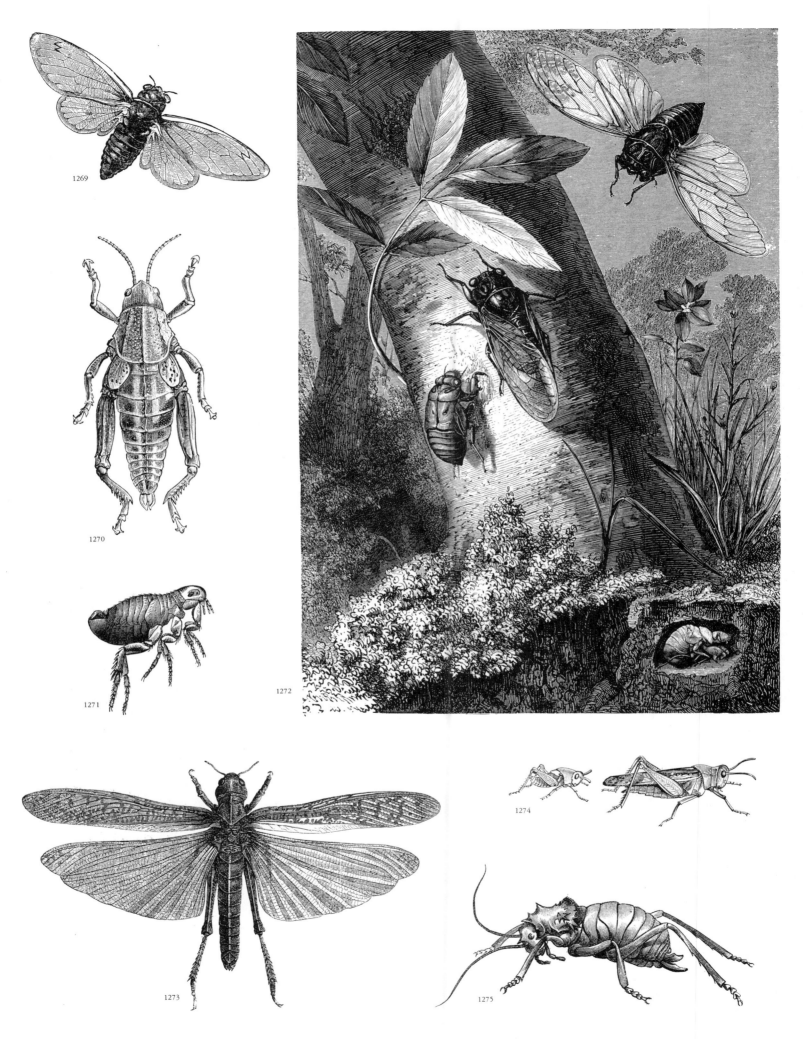

**INSECTS.** 1269, 1270, 1275: Unidentified insects. 1271: Human flea.
1272: Metamorphosis of cicadas. 1273: Locust. 1274: Young and adult
grasshoppers.

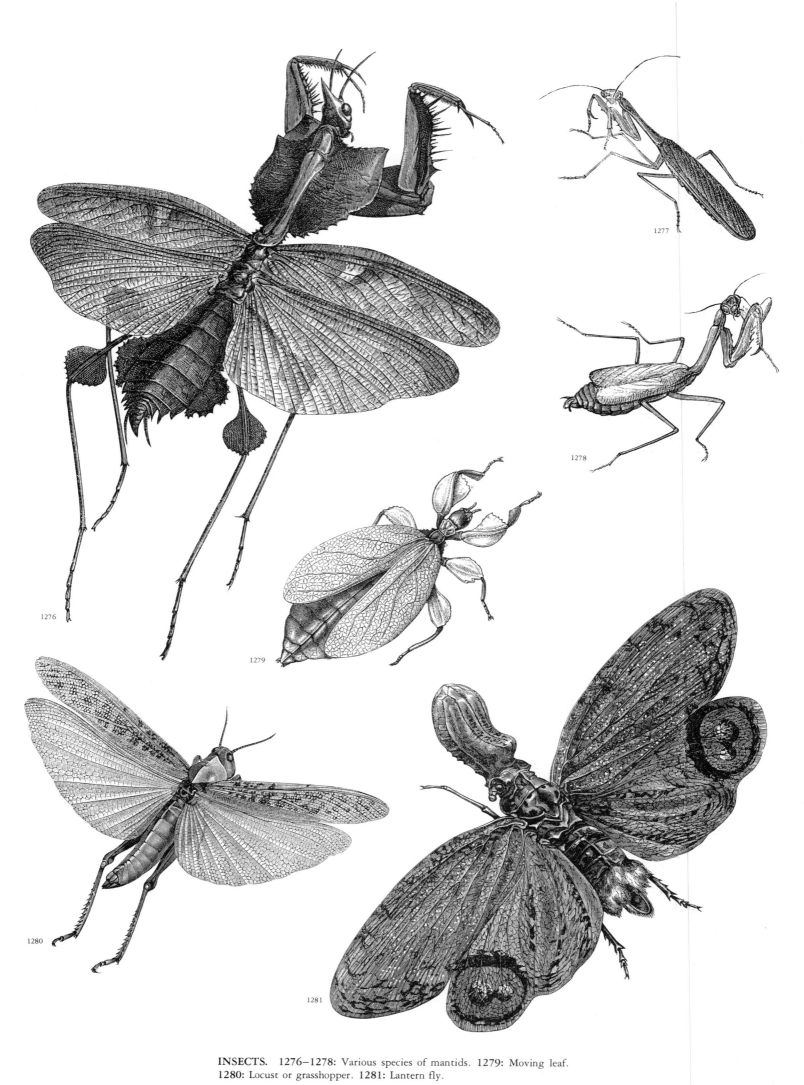

**INSECTS.** 1276–1278: Various species of mantids. 1279: Moving leaf.
1280: Locust or grasshopper. 1281: Lantern fly.

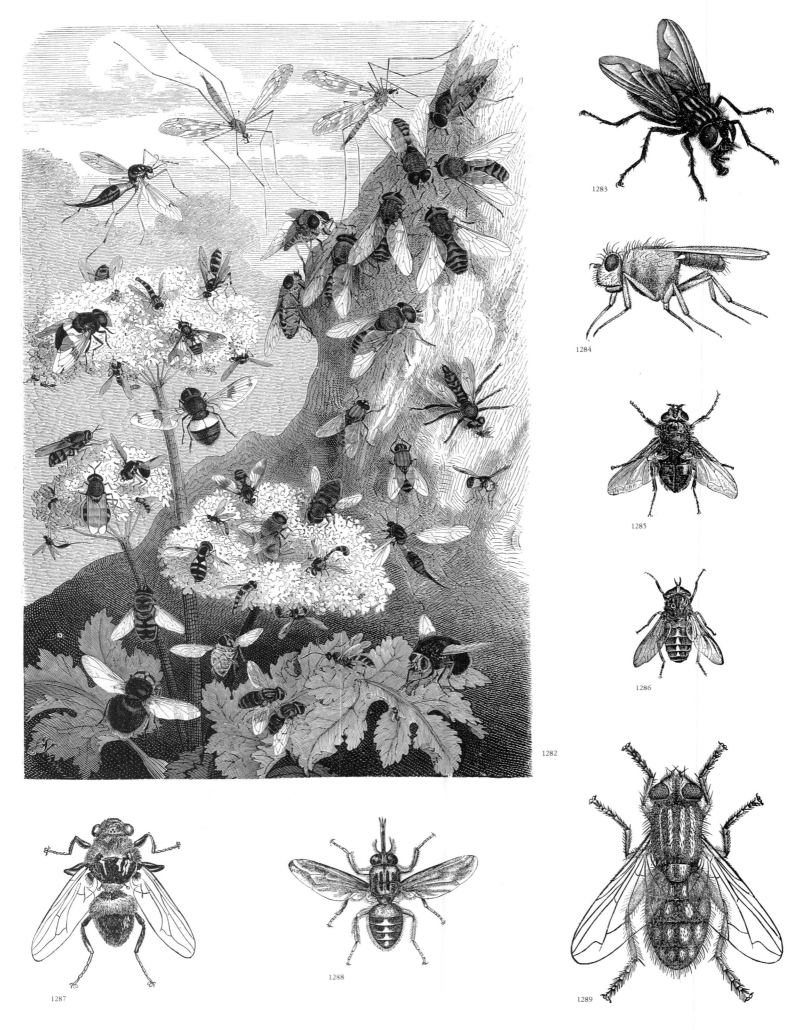

**INSECTS.** 1282: Many types of flies. 1283: Common housefly. 1284, 1289: Types of fly. 1285: A blow fly, or bluebottle, of the family Calliphoridae. 1286: Common gadfly. 1287: A species of bot fly. 1288: Tsetse fly.

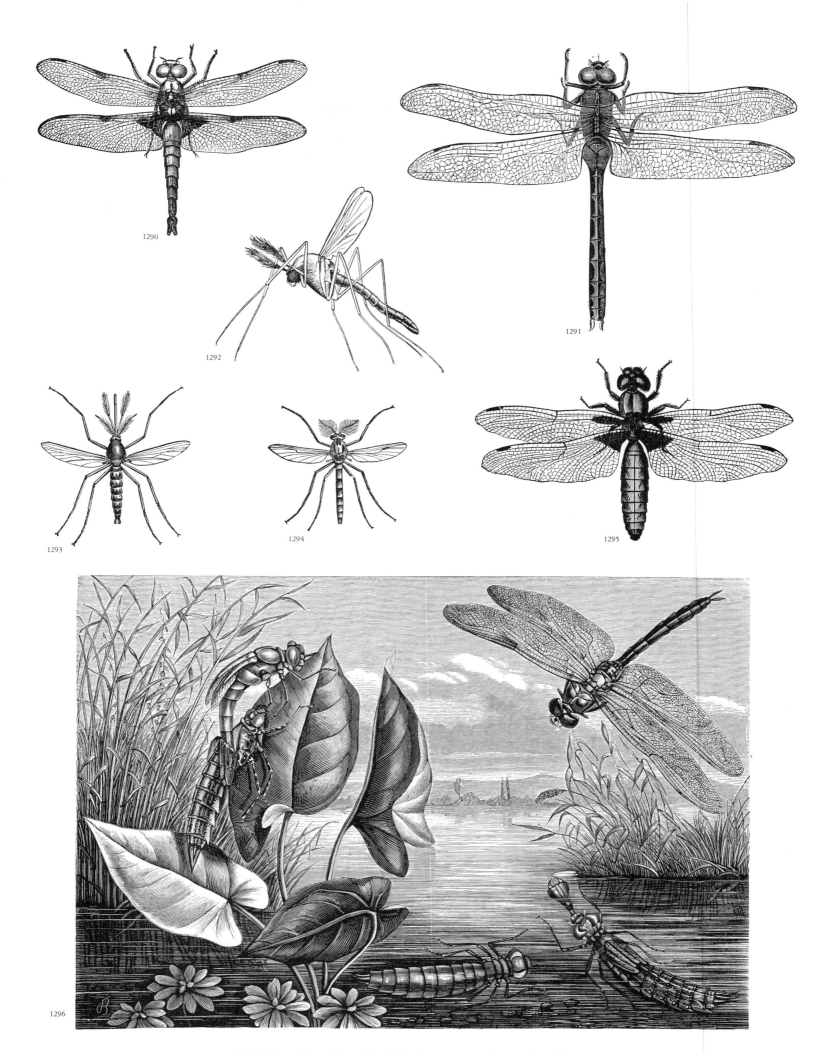

**INSECTS.** 1290, 1291, 1295, 1296: Various species of dragonfly. 1292: A species of mosquito (?). 1293 & 1294: Midges.

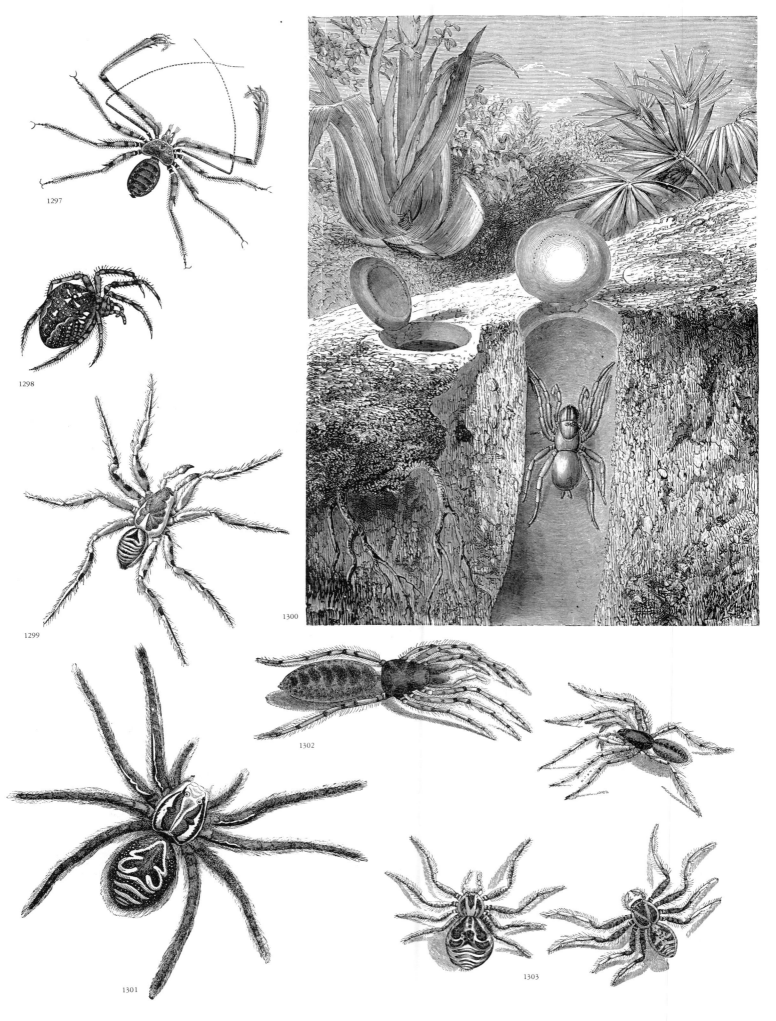

**OTHER INVERTEBRATES. 1297:** A species of whip spider (?). **1298:** Female garden spider. **1299, 1301:** Tarantula. **1300:** A type of trapdoor spider. **1302:** Male and female of an unidentified species of spider. **1303:** A species of crab spider.

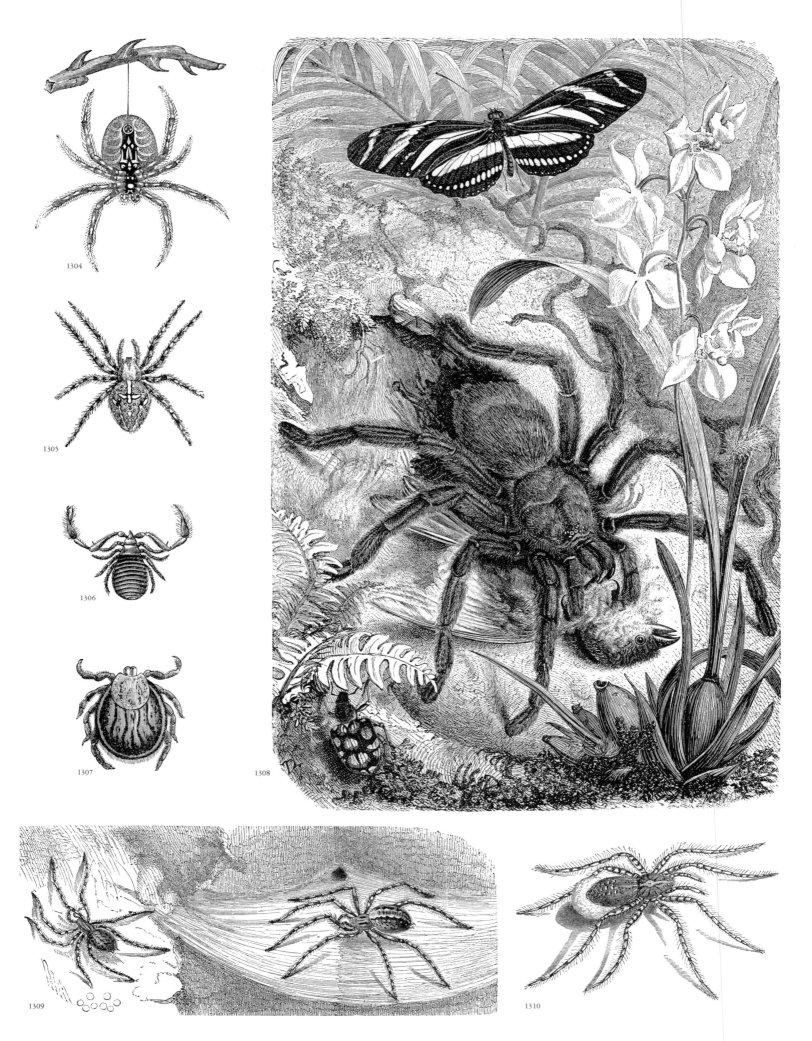

**OTHER INVERTEBRATES.** **1304 & 1305:** Garden spider. **1306:**
Species of tick (?). **1307:** A wood tick of the genus *Ixodes*. **1308:** Bird spider.
**1309, 1310:** Unidentified spiders.

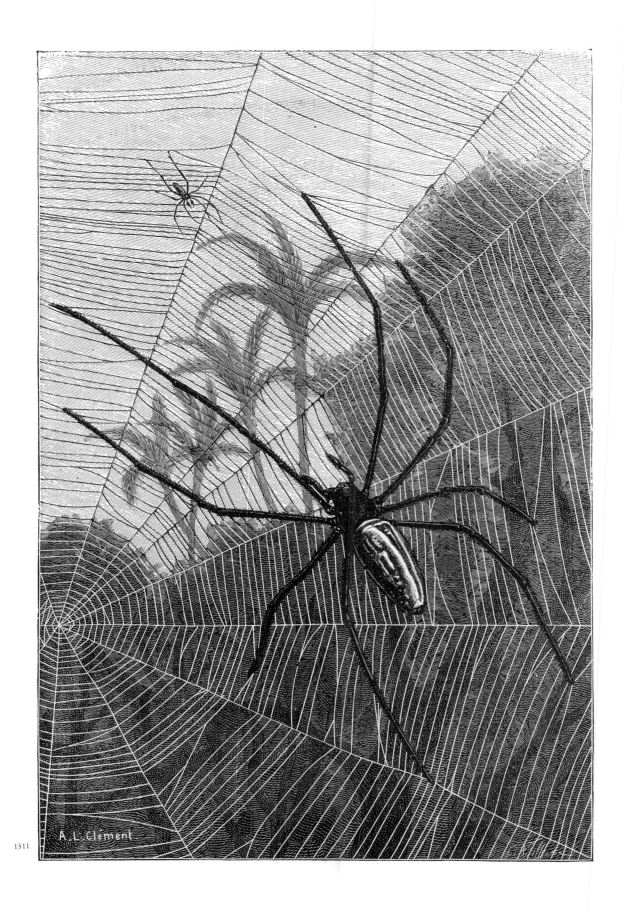

**OTHER INVERTEBRATES.** 1311: A silk spider from Malaysia of the genus *Nephila* (male above, female below).

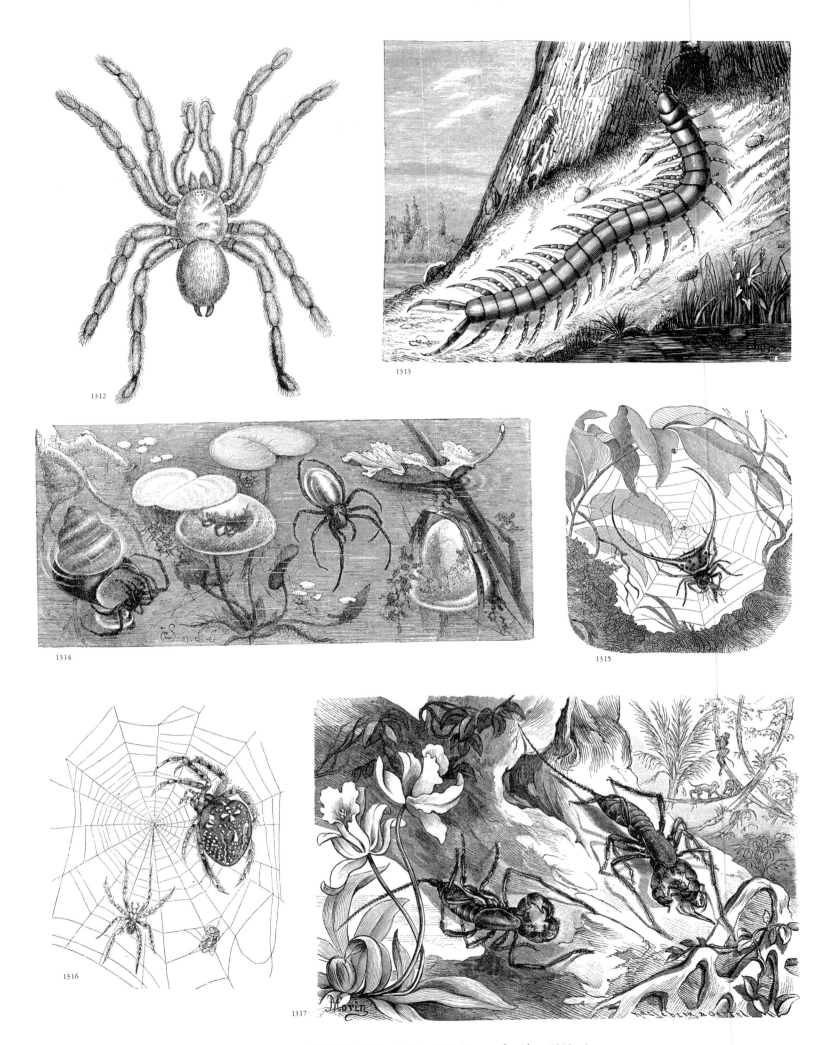

**OTHER INVERTEBRATES.** 1312, 1315: Types of spider. 1313: A species of centipede. 1314: A species of water spider. 1316: Garden spider. 1317: Whip scorpions of the family Theliphonidae.

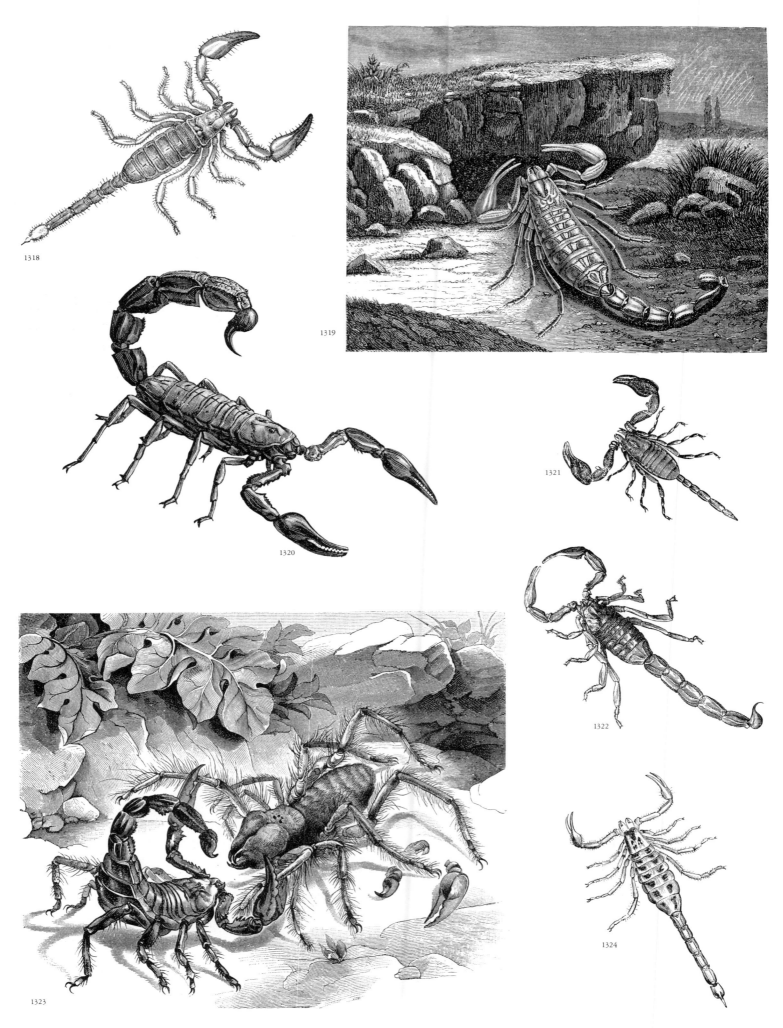

**OTHER INVERTEBRATES.** 1318–1322, 1324: Types of scorpion.
1323: Battle between a scorpion and a common barrel spider.

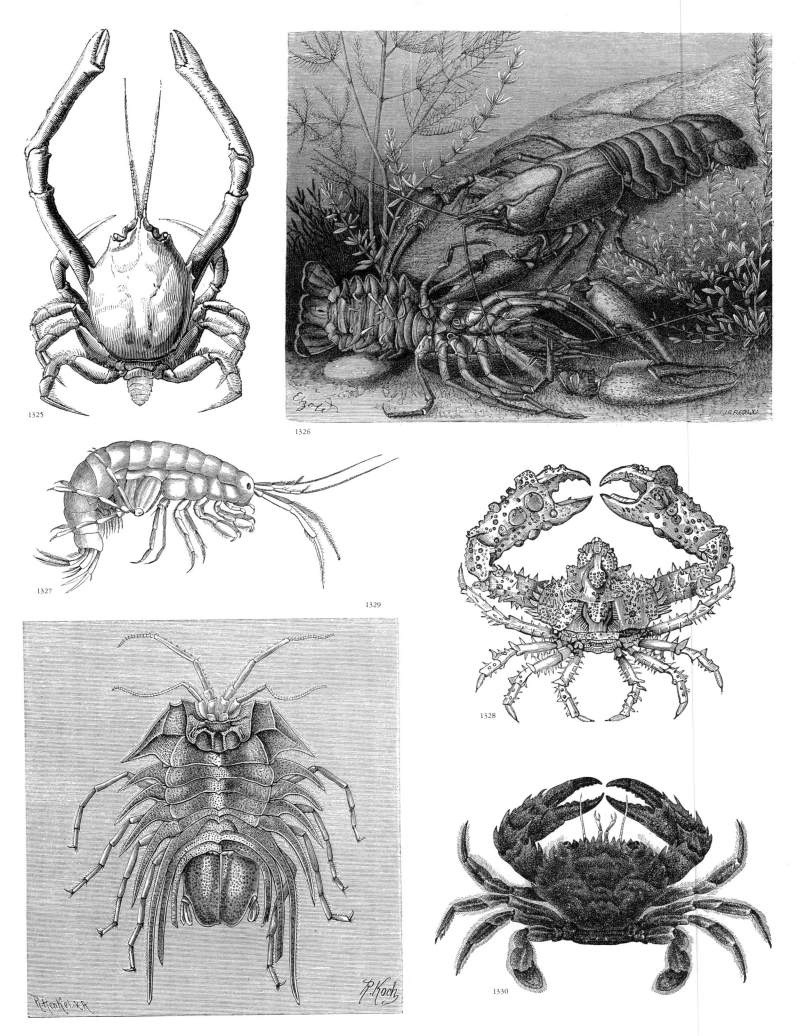

**OTHER INVERTEBRATES.** 1325, 1327–1330: Various crabs and other crustacea. 1326: A species of freshwater crayfish.

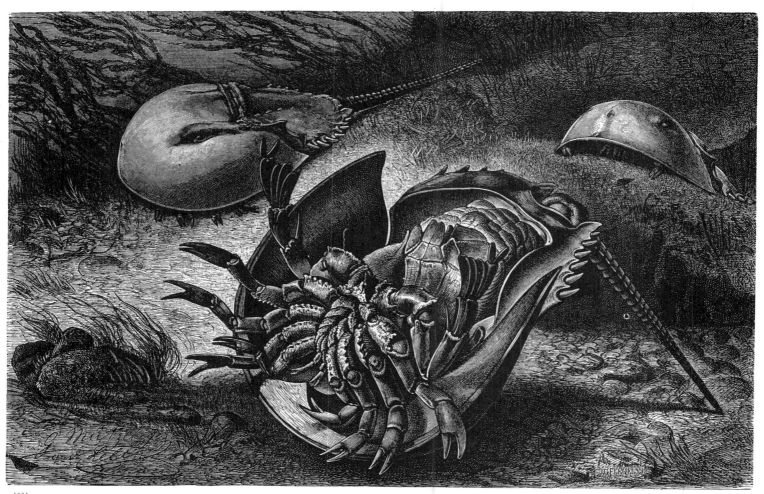

1331

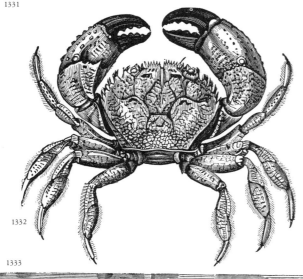

1332

1333

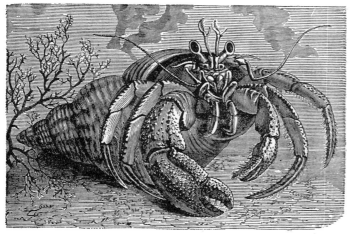

1334

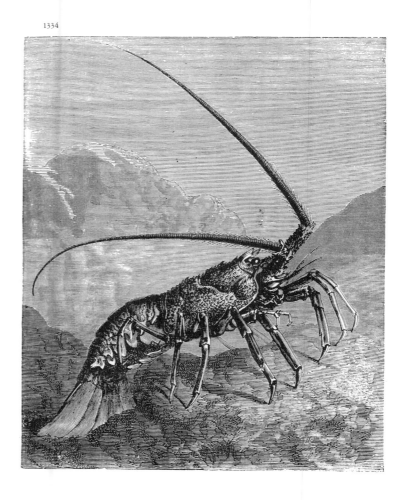

**OTHER INVERTEBRATES.** 1331: Horseshoe, or king, crabs. 1332: Type of crab. 1333: Hermit crab. 1334: Spiny lobster.

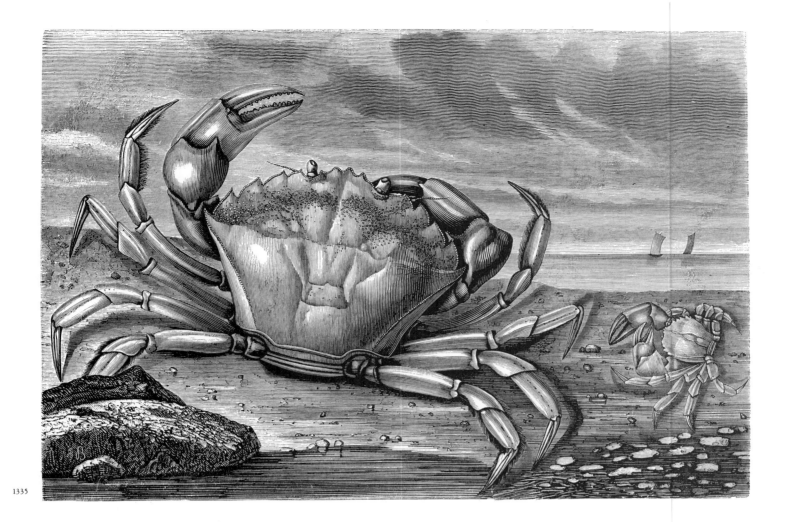

1335

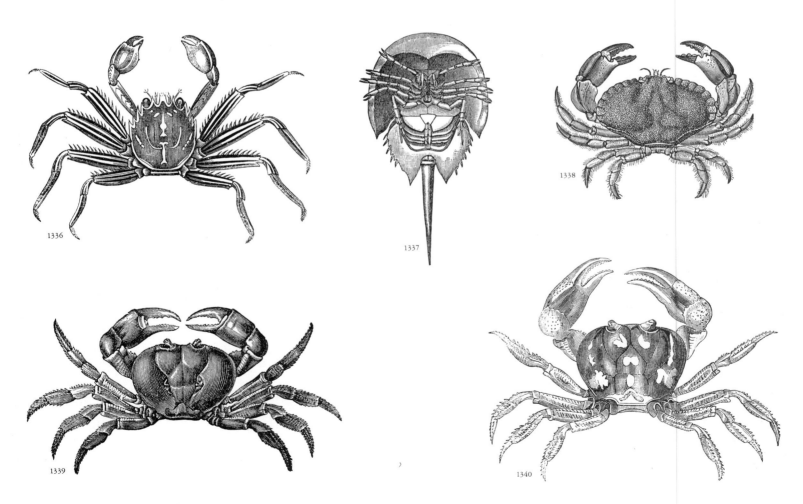

1336

1337

1338

1339

1340

**OTHER INVERTEBRATES.**  1335, 1336, 1338: Types of crab. 1337:
Horseshoe, or king, crab. 1339 & 1340: Two species of land crabs.

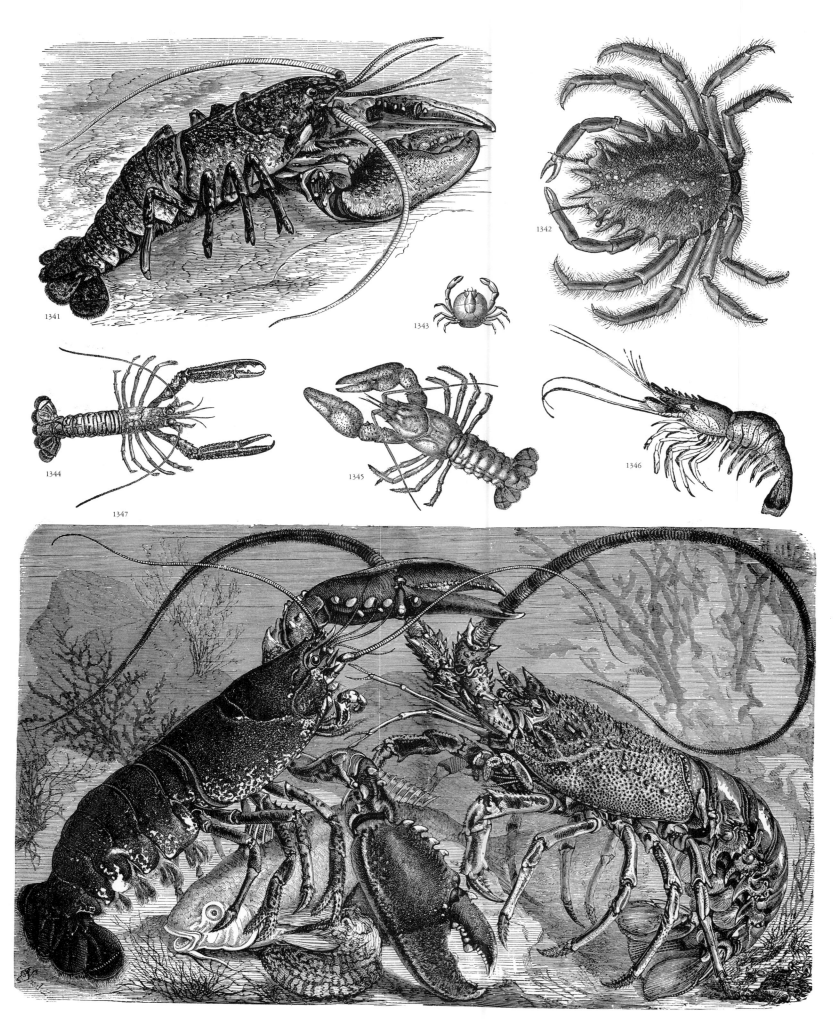

**OTHER INVERTEBRATES.** 1341, 1345: Common lobster. 1342: A species of spider crab. 1343: A species of pea crab. 1344: A type of lobster. 1346: A species of shrimp. 1347: Common lobster and spiny lobster.

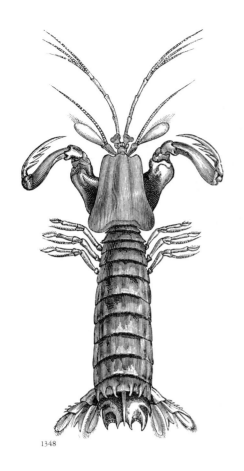

1348

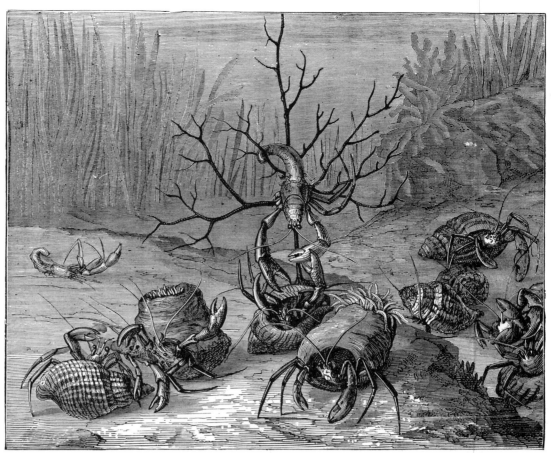

1349

1350

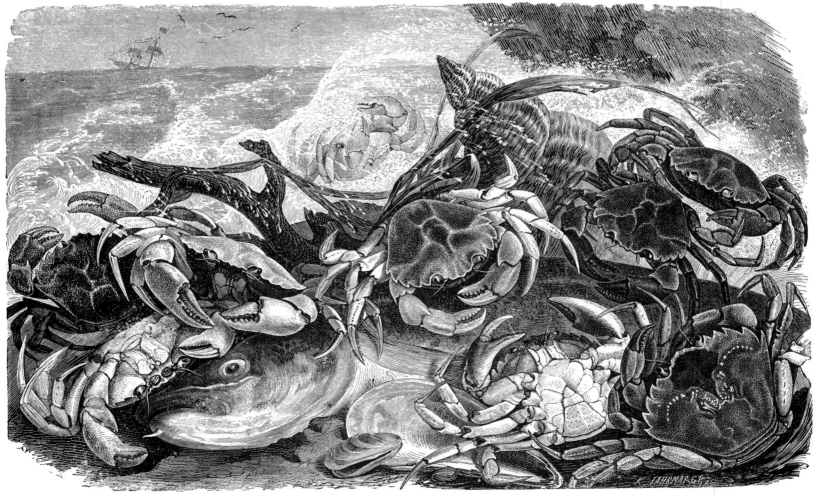

**OTHER INVERTEBRATES.** 1348: A species of squilla, or mantis crab.
1349: Hermit crabs. 1350: Crabs.

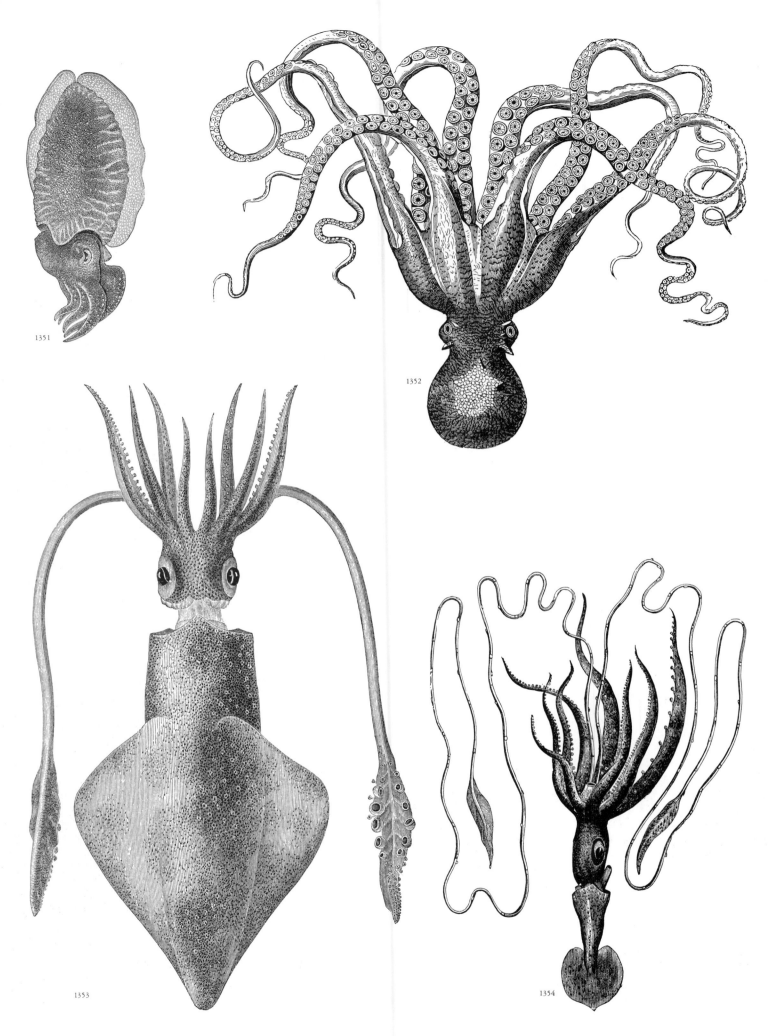

**OTHER INVERTEBRATES.** 1351: Male of the common European cuttlefish. 1352: A species of octopus. 1353: Common European squid. 1354: A species of squid.

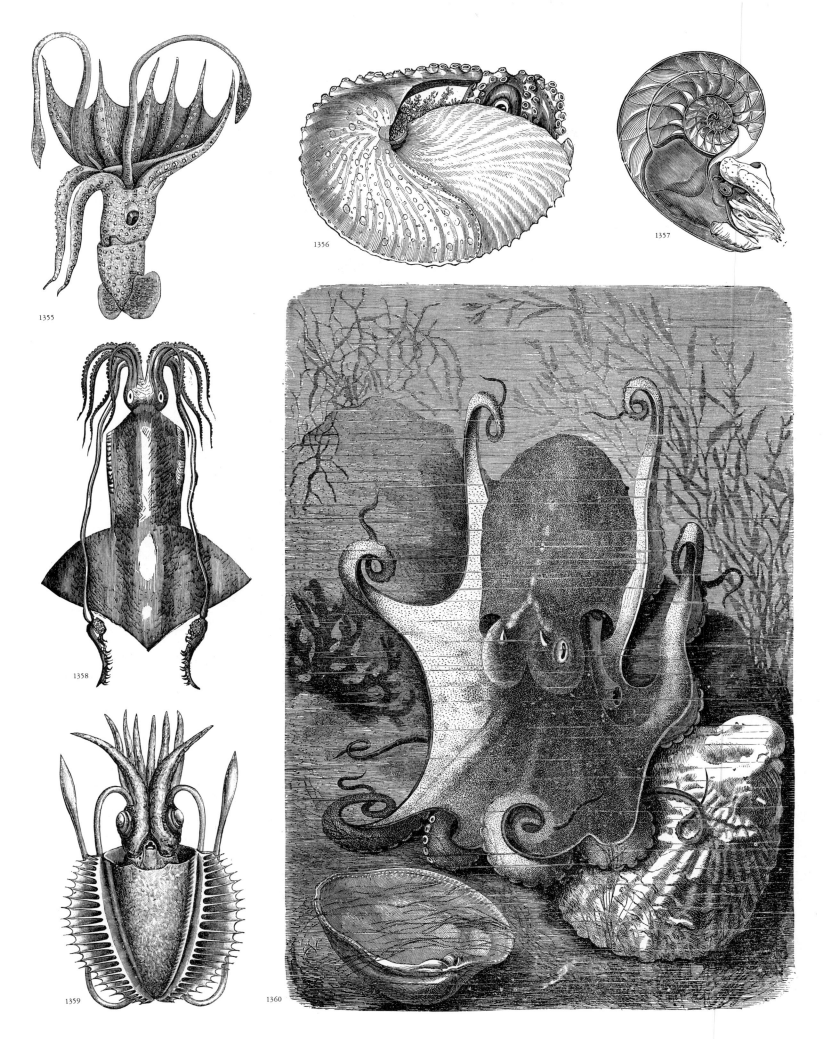

**OTHER INVERTEBRATES.** 1355, 1358, 1359: Three species of squid.
1356: Paper nautilus. 1357: Pearly nautilus. 1360: Musk poulp.

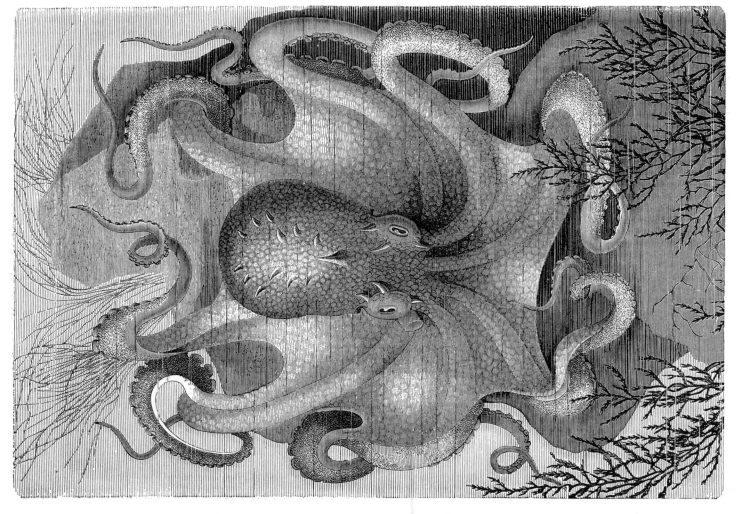

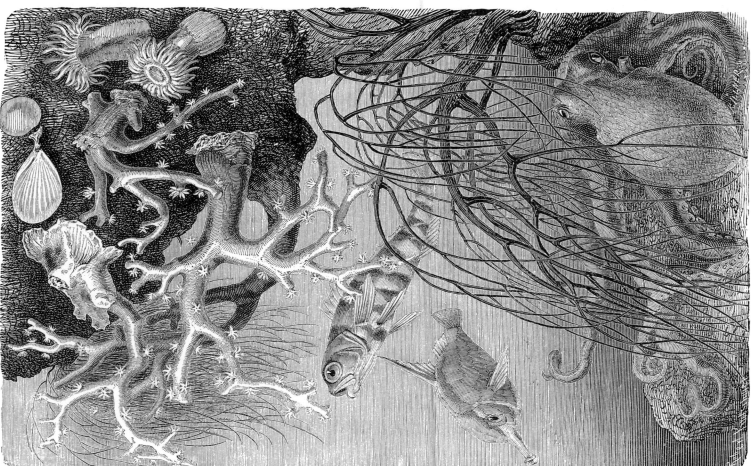

**OTHER INVERTEBRATES.** 1361: Fauna of a coral reef. 1362: Common European octopus.

1362

1361

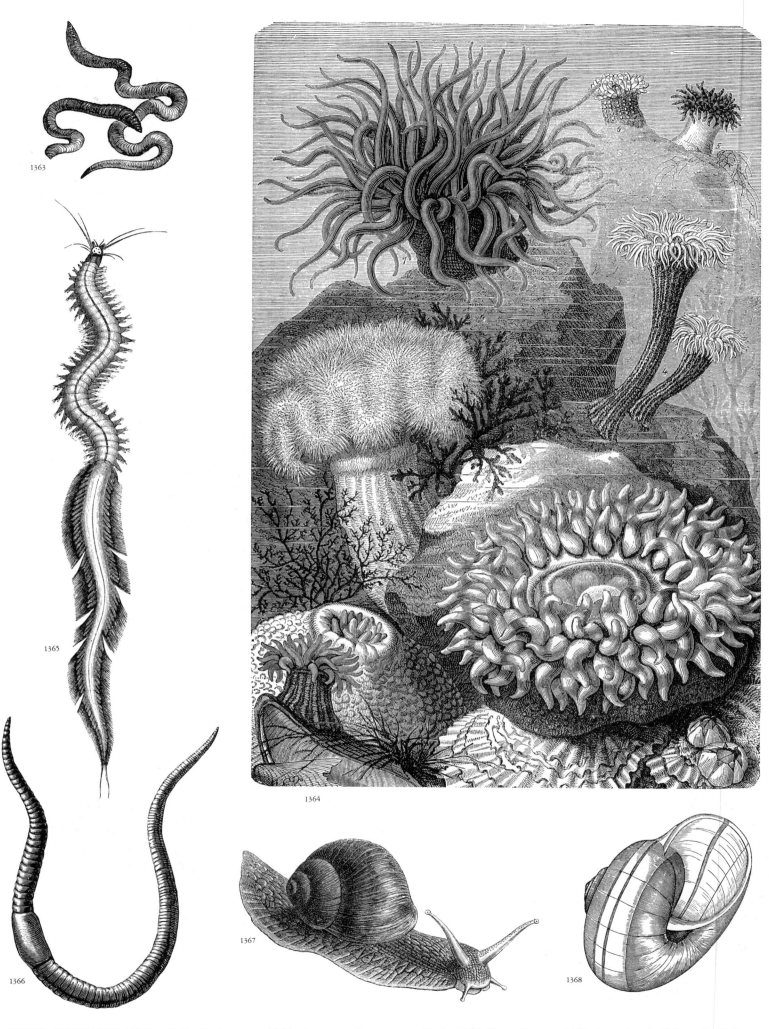

**OTHER INVERTEBRATES.** 1363: Earthworms. 1364: A group of European sea anemones. 1365: The heteronereis of a marine worm of the genus *Nereis*. 1366: Type of worm. 1367: A species of edible snail. 1368: Shell of a snail of the genus *Helix*.

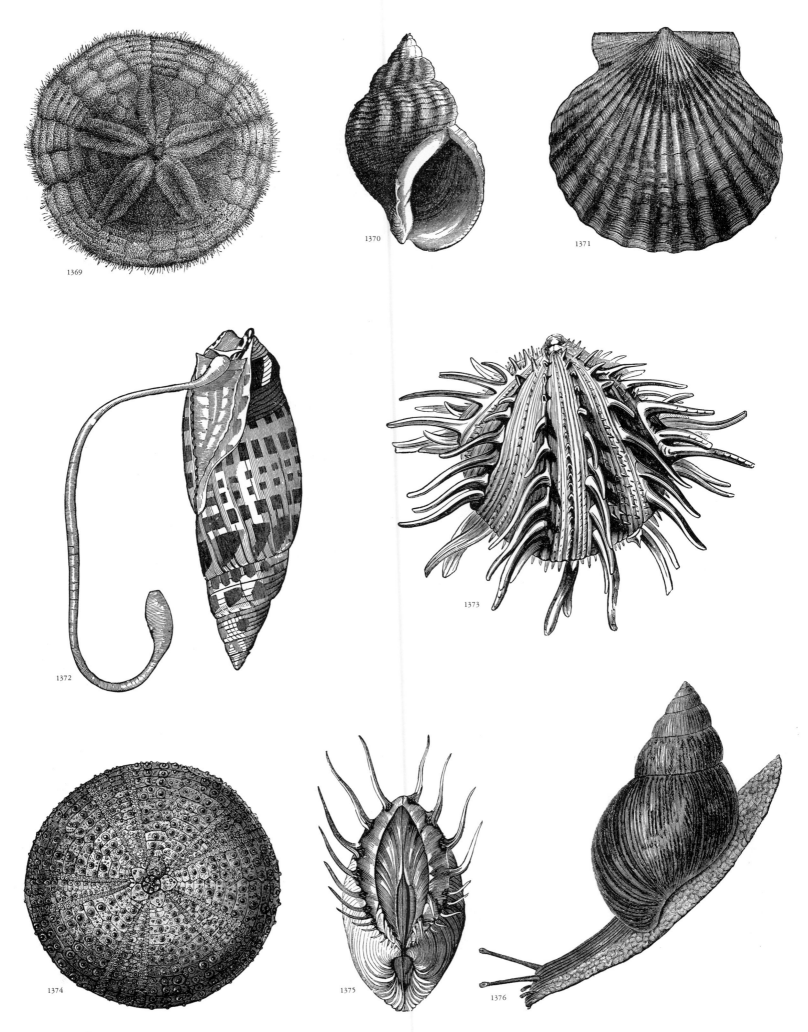

**OTHER INVERTEBRATES.** 1369: Sand dollar. 1370: A species of whelk. 1371: Shell of a species of edible scallop. 1372: A species of miter shell. 1373: A species of thorny oyster. 1374, 1375: Unidentified invertebrates. 1376: A species of agate snail.

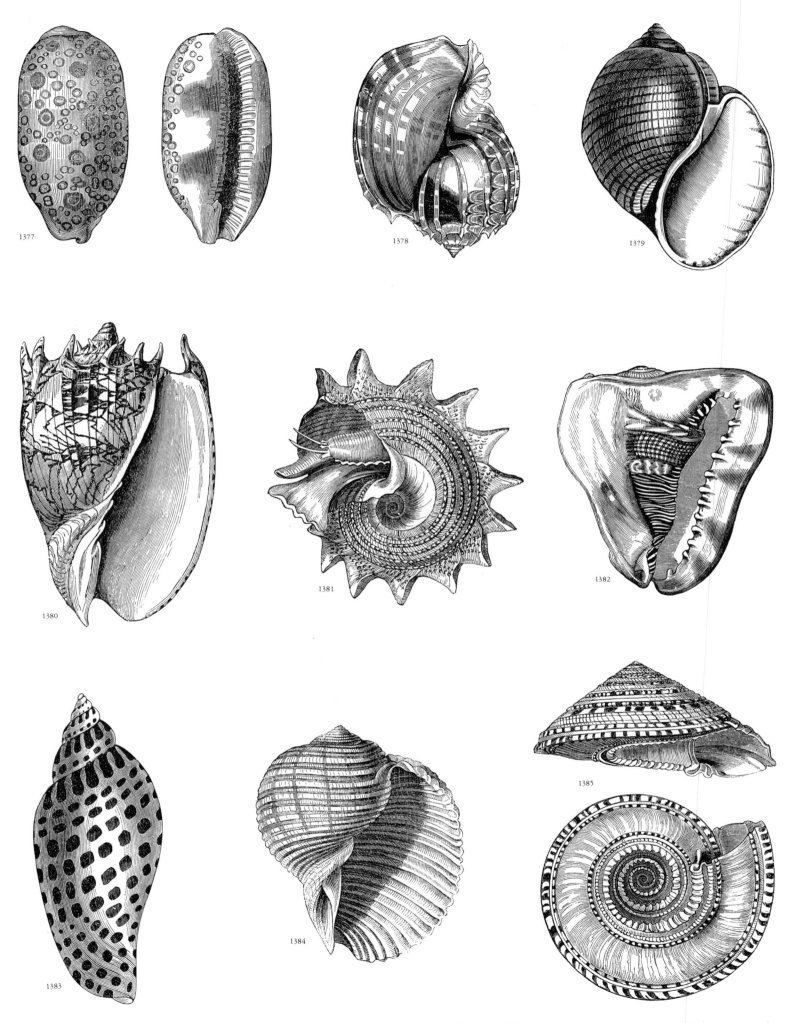

**OTHER INVERTEBRATES.** **1377**: A species of cowry. **1378, 1381**: Unidentified mollusks. **1379**: A species of apple shell. **1380, 1383**: Two species of volute. **1382**: A mollusk of the genus *Cassis*. **1384**: A species of dolium. **1385**: A species of solarium.

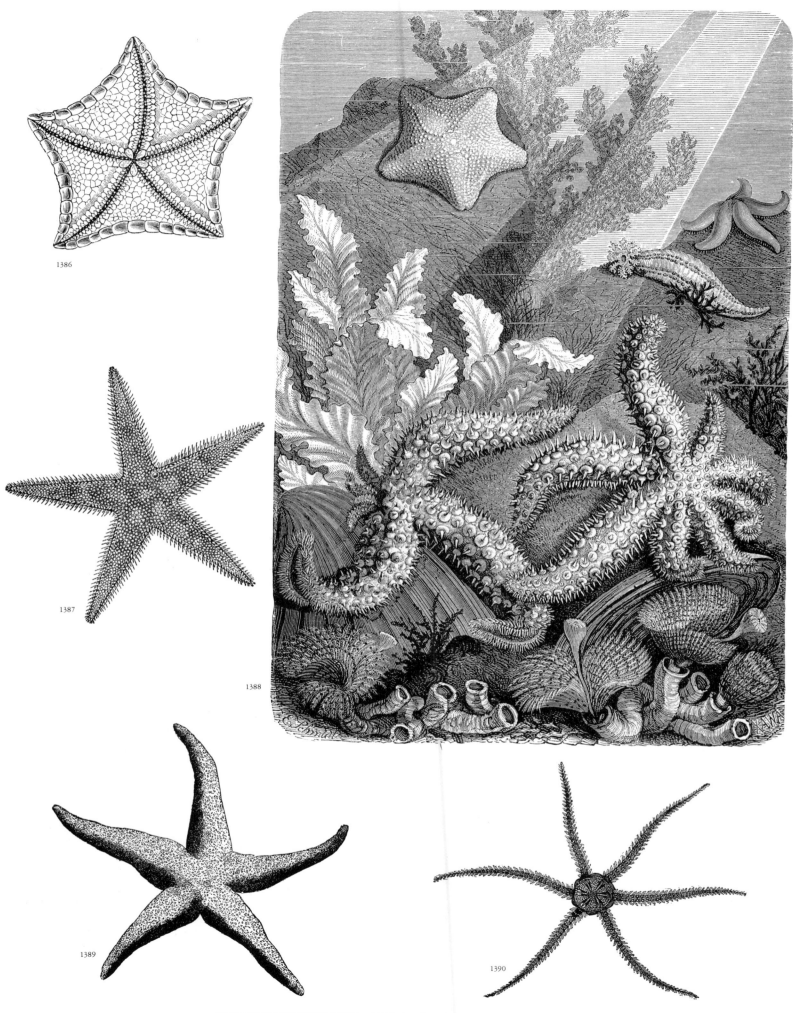

**OTHER INVERTEBRATES.** 1386: Starfish of the genus *Asterias*. 1387,
1389: Other species of starfish. 1388: A varied group of echinoderms. 1390:
Sand star, or brittle star.

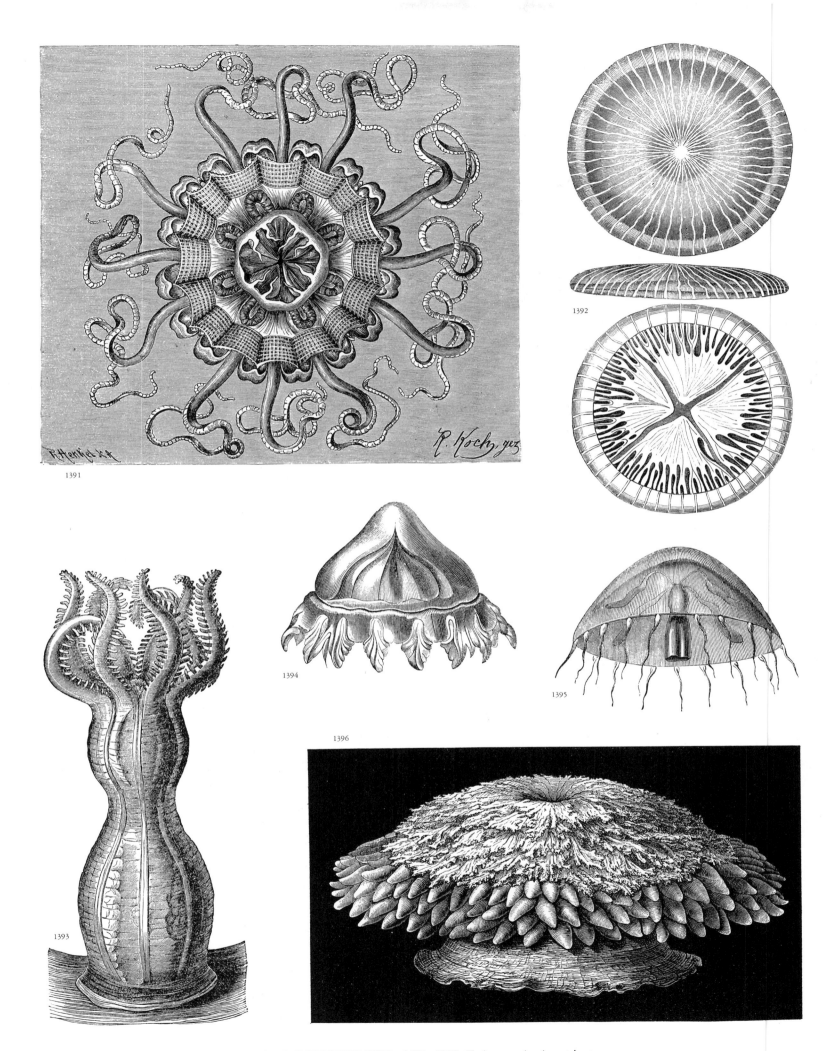

**OTHER INVERTEBRATES.** 1391–1395: Various marine invertebrates
(jellyfish, etc). 1396: A species of sea anemone (?).

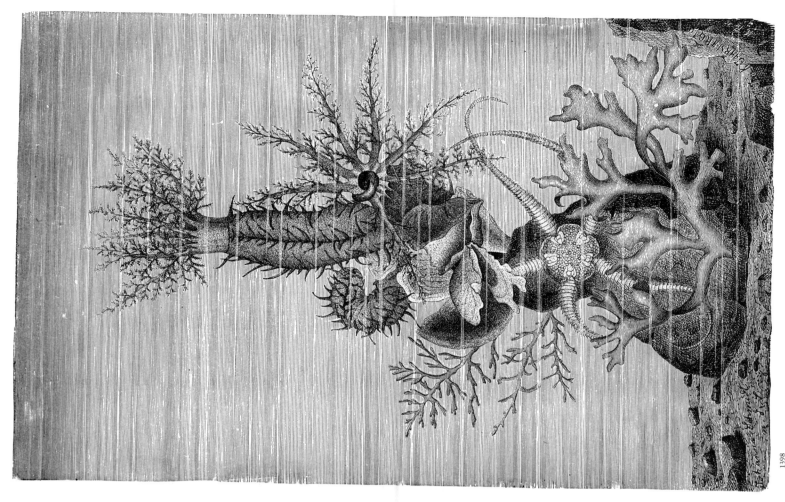

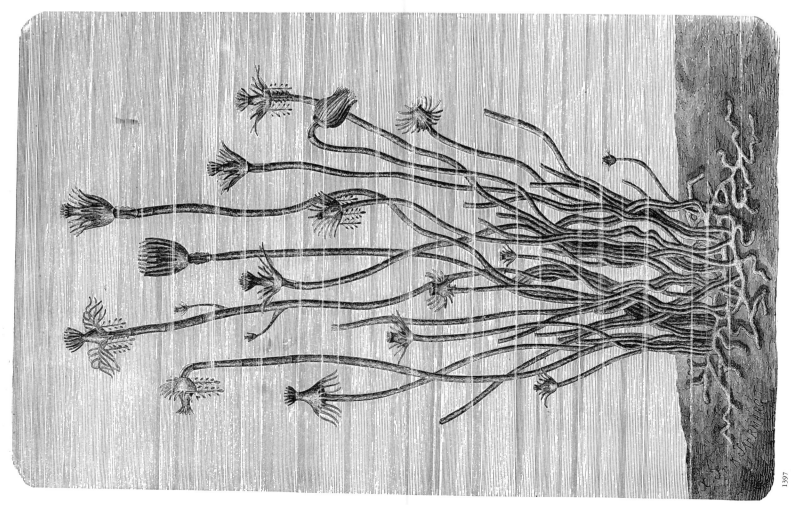

**OTHER INVERTEBRATES.** 1397: A hydroid of the genus *Tubularia*.
1398: A species of sea cucumber.

276

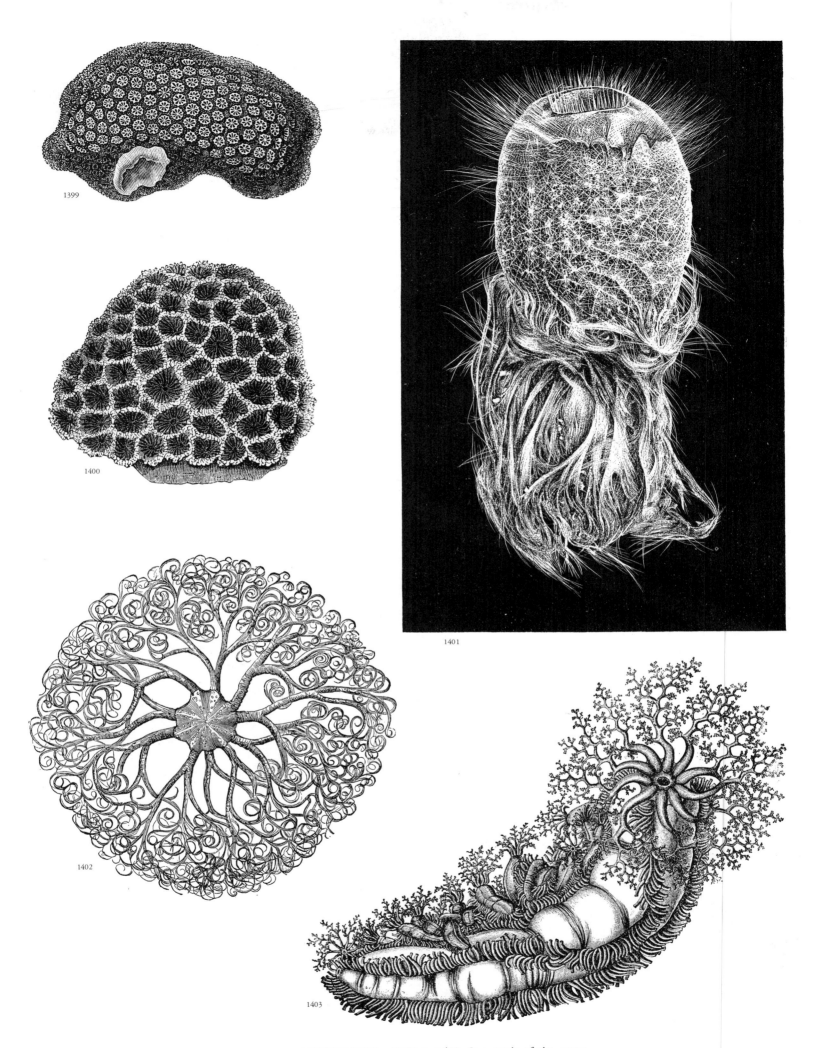

**OTHER INVERTEBRATES.** 1399 & 1400: Star corals of the genus
*Astraea*. 1401–1403: Unidentified invertebrates.

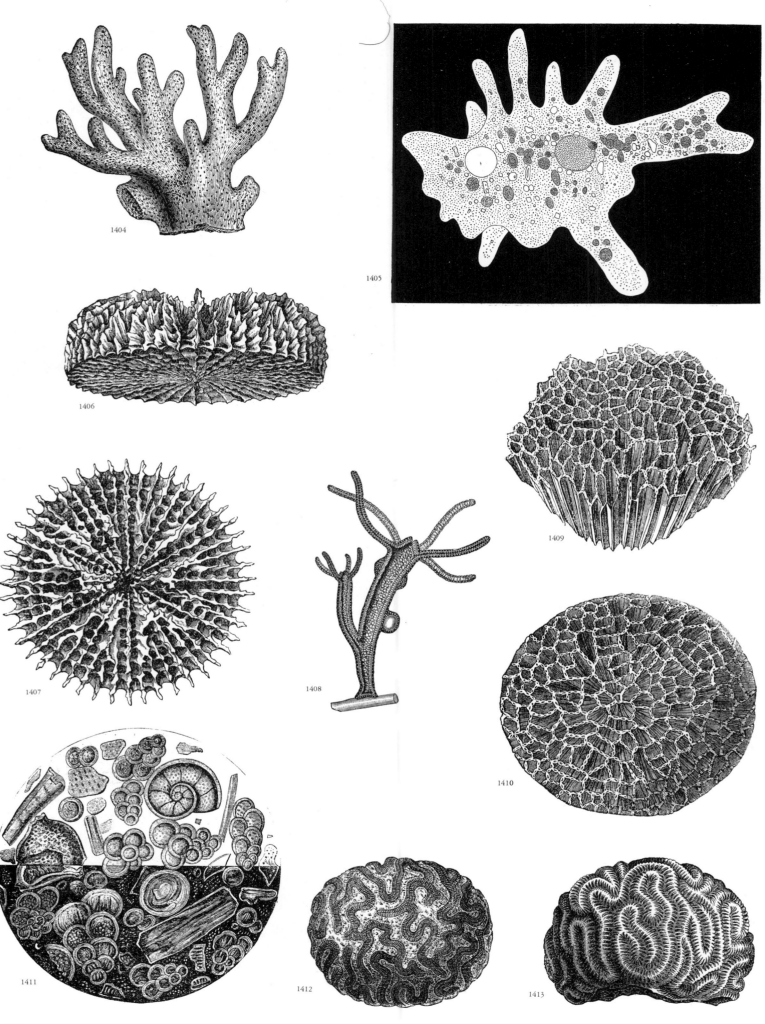

**OTHER INVERTEBRATES.** 1404: A species of coral. 1405: A species of amoeba. 1406 & 1407: A stony coral of the species *Fungia*. 1408: A species of hydra. 1409, 1410, 1412, 1413: Unidentified invertebrates. 1411: Group of prehistoric foraminifers.

278

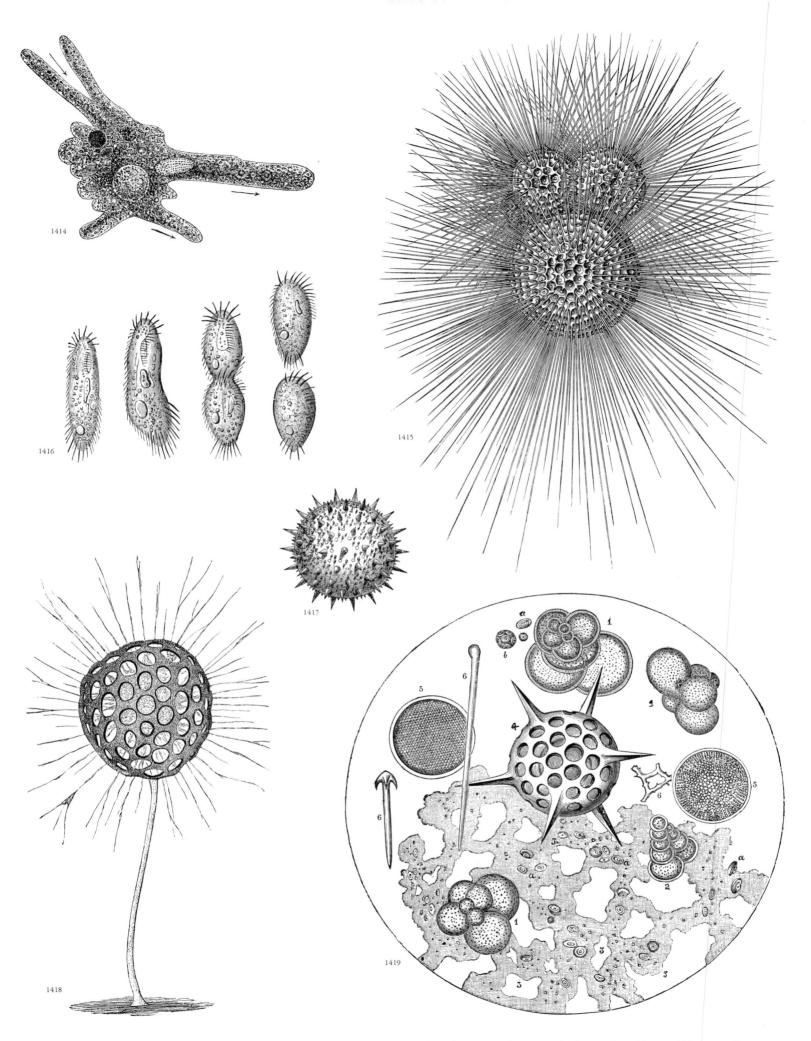

**OTHER INVERTEBRATES.** 1414: A species of amoeba. 1415: A foraminifer of the genus *Globigerina*. 1416: Reproductive process of an infusorian. 1417, 1418: Unidentified invertebrates. 1419: A group of very small specimens (1, foraminifers of the genus *Globigerina*; 2, unidentified; 3, "bathybius," now known to be inorganic, with coccoliths, *a*, and coccospheres, *b*; 4, a radiolarian; 5, diatoms, now known to be algae; 6, spicules of sponges).

# INDEX

addax, 69
adder, 187
   death, 187
   puff, 186
affenpinscher, 36
agamid, 175
albatross, wandering, 130
alligator, American, 190–2
*Ameiva*, 175
amoeba, 278–9
amphiuma, three-toed, 204
Anabantidae, 223
anaconda, 178
angelfish, 221
angler, 212, 223
anole, green, 174
ant, 250–1
   red wood, 251
anteater
   giant, 85
   silky, 86
   spiny, 86
antelope, 68–9
   sable, 68
ant-lion, spotted, 251
ape, 2
apple shell, 273
aracari, 121
archaeopteryx, 169
archerfish, 212, 220
armadillo
   giant, 84
   nine-banded, 85
   six-banded, 85
   three-banded, 85
ass, North African wild, 82
*Asterias*, 274
*Astraea*, 277
auk, 126
   great, 126
   razor-billed, 126
avocet, European, 127
aye-aye, 8

babirusa, 57
baboon, 2
   hamadryas, 7
badger, 9
barbel, 210
barracuda, European, 223
basilisk, 174
bass, 219
   black, 219
bat, 95–7
   common European, 95–6
   "flying dog" fruit, 96
   fruit, 95
   horseshoe, 96
   leaf-nosed, 95, 97
   long-eared, 97
bear, 40–2
   common European, 42

grizzly, 41
   Himalayan black, 42
   polar, 40, 42–3
beaver, 94
bee, 248, 251
   honey, 251
   leaf-cutter, 251
bee-eater, European, 143
beetle, 242–3, 245, 248
   burying, 249
   common rhinoceros, 242
   gloss, 243
   Hercules, 244
   rhinoceros, 242, 245, 247
   spring dor, 249
   stag, 242, 244
   scavenger, 247
bellbird, bare-throated, 141
beluga, 46, 229
bird of paradise, 118–20
   king, 118
   red, 119
bison, 63
bitterling, 211
blackbird, 139
blackbuck, 69
blacksnake, 145
blenny, viviparous, 221
blesbok, 68
bloodhound, 36, 38
boar, wild, 54
bontebok, 68
bluebird, Eastern, 141
bluebottle, 256
bluefish, 217
bluethroat, 145
boa
   constrictor, 180
   emerald tree, 181
bobac, 91
bontebok, 68
bowerbird, satin, 138
bream
   common, 210–1
   sea, 211, 218, 220
*Breviceps*, 200
brittle star, 274
budgerigar, 115
buffalo, water, 64
bufflehead, 165
bulbul, green, 138
bulldog, 36
   French, 33
bullfinch, 135
bullfrog, 203
bullhead, brown, 209
bumblebee, 248
bunting
   corn, 142
   little, 142
   snow, 142
   yellow-breasted, 142

burbot, 209, 217
bushmaster, 185
bustard, little, 159
butterfly, 234–7
   marbled white, 236
   peacock, 235–6
butterfly-fish, 220–1
   criss-cross, 220
   three-striped, 221
buzzard, 101, 104
   rough-legged, 103

caiman, 193
   black, 190
Calliphoridae, 156
camel, Bactrian, 59
capybara, 94
caracara, 102, 104
cardinal, 137
carp, 210
   crucian, 210, 219
   golden, 210
   mirror, 210
*Cassis*, 273
cassowary, 125
cat, 19, 21
   Angora, 25
   domestic, 22–7
   marbled tiger, 19
   Persian, 25
catfish, 209
   electric, 209
   European, 209
cattle, 64
   Ayrshire, 67
   Devon, 67
   domesticated, 65–7
   Freiburg, 66
   Guernsey, 67
   Hereford, 67
   Holstein, 67
   Jersey, 67
   shorthorn, 67
centipede, 261
chameleon, 171
chamois, 62
char, 207–8
   blue, 207
cheetah, 18, 21
chimpanzee, 1, 3, 6–7
chipmunk, Eastern, 91
*Chirotes*, 177
chub, 210–1
cicada, 254
coati, 42
cobra, 186
   Egyptian, 188
   king, 188
   spectacled, 187–9
cockatoo, 113
   Banksian black, 113
   great black, 115

Leadbeater's, 117
   roseate, 114
cockchafer, common, 243
cockroach, 241
   American, 241
cod, 217
collie, 37
condor, 111
   California, 112
copperhead, 185
coral, 278
   star, 277
   stony, 278
*Coregonus*, 218
cormorant, 129
corsac, 32
Cossidae, 240
coucal, Senegal, 143
cowry, 273
coyote, 30
crab, 263–5, 267
   hermit, 264, 267
   horseshoe, 264–5,
   king, 264–5
   land, 265
   mantis, 267
   pea, 266
   spider, 266
crane
   crowned, 151
   demoiselle, 151
crayfish, 263
creeper, wall, 140
cricket, 248
crocodile, 190–2
   American, 191
   salt-water, 192
crow
   carrion, 149
   hooded, 150
*Cryptocephalus*, 243
cuckoo, 136
   great spotted, 137
curassow, 155
curlew, 131
cuttlefish, common European, 268

dab, 216
dachshund, 35–6
*Danaus chrysippus*, 237
darter, African, 127
deer, 73
   axis, 72
   fallow, 74
   red, 72, 75
   roe, 72
   white-tailed, 72, 74
dinosaur, 168–9
Dipper, 139
dodo, 124
dog, 33–9; *see also specific breeds*

dogfish, 230
dolium, 273
donkey, 82
dove, 152, 154
   collared turtle, 154
   rock, 152
   turtle, 154
*Draco*, 176
dragon, (flying), 176
dragonet, 226
dragonfly, 257
drill, 6
dromedary, 59
*Dryophis*, 183
duck, 166
   harlequin, 167
   wood, 167
dung-pusher, 245
Dynastinae, 242

eagle, 99, 105
   bald, 99–100
   bateleur, 100
   Bonelli's, 105
   booted, 98
   crested, 103
   golden, 98–99
   imperial, 99–100
   short-toed, 105
   spotted, 99
   white-tailed, 99
earthworm, 271
echidna, 86
echinoderm, 274
eel
   conger, 214
   electric, 214
   European, 215
eelpout, 221
eider, 167
elephant, 50–4
   African, 53
   Indian, 53
ermine, 9
escuerzo, 200
*Euchroma gigantea*, 242, 246
euphonia, violet, 138

falcon, 101, 104
fennec, 30
fer-de-lance, 185
fieldfare, 139
firefish, red, 226
fish, 212–5, 218, 221, 223–7
   bellows, 223
   hen, 221
   weather, 209
fisher, 10
flamingo, 128
flatfish, 216
flea, human, 254
flicker, 146
flounder, 216
fly, 256
   blow, 256
   bot, 256
   lantern, 255
   tsetse, 256
flycatcher
   collared, 141
   paradise, 122
flying fish, 218
   Atlantic, 218
foraminifer, 278–9
fowl, domestic, 162–3
   Cochin China, 163
   Wyandotte, 163
fox, 28, 30–2

arctic, 32
bat-eared, 31
desert, 30
fritillary, 237
frog, 199, 201–3
   Brazilian horned, 201
   European edible, 199, 202
   horned, 200
   ornate chorus, 202
   Reinwardt's gliding, 200
   South American poison, 202
*Fungia*, 278

gadfly, common, 256
gannet, 129
gar, longnose, 229
gavial, Indian, 192
gazelle, 70
gecko
   flying, 173
   fringed, 173
   wall, 173
ghost walker, 241
Gila monster, 172
gilthead, 218, 220
giraffe, 70–1
*Globigerina*, 279
gnu, 68
goat, 60
   Angora, 62
   bezoar, 60
goldfinch, 135
goldfish, 210, 212
goosander, 166
goose
   brent, 165
   Canada, 164
   cereopsis, 165
   Egyptian, 166
   grey lag, 165
   spurwinged, 164
gopher, pocket, 93
gorilla, 1, 5
gourami, 224
grasshopper, 248, 252, 254–5
grayling, 207
greyhound, 34, 36, 39
griffon, Rüppell's, 112
grosbeak, rose-breasted, 137
grouse, 155
   black, 160–1
guineafowl
   common, 158
   crested, 158
   vulturine, 156
guinea pig, 89
gull
   black-headed, 130
   common, 130
   great black-backed, 130
   herring, 130
gurnard
   saphirine, 223
   tub, 223
gyrfalcon, 106

haddock, 217
halibut, 216
hare, 90
   varying, 90
harrier
   hen, 102
   Montagu's, 102
   pallid, 102
hawk, 102–3
   sparrow, 102, 104
hawk-moth
   broad-bordered, 240

death's-head, 238
hazel hen, 155, 160
*Helix*, 271
hellbender, 205–6
heron, 124
   boat-billed, 127
   Goliath, 127
herring, 218
hippopotamus, 58
honeyguide, greater, 143
hoopoe
   European, 136
   wood, 136
hornbill
   concave-casqued, 120
   North African ground, 120
hornet, 249–50
horse, 76–81
   Arab, 78
   Percheron, 76
housefly, common, 256
huchen, 207–8
hummingbird, 132–4
   giant, 133
   racket-tailed, 133
   sickle-billed, 133
   sword-billed, 133
hydra, 278
Hydrophilidae, 247
*Hydrophis*, 181
hyena
   spotted, 31
   striped, 30
*Hypolimnas missippus*, 237

ibex, 62
   European, 62
ichthyosaurus, 168–9
ide, 211
iguana, 170
   Galápagos land, 170
   marine, 175
   South American, 172
iguanodon, 168–9
*Ilysia*, 180
infusorian, 279
insect, 241, 246–9, 253–4
invertebrates, 272, 275, 277–9
*Ixodes*, 259

jacana, 131
jackal
   common, 31
   side-striped 31
jackdaw, 150
jaguar, 20–1
jay, 149
   blue, 137
jellyfish, 275
jerboa, 30, 94
John Dory, 224

kangaroo, 83–4
kestrel, 105
kingfisher, 140
   European, 140, 147
   pied, 144
kinkajou, 8
kite, 106
   black-winged, 104
kiwi, common, 123–4
koala, 83, 86
koel, 150
krait, 183
   banded, 189
kudu, greater, 69

ladybird, seven-spot, 245
lammergeyer, 111
lappet, pine, 239
largemouth, 219
leafbird, golden-fronted, 138
leopard, 18–9
*Leuciscus*, 211
lion, 11–4, 18
lizard, 175–7
   agamid, 170, 174, 175
   East Indian water, 170
   European fence, 174
   frilled, 172
   girdle-tailed, 175
   glass, 177
   green, 172
   horned, 171
   moloch, 171
   monitor, 173
   short-horned horned, 171
   spiny-tailed agamid, 175
   stump-tailed, 175
   wall, 176
   worm, 177
llama, 60
loach
   spined, 209
   stone, 209–10
lobster, 266
   common, 266
   spiny, 264, 266
locust, 252–5
longhorn (beetle)
   carpenter, 242
   compost, 242
   great oak, 244
   harlequin, 246
   hero, 244
   sawyer, 242
loris, slender, 8
lory, purple-capped, 116
lovebird, peach-faced, 114
lump, 221
lumpsucker, 221
lungfish, 206
lynx, Canada, 20
lyrebird, 118, 162

macaque, 1, 5
macaw, 114–5
mackerel
   common, 217
   horse, 218
magpie, 150
mallard, 166
mammoth, 52
mandrill, 7
mangabey, 3
mantid, 255
marmoset, 7
   golden, 3
mastiff, 33
matamata, 198
meadowlark, 141
*Megasoma elephas*, 245
merlin, 103
midge, 257
minivet, 138
mink, 9
minnow, 211
miter shell, 272
mole, 248
mollusk, 273
monkey, 1, 6–7
   colobus, 1
   entellus, 4
   Hanuman, 4
   proboscis, 3

spider, 1, 6
squirrel, 4
tamarin, 3
woolly, 7
monkfish, 212, 223
moose, 74
moray, common, 215
*Morone*, 219
Morphidae, 234
mosquito, 257
moth, 238–40, 248–9
  cecropia, 240
  garden tiger, 240
  goat, 239
  greater emperor, 238
  lesser emperor, 240
  Viennese emperor, 238
  wood-borer, 240
mouse, 93
  harvest, 92
  house, 90
  pocket, 92
moving leaf, 255
mullet, red, 224
muntjac, 74
musk poulp, 269

narwhal, 46, 49
nautilus
  paper, 269
  pearly, 269
*Nephila*, 260
*Nereis*, 271
Newfoundland (dog), 34, 39
newt
  alpine, 205
  crested, 204
  smooth, 206
nightjar, pennant-winged, 121
Nitidulidae, 243
*Nototrema*, 201

octopus, 268
  common European, 270
oilbird, 123
okapi, 71
olm, 205
opah, 224
opossum, 84, 86
orangutan, 2, 4
orfe, 211
oriole, Baltimore, 144
oryx, beisa, 69–70
osprey, 101, 103
ostrich, 124
*Otiorhynchus*, 247
otter, 10
owl
  American barn, 107
  burrowing, 108
  eagle, 107, 110
  European barn, 108
  great grey, 109
  hawk, 110
  horned, 107
  Indian fishing, 109
  Lapland, 109
  little, 107
  long-eared, 108
  pygmy, 108
  scops, 108
  short-eared, 109
  snowy, 107–9
  tawny, 109
  Tengmalm's, 108
  Ural, 110
oyster, thorny, 272
oystercatcher, 131

*Palaeornis*, 116
pangolin, 85
parakeet, 113, 116
  Carolina, 116
parrot, 113–5
  Amazon, 116
  gray, 116
partridge, red-legged, 155, 160
peacock, Indian, 157
peccary, 54
  collared, 57
pelican, white, 129
penguin, 126
  rockhopper, 126
perch
  common, 219
  pike, 219
petrel, 130
  giant, 130
pheasant, 156
  brown eared, 158
  common European, 160
  golden, 155
  gray peacock, 156
  great argus, 156, 159
  Reeves's, 158
  silver, 159
Pichincha hill star, 132
Pieridae, 235
pig, 55–6
  Berkshire, 55
pigeon, 152, 154
  crowned, 152
  domestic, 153–4
  passenger, 152
  Victoria crowned, 151
pike, 229
pintail, 167
pipefish, great, 213
piraya, 222
pitta, 143
plaice, 216
plantcutter, Chilean, 138
platypus, 83
plesiosaurus, 168–9
plover, golden, 131
pointer, 34, 37
polecat, 9
*Polistes*, 250
*Pomacentrus*, 224
poodle, 37
porcupine
  crested, 94
  tree, 86
porcupine-fish, 223, 226
porpoise, 46
potoo, great, 121
potto, 8
prairie chicken, 159
  greater, 161
pronghorn, 70
ptarmigan, 161
pterodactyl, 168
puffin, Atlantic, 126
pug, 33
pupa-predator, 246
python
  African rock, 175
  Indian, 178
  rock, 178, 180

quail, 161
  California, 159, 161
quetzal, 117

rabbit, 87–9

raccoon, 42
radiolarian, 279
rat
  Norway, 93
  Ord's kangaroo, 92
rattlesnake, 184–5
  Eastern diamondback, 184
  Western diamondback, 184
raven, 149–50
ray, 231–3
  marbled electric, 232
  thornback, 232–3
redstart, black, 148
reindeer, 74
rhamphorhyncus, 169
rhea, great, 125
rhinoceros, 58
roach, 211
roadrunner, 155
robin, American, 141
rodent, 89, 93
rook, 150
rorqual, 48
rudd, 211
ruff, 131

sailfish, 228
salamander, 204
  European blind, 205
  Japanese giant, 206
  spotted, 204
salmon, 208
sand dollar, 272
sandgrouse, black-bellied, 154
sand star, 274
saurel, 217
saury, 228
sawfish, 228, 230
scad, 218
scallop, 272
scorpion, 262
scoter, velvet, 167
sea anemone, 271, 275
sea cucumber, 276
sea hen, 221
seahorse, 213
seal, 43–4
sea lion, 44
secretarybird, 101
seriema, crested, 155
Serranidae, 215
setter, 39
shark, 230
  blue, 230
  fox, 233
  frilled, 232
  hammerhead, 231
  Port Jackson, 231
  thresher, 233
sheep, 60
  bighorn, 60
  domesticated, 61
  Leicester, 62
  merino, 60
  Shropshire, 62
shelduck, ruddy, 164
shoveller, common, 166
shrew
  elephant, 90
  tree, 86
shrike
  great grey, 136
  red-backed, 136
shrimp, 266
siren, 206
siskin, 135
skink, 171
skunk, 9–10

slow-worm, 177
smooth hound, 231
snail
  agate, 272
  edible, 271
snake, 179–81, 183–4
  Aesculapian, 179
  coral, 184, 189
  Eastern glass, 177
  European grass, 182
  Java wart, 182
  sea, 189
  yellow-bellied sea, 182
snipefish, 223
solarium, 273
sole, 216
spadefoot, European, 200
spider, 258–9, 261
  bird, 259
  common barrel, 262
  crab, 258
  garden, 258–9, 261
  trapdoor, 258
  water, 261
  whip, 258
sponge, 279
springbok, 69
spur dog, 231
squid, 268–9
  common European, 268
squilla, 267
squirrel
  European red, 90–1
  flying, 90
  Southern flying, 91
  thirteen-lined ground, 91
starfish, 274
stargazer, 222, 227
starling, glossy, 149
stegosaurus, 168
stickleback, 222
stingray, 231
stonechat, 143
stork, 124
  marabou, 128
  openbill, 128
  white, 128
sturgeon, 228
  common, 228–9
sunbird, 120
sunfish, 222
  pumpkinseed, 219
swallowtail, 235
swan
  black, 164, 166
  whooper, 165
swift
  Alpine, 141
  common European, 141
  crested, 140
  tree, 140
swiftlet, 142
swordfish, 227–8

tamandua, 85
tana, 93
tanner, 242
tapir, Malayan, 54
tarantula, 258
tarsier, 8
teal, 167
tegu, 174
teleosaurus, 169
tenrec, 84
terrier
  fox, 33
  Scottish, 36
Theliphonidae, 261

thick-knee, 131
thrasher, brown, 145
thrush
   blue rock, 148
   mistle, 139
   rock, 136
   song, 139
tick, 259
tiger, 15–17
tilefish, 222
toad, 199
   European common, 199–200
   European green, 199
   midwife, 203
   natterjack, 199
   Surinam, 201
Tora, 68
tortoise, 194–5
   Galápagos giant, 194
   hinged, 193
   Moorish, 195
toucan, 120
touraco, 121
tragopan, 157
treefrog, 202
   European green, 203
triceratops, 168
triggerfish, 214
*Trionyx*, 193
trout, 207–8
   brook, 208
   European lake, 207
   sea, 207–8
*Tubularia*, 276

tuna, 218
turbot, 216
turkey, 158, 160
   brush, 155
turtle, 197
   alligator snapping, 198
   bigheaded, 197–8
   box, 194
   Eastern box, 194
   European pond, 195
   giant side-necked, 198
   green, 193
   hawksbill, 194, 196
   leatherback, 196
   mud, 196
   musk, 196
   painted, 197
   snake-necked, 198
   softshell, 197
   wood, 193, 195–6

umbrellabird, long-wattled, 121
underwing, popular crimson, 239

viper, 186
   asp, 187
   European, 187
   horned, 186
volute, 273
vulture, 112
   American black, 111
   bearded, 111
   Egyptian, 111–2

   king, 111
   Pondicherry, 112

Wagtail, grey, 139
walrus, 43–4
wapiti, 74
warbler
   Dartford, 135
   Marmora's, 135
   sedge, 138
   Southern European, 135
   spectacled, 135
   subalpine, 135
warthog, 57
wasp, 250
water moccasin, 185
waxwing, Bohemian, 137
weasel, 9–10
weaver, 122
   orange, 122
weever, greater, 222
weevil, 247
   great brown, 247
   hazel-nut, 247
wels, 209
whale
   finback, 49
   Greenland, 49
   humpback, 48
   killer, 49
   piked, 45
   right, 45–6, 49
   sperm, 47–8

   white, 46
wheatear, 143
   black, 148
whelk, 272
whinchat, 143
whiting, 217
whydah, paradise, 122
wildcat, 20
wolf, 28–9
wolverine, 10
woodpecker
   black, 148
   great spotted, 146–7
   green, 147
   ivory-billed, 146
   lesser spotted, 147
   Lewis's, 146
   middle spotted, 147
   red-headed, 146–7
   three-toed, 146
worm, 271
wren, 139
wryneck, 147

yak, 64
yellowhammer, 142

zebra, 82
   Chapman's, 82
zebu, 65
zope, 211